Dear Bill,
 one of your best years - Hope
that next year will ever be better. Am
looking forward to your new image.
 Love,
 Lou.

Dear Bill 1977

One of your best years - Hope
that next year will even be better. Am
looking forward to your new images.

love,
Dan.

Adventures in Western Art

Dean Krakel

Leader's Downfall, 6' x 10' oil by William R. Leigh, collection of Mr. and Mrs. Luther T. Dulaney.

Photo by Jon Burris

Adventures in Western Art

Dean Krakel

THE LOWELL PRESS / Kansas City

Krakel, Dean Fenton, 1923—
Adventures in Western Art.

Bibliography: p.
1. Krakel, Dean Fenton, 1923—
2. Museum directors—United States—Biography.
3. The West in art.
4. National Cowboy Hall of Fame and Western Heritage Center.
I. Title.
N654.K7 069'.9'70924
[B] 76-21136
ISBN 0-913504-35-1

FIRST EDITION

Printed in the United States of America

Contents

List of Illustrations vii

Acknowledgments ix

Introduction xiii

 1. THOMAS GILCREASE 1

 2. A PILE OF NICKELS 21

 3. WILLIAM R. LEIGH'S STUDIO: FIRST COUP 41

 4. ON THE TRAIL OF C. M. RUSSELL 67

 5. THE FRASER PROJECT 90

 6. A MILLION DOLLAR MEMORIAL 106

 7. CHARLES SCHREYVOGEL: BUGLES IN SANTA FE 119

 8. WHEELING AND DEALING FOR WESTERN MASTERPIECES . 146

 9. THE CARL LINK WINDFALL 162

10. NICOLAI FECHIN 207

11. A TOUCH OF GREATNESS 222

12. DEALERS I HAVE KNOWN AND LIKED 235

13. FRAUD, HORROR, AND THE CHECKBOOK 254

14. ZEROING IN ON VALUES 271

15. THE OATH 281

16. IN FROM THE NIGHT HERD 306

Sources and Notes 323

Index 371

BOOKS WRITTEN BY DEAN KRAKEL:

South Platte Country, A History of Old Weld County
The Saga of Tom Horn, Story of a Cattleman's War
James Boren, A Study in Discipline
Tom Ryan, A Painter in Four Sixes Country
End of the Trail: The Odyssey of a Statue

Illustrations
by Contemporary Artists

THOMAS GILCREASE by Charles Banks Wilson xviii

A WILD TURKEY by Robert Kuhn 19

GILCREASE INSTITUTE by Paul Rossi 22

THOMAS MORAN by Paul Rossi 29

WILLIAM R. LEIGH by Paul Rossi 42

NATIONAL COWBOY HALL OF FAME by Conrad Schwiering 68

CHARLES M. RUSSELL by John Clymer 75

JOEL MCCREA by Bettina Steinke 79

JAMES AND LAURA FRASER by Robert Lougheed 93

PAYNE-KIRKPATRICK MEMORIAL by Wilson Hurley 107

CHARLES SCHREYVOGEL by Tom Lovell 121

GEORGE A. CUSTER by Ralph Wall 124

NEW YORK SKYLINE by David Blossom 146

M. KNOEDLER AND COMPANY by Paul Calle 151

NICOLAI FECHIN by James Boren 209

JASPER ACKERMAN by Ned Jacob 224

MOUNTAIN OF THE HOLY CROSS by Juan Menchaca 226

FRED ROSENSTOCK by Ned Jacob 250

EASEL by Phil Young 276

LUTHER T. DULANEY by Clark Hulings 285

JOE W. GORDON by Bettina Steinke 313

ALBERT K. MITCHELL by Tom Phillips 318

ADVENTURES IN WESTERN ART
is dedicated to

Jasper Ackerman
Luther T. Dulaney
Thomas Gilcrease
Joe W. Gordon
William G. Kerr
Iris Krakel
Joel McCrea
J. B. Saunders

Acknowledgments

The major source of research for my adventures has been my private collection of personal papers, my Gilcrease journal, correspondence files, and minutes of directors' meetings. The Leigh material accumulated from a number of sources, including my own correspondence with Mrs. Leigh and John Traphagen. Copies of Gilcrease board minutes were useful in documenting the facts and establishing chronology. My Cowboy Hall of Fame sources were close at hand, and materials on Cowboy Artists of America as it relates to the Hall and NAWA are perhaps the most complete in existence. Being a pack rat by nature, my files bulge from within thirty cabinets, holding assorted memorabilia, copies of letters written and received, clippings, articles, and various formal and informal records. Western Art Fund, Inc. papers are complete and intact as is a documentation of CHF activities through minutes, board meetings, financial records, and correspondence files.

I imposed on several readers for their comments and remain grateful to them: my wife, Iris Krakel; Fred and Ginger Renner, then of Washington, D.C.; Paul and Florence Rossi of Tucson; Joe Gordon and Betty Marx of Pampa, Texas; Paul and Theo Strasbaugh and William G. Kerr of Oklahoma City; Jasper Ackerman, Colorado Springs; Victor Hammer, Robert Henry, J.N. Bartfield, and Rudolf Wunderlich of New York City; Robert Rockwell of Corning, New York; and June DuBois of Indian-

apolis. Esther Long, Edrie Weehunt, Bryan Rayburn, Rich and Norma Muno of the Cowboy Hall of Fame read drafts as did Robert and Cordy Lougheed, Santa Fe, New Mexico; Wilson and Rosalyn Hurley of Albuquerque, New Mexico; and James and Mary Ellen Boren of Clifton, Texas.

Shirley Sebert, Lu Osborn, Alisa Krakel, and Donna Dolf brought typewritten order from the several manuscripts over a period of three and one-half years. I'm indebted to them for their typing skills.

Barton Gilcrease, San Antonio, Texas; Eudotia Teenor and William S. Bailey of Tulsa read chapters pertaining to Thomas Gilcrease. Alisa and Dean Krakel II of Livingston, Montana read drafts. Joel McCrea, Camarillo, California read the Russell chapter; Archie D. Carothers, Charles Schreyvogel's son-in-law, liked "Bugles in Santa Fe," as did Mr. Carothers' attorney, John McCarthy. Mitchel Wilder said I told the purchase story of *When Mules Wore Diamonds* satisfactorily. Tom Watson, attorney for the Cowboy Artists of America read "The Oath" and commented astutely on the chapter. Mrs. William F. Davidson and her son Peter read and discussed with me those parts mentioning the late William F. Davidson. All the foregoing helped in various ways from telling it straight to helping with grammar, spelling, punctuation, arrangements, and deletions.

Specifically, Fred Renner gave me excellent criticism in the form of five typewritten, single-spaced pages. He not only commented and helped me in his authoritative way on C.M. Russell but made other suggestions. Dean Krakel II offered pertinent ideas concerning the Gilcrease chapters.

Jasper Ackerman, J.B. Saunders, and Bill Kerr were among my first readers. I sought their approval more than anything for what I had written about them. Jasper, among many suggestions, corrected my consistent misspelling of "nickel." New York City attorney Bob Henry refreshed my memory and counseled me on the circumstances of the Carl Link estate. Victor Hammer was the most inspiring of all readers. "My God," he exclaimed, "no other

museum director has opened up the way you have."

Sara Dobberteen, senior editor of *Persimmon Hill* magazine, checked facts and misspellings and went through the manuscript word by word. She gave good editorial advice, most of which I took, and helped me with the less exciting but important task of preparation of notes and sources. Because of Sara's work, *Adventures* contains less fat and blubber and is a better book.

Rich Muno, colleague and friend of my adventures, beginning June 15, 1961, designed the arrangement of photographs. The fact that the book doesn't contain a photograph of art dealer Tony Bower remains a mystery. We tried. Rich, Sara, and I made the selections. Jon Burris, director of photography at the Cowboy Hall of Fame, did much of the copy work, photographed the studio shots, and photographed the several paintings in the book. Following a concept I envisioned, Jon did the original photography for the dust wrapper, assisted by Rich Muno and Phil Young.

Ed Shaw, director of the University of Oklahoma Press, allowed us to reproduce chapters from *End of the Trail: The Odyssey of a Statue.* Mr. Shaw also permitted me to quote Frank Bird Linderman from University of Oklahoma Press's *Recollections of Charley Russell.* Chapter three, "William R. Leigh Studio, First Coup," appeared for the most part in an issue of *Montana Magazine.* My piece on Fred Rosenstock was featured in my column, "As I Was Saying," *Persimmon Hill,* volume 6, number 2.

The manuscript grew out of my relationship with Angus Cameron, senior editor at Random House Knopf. He suggested years ago that I jot down my adventures. Under Angus's guidance at numerous luncheons and meetings in his office, the manuscript took shape. "Put this or that story down," he would say, and I did.

I am indebted to publisher Payson Lowell and editor Doug Petty for their assistance and manufacture of the book and the freedom they allowed us to meddle in such technical matters as choice of type faces, dust wrappers, chapter headings, and design. The entire crew at Lowell Press was great to work with.

I am grateful to artist friends who contributed terrific drawings

for chapter headings and inserts, thus enriching the book immensely: John Clymer, Tom Lovell, Robert Lougheed, Wilson Hurley, Bettina Steinke, James Boren, Conrad Schwiering, Robert Kuhn, Paul Calle, Paul Rossi, David Blossom, Ned Jacob, Ralph Wall, Tom Phillips, Juan Menchaca, Phil Young, Charles Banks Wilson and Clark Hulings.

As they say, "last but not least," I'm grateful to my wife Iris, daughter Jennie, and son Jack. In my mind and heart, Iris leads the race for frankness, honesty and what's worthwhile. Without her, my *Adventures in Western Art* would perhaps not have happened.

<div align="right">Dean Krakel</div>

Oklahoma City
February 1977

Introduction

My father grew up in Ault, in north central Colorado where the short-grass plains roll up against the Rocky Mountains. For a young person interested in the West's history and the out-of-doors, his was the best of both worlds. He wandered over the prairie in search of arrowheads, buffalo skulls, and the rusted remains of guns. He climbed to the high peaks, followed trout streams and trappers' trails, felt the storm winds in his face, and marked time with the eagles playing among the air currents. He felt the pulse of this land and grew to love its history, its wild, rugged beauty, its people, and its spirit.

When I was old enough to travel, my father took me on trips through his country. One of our favorite areas was around Keota, a small town surrounded by a vast emptiness of wind and buttes and trembling grass. At the age of eleven I wrote of Keota in my journal: "I think God forgot this place. There are no fences. There are no people. I like it fine." As we searched for arrowheads and poked among the ruined homesteads, I was held spellbound by Dad's stories of Indian, buffalo, explorer, trapper, cowboy, and of his own adventures—of once seeing a grey wolf and of his Grandmother Cross who homesteaded near there and was known to clean out the rattlesnakes beneath her house by snapping their heads off.

Today only two buildings remain in Keota. They sit on opposite sides of what was once the main street. One is the old hotel, with a

weather-beaten false front whose windows stare blankly at the windswept plains and chalk bluffs like empty, unseeing sockets. The door is chained and boarded shut and has been for nearly half a century. Across from the hotel and down the street a short distance is the other building, Clyde Stanley's store.

Clyde, a small stooped man, has lived most of his life in Keota. He still talks about the time he went to the Greeley County Fair. Ever since the store's trade tapered off, he has run a printing press in the back room, doing odd jobs for ranchers—mostly stationery and Christmas cards. The last time I was there I bought a dozen cards with bold black lettering printed on them: "Cattle Thieves Beware. You Are Invited to a Necktie Party Courtesy the Colorado Range-Riders." Clyde told me the cards were an overrun and I bought them for a nickel each.

One winter day two years ago, I drove to Keota. Actually, I was enroute to Pawnee Buttes to try and photograph Golden Eagles, but I stopped at Clyde's store to buy a candy bar.

"What's your name, son?" Clyde said peering at me through his glasses and counting my change out on the glass counter.

I told him and he paused a long time. "Thought you looked familiar. Look like your dad. He still at that place in Colorado Springs?"

"No," I said, "He is in Oklahoma City at the National Cowboy Hall of Fame."

"National Cowboy Hall of Fame, huh? That some sort of museum?"

I explained to him about the Hall of Fame and he stood peering at me intently as I went on and on for the course of five minutes about what the Hall contained and all its activities and functions. After I was through, Clyde gave a thoughtful silence and then said, "Managing director, huh? What's he do there, stand up front and greet the folks when they come in?"

I cannot explain to anyone what my father has done in the past years. The distance between Keota and the beginnings of a dream and Oklahoma City can't be measured in miles alone. They must

be measured in the span of a man's life and a very ambitious, energetic man at that—a man with a vision.

Each year three hundred thousand people visit the National Cowboy Hall of Fame. Among them are artists, collectors, dealers, gallery owners, history buffs, and students from all corners of the globe, drawn here to see one of the finest collections of Western art in existence. The Russells, Remingtons, Morans, Bierstadts, Schreyvogels, and Fechins line the walls like brightly colored-jewels. Some, perhaps, are here to participate in one of the Hall's programs, such as the National Academy of Western Art exhibition. To anyone interested in Western art, the National Cowboy Hall of Fame is the center of the world, a growing young giant whose pulse is felt in virtually every corner of our country.

I like the Hall best in the autumn after the summer crowds have faded, when the hillside grass is browning and fallen leaves lay in thick carpets on the pools and an early setting sun scatters broken light across the floor. I like to sit alone in the main gallery surrounded by my favorite paintings: Moran's *Mountain of the Holy Cross*, Russell's *When Mules Wore Diamonds*, Remington's *Hunter's Camp in the Bighorns*. It is easy to be absorbed in the energy of the place, to be caught up in its forward momentum and carried along like flotsam. But for me there is something more in these silent halls than just paintings. There are voices, feelings, and memories that no casual visitor sees or hears. Most of them concern my father, for he dominates this place, if not in person, then in spirit. I do not look in any corner or upon any wall that I do not hear his voice or feel his presence.

When Dad came from Tulsa's Gilcrease Institute more than a decade ago, the Cowboy Hall of Fame was an empty shell standing forlornly atop Persimmon Hill. The entrance gates were padlocked shut. Construction had been halted by what seemed an insurmountable debt. The Hall had been started with a dream, a dream carried to maturity in concept and partial construction by many dedicated people throughout the West. But without funds, without a man with the vision to see what the Cowboy Hall of

Fame could and should be, those dreams became as empty as that shell. It took my father, his energy, his ability, and a good part of his life to make the dream materialize in the shape of a completed building and then to make what that building contained into a national treasure. My father brought this vision with him from the plains of Keota—his desire to shape a lasting memorial to the old West and to do something for the new West, to give it a sense of its own past. And what better way to accomplish this than through the works of masterful artists who lived the West that they painted. Their works are more vivid for us than any journal or book. They are our window to the past.

This dream sustained my father through the beet fields of eastern Colorado, a war, three universities, and two museums, until finally, in Oklahoma City, he found a challenge equal to his vision.

His enthusiasm for any and all projects is boundless. His energy and optimism are catching. There are few people who can meet him without being caught up in his vision and, once caught, all obstacles, imaginary or real, vanish. It is this vitality, this drive, this toughness, this optimism, and this will to see things through, to mold and shape them and give them direction and stability that have made the National Cowboy Hall of Fame what it is. Without his guidance, it would have, as an institution, become lost just as surely as any ship without a captain.

My father has had unprecedented impact on the value and future of Western art. Boasting, perhaps, but very few men have ever assembled such a wealth and variety of the West's great art treasures under one roof—treasures that he keeps nurturing and expanding with continued support from the directors and trustees. This book is the story of how all this was accomplished. It is the story behind the art, but unfortunately cannot hope to be the story behind the man.

DEAN KRAKEL II
Livingston, Montana

xvi

Adventures
in Western
Art Dean Krakel

Thomas Gilcrease by Charles Banks Wilson

Chapter 1

Thomas Gilcrease

I WAS DIRECTOR of the Thomas Gilcrease Institute of American History and Art,[1] Tulsa, Oklahoma, from June 1961 through October 1964. They were difficult times because the Institute was undefined operationally and undergoing physical expansion. Added to this was my administrative inexperience. Whatever unhappy thoughts I may have had of elected politicians and City Hall civil servants trying to operate a fine arts museum, I never lost sight of the Institute's magnificent collections or the memorable times with Mr. Gilcrease.[2] While my first year at the Institute was T.G.'s last in life, for me it was a year filled with excitement. It is not necessary to pass judgment on the vitality of the Thomas Gilcrease I knew contrasted to former years when, as they say, he cut a wide swath. I knew him as a polished gentleman with quiet courtly ways. There had been another side to his life, and I recognized that he had made millions in the oil fields and experienced a lot of living. However, of importance to me was the fact that he had formed the greatest collection of western Americana ever assembled.

A number of attributes were to be an advantage in my relationship with Mr. Gilcrease and the Institute. I had grown up admiring the Plains Indians and thought of them as identifiable human beings, living meaningful lives. I had a great love of books and manuscripts and a knowledge of artists of the trans-Mississippi West: Karl Bodmer,[3] George Catlin,[4] Alfred Jacob Miller,[5] and,

of course, Remington[6] and Russell.[7] My greatest pride, however, grew from the fact that I was a Westerner devoted to keeping the character of the West alive. These were essentially the facts of my case, aside from my educational background and determination to accomplish something worthwhile in life.

I became interested in the Gilcrease Institute through Martin Wenger,[8] an associate and friend dating from our days in graduate school at the University of Denver and tenure on the staff at the Colorado Historical Society. Martin had come to Gilcrease as librarian in 1955 and was the first to hold this position at the Institute under the city's ownership. Martin and I kept in touch and by chance, during a telephone conversation with him, I mentioned that I was leaving the United States Air Force Academy where I had been in a museum development and public relations program.[9] I wanted to return to a historical museum, but before I did I hoped to work at the Smithsonian Institution, while earning a doctorate in history from American University, Washington, D.C. My presentation was prepared and ready to send to the Smithsonian. Martin suggested I try for the Gilcrease job, adding that it had been vacant for a long time while an interim director filled the position. My knowledge of the collection dated from the critical years of Gilcrease's indebtedness and was based on the article that appeared in *Life* magazine[10] featuring Mr. Gilcrease and his collection. I had been highly impressed by the article—even saved the issue, rereading it often.

I talked the matter over with my wife, Iris, and decided I might as well apply. I forwarded my Smithsonian package with a new cover letter to the personnel director for the city of Tulsa, knowing that a number of applicants were to be considered. The possibility seemed remote that I would get major consideration. So it was with a great deal of surprise that I received a telephone call from Lowell Long, personnel director, asking me to come to Tulsa for an interview with the directors of the Gilcrease board, members of the Tulsa Park Board,[11] and Thomas Gilcrease. I flew to Tulsa on the afternoon of May 11th. Later on, I telephoned

William S. Bailey, Jr.,[12] who was my contact, to report my arrival. Mr. Bailey was treasurer of the board of directors and a close and confidential friend of Mr. Gilcrease.

The next morning Mr. Bailey met me in the lobby of the Tulsa Hotel. I remember what a warm, wholesome, gentlemanly impression my host made on me the first time we shook hands. I gained a feeling of respect for him then that I still carry. From the hotel we went to the city personnel offices where I met Mr. Long; Gordon T. Hicks,[13] chairman of the Tulsa Park Board; Alfred Aaronson,[14] past president of the board; Otha Grimes[15] and David Milsten, directors; and Thomas Gilcrease. About two hours were spent in general discussion of museums, their history, and operating programs. My attitude toward the directorship was one bordering on flippancy, since I didn't think I had a ghost of a chance of being hired. Martin had mentioned that there were thirty-nine applicants.

A luncheon was held at the Mayo Hotel. I sat next to Mr. Gilcrease. I recall how quick he was and how impressive was his knowledge of the West.

After lunch, we toured the Institute. The exhibit galleries astounded me. Leaving the museum building, we went to the Gilcrease Foundation, where I saw a great deal more Western art and Mr. Gilcrease's extensive collection of Indian artifacts. At this time I was introduced to Mrs. Eudotia Teenor,[16] Mr. Gilcrease's attractive and devoted secretary. At the conclusion of the day, I told Mr. Gilcrease how pleased I was to meet him and thanked him for his kindness. In passing, I said that meeting him had been a particular pleasure, since I had recently read Aline Saarinen's book, *The Proud Possessors*,[17] containing a chapter about him. He offered me a copy of the book which I said I would very much like to have—especially if he would sign it. This he did, writing, "To my friend, Mr. Dean Krakel, May 12, 1961," signing it, "Wicarpi Waukatanya, Thomas Gilcrease."

His Indian name intrigued me. I recognized it as being Sioux. This pleasantly surprised him, and I explained that I was a

frequent visitor to Pine Ridge and had gained a sparse knowledge of the dialect. Mr. Gilcrease answered that his Sioux name, meaning "High Star," had been bestowed upon him by the Rosebud Sioux at a formal ceremony. In bidding Mrs. Teenor and Mr. Gilcrease good-bye, I felt, whether I got the directorship or not, that I had made friends.

William Bailey then drove me back to the airport for my return to Colorado. Mr. Bailey had a glint in his eyes and wore a big smile but said very little.

Few cities have appeared quite so beautiful to me as Tulsa did on that May day. The grass was green, trees were fully leafed, the lilacs were out, and the birds singing. I contrasted this scene with the cold, snowy Colorado I had left a few hours before. On my return flight, I couldn't help being excited about Gilcrease and Tulsa. Upon arriving home in Colorado Springs, I told Iris that if I were to be their choice, we would know probably Monday or Tuesday. We talked late into the night as I related the wonders I had seen. I really wanted the job!

Personnel Director Long telephoned the following Monday, stating he was authorized to offer me the directorship. It was agreed that I would begin work on June 15th. Excitedly I telephoned Iris. I was walking on a cloud. It was as if I were playing sandlot baseball and suddenly, out of the blue, Casey Stengal appeared before me and, crooking his finger, said, "Son, the New York Yankees want you!"

In coming to Gilcrease Institute, I was in for a tremendous experience—one that I soon realized I was not wholly ready for. It took weeks for me to settle down. I struggled with everything. Aside from day to day pressures, I found Tulsa's heat and humidity oppressive. Each day the collections, appraised in the millions, grew larger and their importance more awesome.

Any illusions I had or bubbles I might have mentally blown about some of the people behind the Institute were punctured shortly after my arrival, when a prominent board member and his wife hosted a late afternoon party in my honor at their home in

the south part of Tulsa. My family had not arrived from Colorado, so I attended alone. The reception was one of those affairs you often read about in the society pages of the Sunday newspaper. Because of who I was and where I had come from, I was ill-prepared for the occasion. Driving the museum's old panel truck, I drove up to the parking circle in front of their sumptuous home, and suddenly the entire thing hit me in the face: it was a world of white Continentals and light blue Cadillacs. I was formally ushered into their home and announced.

I had further added to my discomfort by buying a summer sport suit with a white belt, narrow-brimmed straw hat, and black and white shoes. I was completely out of character from my tradition-al western-cut coat, twill pants, boots, and hat. I remember looking in the mirror in my hotel room before leaving and muttering, "Who the hell are you?"

The entire evening was a strain. I was puzzled by the fact that Mr. Gilcrease and Mrs. Teenor were not present. It was hot and humid and I couldn't seem to stop perspiring. I didn't smoke, so I didn't carry a lighter, nor did I drink cocktails. I wasn't familiar with *Rigoletto* or the Tulsa Symphony. The topper came when a society dude said, "I hope you will enjoy Tulsa's stables—while you're here."

Although it was a comparatively short affair, it seemed to drag on. I shook hands and smiled endlessly at a sea of faces. As the last guest departed, my host invited me out on the patio where we could talk. It had turned out to be a lovely moonlit evening with magnolia blossoms scenting the air and whippoorwills calling. I gave a sigh of relief.

I was tired and prepared at best for light chit-chat when my host surprised me and grabbed my coat lapel. He snapped, "Let's get one thing straight, Krakel. You have a job to do for us. Get next to Tom Gilcrease. Win his confidence. He's got millions in art and real property. Your job is to see that it comes to Tulsa. I want you to keep me informed of everything you can that Gilcrease says and does. And who comes to see him and why! If you do that,

Krakel, you will make the grade here." He extended his hand and said, "Now do we understand each other?" I replied, "All too well," and excused myself.

I spent the night tossing and turning in my hotel room bed, mentally reassessing the reception. One certainty that emerged from the evening was that, whatever happened during my stay and regardless of how long it was, I vowed I would be an ally of Thomas Gilcrease and a confidential friend if he would have me. After I got to know Mr. Gilcrease, when he expressed doubts as to certain peoples' loyalties or pretenses about their friendship for him, I knew exactly what he was talking about. I never mentioned my first party in Tulsa.

From the outset, Mr. Gilcrease and I became good friends. I was completely taken by his quiet manner and personal charm. He often invited me to have coffee and sit with him in his sumptuous home, where, in the course of months, I listened to the unfolding of decades of dramatic living. He had experienced great discovery, was a pioneer oilman, and formed a potentially great company. Mr. Gilcrease had known such notables as Jack London, Ring Lardner, Richard Harding Davis, Jim Jeffries, Will Rogers, J. Frank Dobie, Cactus Jack Garner, Wiley Post, Wallace Beery, and a host of others. He bought Wiley Post one of his first airplanes. He and Jack London witnessed the invasion of Vera Cruz by U.S. Marines on a banana boat he rented. He sat around campfires on the east slope of Denali (Mount McKinley) with the widely known naturalist, Charles Sheldon. Tom had hunted moose, elk, and grizzlies on Kenai Peninsula and, by the time he was eighteen, he had that many producing oil wells. He knew tragedy firsthand because he had seen his own father shot down in cold blood.

He soberly pointed out that his life as an oilman had not been all roses, recalling a period when the Gilcrease Oil Company drilled eighteen consecutive dry holes. He added, "About the fifteenth, I began to wonder."

In Mr. Gilcrease's presence, I experienced feelings of humility and pride. When I sat with him, he talked and I listened. When he

quit talking, the conversation was over, and it was time for me to go. After one of his illuminating discourses on artists Alfred Jacob Miller, George Catlin, and Karl Bodmer, I tried to write down all he had said, in much the way he had spoken. I began testing my ability to recall and then to write down all I could. These recordings were to take the form of a journal. Entries became more important to me each day, as I began to think in terms of the knowledge I needed to gain about the collection. Above all, I wanted to understand Mr. Gilcrease, his spirit, his philosophy, and how he thought programs might be directed to gain the best advantage. Thomas Gilcrease came to the museum almost daily, giving me an opportunity to be with him and to listen to comments about paintings, what he liked about a certain work, or why he bought it. Frequently he would invite me to join Mrs. Teenor and himself for lunch so we could continue a conversation or start a new one.

During the summer of 1961, we were working on building plans and preparing for a bond election campaign in the fall in hopes of raising $600,000 to expand the museum by 25,000 square feet. We were successful in raising the money for the program. Through it all, I found it difficult to draw out Mr. Gilcrease on the proposed building plan. I wanted to know how he felt about it, but his attitude puzzled me immensely. What I was to learn revealed an interesting side to his nature.

One of the first things I did was to have a small scale model of the proposed building made so that I could carry it with me. I waited for an opportunity to show it to Mr. Gilcrease. Finally one evening after work the opportunity came. I saw him sitting on the front porch of his home. I waved and he beckoned to me. On reaching his front porch I said, "Good evening, Mr. Gilcrease," and placed the small scale model at his feet adding, "What do you think of this?" He moved forward deliberately in his chair and looked down at the model intently for several minutes. Then he raised his head and asked, "If we build this addition onto the front of our building, what will it do to my trees?" I replied that I

didn't know, but we could find out.

The next morning, bright and early, we were in front of the museum. Cephas Stout[18] and Legus Chalakee, both of Indian descent and long time Gilcrease employees, were with us. With a tape measure and stakes, Cephas and Legus laid out the proposed galleries. Soon I realized Mr. Gilcrease's concern. The addition meant that a beautiful pine tree would have to be cut down, as well as a great oak and several smaller trees. A beautiful soulangeana would also be lost. In looking over the outline we had staked out, Thomas Gilcrease said, "I love these trees. I planted each one of them. I hate to see them destroyed."

Somewhat perturbed, I asked if he had mentioned how he felt about the plan to the board of directors' building committee. He merely shook his head, muttering, "Nope." Then I asked, "Do you have any ideas or a plan?" After a pause, he said, "Yes, I do. I have a plan."

Within minutes, a faded blueprint was removed by Mrs. Teenor from a file in the Foundation's office. The print showed an expansion of approximately the same size as was proposed, only this was a wrap-around addition primarily on the west and north sides of the building, leaving the original sandstone front and the trees untouched. The concept contained a beautiful glassed-in lounge, and, by taking advantage of the land's natural slope, made possible intermediate and basement floors for the northwest portion of the structure. Mr. Gilcrease made known the fact that he had already quarried sandstone to face the new walls.

I asked him why he had not shown his blueprint to the directors during one of the many meetings he had attended. He looked at me intently for a few moments without comment, then said, "They never asked." He turned and walked back to his house.

A little while later I telephoned E. Fred Johnson,[19] president of the Board of Directors, and told him of my experience with Mr. Gilcrease. He was upset and started to mutter something along the lines of, "Well, I'll be a . . ." and then directed me to call a meeting

of the building committee right away. Mr. Gilcrease attended the meeting and made an eloquent presentation of his ideas as shown in the faded blueprint. In the end, Thomas Gilcrease achieved his goal. The expanded building with sandstone facing, dedicated on October 26, 1963, was as he planned it fifteen years earlier.

Another insight into Mr. Gilcrease's nature came from Cephas Stout. I had been at the Institute a few days when Ceph came into my office and asked if he could have a word or two with me. I said yes, so he beckoned me into the Alfred Jacob Miller Room and asked me to please sit down. He lit his pipe and sat there waiting for visitors to leave the gallery. When we were alone, he spoke. "I believe we're going to like you," he said. "Mr. Gilcrease does, and so does Mrs. Teenor, and so do I. Since I've been around here for more than thirty years, I've seen some good men come and go, and this is my advice to you, simple as it may seem: just remember that when Mr. Gilcrease asks you a question . . . he already knows the answer."

One day in July, Mr. Gilcrease asked me to come to his office in the Foundation building, located near the museum. I found him sitting on a couch and in front of him, on a large coffee table, was stacked a collection of books, manuscripts, and letters beautifully bound and encased in red morocco leather. "This is a collection of George Catlin books, manuscripts, and original letters," he said. "They were sent to me on approval by a firm in London, the Robinson Brothers. Years ago I did business with them, and on one occasion Mr. Lionel Robinson visited our museum and spent a couple of days here as my guest. He feels these things would be a fine addition to our Catlin collection. You know, Catlin spent considerable time in London."

I browsed through the books and letters very carefully, commenting that the collection was historically important.

I asked Mr. Gilcrease what was the status of the collection. I fully expected him to indicate that if I approved the historical value of the collection, he would buy them for the Institute.

On the contrary, he said, "They have a $5,500 price on them

and I have had them for a couple of years. I told Mr. Robinson that I would let him know within ten days if the Institute wants them or not. So why don't you see what you can do, Dean. I asked one of your predecessors to see if he could raise the money, and he swung out at the plate." He then handed me a copy of a letter from Mr. Robinson,[20] dated May 28, 1959, and an inventory of the collection.

I was stunned, to say the least. I thought, "Me, raise $5,500 in ten days?" Mr. Gilcrease closed our meeting by extending his hand and repeating his previous statement, as if I hadn't heard him the first time. "Why don't you see what you can do? Give me a call in a few days, as I have given Mr. Robinson my word that I would let him know." We shook hands and I left his office.

I labored over the situation for five or six days, and nothing fertile came into my mind. I read and reread Mr. Robinson's letter and studied the inventory. I had been at the Institute about a month. I barely knew the names of the board members, so how could I approach one with a "give us 5,500 bucks" glint in my eye? I was being tested for sure; I felt my future relationship with him rested on how I solved this problem. I'm sure he figured if Krakel couldn't raise that trivial amount of money he was not going to be worth much to the Institute. The following day I found out the Catlin letters had been discussed by board members several months before, and the subject had been tabled.

On the eighth day, I had an idea. While my courage was up, I telephoned William S. Bailey, Jr. and blurted out, "Mr. Bailey, Mr. Johnson said if we can find someone to put up half the money—$2,750—for the Catlin papers, he will see that the board puts up the other half. Would you have an interest in the proposal?"

Mr. Bailey replied, "Is that right? In that case I'll give the $2,750. We can't let that go by, can we?"

"Thank you, Mr. Bailey," I said, and hung up. Then quickly I dialed Mr. Johnson. "Mr. Johnson, Mr. Bailey said he would put up $2,750 for the Catlin papers if the board would match it."

10

There was a pause and Johnson laughed, "Hell, we can't pass that up. It's a deal."

A short time later Mr. Gilcrease telephoned to ask me to have lunch with him and Mrs. Teenor. I said it would be a pleasure, casually adding, "Oh yes, Mr. Gilcrease, Mr. Bailey and the board have agreed to buy the Catlin papers."

In the fall, my friend Paul Rossi[21] was to join the staff as deputy director. Paul, our librarian Martin Wenger, and I had all started out in our professions at the Colorado State Historical Society. Bruce Wear,[22] a native of Arkansas, was art director. The four of us ran the Institute.

Gilcrease Institute is located a couple of miles northwest of the heart of Tulsa's business district in the beautiful Osage Hills. In my mind, it belonged to Thomas Gilcrease even though the city held its title. I couldn't separate him from the collections he had formed nor from the building he had built, surrounded by immaculately landscaped grounds. They were all his. To me he was a visionary, connoisseur, collector, and curator.

Mr. Gilcrease's goals were simply to devote his energies and wealth to collecting great pictorial works, three-dimensional objects, and written instruments from the pages of history. He emphasized the portrayal of exploration, conquest, and settlement of North America, with special emphasis on the role of the Indian.

Thomas Gilcrease's dream started taking form as the result of a decision he made in New York City as a young man of twenty. He read in *The New York Times* that the U.S.S. *Leviathan* was scheduled to sail for Cherbourg, France within a few hours. Since he had never been to France, Thomas Gilcrease decided to book passage.

Years later he related the incident. "I arose at 4:30 A.M. and went to the steamship office. But no one was there. I thought everyone got up as early as I did—I didn't know New Yorkers slept all morning. Finally a man showed up and asked what accommodations I wanted, and I said, 'Just give me some place to sleep.'

11

Out of New York the *Leviathan* ran into a terrific storm, which continued through the entire crossing. I went up on deck every day. It did strike me a little funny that I didn't see any of the other passengers."[23]

Paris fascinated the Oklahoman. He rode down the Champs Elysees in style, impressed by the beauty of the wide, tree-lined boulevards. He visited the Cathedral of Notre Dame, the Sorbonne, Luxembourg Gardens, and Place de la Madeleine all in an afternoon. Two days were spent feasting his eyes and mind in the Louvre. He looked down in awe at the pageant of Parisian color from the heights of the Eiffel Tower. He enjoyed mingling with the crowds, dining at sidewalk cafes. The air was intoxicating, and he was a passionate sightseer.

Picturesque as Tom was, he hardly portrayed the average Parisian's concept of a wild, feather-wearing Indian. "I spun some awful tales about my ancestors," he jokingly recalled. Tom could not resist the fashions of Paris and the tailor shops, so very soon a metamorphosis was under way. When he went out, it was with elegance. Parisians would smile in good humor at his efforts to speak their language. The first time he called the Champs Elysees "Chumps Lazee", he brought a round of laughter from his companions. During the nights, Tom tasted the delights of a Bohemian life that was undreamed of in the oil fields. He was not at all immune to the charms of fashionable young women. Gilcrease dined at the Moulin de la Galette and Moulin Rouge, where he enjoyed the sparkling laughter and dancing and viewed the lovemaking going on in private alcoves. From the outset, the handsome young man of Creek Indian descent was popular. Rumors of his wealth, generosity, and capacity for a good time preceded his appearance. Tom's suite in the Hotel Diderot became the scene of lavish parties. Wearying of nothing and wanting to see more of France, Tom was driven to Nice. From there he went to Carcassonne near the Mediterranean. Planning to spend but a day, he stayed a month. He wanted to come to grips with the language. From language he went to culture and always

to art, visiting museums whenever possible.

His interest in art was reinforced by struggling through issues of *La Vie Moderne,* a periodical which he sought for literary reasons as well as for art. As his French improved, he discussed art with his tutors. Terms such as le Barbizon, Impressionism and Expressionism became a part of his vocabulary. In literature, the name Emile Zola suddenly became important to the Oklahoman. Although Tom was able to admire painters such as Renoir, Degas, and many others, his tastes during this all too brief period favored the Barbizon school. His love was for the land, its people, and animals. While he was not an exponent of detail such as Meissonier painted, he was revolted by the work of neo-impressionists and symbolists. "Why should anyone, even an artist, have the right to reduce nature and mankind to distorted geometry?"

Filled with excitement, he wrote to his favorite sister: "Chére Bessie, I'm positively quivering with joy over all that I have seen and done. I have lost my blues and I'm actually happy. I need this life and freedom." Later, while in the south of France, "We have read and studied together while soft rain pattered on the window and the ocean waves roared and pounded the beach. I have learned about France's poets . . . "[24]

Tom never forgot those few precious months. Nor had there been anything more beautiful to him than the Tuileries and the Avenue Du Bois, with their bordering chestnut trees hung with young green leaves and snowy blossoms and pathways crowded with promenaders. He wrote, "I am sure that if I were blind and deaf, and were suddenly dumped into the heart of Paris, I would know it immediately by smell, a curious intangible scent that this city alone possesses."[25]

Winding up his travels in Toulon, he was to understand how the nineteenth century painters had captured light and color on their canvases. Tom was sad at the thought of leaving France.

But a new world had been opened up. He wanted not only to be close to the Louvre, but to go to Rome where he could discover for himself the Renaissance masters. He yearned to spend hours

contemplating Michelangelo's ceiling in the Sistine Chapel. Now the mountains of life that he wanted to climb had grown vastly taller and more beautiful.

At home he was in trouble. Havoc prevailed in the oil fields. His bankers were frantic. Six weeks of planned vacation had turned into six months.

The few days it took to cross the Atlantic on his return voyage to America were all too short for Thomas Gilcrease but long enough for him to ponder what he had seen and experienced. He formulated plans—plans and goals that would give his life direction. His first and perhaps most important observation was the love of the French for their culture—the art, great gardens, cathedrals, palaces. The French loved life itself. They were not reckless—they savored each hour of every day.

Similarly, Thomas Gilcrease loved everything about his Oklahoma. He loved its ruggedness, the beauty of its rolling hills, and now he had an awareness of the value of a culture, his people's culture. He transferred his learning from France to Oklahoma. Why could he not, in his own way, do for the land of the red earth what each Parisian vowed to do for Paris and each Frenchman for France?

All of what he had seen he contrasted with his Oklahoma. "I made a vow," Thomas Gilcrease recalled, "that I would bring the finest things that I could buy to the land of the red earth, and if the people of America and the world wanted to see them, they would have to come up my path and pass through my door." But more than the people of America or the world would come his own people—the Creeks, Cherokees, Choctaws, Chickasaws, Seminoles, and the Osage. They would come, and they would learn to love and appreciate. He would do this silently and unassisted.

When Thomas Gilcrease dreamed of "fine things," he was envisioning great paintings, great instruments of history, and massive collections.

From the period of Spanish discovery he acquired Martin C. Waldseemüller's *Globus Mundi*, published in 1507, which at-

14

tributed the discovery of the New World to Amerigo Vespucci, and the treasured *Bernaldez Codex,* giving an original and contemporary account of Columbus' voyages. He purchased the first letter written from the New World by Diego Columbus to the Viceroy of Spain, dated January 12, 1512. Among the famous papers of this period he acquired is the original manuscript of the first official decree issued by Hernando Cortez the day after he captured Mexico City in 1521. Gilcrease monumentalized this period with an almost unexcelled collection of pre-Hispanic gold. Another national treasure that he captured is the only known letter written by Hernando DeSoto, discoverer of the Mississippi, to Ponce de Leon on June 27, 1535. A bibliographical acquisition that is perhaps great as any in the western hemisphere is Bishop Juan de Zumarraga's *Doctrina Breve, 1543-1544,* the first book published in the New World. Bartolomé de Las Casas' *Brevissima Relacion,* dated 1552, hallmarks the middle period of the 16th Century, as does explorer Alvar Nuñez Cabeza de Vaca's work, *La Relacion y Commentarios de Gouernador Alvar Nuñez* and Truxillo, *Relacion de la Tierra del Peru Descubierta por Pizarro, 1531-1533.*

Gilcrease trapped epochal books and manuscripts from the Colonies' critical founding years. The ten volumes of Theodore Dubury, *Indial Occident and Indial Occidentals, 1590-1634,* contain historical plates from the first paintings done in the New World by Jacques le Moine and John White. Le Moine's work depicts the Huguenot colony on the coast of Florida in 1563, while White painted the colony of Virginia in 1585. Among the Gilcrease rarities are two proclamations by King James I of England, one ordering the arrest of Sir Walter Raleigh in 1618 and the other banning lottery from Virginia in 1620. Christopher Brooke's *The Late Massacre in Virginia, 1622* was the first book printed about the colonies; also printed in the same year was Captain John Smith's *New England Trials.* A 1623 rarity is a broadside titled *Good News from Virginia,* while a rare petition to John Winthrop, filed May 6, 1647, is another Gilcrease gem. A

number of documents in the collection pertain to Indian wars and treaties of the colonial period. Mr. Gilcrease especially enjoyed these choice items, since he was fond of pointing out that, from the earliest times, white men failed to live up to their "contracts" with his ancestors. Among 18th Century works from the pre-Revolutionary period is *New Principles of Gardening*, from George Washington's personal library, containing the autograph of the Father of our Country. Lord Edgemont's *Journal and Proceedings for the Colony of Georgia*, 1732, is a great tract monumenting the founding and first year in the history of the thirteenth colony. This important journal was virtually unknown and unpublished at the time Mr. Gilcrease acquired it from a firm in London. An epoch in itself, it reposes in the Institute's vaults. He bought Roger Williams' *Blood Tenant*, 1644, and the sumptuous twelve volume 1663 geography of Jean Blaeu with its decorative yet authentic maps.[26]

He bought the only certified copy of the Declaration of Independence outside the Library of Congress. It was drafted by Benjamin Franklin, signed by Franklin and Silas Deane, and presented along with a personal letter to the minister of Frederic the Great of Prussia. Gilcrease acquired the only known letter Thomas Jefferson wrote about the Declaration before he composed it. "Soon all the world will know . . .," it reads. Also encased in Tom's vault is the "piece of paper" that authorized Paul Revere to make his historic midnight ride. This national treasure, along with the Declaration and Jefferson's letter, are among freedom's greatest symbols. The Institute houses the only copy of the Articles of Confederation signed by representatives of the thirteen colonies, dated February 1777.

The books, documents, and manuscripts in the collection go down through the centuries in all their magnificence, concluding importantly with the last letter George Custer wrote before shoving off to see an "S.B." (Sitting Bull) at the massacre on the Little Big Horn. Mr. Gilcrease bought carefully and with the sense and intelligence of a fine historian. It was his depth of knowledge

16

that reinforced his talents as a collector. He became a familiar figure in important sales galleries and auction houses in London and New York City. His silence and lack of expression often mystified the talkative sales people.

In collecting paintings, his first major interest involved the trans-Mississippi West. Displaying the usual Gilcrease logic, he began at the beginning. George Catlin's works were among the first he sought. Then Alfred Jacob Miller, Karl Bodmer, and chronologically on to John Mix Stanley, Silas Seymore, Robert Havell, Carl Wimar, Thomas Moran, Albert Bierstadt, Thomas Hill, William Keith, and a host of others. The collection includes Western artists Frederic Remington, Charles M. Russell, Charles Schreyvogel, William R. Leigh, Frank Tenney Johnson, and Will James. The Taos School is well represented by Oscar Berninghaus, Joseph Henry Sharp, Walter Ufer, Bert Philips, Oscar Blumen-schein, E. Irving Couse, and others. The art vaults also have outstanding representations of works by Charles Deas, Charles Bird King, and names not so well known, such as Catherwood, St. Memin, Sanchez y Tapia. Several hundred works by contempo-rary Indian artists complete the massive western collection.[27]

Thomas Gilcrease's acquisition of the Phillip G. Cole collection was dramatic. Dr. Cole was a wealthy physician and industrialist who resided in Tarrytown, New York at the time of his death. The Cole collection consisted not only of paintings and sculpture but also a library of rare books on frontier history and forty-eight letters from Frederick W. Benteen to Theodore Goldin referring intimately to Colonel Custer and the massacre.

Featured in the Cole art inventory were sixty-two pieces of sculpture, including seventeen bronzes by Frederic Remington and twenty-six by Charles Russell. There were fourteen paintings by Frank Tenney Johnson, twelve by Remington, forty-five oils and watercolors by C. M. Russell, sixty-four oil paintings and portraits by Joseph Henry Sharp, five paintings by William R. Leigh, eight oils by Charles Schreyvogel, three oils and one watercolor by Edgar S. Paxon, three oils by Oscar E. Berninghaus,

fifty-four oils and watercolors by Olaf Seltzer, and one hundred and eighty-one miniature oils and watercolor paintings also by Seltzer. Other painters of less importance were also represented in the Cole Collection.[28]

The story of the purchase of the collection is interestingly told by Martin Wiesendanger in David Randolph Milsten's biography of Thomas Gilcrease. Wiesendanger was at that time director of Gilcrease Institute. The agreement to purchase is dated January 18, 1944; the transaction was consummated December 24, 1946. The price was $250,000. Rumors of the whereabouts of Dr. Cole's famous collection plagued dealers for years. On one occasion, Mr. Gilcrease was approached by an "art runner" and asked if he had any interest in the Cole inventory of art. Gilcrease, who had owned the collection for several months, declined the offer.

After Mr. Gilcrease had collected the best in paintings and bronzes portraying the West, he started looking at the American masters, beginning with the colonial period and on to the Hudson River School. Before Mr. Gilcrease hung up his rope, he had put together an unbelievable collection of over 5,000 works of art representing more than 300 artists. His collection would surpass in quality the combined holdings of several museums, including the Western art division of the Smithsonian Institution.

An oil painting that invariably stuns visitors, especially those from the New England states, is John James Audubon's *Wild Turkey*. "How come it's here?" or, "Is this the original?" are frequent questions. The painting, believed to be done in 1847, hung in the artist's home for many years. In 1881, it was given to a granddaughter, Mrs. Morris Tyler, of New Haven, Connecticut. She in turn passed it on to her son in 1910 and the painting was sold years later. Finally it found its way to Chicago. The Chicago Art Institute, desperate for funds during the 1930s, offered the painting for sale. William F. Davidson of M. Knoedler and Company purchased it, selling it to Thomas Gilcrease.

Acquisition of the painting was a great coup for Tom Gilcrease. He loved Audubon's life-sized work. "The turkey is our greatest

bird," he would say, "and no one could paint birds like Audubon. I hope no one ever has this old gobbler for Thanksgiving dinner." Mr. Gilcrease shared Benjamin Franklin's feeling that the turkey, not the bald eagle, should have been our national bird. "After all," T. G. would say wistfully, "the turkey helped keep our first

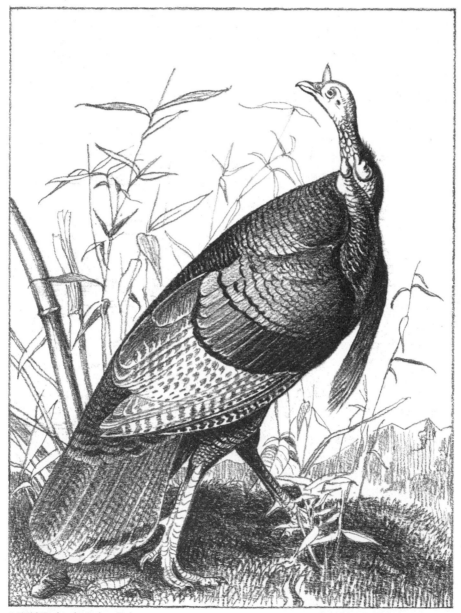

A Wild Turkey by Robert Kuhn

settlers alive, while the eagle is a wicked bird that preys on harmless creatures and is not above being a scavenger." Audubon's *Wild Turkey*[29] is one of several items in the Institute that could be classified as a national treasure.

Another painting of national importance is the portrait *James Madison* painted by Charles Willson Peale. This beautiful oval-shaped painting of our fourth president is perhaps the only painting of Madison done while he was in the White House.

Every so often, Mr. Gilcrease would get queries from Washington, D.C., wanting to borrow this or that work of art or document. The sender would invariably try to impress him with the importance of the request. In his usual diplomatic way, T.G. would politely decline with the comment, "It will always be here for those who visit Tulsa." Invariably he added, "When I want to see the Mona Lisa, I know I have to go to Paris. I know it will always be there."

Cleve Gray, writing in *Art In America*, pays tribute to Mr. Gilcrease: "He did not follow the patterns set by Frick, Morgan, Altman, Lehman, Bache, Barnes . . . the many great amateurs of European art. He wanted Americans to see their own heritage."[30]

The collection, called "the most outstanding in America" by *Life* magazine,[31] is topped off with vast holdings of archaeology and ethnology, Northwest and Eskimo material, Spiro Mound ivory and jade.[32] His buying habits took on gigantic proportions restricted largely by the importance of whatever was offered and his time for study. Gilcrease's collections parallel the movement of the frontier. After he achieved the quality and quantity desired in one area, he would carefully move on to another new and exciting plateau to conquer. Unlike most collectors, Thomas Gilcrease sought each collection and object personally. It was his approach, his thinking, and his acquisition as each discovery possessed his mind, energies, and dreams.

Chapter 2
A Pile of Nickels

"To LOVE A LAND," Thomas Gilcrease said, "you had to be a boy in it." He had been a boy in Oklahoma. He wanted to leave some kind of track in life[1]—and did. That "track" is his world famous Gilcrease Institute in his native Oklahoma.

He was the first of fourteen children born to William and Elizabeth Vowell Gilcrease. The place of Thomas Gilcrease's birth was Robilene, Louisiana in 1890. Life for young Tom was filled with long hours of hard work—rows of cotton to pick and cows to milk. He was happy and curious by nature—happy about the sunrise and sunset with their fountains of color, curious about the trees, the flowers, and the tiny seeds they sprouted from. He loved birds and spent hours watching and feeding them. He was curious about the hills and the earth's formation. Thomas Gilcrease was inquisitive all his life.

In 1904, the family moved to Wealaka, south of the then rambunctious cowtown of Tulsa. The tracts of land taken were allotted to the family by the United States Government because Elizabeth, Tom's mother, had been a Creek Indian—a token form of restitution since Uncle Sam had uprooted her people from their ancestral Alabama. It was stubborn country to farm, but with an abundance of sons to help him, William Gilcrease made a living.

If anyone influenced Tom at an early age, it was Alexander Posey, the Creek Indian poet. He walked to and from Posey's

21

one-room school during his childhood. Alex Posey awakened a love of literature and artistic accomplishment in the boy.

The land, combined with a love of beauty and the fact that Red Man's blood flowed through his veins, were the factors that predestined Thomas Gilcrease to greatness. When dame fortune smiled, he knew what to do. Thus for all his busyness, he attended

Gilcrease Institute by Paul Rossi

22

Bacone College for Indians. In addition to studying the classics, he wanted to be able to read and write land and oil leases as well as any lawyer. By the time he finished his schooling at Bacone, his allotted quarter section in the Glen Pool oil field near Tulsa bristled with oil wells. By the time he was old enough to vote in a national election, Tom was wealthy. His money was in banks scattered throughout the Southwest. In addition to being rich and smart, he was handsome and generous.

In recalling those days when the swindling of Oklahoma Indians was in style, he said, "I didn't like white man's whiskey,

big cars, and most of the contracts he usually wrote with my people. I vowed to be one Creek the palefaces couldn't cheat."

When he was almost thirty years old, Tom had formed the Gilcrease Oil Company, selecting five intelligent and strong men of varied experience to sit on his board of directors. Soon the company had holdings in Texas, Oklahoma, and Kansas.

An unusual set of circumstances gave the company an option on 85,000 acres near Long Beach, California. Gilcrease directors pondered the matter of leasing and drilling for several days, then let their option slip, concluding that a three-state operation was expansion enough for the young company. What the Board voted against was to become Standard Oil's billion dollar strike—the Signal Hill oil field. Tom had been first to stake out what later proved to be the discovery well the first time he examined the structure. Years later he claimed, "I could almost smell the oil in the geological formation."

The eyepatch-wearing Wiley Post flew Tom over the country in the early days of the Oklahoma and Texas oil boom. Mr. Gilcrease bought Post one of his first airplanes. "Wiley gave me thrills I didn't ask for, so I paid him off," Mr. Gilcrease recalled. "Most of all I didn't like the way his wing tips skimmed the tops of my oil rigs. In parting I cautioned him that unless he changed his crazy flying habits he would kill himself for sure and . . . Lord only knows who else."

By the time he was forty, Gilcrease, the executive, had circled the globe and tasted most of the fruits of life. He had his fill of bright lights, discovered an oil-bearing sand, and established a sales division for his oil properties in Paris, France. During these years when he was so busy, he often went to Alaska's Kenai Peninsula in search of solitude and big game. "My people were hunters and loved the out of doors; I didn't want to be any different." The tranquility of a guide-companion and the flickering of campfires in caribou country provided an opportunity for him to meditate.

During one of his prolonged periods of reading and thinking, he

concluded that a man should leave some kind of a track in life. "I wanted to do more than just drill holes in the ground," he reminisced. He had seen museums and art galleries the world over and vowed to collect fine things to bring to Oklahoma, since it was, as he said, "rather short culturally." He wanted to study, to see unmarred beauty on canvas, and personally to feel the magnificence of original instruments of history.

While Thomas Gilcrease had a wide circle of friends, only a few knew him intimately. The true stories of his art transactions were known to his confidential secretary and companion, Mrs. Eudotia Teenor; attorney L. Karlton Mosteller[2] of Oklahoma City; Judge Lester Whipple[3] of San Antonio, Texas; Mrs. Gilcrease,[4] accountants, bankers, and dealers.

The man who taught me the most about Tom Gilcrease, often in conversation mixed with tears or laughter, was William F. Davidson,[5] vice-president of the M. Knoedler Company, New York City.

Davidson guided Thomas Gilcrease as a collector. Once during a visit to Bill's office, I asked him when Mr. Gilcrease began collecting traditional American art. Bill said, "I don't have time to answer fully now, but I will write you the circumstances." Within a few days I received the following letter, quoted in part:

> One day in the late 1940s I was flying to Dallas or Fort Worth and as there was a scheduled stop at Tulsa, I arranged to stay over for the next few hours and if possible, have a short visit with T.G., without anything special in mind. I telephoned him from the airport and explained I had a few hours in town, and as usual, he offered to come to the airport and take me to lunch in town. After waiting for twenty or thirty minutes, I had a call from Mrs. Teenor saying that he had been delayed and since our time together might develop into nothing more than an hour or an hour and a half at the most because of my schedule, he suggested it might be more convenient if we had a bite to eat at the airport restaurant and have our talk there.
>
> On his arrival we had a light lunch and then went over to a corner of the restaurant to spend the rest of the time.

Something came up in T.G.'s part of our conversation (I don't remember just what) that made me suggest to him that entirely apart from pictures he was collecting, relating to the discovery of America and the settlement of the country, mainly covering the period when the Indians still occupied a large portion of it, that he should collect a group of paintings representing key artists whose work had created what had become the tradition of American Art down to today.

I reminded him that the great beginning of American painting in Colonial times started with Smibert, Feke, Copley, and West; after the Revolutionary War, Earl, Stuart, and Sully influenced the artists of the late 18th and early 19th centuries; and Homer, Eakins, and Sargent led the development in American Art down to the 20th Century. In no more than a half hour this conversation ended, because my plane was announced. T.G. did not make any further comment about my suggestion, although he had made his usual notes on the back of an envelope or spare piece of paper.

Fully a year later we were, curiously enough, back in the same coffee shop at the Tulsa airport and Mr. Gilcrease took a piece of paper from his pocket and said, "You know, I think that idea of yours interests me. Let's do something about it." I had by this time forgotten the incident but when he passed over to me the paper he had in his hand, I recognized it as the original memo he had made regarding the idea of getting together a group of key pictures that would be chosen for their importance to American Art, rather than their historical content; and if in addition to importance in quality they also had American historical significance, so much the better.

What resulted from this is the extraordinarily fine collection of pictures and bronzes which today are among the gems of the Gilcrease collection.

Chronologically listed, they are as follows:

John Smibert (1688-1751) *Portrait of John Cotton*
Robert Feke (fl. 1705-1750) *Portrait of John Rowe*
John Singleton Copley (1738-1815) *Portrait of Mrs. John Apthorp*
Benjamin West (1738-1820) *Penn's Treaty With the Indians*

26

Charles Willson Peale (1741-1827) *Portrait of James Madison*

Ralph Earl (1751-1801) *Portrait of Matthew Clarkson*

John Trumbull (1756-1843) *Portrait, Said To Be Thomas Wilkes*

Gilbert Stuart (1755-1828) *William Temple Franklin*

John Vanderlyn (1775-1852) *Washington and Lafayette at Brandywine*

John W. Jarvis (1812-1868) *Portrait of Chief Justice John Marshall*

Thomas Sully (1783-1872) *Charles Caroll of Carollton*

John Neagle (1796-1865) *Portrait of Red Jacket*

Hiram Powers (1805-1873) *Portrait of Benjamin Franklin* (marble)

James A. McNeill Whistler (1834-1903) *Nocturne: the Solent*

Winslow Homer (1836-1910) *Watching the Breakers*

Thomas Eakins (1844-1916) *Portrait of Frank Hamilton Cushing*

Augustus Saint Gaudens (1848-1907) *The Puritan* (bronze)

John Singer Sargent (1856-1925) *Beach Scene*

Bill Davidson and I often dined together when I was in New York. Our conversation usually centered on Mr. Gilcrease and he showed me copies of Knoedler's transactions with Tom. During the summer of 1971, I frequently had the pleasure of being with Bill. He was far from being the dynamo of the international art world he had once been; he was thin, his body drawn, and his mind shaken by a stroke. Yet, when we talked about Mr. Gilcrease, he became animated, the Davidson of old, full of cheer and keen observations.

"On the 24th of February 1947," Bill began, looking at a sales record, "T.G. made the greatest acquisition in not only Western, but perhaps American art history, when he bought Thomas Eakin's[6] portrait of Frank Hamilton Cushing from Michel Knoedler Co. for what was then the generous sum of $6,250. I'm sure this was the most extraordinary single sale made to a museum featuring Western art. The acquisition must be consid-

27

ered famous first of all for the greatness of the artist; secondly, for the importance of the subject, Cushing, the famous ethnologist; and thirdly, for the quality and the size of the painting."

An article published in *Mentor* magazine, September 1938, paid tribute to the painting. The portrait appears in a full page black and white reproduction framed in a most unusual manner. The caption below the portrait reads, "In the dress of a Zuni chief, this portrait of Mr. Cushing by the American painter, Thomas Eakins, occupies a conspicuous position in the recently dedicated Cushing Hall at the Brooklyn Museum. The eminent ethnologist adopted Indian costume, learned to eat Zuni food, cultivated the native speech, and in all respects became one with his adopted people."

In December of 1969, Rudolf Wunderlich, president of Kennedy Galleries, New York City, appraised the painting at $600,000. Thus, in twenty years the value appreciated one thousand percent. Today it would fetch $750,000 or perhaps a million at auction—who knows? Thomas Gilcrease often philosophized, "If you pay any price for the great, you have made a good buy."

On the 15th of September 1947, months after the Eakins acquisition, Gilcrease made the following purchases from Bill Davidson: three oils by George de Forest Brush:[7] *Mourning Her Brave, Crossing the Prairie,* and *Out of the Silence;* an oil by Andrew Melrose,[8] *Indians Crossing the Upper Missouri;* two oils by Ralph Blakelock:[9] *Indian Encampment* and *There Was Peace Among the Nations—Unmolested Worked the Women;* Edward Troye's[10] *Squaw;* Thomas Moran's[11] *Acoma;* and one oil painting by Alfred Jacob Miller, *Chasing Wild Mustangs.* The lot was purchased for $16,500.

During 1948 Gilcrease made four trips to New York to be wined and dined by the cosmopolitan Davidson.

He started out slowly on March 31, acquiring only two paintings, George de Forest Brush's *At Dawn* and Thomas Moran's jewel, *The Three Tetons,* for $4,000. T.G. may have bought

heavily elsewhere on the same trip. At any rate, he was back with Davidson on May 24. This time he virtually stole some of Knoedler's finest fare: thirty-five Alfred Jacob Miller watercolors; Miller's self-portrait, *A.J. Miller Chasing Buffalo*; a watercolor by George Catlin titled *Indian Group, London 1844*; and Catlin's *Self-Portrait*, for $24,475.

On November 10, T.G. and Davidson once again sat in one of Knoedler's fine velvet-lined showrooms, one trying to sell, the other trying to buy. T.G. warmed to the occasion by nodding approval. He'd take twenty-five more watercolors by A. J. Miller. Davidson had four Moran oils brought out. T. G. bought them. Then twelve Moran drawings, and *All Night*, a Moran watercolor.

"Tom, let's quit fooling around. Here is the entire list of the Moran estate collection."

"Hmm. Let's see. 100—200—300—400 items. I'll buy them all. I have to go now, Bill."

Thomas Moran by Paul Rossi

"Wait, T. G. I have one more painting to show you."

"All right."

"This is a great painting. Bring it in boys. Here it is, T. G., *The Wild Turkey*, oil by John James Audubon, our greatest bird painter. This is considered Audubon's greatest painting."

"Let me tell you, Bill, that's some old bird. We want him for Thanksgiving, but not to eat. Bill, this is wonderful."

"Thanks, T. G."

"Bill, will you have these shipped out right away?"

"Yes, Tom. In fact, I'll have our boys drive them out."

"Right away? Bill, how much do I owe you for today, including that old gobbler?"

"Here it is . . . $75,000."

"Is that for everything, Bill?"

"Yes, Tom, everything, including delivery."

"You know Bill, that's a pile of nickels. Good-bye, Bill."

"Good-bye, Mr. Gilcrease."[12]

Seven days later Mr. Gilcrease, having flown to Switzerland and back, was in Knoedler's once more. He told Davidson that he had counted his nickels and had a few left. Did he have any more Millers?

"Yes, twenty watercolors."

"I'll take them."

"An oil by Miller, *Indians Crossing A Stream*. Another Miller oil, *Indians Capturing Wild Horses*. A watercolor and a drawing by Miller."

"I'll buy them."

"T. G., we have a great Frederic Remington oil, 40 by 27 inches, called *Moonlight Scouting Party*. It would add charm to your collection. Do you have a Remington moonlight scene?"

"If we do, it wouldn't hurt to have another one."

"Bring it in boys!"

"I think these old Indians would like to come to Indian Territory. Yes, sir."

"If you want it, I'll toss in a Bierstadt watercolor, Tom."

"Well . . . that's fine. Just lay it there, Bill. Don't toss it."

"T. G., this will cost you . . . a nice round figure: $20,000."

"O.K., Bill . . . here's this crazy old Indian's check . . ."

The year 1949 was a great year for Thomas Gilcrease. Oil prices were up; he felt good; his family was all well. Tom Jr. and Barton were with the company in San Antonio; Des Cygne, his lovely daughter, was in college and loved to go places with her daddy. How they loved to go to New York together. This year would be memorable for T. G. because he would open his museum. At last he would show the world what one Indian could do. There was so much to do getting the exhibit cases ready and the lighting—lighting was important. The walls needed acoustical treatment and painting; the floors had to shine, just like the floors did in the Louvre. The walks and parking lot for the museum had to be built.

On January 12 Mr. Gilcrease got a telephone call from Davidson. He had hit another bonanza. Twenty-six more Alfred Jacob Miller watercolors had been found and, think of it, the artist's manuscript notebook, *Rough Draughts of Notes for Indian Sketches.*[14]

"But heavens, how many watercolors did Miller do? The weather's bad, Bill. I can't come to New York."

"It's cold here in the city."

"Tell me, is the notebook in Miller's own hand?"

"This manuscript is exquisite, T. G. In it, Miller makes notes for 166 paintings. It's a treasure!"

"How much will it total?"

"Sixteen thousand, eight hundred."

"Mighty fine. Bill, someday people will think we're crazy."

At last spring had come. Tulsa was beautiful. Tom's dogwoods were blooming. It was a bright, beautiful world. He surprised Des Cygne and Teenor by asking them to go to New York with him. His dark eyes beamed with excitement.

"But Daddy, on such short notice . . .," Des Cygne protested. They left the following day.

While Des Cygne and Teenor were shopping at Saks Fifth

31

Avenue, T. G. stopped to see his friend Davidson. That night they had a delightful dinner together at the Algonquin and went to see Richard Rodgers' and Oscar Hammerstein's recently opened musical, *South Pacific*, starring Ezio Pinza and Mary Martin.

Next day Tom brought with him snapshots of his new museum.

"See here, Bill. This is the way she looks. All sandstone. Some of my walls are three feet thick. No windstorm will blow her down. And here is the foyer. Look at this painting. Guess you know who sold me that Miller. When we open, we'll have a big pow-wow with all the chiefs we have on canvas. Bill, do you have anything I could buy cheap . . . say, two for a nickel?"

Mr. Davidson recalled, "We had two sessions, one in the morning, then we had lunch at the St. Regis Hotel, and after lunch he bought more paintings. That morning he bought well: two nice little Miller oils, *Indian Encampment* and *Indian Squaws Crossing A Stream*. How he loved Miller! I priced them at $500 apiece. He bought a Walter Shirlaw[15] and a fine Gilbert Gaul[16] oil, for $2,500. I let him have one of the most important Catlins ever painted, *Red Jacket*, Catlin's first major Indian portrait. The picture had Catlin's hand-written account of the portrait written on the back."

Inwardly Tom shook with excitement at having bought Catlin's portrait of Red Jacket. The Seneca chief had been a great orator and was one of the first to speak out against white men's injustices and the trail of broken treaties with Indians.

During lunch Davidson worked Tom's emotions to a high pitch by telling him he was going to let him see nine watercolors by General Alfred Sully,[17] who was the son of the great English painter, Thomas Sully.[18] General Sully had graduated from West Point in 1841. The watercolors were exquisite and of western military posts where Sully had been stationed. After Tom had looked at the Sully watercolors, Bill said he would give him a chance to buy one of the greatest portraits ever painted of American Indians. Tom joshed Bill that he shouldn't treat an

Oklahoma Indian boy in such a manner. They toasted one another, Davidson with his martini, Tom with water. Then Tom surprised Davidson by asking him why the Oriental painters did not do good portraits—at least they did not seem to be good to him.

Yes, the watercolors by Alfred Sully were superb, all nine of them: *Fort Ridgely, 1855; Fort Pierre Looking South, 1856; Monterey, California;* two of *Fort Snelling, 1855; Fort Kearney, Nebraska, 1860; Fort Pierre, Nebraska, 1856; Fort Dearborn, Chicago;* and *Fort Ridgely, Minnesota, 1855.*[19]

Davidson was a master salesman, but he underestimated Gilcrease's sense of history and love of art. Bill had doubted that Mr. Gilcrease would go for the Sullys, yet there seemed to be nothing western that he would not buy. Maybe Bill had priced them too low? No, at more than $400 apiece he wasn't giving them away. Oh well, there were more where those had come from. Or were there?

The *Portrait of Blackhawk and Whirling Thunder*[20] by John Wesley Jarvis[21] caused Tom's heart to skip a beat. Yes, by God, this had to be one of the greatest portraits of American Indians ever painted. What exquisite power, yet there was compassion in the look of those dark, strong eyes. The delicate, sensitive painting showed the nobility and wisdom of the handsome Sac Chief and his son. Tom was further enthralled with the painting when he learned how the chief had spoken his mind when he met President Andrew Jackson:

> "I took up the hatchet for my part, to revenge the injuries which my people could no longer endure. Had I borne them any longer without striking, my people would have said, 'Black Hawk is a woman; he is too old to be chief; he is no Sac.' "
>
> At the same meeting, even though a prisoner of the United States, Black Hawk told the President, "I am a man, you are another."[22]

Tom had an inborn hatred of Andrew Jackson.[23] After all, it was during his presidency that Tom's mother's people, the Creeks, had been driven like scrub cattle from their lands in South Carolina. Hundreds had perished, dying from starvation and disease. Black Hawk's majestic rebuttal to Jackson's brutal treatment of all Indians, including the Seminoles, Cherokees, Chickasaws, and Choctaws,[24] was something that Tom did not want to forget. The portrait would be a constant reminder. Tom's museum would show the Indian side of history pictorially. There would be few paintings of white men killing. That's what Tom liked about George Catlin and Alfred Jacob Miller—no one was killing Indians in their paintings. He often wondered why Uncle Sam had picked the eagle as his national bird. The eagle was such a scavenger and preyed on the weak. White men were like that. Just recently he had told Legus Chalakee and Cephas Stout, Indian employees who were building his museum, that they might build a glass-covered tomb near the museum to "show the remains of a white man as white men did their ancestors." They would call it "Burial Mound Number One." Ceph joked, "Maybe we could get Andy Jackson's bones." All three howled with laughter. Legus added, "Maybe the palefaces would pay a nickel to take a look at Old Hickory's bones." The three rolled in delight and all the Indian workers came running up to see what was funny. Soon the whole place was shaking with laughter.

"Yes, Bill. I want to buy old *Blackhawk*. How much is it in silver?"

"Tom, it's a lot of money."

Tom's heart missed a beat. He knew Davidson had him. He had something Tom dearly wanted. As a bargainer Gilcrease felt weak, yet he remained stoic. After all, he was a Creek.

"Thirty-five hundred."

Gilcrease sighed with relief. He would have given ten times that much.

A story about T. G. that Davidson enjoyed recalling concerned Tom's favorite fantasy. If the artists were alive, Tom planned

what he would do for them and the kind of a banquet he would throw.

"They'd all be there," Tom would say, "and I'd pay their way. Ol' Charlie Russell, Remington, Thomas Moran, Bierstadt, William Cary,[25] Old Man Joseph Sharp,[26] my friends Bodmer, Catlin, and Miller—all of them. Let me tell you, we'd have some party! And Remington . . . wouldn't he be something to see? After dinner we'd all go and look at their art. Yes sir, to think that most of them lived in my time. Why, I was in Pasadena when Charlie was many times. Will Rogers would say, 'Tom, you got to meet this bird, Russell,' but I'd say, 'I'm too busy, Will. How about the next time I'm here?' Well, let me tell you life's mighty short. She sure is. Now they're all gone and I'm about half alive. If I could bring them back, I'd have some party. Bill, I'd invite you, too."

On May 3, 1949, the Thomas Gilcrease Museum, located in Blackdog Township, Osage County, near Tulsa, Oklahoma opened its doors to the public. The occasion was a momentous one for Tom, who had dreamed of such a day for many years. In fact, he had confided the idea back in 1931 to his dear friend, Robert Lee Humber,[27] a staff member of the Gilcrease Oil Company. Now it was a reality.

Tom's friends were there from all over America. Bill Davidson,[28] Rudy Wunderlich, and Frederic Renner. Lionel Robinson had sent a congratulatory cablegram from London. J. Frank Dobie[29] and Will Rogers, Jr.[30] paid high tribute to Tom. Amon Carter, Sr. and Sid Richardson[31] flew in from Fort Worth. C. R. Smith[32] telephoned Tom. Flowers were sent by Earl Stendahl[33] in Los Angeles. The Mayor of San Antonio telephoned and congratulated Tom. But few Tulsans were there, and the Tulsa newspapers barely mentioned the occasion. In fact, they had ignored the event. That evening while walking in the flower garden, Robert Humber advised, "Once again, friend Tom, you will have to be patient with your white brothers."

Thomas Gilcrease's interest in acquiring Western art and artifacts accelerated after the opening of his museum, even

35

though public acceptance of the collection was slow.

As the 1950s emerged, there was an awakening of interest in art of the trans-Mississippi West. A number of books had been published, and exhibitions were held in various museums throughout the West. These facts alone caused Tom's pulse to quicken. He wanted more. His appetite for art was insatiable.

In early 1953, it was learned that Thomas Gilcrease was in serious financial difficulty. News spread throughout the state and the nation. The Oklahoman's plight was the subject of radio and television broadcasts. *Life* and *Time* magazines featured Gilcrease's debts.[34] Rumors circulated—among the strongest was a story that the collection would leave Tulsa. Amon Carter, the Fort Worth millionaire, stated in public announcement that he would like to buy the collection. The president of the University of Texas indicated an interest. Governor Johnson Murray declared that the State of Oklahoma should consider buying the collection.

In December a group from Claremore, Oklahoma, headed by Dr. Noel Kaho, made an effort to secure funds on Wall Street. They hoped to not only pay off Gilcrease's debts but also to move the collection to their town and build a museum there. In attempting this feat, one of the first steps was to have the collection appraised. The library, books, documents and manuscripts were ignored. Still, William F. Davidson appraised the art at $3.5 million in value, and Earl Stendahl of Hollywood, California appraised the artifacts at 1.8 million dollars. News of the collection's monetary value heightened the interest of prospective buyers. The possibility of the collection going to Claremore looked most promising.

In January 1954, Mr. Gilcrease's debts were revealed in the local press as follows:

National Bank of Tulsa	$122,355.68
C. M. Echantz	12,500.00
Otha H. Grimes	1,750.00
Thomas Gilcrease Museum of American History and Art	72,077.83

Lester Hargrett	40,000.00
First National Bank	275.00
Remington Rand	883.50
W. S. Bailey, Jr.	2,500.00
Roland Tree	3,632.68
Marjorie Conway	52,729.02
Rosenback & Co.	208,274.94
Republic National Bank of Dallas	175,680.54
Gilcrease Oil Company	44,605.50
Fourth National Bank	60,550.00
Fourth National Bank	82,842.00
M. Knoedler & Co.	$196,683.01

In February, civic leader Alfred Aaronson and Mrs. Aaronson visited Gilcrease thinking they would be seeing the collection for the last time. Weeks later, Mr. and Mrs. Aaronson decided to invite a group of friends to their home to discuss the matter; this gathering was given added incentive when plans to raise money in Claremore failed.

To make a long story short, a citizens group, headed by Mr. Aaronson, was formed "to save Gilcrease Museum for Tulsa." A bond issue was successfully passed by Tulsa property owners on August 24, 1954 to pay Mr. Gilcrease's debts in art and Americana. The city, in return, would gain the collection.[35]

In discussing the matter, Mr. Gilcrease explained that he had purchased against projected future income from oil production, thus taking advantage of existing prices. He foresaw sharp increases in the cost of paintings, sculpture, and Americana. Unexpectedly, the federal government placed a restriction on oil production, thus virtually eliminating his income. With income from oil production cut off, there was no way he could pay his debts. At times he was philosophical about giving up the art collection, feeling that it was perhaps better that Tulsans work for it than to have it given to them "on a silver platter."

The proposition proved to be a good one for the city and people of Tulsa since Gilcrease deeded royalties from his oil production

to the city. In twenty years, these royalties have paid almost as much in income as the cost of the bond issue. In addition, Mr. Gilcrease deeded the museum building, his home, large tracts of land, and a sizeable art and ethnological collection worth more than $5,000,000 to the city.

Thomas Gilcrease had a prodigious capacity for work and a zest for living. He was an early riser by nature and upbringing. He loved to see the sun come up. Even in his late years his work day averaged ten to twelve hours. He was constantly on the move, always thinking, acting, and pursuing his goals.

He loved sunsets and conflagurations in the sky. They thrilled him just as a sunrise did. Watching a flaming sunrise with him one morning, he turned to me and said, "My god, I'm glad we didn't miss that." But vanishing daylight or darkness seemed to hypnotize him into silence. He hated the dark. He was insecure, superstitious, and abhorred the thought of dying. His love of life and the joy of it grew more intense with age.

Gilcrease was physically slight, standing five feet seven inches in height and weighing about 140 pounds. He was compact and sinewy and walked with a sort of rolling gait. His speech was soft and picturesque. His face was finely featured, slightly pinched, dominated by dark eyes that danced and sparkled when he was pleased or happy. When he became sullen, his eyes took on a dull character, and when he was upset they flashed signals. Mr. Gilcrease's normal look was quizzical, brought on by a mind that never ceased to inquire. His mouth was small and usually drawn. By and large, it was difficult for a stranger to speculate as to what Mr. Gilcrease was thinking. Ordinarily he was quiet and expressionless; the Indian in him dictated that he should be cautious and almost stoic among those whom he did not know. He could be both simple and complex—even Machiavellian.

When discussing a favorite subject with friends, his mind usually outraced his speaking capacity. Mr. Gilcrease had intense enthusiasm, and his energies were ordinarily compressed by the demands he placed on himself. He was conservative, precise, and

immaculate in everything he did. Yet, in his collecting he often accepted the indelicate or low in quality as a means of gaining the delicate or great. Left to his own selections, he was highly discriminating. While he despised stupidity and greed, he hated dishonesty more than any other form of negativism. Modesty, courage, and tenacity were Gilcrease's strongest traits. However, when his tolerance deserted him, he could become vindictive and picayunish, a wrathful foe.

His ability to discriminate was brilliant. He responded to quality. Although he never bought one, he didn't dislike nudes, but he avoided paintings of the white man's religions. He had the ability to look at a painting intently, but no talent for the abstract. T.G. did not want to be an expert, though he knew or thought at times he was being victimized by dealers. He had no interest in what he could not possess and wanted as much money as possible, but only for his museum—nothing for himself.

His silences were attentive, perceptive, and sometimes expressionless, yet charged with the awareness and judgments of a superior intelligence. When he did speak it was often brief and, coming after so much silence, what he had to say gained weight and form. When he felt the talker made sense, Tom Gilcrease would give him free reign. Sometimes he would puncture a long-winded speaker with a sudden handshake and a cool, "It's been nice meeting you." When he chose to, he had the gift of narrative in him. He was a born story teller, a simplifier. Life to him was black or white, never gray.

To those he loved he was devoted and lavish with fine gifts. He was a sentimentalist and, in his vigorous years, wrote long, tender letters. Restrained as he was generally, his affection led him to do the unexpected, if not foolish. As he grew older, much of his love was given to favorite works of art.

I recorded as much as I could from our conversations, especially when he shared his philosophy of art and artistic values:

I learned to discriminate by seeing many . . .

Some men are ignorant of all values except monetary.

I wish I had allowed myself to be tempted by one Renoir.

A painting doesn't have to be fed, nor can it die. It can't run away . . .

I don't like invoices or catalogs, yet I know every object I've bought.

My paintings haven't ever disappointed me . . . not like friends or my family . . .

A museum has to be active to attract and inspire people.

Men will live their entire lives and not know what to do or where they are going . . .

A great painting will live forever. It will outlive any building ever built.

If you can afford it and are lucky enough to buy the priceless . . . you got it cheap. Where could I get another turkey like Audubon's?

It was this kind of wisdom that further endeared Tom Gilcrease to me. He thought and spoke quickly but always to the point. I looked forward to seeing him each day. When he went out of town I missed him.

Chapter 3

William R. Leigh's Studio:
First Coup

ONE DAY IN APRIL 1962, Thomas Gilcrease telephoned me. "I've got a letter I want you to read," he said. "The coffee pot is on, come on over." There was a suggestion of excitement in his voice. Mr. Gilcrease had received a letter from Ethel Traphagen Leigh,[1] the widow of artist William Robinson Leigh. The letter outlined the contents of her husband's studio collection and contained a momentous offer. Mrs. Leigh wrote:

> I wish you, with your keen appreciation of Leigh's works, could now come to New York and see his studio, for you would agree it would be a very valuable accession to install in the projected new part of the museum that already contains some of his finest work.
> The studio at 200 West 57th Street, New York City, contains Leigh's art in every stage from start to finish states. Besides paintings, pencil, pen and ink and watercolor, etchings, and a buffalo—the only piece he ever modeled, cast in bronze—are examples, starting with things he did as a six-year-old boy in West Virginia and continuing with every kind and type, to the painting on his easel just as he finished it half an hour before he died.[2]

A photograph taken in 1951 was a companion to the letter. It showed Mr. Leigh before an easel in his studio. The room was large, with full three-by-eight-foot windows to give the artist an abundance of natural daylight by which to work. There were

William R. Leigh by Paul Rossi

literally hundreds of items: Indian costumes, rugs, weapons, baskets, pottery, models, skulls, studies, and paintings. The photograph gave but a glimpse of the collection's importance. The value of a studio collection is that it demonstrates the way an artist works from initial research, his use of models, authentic costumes, first sketches, and studies, up to the finished painting.

Mr. Gilcrease talked about the studio and William R. Leigh's work. He liked his paintings, especially the ones of moderate size. On one of his trips to New York City, he had met and talked with Mrs. Leigh.

Gilcrease Institute owned six Leigh oils: *An Argument With the Sheriff,* circa 1914 (40 x 60 inches); *Chicken Pull (Western Sports),* circa 1916 (24 x 18 inches); *The Roundup,* circa 1938 (28 x 36 inches); *The Mother,* (36 x 48 inches); *Badlands at Night,*

1910 (28½ x 31½ inches); and *Landscape*, (12½ x 17 inches), not dated. In addition, Mr. Gilcrease held two of Leigh's most exciting works, *Bear Hunt In Wyoming*, 1914 (40 x 60 inches), and *Up Where The Big Wind Blows*, 1918 (50 x 37 inches). The grizzly bear hunt scene, titled variously *Dogs Fighting Grizzly* or *A Close Call*, was purchased in 1953 by Lindley Eberstadt of Edward Eberstadt and Sons, New York City, from Abercrombie and Fitch. Mr. Gilcrease bought it from the Eberstadts.[3]

Less than three weeks after we discussed the Leigh collection, Thomas Gilcrease was gone. He died of a massive stroke on May 6, 1962, the last of a number of disorders that had shaken his body but never the brightness of his mind. I shall never forget standing among the flowering dogwoods and mighty oaks near his home with my family and a large gathering of mourners while heads were bowed, listening to his last rites. The chanting of Indians and shooting of the symbolic last arrow added his people's touch to the funeral. In just a few months a tomb was constructed and his body laid to rest not far from his building with the three-foot-thick walls, housing his beloved collection. His passing left a void for me that couldn't be filled.

My journal, with seventy-two separate entries ranging from a few words by Thomas Gilcrease to whole paragraphs, became more than a cherished possession. This journal, along with a tape recording of a short talk he gave, some personal notes, and books inscribed to me, were my physical link with him. His spirit, philosophy, and extraordinary, sensitive mind accompanied every move I made in his museum. I vowed to continue efforts to acquire the Leigh studio collection. But first I realized I would have to learn as much about the artist as possible.

Born in West Virginia, William R. Leigh's professional career started at the age of seventeen, when he began his studies at the Royal Academy in Munich, Germany. An uncle financed the first period of his study. While in Europe he visited museums, sketched, listened, and learned. It was during the period of Impressionism, a strange experimental age for a young artist, but

Leigh remained unaffected. He was becoming a superb drafts-
man—a skill which always characterized his work. Indeed, the
exactness of his drawing was to become his hallmark. Before he
left Europe, Leigh's paintings won three bronze medals at the
Royal Academy and received honorable mention in the Paris
Salon's Selective Competition.[4]

Writing in *The Mentor* magazine in 1915, the artist tells of his
struggles to gain a formal education in art:

> In Bavaria, I worked one year under Professor Rouffe in the
> antique class, then two years under Professor Gyses in the
> nature class, and one year in what was called the "painting
> school."
>
> At this time I was forced to go back to America and start to
> make my living. I spent a year in Baltimore, and saved up
> $300 with which I returned to Munich and the "painting
> school." In the middle of the winter when my funds were
> exhausted, I went out looking for employment. It was not to
> be had for months; but during the following spring I was
> engaged by an artist to help him with some mural pictures.
> He did me out of almost everything I had, and left me
> destitute and in debt.
>
> However, sometime after this I got work with Philip Fleisch
> to help him on a cyclorama which represented the Battle of
> Waterloo. Fleisch found me useful enough to advance me
> sufficient money to get through the year so that I might help
> him the following season on another cyclorama. I entered the
> composition school of the Royal Academy, painted a picture
> which gained me a silver medal, the highest award in the
> Academy, and an honorable mention in the Paris Salon. I sold
> that picture for $1,000 and it is now in Denver, Colorado. Five
> more years were occupied in painting five more cycloramas
> and some pictures in between, one which gained me a second
> silver medal from the Academy.[5]

When Leigh returned to America in 1896, he was thirty—a
mature artist, enthusiastic, and confident of the future. He
wanted to go west, but the long years abroad had been expensive

and he was in debt. Plans to see the mountains and plains country were put aside.

The artist's first job was as an illustrator for *Scribner's Magazine*. From 1896 until after the turn of the century, his sketches appeared in that widely-read monthly publication. In June 1899, he illustrated an article by Kansan William Allen White (later famous as the editor of the *Emporia Gazette*) titled "Victory for the People." Leigh did four black and white opaque drawings for it.[6] The following month, six Leigh illustrations appeared in an article titled "The Foreign Mail Service at New York." During this period, *Scribner's* sent Leigh to North Dakota on an assignment to do a series of illustrations. This provided his first glimpse of range country.

By 1906, the artist was determined to go farther west. He had long since concluded that the heart and soul of America lay beyond the ninetieth meridian. Now he wanted to see it. Arriving in Chicago, broke but undismayed, he went to the management offices of the Santa Fe Railroad. Displaying a portfolio of sketches and drawings, he "horse traded" a proposed painting of the Grand Canyon for a train ticket to Laguna, New Mexico. Once at his destination, he kept his bargain and produced the painting. Railroad officials, pleased with the result, commissioned him to do five more at $250 each. For the artist it was the beginning of his career as a painter of the West. Babcock Galleries in New York City were Leigh's first agents, although E. C. Babcock, according to Leigh, never really appreciated the West or its art. Years later, the artist wrote:

> My interest in the West began long before I can remember. We had a buffalo (properly bison) robe, which was used in the sleigh and which when not in the sleigh lay on the parlor floor, where we kids could roll on it. I vividly recall how long and thick the hair on that robe was, and how warm and pleasant it felt in comparison with the hard, cold wooden floor. My acquaintance with bisons, as well as animals in general, was derived chiefly from *Cassell's Popular Natural History*, over the illustrations of which I was in the habit of

poring for hours upon hours, long before I could read.

I recall clearly, I was just ten years old, my father's reading aloud the report of the Custer Massacre, and this, too, made an indelible impression on my memory.

It came perfectly naturally to me—it was inevitable that I should love the West; it accorded with my temperament; it suited the cast of my mind. Animals, above all horses, were the central interest in the conceptions which attracted me. I have always felt that the West was the place for me. Even while I studied in Europe, I had this in mind as my objective, and consistently worked and planned to the end that I might go there and paint.[7]

Throughout the formative years of his career, William R. Leigh frequently spent months at a time in Arizona and New Mexico drawing, sketching, and making studies. His unpublished memoirs tell of trips to the Grand Canyon. Alone with his thoughts and talent on this high plateau, Leigh became an accomplished student of the Canyon and its many moods. Of a sunset, he wrote:

Presently the great shadows began to swallow up the depths, while the light on the upper pinnacles gathered color; delicate orange and pearl-lilac; a craggy quilt of magical forms and bewitching colors—a fabulous mosaic; a grand kaleidoscopic array of tints of infinite charm. Now the orange light was changed to rose; to vermillions, the shadows to lavender, to purple. The shadows of the peaks were growing to enormous lengths in the east; in the west a configuration of developing shafts of lurid luminosity. Meanwhile, a dark mist gathering in the depths began to rise higher and higher with the mixture of cold and warm air. No language could describe this sublime drama of light and shadow, of color and form.[8]

It was these early trips which gave Leigh his inspired background on the Southwest. He made studies and drawings of a wide range of subjects—plants, animals, sky, cloud formations, Indians, and cowboys. He was to use these studies, along with a large collection of photographs and other props, to assist him in his studio during his remarkably long career. He continued to be an

avid, meditative student and collector all his life.

William Robinson Leigh was a big man physically. He had large hands, broad shoulders, stood well over six feet tall, and had a deep bass voice. Erwin S. Barrie, director and manager of Grand Central Galleries, New York City, was Leigh's agent and close friend in later years. "He was the most outspoken and forthright artist I have ever known," Mr. Barrie wrote. "What a handsome figure Leigh was, plenty of gray hair, pointed gray beard and the famous handlebar mustache adopted by white men throughout the West during the 1880s and 1890s. He was a large edition of Buffalo Bill and his paintings reflected his bigness and intensity."

His painting, *Bear Hunt in Wyoming*, is considered by sportsmen to be one of the greatest hunting scenes in American art. Now owned by Gilcrease Institute, it illustrates the thorough manner in which Leigh worked. The scene shows a hulking grizzly bear cornered by dogs and an injured hunter lying face down near the enraged bear in the dense mountain country west of Cody, Wyoming. The painting resulted from a bear hunt in the spring of 1912, sponsored by J. D. Figgens, director of the Colorado Museum of Natural History in Denver. Chief hunter and guide was Fred Richards, assisted by Ned Frost. Both were Cody men. Dogs used in tracking and cornering the animal belonged to Richards and Frost. In an interview published in the *Rocky Mountain News*, April 7, 1917, Figgens recounted Leigh's role in the adventure:

> I told him [Mr. Leigh] that I would be glad for him to accompany me on my trip in search of a bear group for the Colorado museum, and he accepted the invitation, bringing along his own equipment and his own guide. I had obtained the services of two famous Wyoming guides, Ned Frost and Fred Richards, with their packs, and we set out in May for the bear country.
>
> We had two camps established and roamed the mountains and timber land day after day, spending the night at whichever cabin happened to be closest. We had found a

great many tracks and had followed them without result over hundreds of miles of rocky and wooded territory, when one morning one of the guides found a new track in the dust near our camp.

We followed the prints through the dust for about four hours and then our dogs got the scent and took up the trail. For two hours we trekked after the bawling hounds as they made straight for higher ground up the side of a mountain.

Leigh's manner was all eagerness now and his eyes glistened as he rode along with his Kodaks and boxes dangling. His object was entirely different from ours, but he entered into the pursuit with quite as much zeal, and there were no indications that he would fall off his horse, although the day had already been a hard one.

Finally the dogs came within sight of the bear. Up the mountainside they bounded with a bruin giving them a fast race. On a north slope of the mountain the animal made a fatal mistake—he plunged into a stretch of snow, soft and mushy now from the spring sunshine, a certain trap for his heavy body. He lumbered along for a time in the snow, with the lighter dogs gaining every second. Then he turned and made for an open space. But it was too late.

The dogs were upon him as he reached firm ground and a terrific fight began. One of the guides and I came up with our guns—I have forgotten now whether it was Frost or Richards—and Leigh was right at our heels. He asked if we would let him make some sketches before we killed the grizzly, and we consented. We knew that the bear could not get away, because we were within a few yards of him and both the guide and myself were better than ordinary marksmen.

Leigh got to work with his Kodaks and pencils and we waited nearby, changing our position occasionally in order to maintain a vantage point in case the bear should make a break for liberty. It was in one of these maneuvers, I think, that the guide came too close to the fighting dogs and was knocked down. This gave Mr. Leigh the idea which he has incorporated in his picture as it was finished—the spectacle of one of the hunters lying prone under the bruin.

Leigh developed his pictures and made numerous visits to the spot before he put the painting in its present form. He measured distances and counted trees and lived over again

many times the whole encounter in order to give every detail
as it had actually been.

Perhaps the most thrilling chapter in William Leigh's life
concerned his adventures in Africa.[9] Being an artist, he saw the
dark continent in a perspective different from that of a hunter. In
1926, he accompanied the Carl Akeley expedition to equatorial
Africa. The expedition, sponsored by patrons of the American
Museum of Natural History in New York City, had as its purpose
the collection of specimens for major habitat groups in what was
to become African Hall. Leigh made sketches and studies used in
painting background murals for each habitat group. In addition to
Akeley and Leigh, the party included, among others, George
Eastman, the noted founder of the Eastman House of Photogra-
phy. The expedition made contact with Martin and Osa Johnson,
noted African game collectors, during their fourteen months in
Africa.

Leigh became a great admirer of Carl Akeley. He wrote, "With
artistic insight Akeley saw that all the attempts to depict Africa
had failed in one essential—no one had ever conveyed the savor,
the feel of Africa." As to Akeley's approach to exhibiting animals,
Leigh said, "He evolved new techniques in mounting animals. His
descriptions of what ought to be done—of what he could create—
baffled the museum authorities. Yet all of them put together
could not equal the brilliant imagination, this dynamic individu-
al's energy."[10]

Carl Akeley made the art of taxidermy a sculptor's work.
Strongly opposed to stuffing or filling skins with unconvincing
lifeless forms, Akeley pioneered the development of frameworks
on which clay was added and then sculptured to exact size. From
the clay model a plaster mold was made. The mold provided a
basis for creation of the figure on which the actual skin was fitted.

The expedition was Carl Akeley's sixth. He had accompanied
Theodore Roosevelt on an elephant hunt to Kenya in 1909. In
spite of the strides made in travel and communication, and the
slaughter of game that had been going on for years, Leigh stated

that conditions were primitive in 1926 and magnificent game in abundance.

The party docked at Mombasa, British East Africa and assembled in Nairobi. The expedition moved about equatorial Africa in quest of specimens and knowledge of flora and fauna for the exhibits. The primary groups planned were Impala, Wild Dog, Plains Group, Greater Kudu, Lesser Kudu, Water Hole Buffalo, Klipspringer, Gorilla, and Elephant.

A thread of sadness about Akeley runs through Leigh's African narrative. Having worked to the point of exhaustion in the months prior to the actual trip, Carl Akeley was in no condition to endure its physical hardships. In addition, according to Leigh, he was worried about financial aspects of the venture. Years of emotional strain and hard work, combined with the inability to "politic", shortened Akeley's life. First there was exhaustion and prolonged weakness, then pneumonia, and finally death. He died in gorilla country in the last stages of the highly successful expedition. Leigh wrote in his memoirs, "It was a dreary experience, sitting in the dead of night on this lonely mountain amid primeval savagery and thinking of the career cut short—realizing that a great man lay dead. For Carl Akeley was a great man—an idealist in the highest sense. He had given his life to pursuing a magnificent idea; he died a soldier on the battlefield of science." Carl Akeley was buried November 21, 1926, in his beloved Africa.

In 1928 Leigh returned to Africa with the Carlisle-Clark expedition, launched to collect specimens for the lion habitat group in the American Museum of Natural History's African Hall. Mrs. Leigh accompanied her husband on this trip.[11] It was not until 1932, however, that museum officials were able to resume work on the famed exhibits. From 1932 through 1935, Leigh worked on murals for African Hall and the artistic details of each setting. The entire project, from collecting specimens, sketching and photographing on the expedition, transporting, and preparation in the museum, had taken ten years. The hall, when finally completed, was the greatest and costliest exhibit of its kind. The

wing, dedicated to Carl Akeley, was opened to the public in 1936.[12] Leigh remained an avid student of Africa for the rest of his life.

William Leigh was a perceptive and gifted writer. He has three books to his credit and dozens of articles for which he was both author and illustrator. *Clipt Wings*, a drama published in 1930, concerns the authorship of works attributed to Shakespeare, the parentage of Francis Bacon, and the character of Shakespeare. Leigh's best book, which has become a classic of the West, is *The Western Pony*, published in a limited edition in 1933. Among his minor published works is a lengthy poem, *The Painted Desert*. Perhaps the most popular of the early articles Leigh wrote was one titled "A Day With A Navajo Shepherd," published by *Scribner's*.[13] Late in life Mr. Leigh wrote his highly reflective and sensitive "My America" for *Arizona Highways*. The article was illustrated with a colorful portfolio of his art.

Leigh was a strong opponent of non-representational abstract forms of art. He wrote and lectured against them. However, one of his most frequent essays dealt with impressions in art, which in part is as follows:

> Since painting is an art, its mission is to produce impressions; only in scientific books to convey mathematical facts. Two illustrations will make my meaning clear: Let us suppose an artist is painting an express train moving at a mile a minute. The smoke of the engine would be streaming back in a flat line as taken by the camera. But in the instantaneous photograph, every spoke in the wheels of the engine would be clear and sharp, as if the machine were standing still. The painter, however, must show these spokes as a blur, otherwise he would totally destroy the impression of movement he wanted to suggest. From the point of view of the observer, he would be exactly right, since no human eye could see anything but a blur. Now let us suppose the same painter, picturing a hummingbird hovering over a flower. To the eye the wings of the bird would be quite as much a blur as the spokes of the wheel, yet so painted they would not convey the idea of motion, but merely of a smeared or unfinished

picture. The only thing the painter can do to give the impression of the bird is to paint the wings out in detail, exactly the opposite procedure to that involving the wheel. Why one riddle with two answers? The reason is that the painter must convey the impression of truth as best he can; sanity, knowledge, taste, common sense are the guides which he must follow, since they are the only guides. It is photographically correct to paint the horse in action as the camera shows it, but it is artistically wrong, because to depict some of the instantaneous phases of the stride, even though we now are able to do so, does not convey the idea of rapid movement. Outlandish-looking poses in the movement of the horse or any other animal shown by the camera, should be avoided by the painter.[14]

A study which has located 400 of Leigh's finished works (not including his studio collection in Tulsa or his African collection in New York) is interesting.[15] Paintings by the artist were found in museums, galleries, and in the hands of collectors from twenty-three states. Renowned dignitaries possessing Leigh oils have included Prince Albert of Belgium, Prime Minister Eamon DeValera of Ireland, and the Duke of Windsor. Among American art patrons holding prize Leighs have been Huntington Hartford,[16] Alfred E. Clegg,[17] C. R. Smith,[18] George Eastman, Dr. Philip C. Cole,[19] Frank Phillips,[20] Walter S. Gifford, and August Heckscher.

Of the 400 Leigh pictures accounted for in my survey, there were thirty-one watercolors, four charcoal drawings, eleven etchings, and the balance of 354 were oils ranging from miniature size to mural-like canvases.

An analysis of his subject matter clearly shows the artist's first love and devotion. Of the 400 works, 169 were Indian subjects and settings, predominantly Navajo, Hopi, and Zuni. Cowboys and cattle accounted for eighty-six compositions. Sixty-three were western scenes, as contrasted with nineteen eastern landscapes and city skylines. Forty-eight of the paintings were domestic and game animals, including ten African subjects. Ten paintings portrayed big game hunts in Wyoming. The study revealed eleven

Indian by W. R. Leigh

portraits and one mining scene. Three of the paintings could be categorized as miscellaneous. In 1945 Leigh compiled a list of one hundred and fifty works titled *Reproductions of William R. Leigh's Paintings Appearing in Color and Black and White in the Following Publications Since 1910.*[21]

To generalize about Leigh's career could be misleading, yet it has been established that most of his greatest works were created late in life. In 1939, at the age of 73, he produced such famous canvases as *The Lookout* (5' x 7' oil) and *Custer's Last Fight* (6½' x 10½' oil). The latter was one of the first Leigh paintings to bring $10,000. The year 1941 saw six fine canvases, notably *The Best of the Bunch.* The following year he painted *Westward Ho* (6½' x 10½' oil), another $10,000 classic. In 1943 Leigh may well have been at his best, creating his largest canvases: *Pocahontas* (6½' x 10½' oil), *Navaho Fire Dance* (6½' x 10½' oil), and *Visions of*

Yesterday (6½′ x 10½′ oil). During 1944 and 1945 his output appeared limited, but in 1946 he came up with *The Leader's Downfall*, a great 6′ x 10′ oil, and *The Struggle for Existence*.

Erwin Barrie said Leigh considered *The Leader's Downfall* (sometimes titled *The Master's Hand)* his finest. In 1947 he painted both *Buffalo Hunt* (6½′ x 10½′ oil) and *The Buffalo Drive* (6½′ x 10½′ oil), which brought him $15,000 apiece. In 1948 he produced 17 works. The artist was 83 years of age in 1949 and still going strong with an amazing production of thirty paintings. The following year he hit a stride that may well be unequalled, considering his age, by turning out 32 finished paintings. The next year saw completion of his last mural-size painting (6½′ x 10½′) of his beloved Grand Canyon. During the remaining years of life, with eyesight weakening, he is known to have done more than thirty additional paintings.

In January and February of 1955, Grand Central Galleries of New York City paid tribute to the eighty-eight year old artist by holding one of the most unique retrospective exhibitions in history, entitled *Eight Decades in Review*. It began with paintings and sketches the artist had done as a boy and continued with more than sixty paintings from his long and distinguished career. One of the highlights of the show was the painting, *Midnight Ride of Paul Revere*,[22] a historical work now owned by Old North Church in Boston. Several important mural-size works were included in the exhibition.

Greatest of the honors paid to William R. Leigh was his election to the National Academy of Design a few days before his death on March 11, 1955.

My weeks of study of the artist had paid off and heightened my desire to acquire the studio collection, so I began corresponding with Mrs. Leigh. We became good friends through the mail.

During the summer of 1962, she suggested I write an article about Mr. Gilcrease for the Traphagen School of Fashion Magazine. On October 8th I wrote:

Dear Mrs. Leigh:

I fear my inability to settle down to writing the Gilcrease article has caused you concern. I apologize for it. It seems hard to realize that Mr. Gilcrease is gone. I hope that my article will be acceptable for printing in your fine publication.

An artist [Willard Stone] very close to the Institute is having a showing at Kennedy Galleries there beginning the 15th of November. I have postponed my trip so I can accompany him. He is Cherokee and does beautiful sculpturing in wood.

If my invitation to meet and visit with you is still open I shall look forward to seeing you.

> Best wishes,
> Dean Krakel
> Director

The following month I was able to go to New York. Excited at the prospect of meeting Mrs. Leigh, I found her to be quite a person in her own right, rather tall and sinewy for her almost eighty years. She possessed tremendous energy and her accomplishments in life, like those of her husband, had been many. Mrs. Leigh had established the Traphagen School of Fashion and Design in New York City.

Ethel Traphagen and William Leigh were married in 1921. During their life together, they roved the world, while she looked for clothing design and jewelry concepts among the various primitive societies and Leigh sketched subjects he later painted. They were an interesting couple, strong-willed and independent, who adored each other. Mrs. Leigh was the artist's best press agent and through the years he was featured at one time or another in many major publications.[23]

After a tour of the Traphagen School of Fashion and Design, I was taken by Mrs. Leigh and Douglas Rowley, Mr. Leigh's personal secretary, to the studio at 200 West 57th Street. At first the studio seemed out of place, eleven stories up in the heart of Manhattan, but soon I found myself absorbed in one of the finest private museum-libraries I had ever seen, organized for each phase

of the artist's work. Research files contained hundreds of photographs taken throughout the West and Southwest. There were grass samples, sagebrush, and soils. The library ranged from books on philosophy to the minutiae of lower mammals—more than fourteen hundred volumes. Like Remington, Leigh was a student of animals in motion. The Indian paraphernalia he had acquired was amazing. Three Navajo saddles were there, along with silver inlay bridles and bits. There were velveteen blouses and skirts, silver conchos and turquoise-studded necklaces, all common in the artist's scenes. Pottery, baskets, rugs, and blankets made up an important part of the studio. There was a large assortment of both white and red men's weapons. The studio clearly showed how Leigh perfected the anatomy of his figures, for there were many plaster models of human and animal figures. Here was Leigh's home and heart for more than thirty years.

From what I was to observe, Mr. Leigh took his work through various stages to completion. Following the first sketches came research and then the drafting table. With meticulous care, he penciled in each detail of a planned composition. For one painting I counted more than ten pages of pencil drawings on tissue paper. These were overlaid one on another until the composition took shape. After this was done, a master drawing was made for transferral to canvas. For some of his more complicated works he made studies in oil. Leigh had an unusual feeling for color harmony and his color sense was completely liberated. He is probably the only artist admitted to the National Academy of Design who painted a purple horse.[24]

At the December 18, 1962 meeting of the Gilcrease board of directors, I gave a report of my visit with Ethel Leigh and my judgment regarding the studio. It was still my belief that the value of the collection was in a studio setting. The directors authorized me to continue exploration of the matter.[25] Ironically, at the same meeting, the board voted negatively on the tentative invitation of Mrs. Robert L. Storck, of the West Virginia Centennial Commission, requesting that we participate in a William R. Leigh

retrospective exhibition. The artist was to be recognized by West Virginia as an outstanding son and the exhibition had received the enthusiastic support of Mrs. Leigh and of the Grand Central Galleries. Gilcrease's holdings accounted for some of Leigh's outstanding works.

It was more than a dilemma for me. I wanted to maintain our good relationship with Mrs. Leigh, and at the same time I concurred with the board's decision. My letter to Mrs. Storck, with a copy going to Mrs. Leigh, stressed the hazards of releasing irreplaceable art and the problems presented by a year-long exhibition, especially one that is circulated. "It would be flirting with the great artist's destiny," I wrote. "If something should happen, his finest works would be lost forever." A few days later I received an airmail special delivery letter from Mrs. Leigh. She agreed—the show should be called off.

By late spring, I had crystallized my thoughts about the studio. On May 10, 1963, I sent the following message to Mrs. Leigh: "On behalf of the board of directors we invite you to consider placing Mr. Leigh's studio collection in the Gilcrease Institute, side by side with Remington, Russell, and many other great artists. This is an invitation to immortalize Mr. Leigh in a great western museum." The message was sent by night wire. Two days later I received a return reply from Mrs. Leigh's secretary, informing me that the seemingly indestructible Ethel Traphagen Leigh had passed away two days before my message was received.[26]

I was stunned. Aside from the loss of a friend whom I had grown to admire, I felt other provisions might now be made for disposal of the studio collection. I was reasonably certain that there was little that we could do in the way of competitive bidding should the collection be offered for sale. Then, to my pleasant surprise, John C. Traphagen, Mrs. Leigh's brother, telephoned regarding the collection. I was out of the office at the time but he left the following message:

> I was Mrs. Leigh's brother and am executor of her estate with the Bank of New York. I am distinctly interested in

suggestions made in your telegram and would be pleased to confer with you in New York City if possible when you could identify the articles of Leigh's collection you would like to possess.

Mr. Alfred Aaronson of our Board of Directors and I had the good fortune to visit with Mr. Traphagen and discuss the possibility of the Institute acquiring the Leigh studio collection. We found Mr. Traphagen to be a gentleman of the highest standing, who had led a long and distinguished career in banking.

In making an inventory of the collection with Mr. Traphagen, we discovered a fine C. M. Russell watercolor. Its size, date, and subject matter made it important. Mr. Traphagen included the painting in the inventory. When it came to the essentials of the project, I said we would like to have the entire studio—lock, stock and barrel. All five and a half tons!

On the 17th of June, I received the following letter from Mr. Traphagen:

> I want to tell you how much we appreciated your visit and that of Mr. Aaronson and the interest which you have shown in William Leigh's studio and his pictures. I am hopeful that arrangements can be made to have you receive the paintings and artifacts which you looked over when you were here June 6th, although there will undoubtedly be delay until we can get various matters straightened out in connection with my sister's estate. As I explained to you and Mr. Aaronson, there are some items which we may wish to withhold. If you are still interested as ever in wishing to establish a corner in your Institute for Mr. Leigh, would you be good enough to write me a note telling me just what your plans are so I may talk it over with my co-executor, the bank, and with our attorneys. The delay I am sorry for but hopeful it will not continue too long.

Following our July 9 board meeting, I wrote Mr. Traphagen of our plans to devote one entire gallery to the collection, attempting to duplicate a small portion of the studio. In his prompt reply he

seemed pleased with our ideas. We waited.

In September 1963, Mr. Traphagen agreed in a letter to the President of the Board of Directors, Otha H. Grimes, to present the entire collection to the Institute as a gift! I flew to New York to make arrangements for transporting the collection to Oklahoma. It took two days to pack the studio for shipment by commercial van. The collection was conservatively appraised for the museum's insurance program in excess of $530,000. In art alone it contained 534 oils (primarily studies), 344 charcoals, a number of pen and ink and pencil drawings, and three watercolors.[27]

Leigh (born in 1866) was a contemporary of both Remington (1861) and Russell (1864). Yet he outlived Remington by more than forty-five years and Russell by almost thirty. His basic art training was superior to either of these great painters. In fact, he was one of the few artists associated with the West who was formally schooled in Europe. Unlike Remington and Russell, Leigh made no pretense at being a "Westerner", a lover of horses, or the out-of-doors. He was a student. In his book, *The Western Pony*, Leigh compliments his contemporaries:

> When Frederic Remington, as a young man, went to the West, he sent back drawings of bucking horses, which were the most accurate and sensational drawings of this kind that had ever been seen. The magazines of the East seized them avidly. Soon afterward C. M. Russell, far more intimately acquainted with the cowboy life, and with a wonderfully correct knowledge of the horse, began painting his remarkable series of compositions portraying situations in the life of cowboy and pony. When one turns from the work of these two men to look at the paintings by Meissonnier, Detaille, de Neuville, Schreyer, one smiles; when one goes further back to the horses of Rubens or Velazquez —one laughs![28]

Many artists have copied subjects made famous by Remington and Russell, but William Leigh was not among them. He especially steered away from traditional buffalo hunts, cavalry, and Indian conflicts. Indeed, I have yet to see a cavalryman painted by Leigh. He was far more interested in portraying life in the

Southwest—its drama, simplicity, and beauty, with very little of its violence. The California art critic, Eugene Neuhaus, in comparing the three, wrote of Leigh in his *The History and Ideals of American Art*. "His pictures have the sophistication and finesse of the schooled painter, but they lack the freshness and vigor of Remington's or Russell's work."[29]

Leigh was as much a student of the Navaho and Hopi as Remington was of the army and Russell of the Northern Plains people. Leigh caught the Indians' mysticism in his paintings and drawings as well as his writings. The Hopi and Navaho of fifty and sixty years ago, of Leigh's time, had not changed. They were isolated and clung to the old ways. This was the life to which William Leigh was dedicated.

Leigh's figures were "molded". No artist of the West has so finely drawn the torso of the male as Leigh. He shows muscles growing taut, as an arrow is fitted and the bow bends. A dramatic Leigh composition with outstanding anatomical portrayal is *Pocahontas*. The great Algonquian chief, Powhatan, has decreed that John Smith, the founder of the colony of Virginia, should die. The canvas depicts the chief, flanked by advisers, watching as a warrior stands tense with a war club held high over his head ready to bludgeon the helpless Smith. Then Pocahontas intercedes, appealing to save Captain Smith's life.

Nor is there a more graceful and delicately textured female than in *The Lookout*, a magnificent scene portraying women in a cliff dwelling. These paintings, *Visions of Yesterday, Navaho Fire Dance*, and *Westward Ho*, are in the late Frank Phillip's Woolaroc Museum near Bartlesville, Oklahoma. Painted between 1939 and 1943, these mural-sized works are surely among the artist's greatest achievements.

Leigh was something of a social rebel, to the point of being anticapitalistic. There was an inner restlessness about the man. Some of his most powerful works portray industrial greed, political hate, and war. A controversial 1922 Leigh oil painting, expressing his feeling toward capitalism, is titled *The Reckoning-*

Conscience (40 x 50 inches). It portrays the moneyed man as the central theme, surrounded by a study in hands—the hands of the old and young, hands of infants and children, hands pleading, begging, shaming, accusing, threatening, hands that are soft and smooth, others that are hard and powerful. Even the hand of death appears in the painting.

He became a master of the desert's tempo—its vast landscape, cloud pileups, mesas, and endless drought. He could relate the details of a Navaho woman creating a blanket from shearing of sheep, washing the wool in a solution of yucca roots, carding and dyeing, spinning on a primitive spindle, twisting the fibers, and finally placing them on the loom. He knew the rituals of the kiva, and the holiness of sand painting. He could read the signs and speak the language of Canyon de Chelly country. Picture the towering Leigh sitting crosslegged in a hogan smoking and gambling with Navahos—it was so.

Leigh especially loved Indian children and he painted them as

Burro by W. R. Leigh

61

no other artist has: boys herding goats, a child holding a goat by the head while another milks it, a child sitting by the hour scanning the sky for marauding eagles. A mother bathing her infant was a favorite Leigh subject as was an old man telling his grandson of days of old. Leigh made pets of the Indians' burros, and usually they are standing silently, bearing their burdens while flicking ears and switching flies. There are few facets of hogan and pueblo life that he didn't record. We find considerably less action in Leigh's paintings of Indians than those of his contemporaries, yet when he did paint dramatically, he did it in a grandiose manner.

Leigh worked harder, lived longer, and may have gained less monetarily than most artists of comparable stature. He had little time for humor in his art, writings, or personal correspondence. He was a master with the sketchbook. Indeed, the quality of meticulous detail in his studies often surpassed the finished products, for at times in his career he was prone to overpaint. His greatest works are the enormous canvases documenting an event or person from the pages of history. He seldom worked in watercolor or charcoal and only one bronze, *The Buffalo*, reveals his talent in sculpture.

William Robinson Leigh's longevity and experience gave him the unusual privilege of recalling stirring scenes of decades gone by. He was eminently qualified and deserving of the recognition that came to him late in life. It may be said emphatically that, with great talent, he helped preserve the fading image of the Old West.

The Leigh acquisition, glorious as it was, caused problems at Gilcrease. One that I vividly recall was my argument with a Tulsa city official by telephone from New York regarding payment of the charges for transport of the collection. (The expenses were to have been settled before accepting the collection.) I remembered him exclaiming, "Hell, you have more God damned art now than you know what to do with!"

In my short tenure at Gilcrease, we had achieved a great deal; in

fact, our progress had been tremendous. Yet I knew I had committed unpardonable sins, in addition to insulting officials over the Leigh Studio shipping bill. For one thing, I had refused to be a tool of City Hall. The old adage applies: "If you can't 'buck' city hall, join them." I bucked them and did not join. An incident, now humorous to recall, occurred when I argued strongly with a city commissioner over the terms of the insurance policy covering parts of the art collection, particularly our pre-Columbian gold. The collection had not been tested, weighed, measured, or cataloged and had high value as raw gold as well as historic worth. Some of the objects were the size of an ordinary dinner plate. I estimated the collection to be worth more than $200,000. I closed our heated conversation with, "This could make damn good reading in the press."

The next day I was summoned to City Hall. Arriving there, I was escorted to a basement room that looked much like a gambling parlor. There were green-covered poker tables with hooded globes casting light down on the tables. Smoke was so thick you could cut it with a knife. There was the commissioner with whom I had the tiff, along with three or four high-ranking city officials that I recognized and a couple of men I had not seen before.

The spokesman was one of the men I did not know. He told me to sit down and I did. His coat was off, tie disarrayed, and sleeves pushed up. He was wearing a shoulder holster and packing the biggest side arm I had seen in a long time. I couldn't take my eyes off of it.

The conversation started with one of the men stuttering, "d-d-d-Dean. We d-d-don't want you to get us wrong." The gun-toter bluntly interrupted with, "Cut the crap. Krakel, you're here because of the way you shot off your big mouth to the Commissioner over Gilcrease's insurance coverage. This administration is clean. Understand? Clean! An' we don't want no son-of-a-bitch to 'mbarrass it in the papers over insurance or nothin' else! Know what I mean?" The meeting was short and sweet.

The spokesman then took his gun out of the holster, pulled the clip out and began removing shells.

I said, "Can I go now?" Without looking up, he said, "Yeah. Get your ass outa here and I hope we don't have to have another talk." I understood fully. In no way would I embarrass the administration.

Another unpardonable sin was committed when I pleaded with the Gilcrease Foundation's attorney to discourage the Foundation from giving the city-owned Institute approximately $5,000,000 more in art and real property. My arguments fell on an ear that was more cautious than unsympathetic. Members of the Gilcrease Foundation were Tom, Jr., Des Cygne Gilcrease Denney, Barton Gilcrease, and Eudotia Teenor. Their gift was to be synchronized with the dedication and opening of a spectacular new building addition set for October 27, 1963. What was at stake included several thousand artifacts and a collection representing America's greatest artists.

A few days after my session with the attorney, Foundation members signed the proffer of gift; even after the signing I again urged them to make demands on the city. I pleaded for improved standards of operation. I cited ills that began with Gilcrease's pitifully inadequate operating budget. "Why give them more," I complained. "They haven't cataloged what they have." The Institute required four curators in the art division alone and had only one. A massive ethnology and Eskimo collection needed basic attention.

My thoughts were that the entire museum system desperately needed upgrading and the overall administration required careful study. I had been told, in effect, by city officials that money put into Gilcrease earned few votes—unlike efficient care of streets, sewers and prompt garbage collection.

"Don't give all this to City Hall on a platter," I argued. "Set forth terms that would improve the operation. If Mr. Gilcrease were living, he would agree with me. As you know he was extremely

disappointed in many aspects of the museum's operation under the city," I continued.

The attorney agreed with me after hours of arguing but wouldn't consent to discuss it with Tom, Jr. or other members of the family.

Later, the attorney told others of my conversation. I received a strong reprimand from two directors over the matter. I'm probably one of the few administrators ever to recommend that patrons not give his museum such a magnanimous gift. In the end, the thought flashed through my mind (though I remain strongly anti-government) that Gilcrease's holdings were so rich and priceless that perhaps they should be nationalized and taken over by either the Smithsonian or the National Gallery.

I resigned from Gilcrease Institute to become Managing Director of the National Cowboy Hall of Fame on November 1, 1964. The Leigh Studio was dedicated Friday evening, November 7.[30] I felt that the first public showing of the collection would be an appropriate way for my friend Paul Rossi to launch his career as the new director of the Institute.

During his Gilcrease years, Paul Rossi sailed the same turbulent administrative waters that I had. Talented and with a steady hand, he was less apt to rock the boat than I; yet he was to be caught in the inevitable power struggle between City Hall and the Citizen's Board for control of the Institute.

Time has evidently taught Tulsans little regarding the administration of the Gilcrease Institute. On November 4, 1972, a newspaper editorial pointed out in part the hazards a director must face in taking over the reins:

> Any director of Gilcrease has built-in problems. He must be responsive first of all to the city parks and recreation board, which hires him and represents the city's authority over the museum. At the same time, there is a separate board of the Gilcrease Institute of American History and Art which embraces much of the community-wide support of the museum. It is a two-headed leadership, awkward and sometimes hard to deal with, but it is a fact of life.

In leaving Tulsa, I consoled myself with the fact that the Board of Directors and city fathers had not lost money during my tenure. Gifts from Charles S. Jones, the Leigh Studio acquisition, the endowment of properties from the Gilcrease Foundation, and the building of a 25,000-square-foot addition with bond monies raised in a campaign were all solid achievements. We had our magazine, *American Scene*, going great guns plus the prospect of Alfred Knopf publishing a major art book on the collections—negotiations were near the contract stage.

And so I left my friends in the Osage Hills, knowing I was leaving the greatest collection of western Americana in the world. In the not too distant future, it would appraise at fifty million dollars. As Art Curator Bruce Wear said, "When you leave Gilcrease, whatever professional direction you travel, it will be downhill."

Even more than money and treasures, I was leaving Gilcrease for a concept, an ideal of the West and of free enterprise. At the National Cowboy Hall of Fame, I would have no government agency to contend with, no civil service commission, no red tape, no built-in meddling bureaucracy. It was the beginning of a new dream.

Chapter 4

On the Trail of C.M. Russell

ONE OF THE FIRST conclusions I reached after moving to the National Cowboy Hall of Fame[1] was that we couldn't have a great western cowboy museum without a strong representation of C. M. Russell's work. Furthermore, the Cowboy Hall of Fame on Persimmon Hill[2] was at the apex of an awesome art triangle formed by Gilcrease at one corner and Fort Worth's Amon Carter Museum[3] on the other. Within a few hours' drive in either direction, Western art enthusiasts could see not only the best of Russell but of Frederic Remington and many other major artists as well. I felt we had to acquire a strong collection, a collection that would establish high standards at the outset. Unlike Gilcrease Institute and the Amon Carter Museum, the Cowboy Hall of Fame had no king-size benefactors at that time, much less bountiful funding by appropriations or trusts. Additionally, the price of art had increased immensely since the 1930s and 1940s when Gilcrease and Carter made their great buys.[4]

Shortly after coming to the Cowboy Hall of Fame, I phoned Charles S. Jones[5] of Los Angeles. I had met Mr. Jones at Gilcrease, where he had given us a major western bronze. The project to acquire his collection of C. M. Russells was dramatic and in the end had an unexpected twist.

The Russell Collection[6] owned by Mr. Jones consisted of two major oil paintings, *Redman's Wireless* and *Smoke Talk;* a drawing, *In For Christmas; Father DeSmet* and a number of other

National Cowboy Hall of Fame by Conrad Schwiering

small watercolor illustrations; four large pen and ink drawings used as illustrations, titled *The Stagecoach Attack, Battle of the Bear Paws, Hazing a Steer,* and *Battle Between Crows and Blackfeet;* a number of extraordinary works, such as *Xmas Where Women Are Few, Tommy Simpson's Cow, Armored Knight and Jester,* and *Milking Time;* and a letter to Nancy Cooper written a few weeks before their marriage. The letter, dated August 9, 1896, is perhaps as much a love letter as the cowboy artist was capable of writing. In addition, the collection contained more than seventy-five pencil sketches and notes. Also included were all of Russell's great subjects in bronze: *Meat For Wild Men, Counting Coup, Lewis and Clark and Sacajawea* by Henry Lion (done after a

watercolor by C. M. Russell), *Scalp Dance, A Bronc Twister, Where the Best of Riders Quit, Buffalo Hunt* and *Changing Outfits*—a total of ninety-two bronzes.

When I told Jones that the Cowboy Hall of Fame was definitely interested in buying his collection, he agreed to give us a six months' option. He then notified William F. Davidson of the M. Knoedler Company, New York City, who served as his agent in the transaction. The price of the collection was $500,000.

The chairman of the Board of Trustees called a general meeting of our board in Oklahoma City in January, 1965 to discuss purchase of the collection. After much conversation and speculation, the board agreed to take on the Russell acquisition.

Trustees of the Hall floundered with the project from the outset and after several weeks were unable to come up with any kind of financing plan. It was a great disappointment to me. Board members at this time did not appear to have enough faith in the institution which they had created to "lay it on the line." In my mind, the Russell art project was replaying the Hall's history, which had been riddled with failure. The board had given up title to the building shell and thirty-seven acres of land for a $1.2 million loan to complete construction of the building and begin operation. Little did I realize the burdens I would carry, not only in the development of the museum's collections, but in its day-to-day operation. The building debt, I discovered, would have to be serviced from our admissions revenues. Before our title was regained, it cost us more than $600,000 in interest.

The overall situation puzzled me. Why would a group of prominent men take on such a project and not be prepared to work and sacrifice for it? A museum, after all, is only as great as its collections. People will come to see exhibits that are worthwhile; thus, great attendance comes from great attractions. The Jones Collection, modest as it was, was vital to our future. The collection would keynote the quality I had hoped for. To open and dedicate the museum, we had borrowed more than two million dollars worth of Western art from the Robert Rockwell

and Sid Richardson Foundations and from art dealer friends in New York. Borrowing high value art is like borrowing money—it is not destined to last. A payoff or return date rolls around quickly.

Frustrated by the board's indecision and playing for time, I "bicycled" the matter with Davidson and Charlie Jones, hoping something would happen. And it did. I succeeded in selling the idea of the collection's value to Luther T. Dulaney.[7] Mr. Dulaney, a prominent and wealthy Oklahoma City businessman, was also president of the Oklahoma City Industrial and Cultural Facilities Trust[8] (to which we were already in debt). The Trust had the financial capability of buying the collection. Two other men who supported the idea were Paul Strasbaugh,[9] manager of the Oklahoma City Chamber of Commerce, and Stanley C. Draper, Sr.,[10] executive secretary of the Chamber.

Art Director Jim Boren[11] and I flew to California and met with Mr. Jones. Together, the three of us inventoried the collection. After several hours work, Jim and I were fully convinced of its tremendous worth. Upon our return, we met with members of the Trust.

One of the next steps was to have the collection appraised. The expert hired by the Chamber of Commerce and approved by Hall officials to make the appraisal was John Pogzeba[12] of Denver. Mr. Pogzeba, an authority on art, was trained as a conservator in Europe. Coming to America following World War II, he became active in Western art circles. When Mr. Pogzeba's appraisal came back for the amount of $1,050,000, it was a surprise to everyone except James Boren and me. Mr. Jones was virtually giving the purchasers half a million dollars. This, of course, sweetened the plum considerably. In addition, Jones agreed to will a fine 1925 Russell watercolor, titled *Worked Over*, to the Hall. (This was to come to us years later, but not without problems.) After several meetings, the Trust agreed to buy the collection and lease it to the Cowboy Hall of Fame. The rent the Hall would pay for exhibiting the collection would service the interest on the debt incurred by

the Trust. Mr. Strasbaugh put the paper work together and did all of the negotiating with the seller. *The Daily Oklahoman* announced the acquisition on September 30, 1965 in a release prepared by the Chamber as follows:

MILLION DOLLAR C. M. RUSSELL
COLLECTION OF WESTERN ART COMES
TO NATIONAL COWBOY HALL OF FAME

Trustees of the Oklahoma City Industrial and Cultural Facilities Trust and the Trustees of the National Cowboy Hall of Fame announced today at a press conference in the Board of Directors' room of the Chamber of Commerce, acquisition of the Charles S. Jones collection of Charles Russell art. Mr. Jones, Chairman of the Board of the Richfield Oil Company of Los Angeles, originally purchased the Collection containing more than two hundred items, from the Estate of the late Nancy Russell, widow of the Montana cowboy and sculptor.[13] Russell died in Great Falls, Montana, October 1926.

The Trust is composed of Luther T. Dulaney, Jean I. Everest, John Kilpatrick, Jr., Dean A. McGee, and H. C. Webb. The Trustees said the details for the transaction had been under way for several months. The Trust, in cooperation with four Oklahoma City banking firms, The First National Bank and Trust Company, The Liberty National Bank and Trust Company, The Fidelity National Bank and Trust Company, and the City National Bank and Trust Company, was able to make the acquisition for the National Cowboy Hall of Fame and Western Heritage Center through an interim financing program until the Center could raise funds from a planned drive from throughout the seventeen western states to make the purchase.

The Executive Committee of the National Cowboy Hall of Fame, headed by Albert K. Mitchell, New Mexico rancher, approved the purchase at a recent meeting. Glenn W. Faris, Executive Vice-President, said the Committee considered this an opportunity which could not be passed up.

Also on hand at the preview showing were Stanley Draper, Sr., Governor Roy Turner, E. K. Gaylord, O. M. Mosier, Mayor George H. Shirk, and other members of the Local Operations Committee. Cowboy Hall officials indicated the

Collection would be placed on exhibition prior to the opening of the National Finals Rodeo which begins December 4.

Only a few items from the Collection were unveiled at the preview. Among them was *Red Man's Wireless,* a major Russell oil, 42 x 72 inches, dated 1916. Authorities state this is one of the largest paintings done by Russell. *Smoke Talk,* another large oil, has the distinction of being the only Russell painting to hang in the White House. Mr. Jones lent the work to Dwight D. Eisenhower during his presidency. Mr. Eisenhower and Charles S. Jones have been lifelong friends. Of the 92 bronzes in the Collection, only a handful were exhibited. Among those selected was *Meat For Wild Men,* which is considered Russell's masterpiece in bronze. The work is 13 inches high with a base 22 by 37 inches. It depicts in excitement and in accurate detail the buffalo hunt, one of the most important aspects of the Plains Indians' life. This piece has been appraised at $45,000. *Counting Coup* is a 1907 casting by the Roman Bronze Works of New York City. Most imposing in the array of sculpture is the 35 inch statue (by Henry Lion) of Lewis and Clark with their Indian girl guide, Sacajawea, at the Great Falls on the Missouri River. *Buffalo Hunt, Will Rogers, A Bronc Twister,* and *Changing Outfits* are other well known Russell bronzes in the collection. *White Man's World* depicts a once proud Cree, Young Boy, a close friend of Russell's, who was reduced to selling buffalo horns to earn a living. The Heritage Center's Wrangler Award is patterned after *The Horse Wrangler. It Ain't No Job For A Lady,* also on exhibit at the preview, is Russell's last sculpture before his death in 1926. It was intended as a Christmas present for his wife, Nancy.

The collection consists of 92 bronzes, two major oil paintings, eight watercolor drawings, eight pen and ink drawings, an illustrated letter written by Russell to his wife, Nancy, shortly after their marriage. Eighty-seven items, many pencil and pen drawings and sketches, are stamped from the effects of Charles M. Russell, estate of Nancy C. Russell, June, 1941.

The Charles S. Jones Collection was considered to be the last major exhibition of C. M. Russell's work in the hands of a

private collector. Most of the artist's work is now reposed in museums throughout the West.

Within a few months after we signed the lease with the Oklahoma City Industrial and Cultural Facilities Trust, members of their board became concerned about the Hall's operation and started to exert pressure and make demands on me that would have led to their control of the operation. They wanted first authority in such matters as budget and expenditures. A clause in our lease agreement with them provided those rights. A number of related committees, aside from finance, were formed "to assist us." I was upset by this turn of events. Even though the Cowboy Hall of Fame was in difficult operating circumstances, we had never defaulted on any kind of a payment—neither operative nor payroll obligations.

In anger, I invited Mr. Jasper Ackerman[14] of Colorado Springs, then treasurer of our Board of Trustees, to come down on one of the days we were to be "helped" and witness the appearance of the various committees. The turn-out was good and nearly one hundred volunteers appeared. Jasper was dumbfounded and as upset as I had been. Compounding our problem was the fact that many of the senior members of our own Board of Trustees endorsed the "take over." Jasper and I felt that if this ever happened, the National Cowboy Hall of Fame would lose its identity as a seventeen-state-sponsored institution and its Trustees would become little more than figure heads. As far as we were concerned, if the Hall was to be an adjunct of any Oklahoma City entity, we might as well throw in the towel.

That night I took Jasper to the airport for his return flight to Colorado. We talked over the matter and vowed we were not going to give up control of the Hall under any circumstances. In parting Jasper said, "You'll hear about an idea I have in a few days." He added, "Remember that leadership comes from strength, not weakness."

A few days later John E. Kirkpatrick,[15] who had met Jasper at board meetings, telephoned and asked that I come to his office

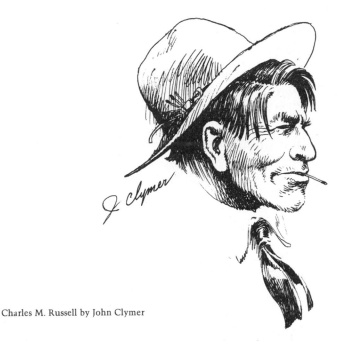

Charles M. Russell by John Clymer

right away. John had a large envelope from Jasper containing bank stock collateral in excess of the amount owed the Trust. An enclosed letter read:

> Dear John,
> Take this to your bank [Liberty, National], secure a loan. I will sign the note. Pay the Trust off. Clear up the Russell matter. Put the Collection in the Cowboy Hall of Fame's name. I'll pay the interest annually.
> Sincerely,
> Jasper

This was done immediately, and, thanks to Mr. Ackerman, for the first time in our history the Cowboy Hall of Fame had title to the Russell Collection, though the amount was owed to Jasper.

The building of our great Western art collection was not done through orderly planning, but in a helter-skelter manner. I often had three or four art projects up in the air, trying to juggle them while operating the Hall, with our staff invariably knee deep in

some art show, Western Heritage Awards program, or the National Finals Rodeo.[16]

During the first three or four years' operation, in spite of the Russell crisis and the Fraser Studio and *End of the Trail* project, dealers sent us paintings. Sometimes they came to us on loan; in other instances I had given firm intent to purchase. Regarding three such paintings, I had said, "Yes, we will buy—when I can find the money." I had to do this for obvious reasons. First, we needed art to fill a very big gallery. Secondly, I knew that if I didn't take the bull by the horns, the job would not be done—ever. And, of course, there was the matter of values. I knew that each work of quality was a good buy and that within a few years it would increase in cost or perhaps become unobtainable.

One collection consisted of three paintings by Nicolai Fechin: *The Corn Dancer, Tea In Santa Monica (Mrs. Krag)*, and a still life. *The Corn Dancer* was considered by the artist to be his masterpiece. Another classic work was *La Trinidad* (76½" x 38") by Robert Henri.[17] This great painting was done in 1906 while Henri was in Spain. *La Trinidad* had been exhibited at the Metropolitan Museum of Art, the National Gallery, Chicago Art Institute, and the Cleveland Museum of Fine Arts.

I acquired one of the best Walter Ufers[18] I have ever seen for our collection. It is titled *Sleep*, a 50 x 50 inch oil. E. I. Couse's[19] *The Sand Painter*, a beautiful 30 x 36 inch oil, was added. A Remington watercolor was *Wild Wild East*,[20] 19½ x 20 inches, a faultless creation. A fine William R. Leigh painting titled *Big Horn Sheep*[21] was purchased from Hibbitts Art Gallery, Colorado Springs, and the only bronze Leigh created, *The Buffalo*, was purchased from Stanford University. Three Russell paintings were included. Outstanding was *Wolves Attacking in Blizzard*.[22] I considered this painting very important and catalogued it as follows:

> This painting was accomplished in a period of Charlie Russell's career as an artist in Montana that is often called "early." He was in his late twenties. *Wolves Attacking In*

Blizzard is painted on paper, using watercolor. This work is important for several reasons. First of all, it is important because of its size, 20 by 30 inches. The situation is one that illustrates the harshness of the open range in the Judith Basin as Russell knew it. In his later years, he became more romantic and his colors less real. The small herd is surrounded by wolves, and the action shown is true to the animals' instincts. The bull, the central defensive figure, is a shorthorn, one of the first of the breed on the ranges of Montana. The cow shown broadside in the painting is similar to the one drawn in his famous picture *Waiting for a Chinook*. The scene is suggestive of the blizzard of 1886-1887. The cow has sheltered her calf. The brands shown are those of Russell's employers: the quarter circle box, the "t" and OH.

Another Russell was a scarce, non-western scene titled *Bird Hunting Near St. Louis. Wolf Tail*, a magnificent 50 x 57 inch pastel drawing, was of a Blood Indian by a little known but talented German artist named Carl Link.[23] The last painting added during those years was Charles Schreyvogel's famous *Nearing The Fort*, a 25 x 34 inch oil, one of the few non-violent scenes painted by this artist of the military frontier.

Fifteen works in the collection were owned by various friends and the Hammer[24] and Chapellier Galleries,[25] both of New York City. Fred Rosenstock[26] of Denver owned two of the paintings, and the Country Store Gallery[27] of Austin one, as did Jim Khoury,[28] art dealer from Amarillo. The Biltmore Gallery[29] in Los Angeles sent us one of the works and an Oklahoma City bank held an interest in another of the paintings. Private parties owned the rest. After several months, pressure began to build up with some of the dealers. Three of the paintings, in fact, had been hanging in the Hall for over two years without our making a genuine commitment to purchase. I considered our chances for buying the entire lot slim.

During one of my trips to California I told Joel McCrea[30] about the collection as I inventoried our problems. We were in Visalia at the time on behalf of another art project, the *End of the Trail*

statue. Joel told me to send him photographs of the fifteen works of art along with the amounts we owed, and he would give the matter some thought. I made up an album of color photographs, including biographical information on each artist. I provided price appraisals and other details. While I felt the collection was worth more than $400,000, we actually owed $302,000 for it. The value had increased considerably since first exhibited in our museum.

Weeks later I was once more in California with Joel. When the subject of the collection was brought up again, we were driving to the Cuyama Ranch in central California, owned by the late cattleman, Hubbard Russell.[31] Hub and Joel had been close friends. Joel had helped Hub and his brothers buy the ranch. Shortly after purchase, the Richfield Company struck oil, and overnight Hub Russell became immensely wealthy. Hub wanted to cut Joel in on his wealth since the movie star had loaned him the money to buy the ranch. But Joel declined, being satisfied with repayment only of his loan.

Being with Joel always gives me a great sense of pride. He is easily recognizable to millions of motion picture fans as tall, silver haired, broad shouldered, and handsome. He walks and rides horses with similar ease and speaks with a firm resonant voice. His voice of Jason Pierce won him acclaim as narrator of the popular radio program, "Tales of the Texas Rangers". Joel's mannerisms are the same on and off the screen—nothing put on, no affectation. His sense of values and ethics have always been above reproach. He has been a "good guy" in life as well as on the screen.

During the course of eating in a restaurant, two or three people will invariably come up to his table and say, "I saw you the other night on television in a film rerun" (he made eighty-three full-length films), or, "I remember you in this or that role." The western film historian Ernest N. Corneal characterizes Joel in his book as "an all time favorite among the superstars who became particularly famous for his cowboy roles. His success in westerns

Joel McCrea by Bettina Steinke

was not just a matter of choosing the right pictures, but was due largely to fine acting ability."[32]

In the Hall's history we can date a change and growth in public confidence from the day Joel and his wife, Frances Dee, arrived. Joel had been elected honoree in the Hall of Fame of Great Western Motion Picture Actors. The board commissioned Bettina Steinke, of Santa Fe, to paint his portrait, the first in what was to become an important collection.

Unlike some movie stars who have come through the Hall's portals, Joel and Frances have given much and never once asked what we would do for them. As a rancher, he knows that to make things grow and prosper one also has to put back into the soil. Mr. and Mrs. McCrea have not only made our Western Heritage Awards programs successful and beautiful but encouraged the coming of such celebrities as Walter Brennan, Barbara Stanwyck, Charlton Heston, Tim McCoy, George O'Brien, director-producer Delmer Davies, the great cinema-photographer William Clothier, and many others. The first on-the-spot network promotion the Cowboy Hall of Fame received was in the filming of "This Is Your Life, Joel McCrea" by Ralph Edwards Productions. In 1971-72 Joel served as president of the Board of Directors and chairman the following year.

A story that to me depicts Joel's modesty and basic nature occurred several years ago, when, enroute to his cattle ranch in central California, he checked into a famous old inn for the night. The desk clerk asked what kind of accommodations he preferred.

"Just a plain room with bed," Joel replied.

The clerk said, "Your son was in here the other night, Mr. McCrea, and he took the large suite with bath and all."

Joel thought a moment and explained, "Well you see, it's different with him . . . he's the son of a rich man."

To continue my story about the Western art collection, in the course of our drive, Joel said, "I've been thinking about the collection you photographed for me. I like the works, but paintings like *La Trinidad*, *The Corn Dancer*, and *Sleep* are not my

kind of paintings. If I bought them for you, people might say, 'McCrea played he-man roles in western movies; strange he would collect paintings of exotic looking women . . .' "

Joel had a good point. I replied, "I had not thought of the collection in that sense. Paintings such as you've mentioned are classic. You have a classic mind."

I knew Joel had given the matter serious consideration. He was right and I was disappointed. We arrived at the ranch and looked over the corrals, horses, and livestock. Then we had a leisurely dinner with Russell's son and wife. That night Joel and I stayed in Hub's old ranch house. Hub had a good library of western books which I enjoyed browsing through. (I am a bookman at heart and I wish at times I had stayed with it.) We went to bed fairly early. We were going to ride horses in the morning.

That night I lay awake tossing and turning, thinking about Joel and the collection. Suddenly I had an idea—something to sleep on.

The next morning we were up early. Joel cooked breakfast. As we were eating, I said, "Joel, you know we owe for the Jones Charlie Russell collection. Jasper holds the mortage on them. Will Rogers knew Russell and collected some of his finest paintings; Will started you in films. Would you be interested in having your name on our Russells?"

I remember Joel holding his fork and looking at me for an instant. Then he asked how much it would cost. I answered, "About $100,000 more than the collection you were considering."

"Do you think it will be all right with Jasper?" he asked.

I said, "I feel certain it will be. His interest, like yours, is to save them for the Cowboy Hall of Fame."

Joel stood up and said, "All right, kid. If it's all right with Jasper, I'll do it."

After breakfast Joel wrote:

September 24, 1970

Dear Jasper,

I have had a good visit with Dean. If it's all right with you and the Executive Committee, I'd like to purchase the Jones Russell Collection and someday will it to the National

Cowboy Hall of Fame. In the meantime, of course, it will remain in the Hall.

Let me know your reaction to this. Hope to see you soon.

As ever,

Joel

Leaving the Russell ranch later in the day, we drove into Los Angeles. I had to catch a plane for San Francisco where I had a short meeting regarding a fund raising project at the Cow Palace. Joel and I parted with a handshake. We were excited. Enroute I thought of perhaps catching a plane from San Francisco to Denver and then driving to Colorado Springs to see Mr. Ackerman. That's what I would do!

By eleven o'clock that evening I was in the Antlers Hotel in Colorado Springs. It was snowing hard, with about eight inches already on the ground. I telephoned Jasper, and we agreed to have breakfast together the next morning.

At breakfast I told him that Joel had decided not to purchase the collection of fifteen loaned works. Filled with disappointment, I even showed him the album and price list. Nonetheless, Jasper was pleased about Joel's proposition to pay off the Russell debt.

We discussed it at length and Jasper wrote the following message for me to send to Joel:

September 25, 1970

Dear Joel McCrea,

Replying to your letter of September 24, 1970, with reference to your purchase of the Jones Russell Art Collection, I would be proud to see this great collection in such wonderful hands and hereby give my consent to its sale to you. For your convenience, Dean Krakel has been designated my agent.

My plan was for the National Cowboy Hall of Fame to have final permanent possession of this art and I am happy to know that you have the same idea.

With my best personal regards and complete confidence, I am,

Jasper D. Ackerman

With that, Jasper said he had to get back to his ranch and feed the cattle. I thanked him; we shook hands and said goodbye. I went to the cashier's counter to check out. I was content, for at least half my problem was solved. I looked around a few minutes later, and there was Jasper coming back through the lobby, snow all over his hat.

"What are you going to do about the other collection?" he asked.

I said, "We don't have much choice. I can't break faith with my dealer friends so I'll have to return them. At least none have lost value since we've exhibited them."

"Don't do that," he said. "I'll buy them for you."

I was elated! Within a few years the combined worth of these two collections would exceed $2,000,000.

When Charles S. Jones died on December 9, 1970, officials of his estate notified us that he had willed Russell's important watercolor, *Worked Over*, to the National Cowboy Hall of Fame. The painting had been in our possession for a couple of years. Mr. Jones had invited me to visit him shortly after Christmas, 1967, and at that time he gave us possession of the painting during a breakfast in his penthouse in the Richfield Building in Los Angeles.

Mr. Jones was a towering giant of a man, very kind and considerate. He was one of the early organizers of the Richfield Oil Company. I first met him while I was still at Gilcrease and he had invited me to meet him in his suite at the St. Regis Hotel in New York. I felt a little stage fright to say the least. Being in New York was scary enough, but add to that meeting a man like Charles Jones. He wanted to know if Gilcrease would accept a bronze casting of the sculpture *Lewis and Clark and Sacajawea*, done by Henry Lion. My answer was, "Sure." It seemed a long and expensive way to come for a one line question and a one word answer.

Sometime later, after I had gotten to know Paul Francis, Mr. Jones' administrative assistant, I asked him why Mr. Jones had put

me through all that trouble over the sculpture gift, when it could have been done by phone or letter. Paul explained that Mr. Jones was making sure Gilcrease wanted the bronze badly enough to spend a couple of hundred dollars for travel fare to talk about it, and, secondly, it gave him the opportunity to meet and talk with me. He didn't want to give anything to a fruity-looking museum director who might forever be bandying his name around.

After accepting *Worked Over* for the Hall, I thanked Mr. Jones and carried my prize to the Biltmore Gallery, where my friend, owner-manager Steve Rose, helped me pack it for the return flight to Oklahoma City. While we were there, Earl Adams,[33] a prominent Los Angeles attorney who represented the Nancy Russell Estate, dropped in by chance. He was pleased to see the painting and gave me interesting bits of background about it. The painting, he said, had been a favorite of Mrs. Russell's and hung over the fireplace in the bedroom of her Pasadena home.

A few weeks after Mr. Jones' death, his attorneys notified me that the Internal Revenue Service was contesting the appraisal I had made on *Worked Over*. Two Los Angeles art authorities, called in as consultants, had criticized the appraisal as being extraordinarily inflated. The matter was not easy to solve, and tax officials were hard to convince. The clincher came, however, when a dealer offered to purchase the painting for more than the appraised amount. It was the same old story: so-called art experts not accepting Western art for its real worth. The I.R.S. eventually accepted my appraisal figure.

Several months earlier, in October 1970, I got a telephone call from my friend Tony Bower of New York City. We had first met when he was an editor of *Art In America* and the magazine had commissioned a feature on Gilcrease. Bower informed me that he now headed the American Department of Knoedler's. This came as a shock for several reasons. First, my old friend, Bill Davidson, had not only been head of the American Division and the firm's vice-president, but had for thirty years or more reigned as Mr. American Art himself. Secondly, I knew from talking with Bower

years before that he knew very little about American representational art, much less Western.

Tony explained, "Davidson sold out. He's been ill. We've got new owners, and it's a whole new ballgame!" He then went on to tell me about a great collection the firm had acquired. I was astounded because Bill Davidson had formed this collection of some sixty works over a period of years. When he told me that the titles of the Russells were *The Cinch Ring* and *Wild Man's Truce*, along with Remington's *Hunters Camp In The Big Horns*, I flipped. I asked how much, and he answered $90,000 apiece for the Russells (if we took both) and $118,000 for the Remington. "Cash," he specified. I asked if two of our staff members could come and photograph the entire collection. He consented, so I promptly sent Ed Muno,[34] our photographer, and Don Hedgpeth,[35] then editor of *Persimmon Hill* magazine.

Bower cautioned that I would have to act fast and in secret, as the company needed the money and didn't want any publicity about the sale. At that moment, I knew of at least four art dealers who would give $125,000 each for the Russells and $150,000 for the Remington. They would buy them with the intention of making money.

I worried about the Russells getting away yet didn't see how we could buy them. I decided to think about the Remington after we got the Russells—if we could. I called Bower back and told him we were serious about *Wild Man's Truce* and *The Cinch Ring*, but before I could act we would have to have them at the Hall to show. He agreed. At least we would gain possession, and they couldn't be shipped or shown elsewhere. I wasn't going to let such prizes get away, although I realized I couldn't raise any money locally because of our heavy debt.

The financing would have to be backed up with a reliable take-out letter and a note co-signed by someone other than myself. I counted off the prospects: Joel and Jasper were committed. Mr. Dulaney was already on a note and out of town. John Kirkpatrick and Mrs. Dave D. Payne were donating a building.

Dean McGee was paying $75,000 to have an *End of the Trail* cast in bronze for Visalia, California. At that time I didn't feel I knew Trustees Rex Nicholson[36] and Bill Kerr[37] well enough to ask them. So that left J. B. Saunders.[38] My one deal with him, involving the purchase of $160,000 worth of Schreyvogels, had succeeded so I thought I'd ask J. B. to co-sign. For the take-out person, I asked my friend Bob Rockwell,[39] of Corning, New York. Bob had the wealth to buy the paintings and wanted to take *The Cinch Ring* off our hands right then and there. He sent a "To Whom It May Concern" take-out wire, along with credit references.

I called Mr. Saunders and made an appointment. He was then executive vice-president of the Kerr McGee Corporation, a dynamic guy and a born speculator—smart, tough, with a heart of gold. I reviewed the $180,000 project with him by displaying sales reports on Russells over the past year and Bob Rockwell's telegram offering a take-out. I explained that I would need to have him sign a six months note with me, containing an option to renew. This would require that he give the bank his financial statement. Everything went well. He agreed, then asked where I was going to try to borrow the money. I told him I hoped it would come from the Republic National Bank in Dallas. He said, "Good luck, Dean."

When I returned to the Hall there was a message waiting from Bower. It was short and to the point. "Have full amount here Friday or ship paintings back to us." The pressure was on.

Quickly, I telephoned Homer Stewart, senior vice-president of Republic Bank, asking for an appointment. He invited me down and within hours I was in Homer's office. I outlined the project for his consideration, giving him a sealed envelope containing J. B.'s statement and the original of Bob Rockwell's take-out telegram. Homer said, "I'll consider it. Call me in the morning." I flew back to Oklahoma City, called Tony Bower and, with my fingers crossed, said, "How about having lunch with me Friday, and make out the Bill of Sale in the name of Dean Krakel and J. B. Saunders . . . for the time being."

The next morning I telephoned Homer and he asked, "Sure you can pay this off within a year?" I said, "Absolutely." Homer replied, "Come on down. I'll loan you the money. It'll cost you ten per cent."

I kept my luncheon date with Mr. Bower and during the course of the meal gave him our check. Within a few months, I was able to get the Board to agree to roll the $180,000 note plus $5,000 interest into our special Art Fund's account. After the meeting, J. B. laughed and said, "Those Russells would have looked good with my Schreyvogels."

Another big break in our quest for Russells occurred when the Amon Carter Museum agreed to sell us the famous painting, *When Mules Wear Diamonds*. The transaction originated during a telephone conversation about an art exhibition with Director Mitchell Wilder.[40] I concluded our talk with, "I wish you would sell us *In Without Knocking.*" Mr. Wilder said he believed that would never come to pass, but maybe they could sell another: *When Mules Wear Diamonds*. We discussed the matter further, and I said I would take it up with a board member. The asking price was $110,000.

Within a few days he telephoned to report that he could sell the painting, then confirmed it in writing. I agreed to pay $10,000 down and the balance within sixty days. On December 23, 1971, I mailed the initial payment.

After the first of the year, Bryan Rayburn[41] and I drove to Fort Worth to pick up the painting. The next day I took it to Mr. Dulaney's office and showed it to him, hoping that he would buy it outright and give it to us, but he wouldn't. He had just given us a magnificent William R. Leigh, *The Leader's Downfall*, then worth $85,000. (Since that time it has doubled in value.) My timing, as usual, was bad. So, on February 7, 1972, we borrowed $100,000 from the First National Bank to make the payment. Throughout my career I have had to sweat blood over not only *When Mules Wear Diamonds* but a lot of other paintings, too.

Along with the Russell painting came some interesting history

as well as an insight into the observant nature of Amon Carter. The work had come from the Nancy Russell Estate. Homer Britzman[42] bought the painting from C. R. Smith, who had purchased the estate collection. John P. Nicholson, a New York art dealer, bought the painting from Britzman and consigned it to William A. Findlay of the Findlay Galleries, also in New York. In 1947, Mr. Findlay offered the painting to Amon Carter of Fort Worth, but Mr. Carter questioned the painting's authenticity since the painting was dated in the body. Findlay handled the situation well, writing to Carter:

> For some reason, I do not know why, Russell always dated his later paintings in the body of the composition. In the past year I have sold five or six Russells which were painted after 1920. All of these were dated in this manner. Notice Mr. Sid Richardson's painting, *When White Men Turn Red.* It is dated in the body of the picture. I am enclosing a photograph of the picture. I am also enclosing a photograph of your painting, showing the date of 1921, outlined in ink. Compare it with the original.

The skeptical and shrewd Carter replied to Findlay a week later:

> I find the date as marked on the picture which you enclose with your letter. However, for the life of me I cannot keep from being skeptical about the fact that this date was inserted after Russell had painted the picture. It is the only instance that I know of in all the Russell pictures that I have seen wherein the date was not together with his signature and frankly I have some hesitancy in the matter. However, the fact that Findlay Galleries are guaranteeing it to be an authentic Russell picture, I am enclosing a check for the amount of your bill, $8,000, and I am also returning the photograph, and would ask you to add your same guarantee typed on the back of the picture and signed the same as indicated in your letter of June 18.

Not every Russell painting has been acceptable to us. At one time we had an opportunity to acquire as a gift a large valuable oil of a frontier fight scene. We looked at it for several days and

concluded that it was too bloody. It was not subject matter that we wanted to show to the general public, especially school age children. The Hall stands for pioneering but not necessarily for bloodshed. The difficult choice was ours, and we decided not to accept the work.

Of the Cowboy Hall of Fame's large collection of Russell paintings and bronzes, only one work has come our way without some sort of struggle, and for this acquisition we thank Ward McGinnis, rancher in Eureka, Kansas. His secretary wrote that Mr. McGinnis had gone to the hospital, and one of the last things he requested was that she write and "tell Dean Krakel I like the way he does things. I'd like my C. M. Russell oil painting, *The War Party*, to be in the Cowboy Hall of Fame's great collection. Tell him to come and get it."

I got a ticket for speeding on my way to Mr. McGinnis' ranch in Kansas. According to the aircraft patrol officer who clocked me, I was doing ninety-two miles an hour.

Chapter 5

The Fraser Project

THE FRASER PROJECT was the most complex art adventure that we ever entered into. It dealt with the works of two highly talented artists, James Earle and Laura Gardin Fraser,[1] who were husband and wife. Their studio collection was located in Westport, Connecticut, while the *End of the Trail* statue stood in Visalia, California.[2] Our purchases meant that both had to be prepared for shipment, then transported the great distance to Oklahoma City.

The decision to move an aging, fifty-five-year-old plaster statue fifteen hundred miles by truck, with the intention of performing major restoration work, appeared at times not to have been one of my brightest ideas. Ultimately molds made from the statue went to New York, then Pietra Santa, Italy, where after a year's time the bronze casting was shipped to Los Angeles, then trucked to Visalia. The molds, weighing tons, had to finally be returned to the Cowboy Hall of Fame.

Then there was the cost factor. Large amounts of money were needed to pay for the studio collection itself, the cost of travel, the expense of moving and restoring the *End of the Trail*, making of molds, cost of airfreighting the molds, the cost of returning the 18-foot-high bronze to California, and setting it on a base we would design.

I remember a member of our Board of Trustees speaking his mind in a meeting after I had reviewed the entire project through

to the point of restoring the statue and acquiring a large metal building for the restoration work. "Once we get this statue here," he began, "and once we get it restored with money we don't have and get a casting in bronze and Lord knows who will pay that bill, what in the hell are you going to do with that big white monstrosity?" Admittedly, he had a good point. What was really in it for the Cowboy Hall of Fame?

The hazards of being director of a public museum are many. A primary danger is that the most influential or authoritative member of the Board can be the least enlightened. In the case of the Cowboy Hall of Fame where we had at that time a large board (50 members or more), only three or four at most knew anything about Western art, and in their case it didn't mean they would look with favor on a project that they could see would ultimately cost $400,000. The trustee who was realistic about costs criticized the horse the Indian was mounted on as being "the sorriest looking damned animal he had ever seen." Being a quarter horse breeder, he would think that way.

My reasons for going into the project are easy to explain. In the fall of 1967, when I first agreed to go to Westport and look at the models in the Fraser studio with the executor of the estate, Dr. Martin H. Bush,[3] the National Cowboy Hall of Fame had nothing in the way of assets—art or otherwise. We owed $1.2 million on our building and were leasing the C. M. Russell collection from a Trust, paying interest annually. We were less than two years old and I felt we had nothing to lose. If, on the other hand, I was successful, we could have a lot to gain. The main loss would be my own, for if I failed, it could only get me kicked out. That distinct possibility existed not only in the Fraser project but in every art project I entered into and every financial corner I turned. The hazards were always there. The greater the risk, the greater were the chances of getting into trouble with the Board. Long before the Frasers entered my life, I chose not to live a do-nothing professional life.

Certainly the Frasers were great, nationally recognized talents. I

had been given an opportunity to see what they had accomplished when I visited Laura Fraser in the studio in 1963. With research, I soon realized their preeminence as sculptors. Laura and Jimmy formed what undoubtedly was the greatest husband and wife team in the history of American sculpture. Their expressive, heroic-sized statues, displayed throughout the United States, and their bas-relief panels, coins, and medals visually immortalized the giants of America's historic past. Their contributions stretched over more than six decades. Their works endure as enormous lessons in American history and art, influencing America's cultural standards.[4]

No work of art has more universal appeal than the *End of the Trail*. If the West has a *Pieta*, it's the *End of the Trail*. From the time I first visited Laura Fraser and lunched on martinis and scrambled eggs with her, the original small model of the *End of the Trail* and the plaster models of the buffalo-Indian head nickel were my acquisition goals, even more so than the twenty-one-by-four-foot *Oklahoma Run* panel sculptured in relief. I felt these two works, both by James Fraser, could be the crown jewels in any collection. At that time, I had no idea that the 18-foot-high *End of the Trail* still existed. I knew of it only from pictures. Thus, my first goals were limited to pieces in the studio.

When I went to Westport that August to meet with Martin Bush, I was armed with $16,000 to pay for the Laura Fraser *Oklahoma Run* panel. I had borrowed the money from Fidelity National Bank of Oklahoma City, having talked Glenn Faris[5] (then executive vice president of our Board of Trustees) into co-signing with me. The action was without board approval. Had the bank wanted a resolution or letter of authority, I would have been sunk.

Mrs. Fraser had priced the panel in bronze to me at $75,000 while I was still at Gilcrease. I had been close to raising the money from private sources when I resigned to come to the Hall. My resignation ended the deal in Tulsa since, luckily for me,

James and Laura Fraser by Robert Lougheed

Gilcrease officials ignored the negotiations I had begun with Mrs. Fraser.

In Westport that day, at the Frasers' beautiful colonial home and split-level, rock-faced studio, I was about ready to put down the $16,000 for the panel when, as a matter of curiosity, I asked Bush what he was going to do with the bulk of the models—pieces like *John James Audubon, Meriwether Lewis, George Rogers Clark, Daniel Boone*, Laura's equestrian model of *General Robert E. Lee and General Stonewall Jackson*, the beautiful West Point panels, an original model of the *End of the Trail*, buffalo-Indian head nickel models, coins, medallions, etc. Furthermore, my mind was already envisioning a re-creation of the Frasers' studio

93

on Persimmon Hill. We skirted around the issue, talking back and forth. I brought the heroic Lincoln statue (12-feet-high) into the discussion and added that we would consider it also.

Within a short time, Dr. Bush pressed me for a quotation. I said, "All right, we will pay the executor $25,000 for the *Oklahoma Run* panel; the four standing figures of Lewis, Clark, Audubon, and Boone; three West Point panels; the original *End of the Trail* model; a set of the buffalo-Indian head nickel plasters; Laura's Lee and Jackson; and assorted small models, medals, medallions, photographs, and papers. Next February I'll pay Syracuse $15,000 for the Lincoln statue." A total of $40,000 would buy the western-oriented pieces in the collection. Dr. Bush quickly agreed, "It's a sale."

Weeks later when we got into cataloging the collection, we realized our holdings represented almost one-half million dollars in commissions paid the Frasers. Our purchase would weigh seven tons. I hadn't made such a bad deal. On my way back to Oklahoma, all I had to worry about was $9,000 more, plus $4,000 or so needed for packing and shipping. Come February of 1968, I would worry about the $15,000 pledged to pay for Mr. Lincoln. In the meantime, I felt good about the deal.

Within a day or so after returning, I telephoned John Kirkpatrick of the board and told him about the studio and essentially what I had done. I said we needed $25,000 to pay for the collection. When I met with John a couple of days later, I took along two specially selected pieces from the collection. One was the Navy Cross designed by Jimmy, and a small model of a goat sculptured by Laura for the Naval Academy. I knew these two objects would be of interest to John, who was a graduate of the United States Naval Academy at Annapolis, had served as executive officer on the battleship *South Carolina* during World War II, and held the rank of rear admiral. He became enthused over our acquisition after I reviewed the status of the collection and the value it represented in commissions. He said he and Mrs. Kirkpatrick would donate $25,000 to the Cowboy Hall of Fame to

make the purchase. He was happy about it, and I was elated because now I could pay off the bank note as well as the balance owed. When the Executive Committee of the Board of Trustees met on the 20th of September, I gave them a report and John formally announced the gift, insisting that I carry on with the project. "Bring as much of the studio as is offered," he said. "Mrs. Kirkpatrick and I will do all that we can to assist you."

Returning to Connecticut a few days later, I met with Dr. Bush to make arrangements for shipment of our portion of the collection to Oklahoma. This time I took our Chief Exhibits Curator Juan Menchaca,[6] and Associate Curator Richard Muno[7] with me. I wanted them to feel what I had felt upon seeing the studio with its holdings. For, as Laura said to me, "There is a mood not only to our lives, but to our studio and to everything we have ever done. I saw the frontier in a different light from Jimmy. I saw it with all its glamour, excitement and motion, and so created my *Oklahoma Run*. Jimmy saw the spiritual mood, the tragedy, and emotional undercurrents of the frontier and so created his *End of the Trail*."

In the days and weeks after receiving our purchases, I began thinking in terms of how and where to display the collection. I asked Art Director James Boren, who is a superb watercolorist, to paint a rendering of a studio concept with the Lincoln statue as the central figure. Within a matter of hours, Jim asked me to come to his studio and take a look at the pencil drawing he had done. Studying it a few minutes I said, "Take the Lincoln out." While the Lincoln was a great piece, I felt it inappropriate for our theme. Without hesitation, I told Jim to go ahead with the rendering, substituting a life-sized *End of the Trail* for the central figure. Meditating a moment or two, he asked me where I was going to acquire such a figure. I said, "I'm not sure, but I will let you know soon."

A short time later, a former associate of Mrs. Fraser, Mr. Richard Murphy of Philadelphia, visited our museum. Mr. Murphy was returning east from a trip to California. He knew

95

that we had acquired a number of items from the studio and, out of personal curiosity I suppose, wanted to see the collection and size us up. We spent the large portion of the day together talking and visiting. Murphy freely related his memories of Mr. and Mrs. Fraser. He told me of recently seeing the huge 1915 plaster statue of the *End of the Trail* in Visalia, California, commenting that it was in extremely poor condition.

On the basis of Dick Murphy's remark, the next day I made an exploratory telephone call to Visalia. Upon asking for someone in the Parks Department who would know about the *End of the Trail*,[8] I was soon talking with Merle Harp,[8] director of the Tulare County Parks System. I introduced myself, explaining to him our museum's plans for the Fraser collection. I told him I had learned that their statue was in poor condition. Mr. Harp stated that it was true, and that he and a number of persons there had been concerned about it for several years. Harp said he had reinforced the statue's legs with heavy steel rods and painted it a number of times but felt that there was not too much more that could be done without going to a great deal of expense. Tulare County officials, he added, had been reluctant to appropriate funds for the project. I asked if he thought that officials there would consider making a trade—we would save the statue, preserving the model, and replace it with a bronze casting made from the original. Mr. Harp said that the idea appealed to him personally, but the decision would have to be up to the Tulare County Historical Society and the Board of County Supervisors. It was agreed that I would state our proposal in a letter. On February 2, 1968, I wrote:

> I would like to come there and meet with you and members of your Parks and Recreation Board to discuss the possibility of our trading a bronze model for yours, creating and placing the new model there at the National Cowboy Hall of Fame's expense. I would like to tell you and your Board members about our project here. If such a transaction could be done, we would place a bronze tablet in the Studio recognizing Tulare County and those who had made the transaction possible.

Within a few days I received a reply from Mr. Harp informing me that a meeting date was set for my appearance before the Board of Directors of the Tulare County Historical Society and the Board of County Commissioners or Supervisors of Tulare County.

Visalia is a beautiful, progressive little city centrally located in the agriculturally abundant San Joaquin Valley. Without delay I drove to Mooney Grove Park and was soon looking up at the *End of the Trail*. It was two-and-one-half times life size. For some reason, I had thought of it as being smaller. The outline work had been designed to view from a distance and to look up at when one was close, thus the head and shoulders of the Indian were molded to look down. In spite of a loss of detail, numerous fissures throughout the surface, and general deterioration, the statue still was the most moving creation I had ever looked at. The defeat of the Indian is totally embodied in the figure. The statue's balance is given a geometric simplicity and beauty by the diagonal line created by the spear. The Indian's defeat is shown fully in his face. The horse's head and swollen eyes dominate the figure, while the windblown tail and mane give a feeling of motion; the slightly raised hoof creates an impression of tenderness and almost unbearable pain. As a monument, it literally weeps.

Only a talented artist who fully understood the Indian and had observed him in his historical habitat could have created such a work. Fraser combined several important elements in the composition. The *End of the Trail*, in my mind, suddenly became an epitaph of national importance, a monument to all Indians, to their nobility as well as their tragedy. Before me was a treasure that I vowed should be preserved for America.

In Merle Harp, I found a tall, imposing, soft spoken person. It was obvious that he fully appreciated the *End of the Trail* and had felt frustration in watching its progressive deterioration for several years. Coincidentally, Merle had been raised to manhood in Enid, Oklahoma.

At the Tulare County Historical Society meeting, I met several persons who were vitally interested in the project and felt strongly that the statue should be saved. The Board of Directors of the Historical Society went on record as recommending to Tulare County Supervisors that a trade be negotiated: "that the *End of the Trail* be sent to the National Cowboy Hall of Fame and Western Heritage Center, restored, and that molds be drawn from it to make a casting to replace the model."

In my presentation, I had shown a series of color slides depicting the National Cowboy Hall of Fame's exterior, interior, and activities. All were convincing enough. Walter S. Johnson, industrialist and philanthropist from San Francisco, was present. He reported that the Palace of Fine Arts from the Exposition was being restored and that he wanted to procure a bronze casting of the *End of the Trail* for placement there as it had been in 1915. Johnson urged that the original not be allowed to leave the state of California. I said that it would be virtually impossible for us to restore it and do the work without moving the statue as he proposed. The sentiments of the board were with me.

During the evening I became restless. I was apprehensive as to what the County Supervisors' attitude might be. At 3:00 A.M., I went once again to Mooney Grove Park and studied the statue. It was bathed in moonlight. I looked at it from a distance, as well as up close. Leaving the park, I had feelings of excitement mixed with apprehension such as I have seldom experienced.

I had learned the names of the men of the Board of Supervisors. The chairman was Charles Cummings; vice president, Donald M. Hillman; Carl E. Booth, Fred Batkin, and Raymond J. Muller, members. Before returning to the motel, I drove around the Tulare County Courthouse to orientate myself as to its location.

My appearance before the Board of County Supervisors the next day was not without problems. The Historical Society's report and recommendations were read, and I then had an opportunity to outline our plans for creating the Fraser Memorial in the National Cowboy Hall of Fame and Western Heritage

Center. There were those who voiced opposition to my proposal and were given an opportunity to speak by Chairman Cummings. And so began the controversy over our proposed trade. That evening at dinner I asked a waitress why there was so much going on in the press about this *End of the Trail*. She blithely replied, "Some nut from Oklahoma wants it."

In the meantime, I had gathered enough assurance regarding the trade and wanted to gain further counsel, so I telephoned the Hall and asked Juan Menchaca and the renowned Oklahoma sculptor, Leonard McMurry,[9] to come to Visalia. I wanted to hear their reaction to the statue's appearance and to see what they thought about moving and restoring it. Figuring the difference in time between Oklahoma City and Visalia, the two had about an hour and a half to catch the 6:00 P.M. flight for California. I met them at the Fresno airport. Sometime around 1:00 A.M., we were in Mooney Grove Park. Both men were immediately impressed with the statue's magnificence.

The next morning, we met Merle Harp at the site. Menchaca and McMurry took over-all measurements of the statue and core samplings of the plaster. Both believed that the removal could be accomplished. Another meeting was held with Mr. Cummings and then with the county's attorney and legal counsel, Calvin Baldwin. The next step would require the drafting of an agreement to outline the specifics, to be signed by Tulare County Officials and Trustees of the National Cowboy Hall of Fame. This was presuming, of course, that the County would vote favorably in face of whatever opposition might develop and accept a contract. As we left Visalia, I had feelings of uneasiness.

A few days later, Merle Harp wrote me that considerable opposition had appeared and that the outcome didn't look too favorable. Pros and cons were being voiced. An editorial appearing in the *Visalia Times-Delta*, March 1, 1968, was titled, "Must We Lose 'The End of the Trail'?"

Surprisingly, the opposition seemed to fade and attorney Baldwin drew up a tentative agreement for study. Defining of

time periods, posting a $25,000 cash deposit as a surety, and rights to repossess the statue in event that everything else failed were provisions in the documents that substantially represented Tulare County citizens' interests.

By the same token, the contract nailed the project down tight for me, and I began to look about for financing that would consummate the agreement. Once this was done, we would dismantle the statue, transport it to the museum and begin to conduct restoration. I estimated we would need $36,000 as a minimum to start the project.

After a few days of talking over requirements, we came up with a bank note in the amount needed, carrying the signatures of the Cowboy Hall of Fame's great friends, John E. Kirkpatrick, Luther T. Dulaney, and Jasper D. Ackerman. The note was for six months with renewal options.

The agreement drawn up was both conclusive and equitable. The instrument was signed by John E. Kirkpatrick, vice chairman of our Executive Committee, and Glenn W. Faris, executive vice president. I attested to the instrument as assistant secretary. The person signing for Tulare County was the purchasing agent. With the agreement signed and the surety check placed in the bank, I assembled our group for the return flight to California and an exciting adventure. I believed that, if successful, the *End of the Trail* and the Fraser Collection would possibly become the National Cowboy Hall of Fame's greatest assets.

Once in Visalia, I began working on the legal aspects and paper work while Menchaca, Muno, and McMurry discussed their ideas for dismantling and crating the statue. A fifth member of our crew was Gene Dillehay,[10] then a motion picture photographer and journalist for Channel 5, the ABC-TV affiliate in Oklahoma City. I had requested that Gene come with us since I felt the occasion was historic enough to record, especially if we were successful in getting the *End of the Trail* designated a National Memorial. Secondly, if something were to go wrong—if the statue were to crumble—our defense attorneys would have

visual evidence. So, under the watchful eye of Dillehay's lens, we began work.

The major problems facing us were that we didn't know how much bond there was in the plaster, what kind of a core armature existed, or the extent of weight support in the legs. From all appearances, the hind portion of the statue had settled about eighteen inches since being placed there in 1919. The surface of the statue, now that we had made the deal, seemed to look worse. There were large surface cracks, several places were deteriorated, and generations of school kids had carved their initials even in the remotest of parts of the figures. To begin with, we resolved that we would not break the strength that held the statue lengthwise, from head to tail. We decided to cut the figure off at the waist. The basic engineering was planned by Rich Muno, who proposed that we build a rigid framework around the figure, leaving the upper torso to tower above. The framework would rest on stilt-like legs. A determining factor in building the crate to contain the horse was an overall height limitation of twelve feet for shipping. We could place the crates on a low-hanging flatbed trailer for hauling to Oklahoma City. The crate for the torso would not be over seven feet high. Thus, after three days study, with this concept in mind, we finally went to work. To accomplish the project, I hired three carpenters, bought $300 worth of lumber, and rented hand and power tools.

On our fourth day, we were ready to outline the first cuts, with many friends and skeptics watching. Our timetable was well planned. The locally-hired carpenters proved to be able men, and we soon had the framework up. I recall being impressed by the fact that after sixteen hours of carpentry, the project had used up more than thirty pounds of nails.

The next morning we were on the job early in hopes that we could make our first cuts into the torso without benefit of the local cameramen. But no such luck. Two had been there since daybreak shooting the first daylight hours of the *End of the Trail's* last day in Mooney Grove Park. Our fears that the torso would

crumble and disintegrate were soon eased, as our saws began cutting into heavy cross timbers, guy wires, and metal mesh. The going was slow. After working most of the morning, we felt we were ready to move a large crane into position with a large overhead boom and a chain hook over the torso. We placed straps in and under the figure's arms with supporting cables, and the crane operator delicately picked up the tension, to the point where the whole statue shook. Then slowly the cuts were made. The pull of the crane and the weight of the statue below suddenly caused the entire statue to shake and the figure to pop loose. The torso, in an unpredicted action, swung in a wide, easy, breathtaking arc, with the figure gently rocking to and fro, much like a chair on a ferris wheel. After several passes back and forth over the framework, it settled down. The operator gently raised his crane boom up and moved the huge figure out over the side of the framework, suspending it momentarily in the air. Then he began lowering it. Once he had the torso on the ground, we all breathed sighs of relief. Our approvals were interrupted when Gene Dillehay ran up to ask if we could have the crane operator repeat the removal sequence, as he wasn't sure his film had caught it!

With the successful, delicate operation of the torso removal behind us, the crowd began to thin out. An attitude of confidence finally began to prevail in Mooney Grove. While carpenters began crating the torso, we turned our attention to the horse and greater bulk of the project. Once the crane operator had fastened slings around the large framework that looked like a small building without the side sheeting, a pulling pressure was applied. We could now begin work on the hooves and separation of the horse from the base. Our attempts with a jack hammer to break through the concrete failed. We found reinforced concrete and two inch metal rods running up through the legs, part of the restoration work of Merle Harp. Finally, after a couple of hours' labor, we gave up using the jack hammer and called in a welder with a cutting torch. Within an hour the old horse, like the rider before it, suddenly shook free with a jolt, after having stood in the same

position for more than fifty years.

Superintendent Harp arrived in time to witness the easing of both crates onto the flatbed and, chained together, prepared for their long journey to Oklahoma. After this was done, we adjourned to Merle's office to open a bottle of champagne and toast the project. We paused for a few minutes to think about what we had done and what lay before us in trying to save one of America's greatest symbols.

From the outset, the *End of the Trail* project had elements of high excitement and challenge intermingled with fear, but nothing came close to the sinking feeling that I felt the following Saturday morning. After returning home from California on the late flight, the phone rang the next morning; it was the dispatcher from the trucking company hired to haul the crates. The voice at the other end of the line said, "Your statue is disintegrating. If we haul it any further, it will be entirely lost." Luckily the driver had retrieved all the pieces but it looked pretty bad. What were my instructions?

I said, "Pull your truck into a yard and get it out of the public eye if you can. Above all, I don't want the press to learn about this state of affairs." In my mind's eye, I could envision a photo story on the front page of the *Los Angeles Times*. I told the dispatcher we would be out the next day. Quickly, I phoned Rich Muno and Leonard McMurry to meet me at the Cowboy Hall of Fame. It was decided that they should fly out right away and arrange for the framework to be sheeted, closed in, and then filled in with some kind of packing.

A few hours later Rich called. He said the Indian had been damaged. I had every excuse to become sick. Then McMurry, who was on a second phone, spoke up, "Shucks, Dean, it won't be nothing at all to restore it if I can hang onto the pieces." I shouted, "Guard those pieces with your life." In a few hours Muno called back. He had come up with the idea of filling the sheeted crates with sawdust. A day or two later he located a sawmill and contracted for delivery of three tons of sawdust. The filling and

packing proved to be all that was needed, and within five days the shipment was back on the road. In the meantime, word had somehow gotten back to Visalia that the statue had fallen apart, and the critics of the project were after Merle Harp. Merle telephoned me, and I assured him that what had been done was necessary to insure the safe arrival of the statue and was merely the result of our inspection instructions with the trucking firm. We had insured it for $100,000. Minutes later, the telephone rang again. It was a reporter from a San Francisco newspaper. They had learned that the *End of the Trail* had been in an accident and was in a million pieces. I said I had no idea as to the origin of such a tale and, since the shipment would be arriving in Oklahoma City within two days, I invited him to come out to cover the unpacking. The reporter gave a disgruntled "Oh" and regretted he didn't have a scoop. Within the next few hours I had a number of similar calls from California.

Three days later the truck and trailer carrying the two huge crates rolled onto our museum grounds. It was with a great sigh of relief that I signed the receipt for "goods delivered" and paid the shipping bill.

The upcoming Board of Trustees' annual meeting and the Western Heritage Awards programs prevented further work from being accomplished on the project in April. The crates were left sealed. Passing by them each day, I couldn't help wondering what was the real condition of the *End of the Trail*. The Executive Committee gave me authority to pursue the project by soliciting funds for the restoration and for a memorial building.

The entire concept was assuming larger proportions. The Studio Collection in its entirety represented $475,000 in commissions paid to the Frasers. A leading art authority categorized the *End of the Trail* as a nationally important treasure, irreplaceable, and, when restored, alone valued at $330,000. The building addition, if we were successful with our fund raising, would cost approximately $250,000. Thus, the entire package was to become a "million dollar memorial".

After the Trustees' meeting was over, I felt more confident of looking at what was inside the crates. As the sides came off and tons of sawdust spilled out, we soon saw the stark realities of our problem. Parts of the Indian's chest and face were damaged. Everyone was greatly concerned—everyone except for sculptor Leonard McMurry, who had carefully saved the parts. Within a couple of days he had the Indian, unlike Humpty Dumpty, back together again. Working from photographs, he performed before our eyes what I felt was a restoration miracle. A few days later, the entire torso was ready for replacement on the horse, as if nothing had ever happened.

Chapter 6

A Million Dollar Memorial

D URING ITS FIRST one hundred days at the museum, more than 150,000 visitors came to stand in awe of *End of the Trail*. It was coming back into the national limelight just as it had once been at the Panama-Pacific International Exposition in San Francisco in 1915. Photographed dozens of times daily, the statue quickly became a symbol of the National Cowboy Hall of Fame.

Leonard McMurry, in his initial hours of restoration work, made some interesting discoveries about the statue. First was the point system used by Fraser in determining the thickness of layers of plaster. Next, he found the alcohol wick burners that had been sealed inside to dry and cure the statue. By comparing photograph measurements, it was determined that the entire figure had settled fourteen inches since it was placed on the base at San Francisco.

In the months to come, McMurry removed six distinct layers of paint in a variety of textures and colors. The critical problem was the pulling together and sealing of fissures throughout the body.

The artist worked on the large scaffolding used by the Frasers. During the first period of restoration, photographs were enlarged to afford detailed study of each area. Photographs of the facial features showing definition of the extent of chin and upper chest separation were especially hard to find. McMurry recreated one of the moccasins, the horse's ears, all four hooves, and redefined the mane and tail.

In order to keep the hundreds of visitors from conversing with McMurry as he worked, we installed a push button audio message repeater giving a brief history of the statue, its origin, and comments on the Frasers and the studio collection.

During the fall of 1968, I began soliciting bids from major foundries for the casting. The requirements of the project were completion of the restoration, preparation of piece molds by a highly qualified mold maker, and then the casting into bronze. Bids began coming in from all over: two from New York, one from an Oklahoma foundry, one from California, and one each from France, Italy, and Mexico. Bids ranged from the impossibly low to the unbelievably high. All bids were kept in a file for the Executive Committee to consider. Luther Dulaney was appointed the board's representative for the project.

On the 7th of December the Board of Trustees met. It was a busy and difficult time for me. I had too many things going, none of them too well. Our meeting began early in the day and ran late into the afternoon, with an unusual amount of time devoted to unnecessary rag chewing and trivia.

Payne-Kirkpatrick Memorial by Wilson Hurley

While I felt that we had made excellent progress on the *End of the Trail* and the overall Fraser project, a few trustees were not enthused. At the end of that difficult day, we unveiled the *Oklahoma Run* panel by Laura Fraser. Mrs. John Kirkpatrick and Mrs. Luther T. Dulaney did the honors, while Leonard McMurry commented on the problems he had encountered in restoration. The weekend was highlighted by the final performances of the National Finals Rodeo and the Rodeo Awards Banquet.

On December 11, I went to New York where I had been invited to speak before the National Sculpture Society. I carried our *End of the Trail* film and notes for a short presentation. Since the sculpture society's board of directors had issued a resolution supporting the Fraser Studio and the *End of the Trail* restoration project, I felt my appearance was in our best interest. It was a cold evening but filled with holiday cheer. The meeting was held in an antique Gramercy Park home, brightly decorated with Tiffany glass and period furnishings. During the evening, in my mind I began to question the future of American sculpture if it rested with this society. The members present were sharply divided, philosophically, between representative and abstract forms. It also occurred to me that I was indeed fortunate to have been born and raised in the West, and that I was the director of so vital an institution as the National Cowboy Hall of Fame and Western Heritage Center.

That entire month of December had its ups and downs for us. The National Cowboy Hall of Fame's operating statement brightened with year-end gifts amounting to nearly $100,000. The benefactors were the Mary W. Harriman Foundation of New York City, J. B. Saunders of Oklahoma City, and Jasper D. Ackerman of Colorado Springs, Colorado. Without their gifts we would have indeed been in for a difficult operation period since attendance is always low during January and February. If we had not received these cash gifts, I would have had to postpone the Fraser project and devote my time to a critical operating situation.

The decision as to where to cast the *End of the Trail* was soon

resolved when we made an agreement with Bernhard Zuckerman[1] of New York City. Mr. Zuckerman, experienced in casting heroic sized statuary, had working relationships with foundries in northern Italy. A price was agreed on, stipulating that we were to deliver the molds to a pier in New York City, crated for shipment to Italy. Zuckerman was to have a casting done from the molds according to American specifications. The completed statue was to be returned to Visalia at Mr. Zuckerman's expense. The terms of payment were basically one-third of the expense in the beginning, one-third upon inspection of the project in Italy, and the balance on completion of the job at Visalia. It was also specified in our agreement that Cesare Contini,[2] was to work for Zuckerman, and Contini's pay was to come out of the total amount. Mr. Contini was the right person for the task. He had known and worked with his father on Fraser projects since the 1920s. Cesare, an amiable and gifted man, is America's foremost mold maker.

One of the unforgettable interludes we experienced in our Fraser project adventure was the unveiling of Jimmy's great statue of Abraham Lincoln on February 12, 1969. The work acquired was the original plaster model commissioned by the Abraham Lincoln Memorial Association of Newark, New Jersey. The bronze casting of the statue had been unveiled in 1930. My apprehensions about the cost of the model (a sum of $15,000) were overridden by my unswerving belief that the Lincoln statue was vital to the exhibition and, except for the *End of the Trail*, more important than any other work in the studio collection. Some critics thought the statue was the finest ever sculptured of Mr. Lincoln. I paid for the statue by siphoning off funds from our low payroll and operating accounts. Rich Muno did all the leg work in the deal; Juan Menchaca restored the statue and made it uniquely presentable for public appearance.

I had heard from Laura the story of Jimmy's trials and tribulations in determining the pose. He had interviewed one of Lincoln's body guards, who told Fraser of a favorite rock in a grove

109

of trees near the White House where the President would often go to sit and meditate alone. Using the rock as a support for the figure rather than the executive chair seemed a stroke of genius in portraying the Rail Splitter. I like Lincoln without the beard and Laura had said she, too, supported the idea from its formative stages.

The unveiling of the statue was an emotional experience for me, heightened by a band playing "The Battle Hymn of the Republic." I concluded that the pace I had been traveling was getting to me. About half my days and nights were on the road; I was virtually a stranger to many at the Hall—and at home.

During the winter, I had written to Mr. and Mrs. Dean A. McGee[3] to solicit support from the McGee Foundation for the all-important *End of the Trail* casting. It was not until the annual Cowboy Art Exhibition held in June, however, that I had my first opportunity to talk with the McGees personally about their support. They seemed to favor the idea. In the meantime, Trustee Saunders signed a bank note with me for $20,000 which enabled us to establish a time-table for the actual work.

By mid-summer of 1969, I had resolved all the terms in our agreement with Zuckerman. Cesare Contini made his appearance and began the long arduous task of mold making, taking over where Leonard McMurry had left off several months before. The condition of the statue was not immediately suited to making the molds, so Contini set about refining surface areas. Weeks turned into months as the restoration continued under the hands of Contini, the perfectionist.

In December, I received a letter from Mr. McGee stating that the foundation would support the project with a sizeable amount of money. Grateful for this, we were able to forecast costs and payments with confidence.

It was now obvious that we were not going to be able to get the molds made and shipped to Italy in time to return a bronze to Visalia to meet the terms of our contract. This posed a problem that was becoming increasingly sensitive in Visalia. Citizens there

110

began doubting the wisdom of the supervisors in letting the original leave the state. The supervisors, in turn, were asking Mr. Harp questions about our progress. To provide assurance, early in 1970 Joel McCrea, Cesare Contini, and I went to Visalia to meet with the Board of Supervisors at a public meeting. When we left, confidence was restored, and we had gained an amended contract with one year's extension of time.

Returning to the National Cowboy Hall of Fame, little did I realize that it would be several months before the molds would be ready to ship to Italy. All the while, thousands of visitors were pouring through the museum, spending much of their time in the Fraser building. In September, the piece molds were finally in place on the statue and thus the exhibit closed for the first time in two years. The National Cowboy Hall of Fame's floor personnel had to tell hundreds of disgruntled visitors each day why they could not see the *End of the Trail.*

By mid-fall the molds had been removed, crated and made ready for shipment to Italy. I declined to move the molds by truck to New York City as specified; rather, we decided in the best interests of our contract to airlift them to Italy. If the piece molds were in Italy in December, Mr. Zuckerman had assured us that the casting would be completed by May. I was afraid of a dock strike and, if by some quirk of fate, the molds were damaged or lost enroute, I would be sunk—literally. Over two years of work and thousands of dollars had gone into making the molds. The friendship and trust of the people of Tulare County, California were at stake. Although the cost of airlifting would be approximately $12,500, we could avoid possible shipping problems. I had discussed the matter with board members. While they were not pleased about added costs, the trustees couldn't help but agree with the reasoning.

After shipment of the molds, Cesare Contini's long and important role with the *End of the Trail* ended, and we entered into another phase of the project: raising money to build a permanent building not only for the statue but also for the entire

James Earle and Laura Gardin Fraser Studio Collection.

With the *End of the Trail* well along in its process of restoration, I began seriously to ponder with Executive Committee members our ultimate goals in developing the Fraser Memorial. The National Cowboy Hall of Fame now had important major and minor pieces from the studio and one of the greatest works in the history of American sculpture as the central figure. At first we considered two concepts. One was to display the entire collection as a large unit in Honorees' Hall. The second was to build a forty-by-eighty-foot addition extending west over the loading dock. Height was a major concern, since the *End of the Trail* stands eighteen feet tall.

After analyzing both plans, we concluded that to devote such an area as Honorees' Hall to the works of the Frasers would be a misinterpretation of our theme to memorialize the men and women who had pioneered the American West. The studio collection would have to complement, not dominate, the museum's collections. The idea of building onto the existing structure was impractical from an engineering point of view as well as design. The devotion with which some individuals viewed the architecture of the Cowboy Hall of Fame began to make itself felt, mildly at first, but becoming more heated later.

The feeling I had in the beginning, and still have, is that the Cowboy Hall's building design, while exciting, could become monotonous. Too much of the same architecture, I felt, would be a mistake; if continued, the Hall of Fame would take on the appearance of a gigantic rambling motel. The suggestion that I took to the Executive Committee was one of a slight change in form, yet compatible in design. I maintained that the National Cowboy Hall of Fame's ultimate development should take on a campus-like or academic feeling using varied modern forms.

Since the Star Building Company had come to our rescue in putting up a temporary building to house the *End of the Trail* for the restoration and mold making, I continued our relationship by asking their architect, Afton Gille, to design and build a scale

112

model of the Fraser Memorial as an entirely separate structure, connected by a closed-in courtyard. The size that we thought of, in keeping with our original ideas, was eighty by sixty feet. The addition would have to contain a lounge, restrooms, space to allow for viewing the collection, and ceiling peaks not less than thirty-two feet high.

Gille's scale model was exactly what I wanted. Leonard McMurry made scale models of the statues to place inside it. A case was made for the model to enable me to carry it to various parts of the country for presentation speeches. The idea of a prefabricated building with a metal roof rankled some of the original designers. My defense was rather strong since the composition roof on our building leaked and had cost us considerable time and money. Certainly we did not wish to repeat that experience. The cost of the Fraser building would depend on how soon we could get started.

My first thoughts were to solicit the amount needed from a single source or donor. I had several prospects in mind. I sent feelers out in the form of the study we had published and received only lukewarm response. In the course of a conversation with Mr. Kirkpatrick, I asked if he thought the Kirkpatrick Foundation would consider the project on a matching basis—that is, if someone or some group would contribute half the cost, now set at $230,000. Mr. Kirkpatrick said they would consider such a gift, but wanted first to know about "the partner."

Almost as if by providence, into our lives came one of the sweetest persons I have ever known, Mrs. Nona S. Payne,[4] of Pampa, Texas. Mrs. Payne, widow of Dave D. Payne, a widely known and respected Roberts County pioneer rancher, was interested in a project to memorialize her husband. Mr. Payne's life as a west Texas pioneer rancher reinforced from the outset some of the feelings we had about the memorial: that its benefactors should have led lives compatible with James Earle Fraser's humble beginning in South Dakota.

When Mrs. Payne's friend and counselor, Joe Gordon, Jr.,[5]

113

asked what project the National Cowboy Hall of Fame had that would pay fitting tribute to Mr. Payne, I informed him of our $25,000 benefactor membership. Mr. Gordon replied, "Is that the best you have?" I replied that no, it wasn't, and that I would be glad to make known to Mrs. Payne the nature of our most important project. Gordon replied in his resonant West Texas voice, "Mighty fine."

While I was cultivating a relationship with Mrs. Payne, I continued to meet with Mr. Kirkpatrick at every opportunity, giving him the benefit of my optimism. At the February meeting of the Executive Committee, Mr. Kirkpatrick committed his foundation for half the amount. After several weeks, I began to doubt if Mrs. Payne would share in the project, although I had not told members of the Executive Committee about my feelings.

Mrs. Payne, Mr. and Mrs. Gordon, and Mr. and Mrs. Paul Bowers accepted our invitation to attend the annual meeting of trustees and members held at the Cowboy Hall of Fame on April 24, 1970. The group arrived from Pampa during our membership meeting. At the conclusion of the meeting, Admiral Kirkpatrick and I had the opportunity of greeting Mrs. Payne and her friends. The towering Kirkpatrick placed his arm around Mrs. Payne and said, "How's my partner?" Mrs. Payne later laughingly recalled the incident and said that she didn't fully agree to the proposition until she saw the statue for a third time. After viewing the statue for a few minutes she exclaimed, "Joe and Janie, I want to do this!"

Mrs. Payne's acceptance was an emotional experience for me because it meant that the great memorial to the Frasers was assured. In spite of the problems that were to develop, the major hurdles had been surmounted. That night at our Western Heritage Awards Banquet I had the privilege of announcing the gifts of Mr. and Mrs. Kirkpatrick and Mrs. Payne.

At the May meeting of the Executive Committee, the building design was brought up and openly opposed by a senior member of the Executive Committee of the Board of Trustees. He requested

that his feelings of opposition to the design be included in the minutes.

The trustee's objections came as an unexpected bombshell since I had presented the plan and model to the Executive Committee on numerous occasions without opposition from him. Now that we were virtually ready to break ground, I found myself in hot water. Mr. Kirkpatrick suggested that the Executive Committee serve as a building committee and review the plan I had sold to both the Kirkpatricks and Mrs. Payne. An alternate concept was then created by a prominent local architect. Within a few days the new concept was in rendered form and a meeting called to review the plans. The Executive Committee appointed three architects to submit an opinion of the two designs. At the next meeting of the Executive Committee, another strong plea was made by the dissenting trustee against the Star Building design. He even questioned our right to build where we had planned, since that portion of the site had been deeded to the city of Oklahoma City by Cowboy Hall of Fame Trustees in 1964, so that bonds could be issued to raise money for resuming construction. Interesting sidelights of our institution's early history were thus involved in the controversy.

At the first opportunity I flew to Pampa and showed Mrs. Payne and her friends the "new concept," asking for their opinion. Mrs. Payne was reluctant to comment. But by late May both donors had taken strong stands in favor of the Star plan, as had Board President Jasper Ackerman. Fortunately for the project, the reviewing committee of three architects voted two to one in favor of the first concept. Even the architect who placed the dissenting vote said the plan was commendable. And so ended the saga of the building to house the Fraser collection.

Ground was officially and quietly broken on Sunday, June 14th, 1970. Mrs. Payne and the Kirkpatricks turned the first shovelfuls of dirt. Special guests at the ground breaking ceremony were Dr. and Mrs. Leland Case of Tucson, Arizona, close friends of James Earle and Laura Gardin Fraser. Dr. Case[6] reviewed the lives of the

115

Frasers and their work. The ceremony also gave me the opportunity to thank Leland, since it was at his suggestion that I contacted Laura Fraser while I was at Gilcrease. In fact, the long road to the ground breaking could be traced back to that initial correspondence.

Construction was without mishap and proceeded on schedule. At last, we were ready to move in the *End of the Trail*. The temporary building was dismantled and removed. The contractor agreed to move the huge work but at the same time absolved his company of any damage that might occur. One morning late in October 1970, a small crowd gathered for the *End of the Trail's* final move. The story was picked up by the Associated Press wire service and sent throughout the country. Installation of the *End of the Trail* was followed by the addition to the memorial of other pieces from the Fraser studio, principally, James Fraser's *Abraham Lincoln*, Laura Fraser's United States Military Academy panels, and a case containing such important objects as the original plaster models for the buffalo-Indian head nickel, the Navy Cross, Victory Medal, and other small items.

On November 12th, Mrs. Payne came from Pampa to inspect progress and make plans for the dedication. The board had agreed to dedicate the memorial at 11:00 A.M. on December 13, the last day of the National Finals Rodeo. Mrs. Payne requested that Texas Senator John Tower give the principal address; Trustee Joel McCrea was invited to introduce Senator Tower. Other important persons who would participate, besides Mrs. Payne and Mr. and Mrs. Kirkpatrick, were Mr. and Mrs. Dean A. McGee, contributors to the restoration and bronze casting, and Albert K. Mitchell,[7] board chairman.

The morning of December 13 was cold and clear. The grounds around the memorial were immaculate. A platform had been erected for the program and chairs for more than four hundred guests placed in the area where the garden would ultimately be located. The dedication ceremony lasted one hour with Jasper Ackerman, president of the trustees, as master of ceremonies.

116

Mrs. Payne and Mr. and Mrs. Kirkpatrick presented the facility to the trustees for the people of the West and all America. Senator Tower spoke strongly and reminisced about the late Dave D. Payne, paying tribute to the West Texas rancher for his vision, frugality, and devotion to his state and country. The ideals and life of Mr. Payne were, the Senator remarked, examples of all that the National Cowboy Hall of Fame stands for, and now the Memorial, containing the great art works of the Frasers, embodies the ideals and individualism of Mrs. Payne and Mr. and Mrs. Kirkpatrick. The unveiling of a bronze commemorative tablet completed the ceremony.

A major part of the project was over. My word with the Hall officials had been kept. Completion of my bargain with our friends in Visalia was a year away—twelve damnable, frustrating months.

When the casting from Pietra Santa finally arrived in Los Angeles Harbor, the shipment was tied up in a dock strike that lasted one hundred days. Finally, it was released and by early December it was in Visalia.

The satisfaction of the job well done in Visalia was heightened when we received another check from the McGee Foundation. At last the National Cowboy Hall of Fame was out of debt for one of the greatest statues ever cast into bronze.

On December 19, 1971, we went to Visalia for the dedication ceremony. Joel and Frances Dee McCrea met Jasper Ackerman, my wife and me at the airport in Los Angeles. The Vice-chairman of our Board of Trustees, Fred Dressler and his wife, arrived from Gardnerville, Nevada. Also present were our curator, Juan Menchaca, and his wife. The dedication and turning on of fountains took place at 2:00 P.M. with Tulare County Supervisor Robert Harrell as master of ceremonies. Our trustees were seated with supervisors and county officials. Congressman Robert Mathias represented Tulare County and the central California Congressional district. John Svenson, president of the National Sculpture Society, was also present. Jasper Ackerman spoke, reviewing the

history of the transaction, and then he formally presented the work. Robert Harrell and Walter Sunkel accepted the statue on behalf of Tulare County. Joel McCrea gave the principal address; he had seen the statue in San Francisco as a boy and had commented to his father how much he liked it. Joel reminded the four thousand or more persons in the audience that the National Cowboy Hall of Fame and the citizens of California had a durable bond between them, one that would last as long as there was a love of America's heritage.

A great many thoughts and memories ran through my mind during the ceremony. I thought about James and Laura Fraser and wished they had lived to see this moment. I remembered my first lunch and conversation with Laura. I thought of the time that Leonard McMurry and Richard Muno called from California to report that the *End of the Trail* looked like a terrible disaster. I thought of Cesare Contini. I thought of the nights I had lain awake wondering whether we could raise the money to meet the cost of some particular phase of the project. I thought about the criticism the statue and the Payne-Kirkpatrick Memorial Building had received. I remembered the times the tempers of all of us had flared from the strain, though all of us remained friends. I thought of the Kirkpatricks, Mrs. Payne, Mr. McGee, Joel McCrea, and Jasper Ackerman. I looked at my wife sitting in the first row in the audience. Next to her were Felicia Menchaca and Frances McCrea. Then I thought again of the waitress in Visalia who, after I asked what the ruckus over the *End of the Trail* was all about, had looked at me and said, "Some nut from Oklahoma wants it."

Chapter 7

Charles Schreyvogel: Bugles in Santa Fe

CHARLES SCHREYVOGEL'S western action work can be reduced to basic themes.[1] A favorite consists of subjects riding hell-bent into or away from the action. Works utilizing these concepts are *Going Into Action, Lost Dispatches, Dead Sure, On Patrol, A Hot Trail*, and the gold medal winning painting, *My Bunkie*. Schreyvogel's blue-coated troopers are complemented by the magnificent horses they ride—strong, powerful, well bred, and well drilled animals.

A small portion of Schreyvogel's output consisted of complex portrayals utilizing many figures, such as *Defending the Stockade, Early Dawn Attack, Rescue at Summit Springs*, and *The Skirmish Line*. All are compositions that only a talented artist and a good student of the hostile Indian frontier would attempt. These scenes are often brutal. Invariably, they catch the action before victory or defeat is in full evidence; the fighting appears to be frozen in suspension rather than in full motion. None of Schreyvogel's involved canvases portray rhythm or sweeping movement, in my opinion, as well as many of Russell's, Remington's, or William R. Leigh's paintings. Leigh's *Custer Battle* and Remington's *Indian Warfare* are examples of this excitement, as is C. M. Russell's *Gun Powder and Arrows*. Schreyvogel's *The Skirmish Line* decidedly has the frozen action feeling. The troopers are well placed, finely drawn and identified, and they remain immobile. Unlike any other art historian of the West, he

119

was able to stop the fight—so that it might be better understood.

Another painting of complex composition is *Rescue at Summit Springs*. The painting glorifies Buffalo Bill Cody as the hero and leader in the Summit Springs Battle. The engagement occurred July 11, 1867 in a remote portion of Northeastern Colorado Territory, where companies of the Fifth Cavalry led by General Eugene N. Carr met Tall Bull's band of hostile Cheyennes. The Fifth's victory brought with it the recapture of two white women. The role of Buffalo Bill in the killing of Tall Bull is controversial, and this painting was done by the artist as a favor to the scout. Unlike his other works, *Rescue at Summit Springs* appears contrived, stiff, and almost melodramatic. The commission, while important, may well have proven a dilemma for Schreyvogel, who was a faithful student of frontier history.

The third major category of Western compositions employed by the artist was a compromise between the canvases containing a few figures and the complex group situations. In this category, Schreyvogel detailed action in the foreground of the painting with two or three cavalrymen and Indian figures, while the main body of the conflict, involving many figures, is set in the background. *The Silenced War Whoop* is a superb example of this type of presentation. The action in the overall scene in this painting is intricate. Figures in the foreground dominate, and a cavalryman has killed the lead Indian figure. This work also gives one a feeling of circular motion as the opposing hostile forces clash with tremendous momentum. Several other major works by Charles Schreyvogel fall into this category, among them, *How Kola*, *Tomahawk* or *Even Chances*, *Picket's Rear Guard*, *Saving the Emigrant*, and *Fighting Scouts*.

The number of subjects Schreyvogel painted outside the din and clatter of battle is limited. A few of his paintings utilize sentimentality as a theme: *My Bunkie*, *A Friend In Need*, *The Last Drop*, *In Safe Hands*, *Saving the Lieutenant*, and *How Kola*. Not many portrayals of frontier conflict are more brutal than *Fight for the Water Hole*, *Defending the Stockade*, or *The*

Charles Schreyvogel by Tom Lovell

Surround. However, in spite of the violence at close range, there is always the absence of blood, open wounds, and maimed limbs.

Another characteristic of the artist is his reluctance to depict women often in his canvases. However, *Rescue At Summit Springs* graphically portrays the recapture of women captives. Another widely known portrait is titled *Gladys. In Safe Hands* is unique not only because of the little girl in the painting, but because she is the artist's only daughter, Ruth. The trooper holding and protecting her is her father—a self-portrait undoubtedly painted by using mirrors.

The number of paintings by Schreyvogel depicting buffalo is slight; nevertheless, he knew the animal was important for life on the frontier. Only two oils the author has seen portray the killing of buffalo. In *Doomed*, an Indian in full beaded buckskin regalia has cut a young cow out of the herd and is poised to drive his lance into the animal's vital front quarter. The other work is *U. S. Cavalry Hunting Buffalo*. The weapon used in this painting is a high-calibre revolver. There is a striking similarity in the placement of figures and settings in these two canvases. However, it is unlikely that an Indian would hunt in full costume, or that a cavalryman would attempt to kill a buffalo with a side arm.

Schreyvogel's sympathy and kinship for the Indian were strong and grew each passing year. In 1907 he was to write, "Small wonder that the Indians, seeing the means of their livelihood thus ruthlessly destroyed, became desperate and levied reprisals by raiding the settlements, killing the intruders, and driving off their cattle. Small wonder that they attacked the emigrant trains, in the vain hope of stemming the tide which must inevitably overwhelm them and cause their own doom."[2]

Like that of the female figure and the buffalo, Schreyvogel's use of vehicles in his paintings is limited. Only occasionally would he feature a covered wagon or a stagecoach as a theme. Major works in this vein are *Protecting the Emigrants*, *In Safe Hands*, *The Attackers*, and *Saving the Mail*.[3]

Charles Schreyvogel's devotion to the trooper and Indian allowed him to give the cowboy and buckskin-clad frontiersman only scant consideration, and he obviously preferred to keep his figures mounted on horses. The extent to which he confined his artistic scope within the military theme is remarkable. It may have required a full measure of discipline, but he stayed away from strong subjects well within the framework of his talent, such as army barracks, staff and command situations, the parade ground, columns on the march, drill teams, target practice, bivouac, equestrian training, and a myriad of related scenes.

For the most part, Schreyvogel's paintings can be regarded as

authoritative in the field of military equipment and accoutrements. Paintings which show both trooper and horse broadside reveal the fully equipped cavalryman. The artist was a stern military master with his troops and required that they be equipped according to regulations, regardless of the outpost or situation. The horses they rode met army specifications and wore the traditional field brand, "US". In rare instances, he brought mules into combat. In all probability, when an old soldier would call his attention to this detail and ask why he used a mule, Schreyvogel's delight must have been instantaneous.

By virtue of subject matter and size (and aside from the controversy that surrounded public previewing), the masterpiece of Charles Schreyvogel's all-too-brief career is *Custer's Demand.*

This painting was exhibited at Knoedler's Gallery, New York in April 1903, and subsequently went on to the Corcoran Gallery in Washington, D. C., then Buffalo, and St. Louis, where it was awarded medals.

In formulating the composition for *Custer's Demand,* Schreyvogel showed discerning judgment. Undoubtedly he had long yearned to paint a Custer battle scene. While the subject may well have been an obsession with him, he chose to place the controversial Custer in a more gallant setting. For those who loved Custer and cherished the memory of the Seventh Cavalry, the painting was high tribute. The concept for the painting undoubtedly came from Mrs. Custer, who, when relating stories to the Schreyvogels of her life on the frontier with the General, recalled this as among her husband's finest hours. The setting was in Indian Territory (Oklahoma) near Fort Cobb, located approximately one hundred miles southwest of present day Oklahoma City; it was south of Camp Supply and a considerable distance from the military forts in Kansas.

The figures in the painting are, from left to right: Little Heart, Lone Wolf, Kicking Bird, Satanta, Grover A. Scout, an interpreter, Colonel Custer, Lt. Col. Tom Custer, and Colonel John Schuyler Crosby. General Phil Sheridan is in the distance.

The episode was in the wake of the bloody Washita massacre of Black Kettle's band of Cheyenne. The Kiowas and Comanches were apparently becoming unruly and were taking "liberties" beyond the prescribed boundaries of their reservations. General Phil Sheridan ordered Colonel Custer who, by this time was much feared as a killer of old men and children among the plains tribes, to emphasize what the United States Army expected of them.

After the Washita massacre of November 23, 1868 and a triumphal return to Camp Supply, Custer, with his cavalry, set out again in search of the Indians who had been camped below Black Kettle's village. Reaching the Washita, the army found the village deserted. The Indians had fled in fright and had gone to Fort Cobb, where they hoped they would be protected by Colonel William Hazen, the Fort commander.

During a tense and dramatic confrontation, the affair was resolved without bloodshed. As a result of his forceful role in this episode with the Indians, George Custer went on to higher command.

The hundreds who came to Knoedler's and subsequently to the

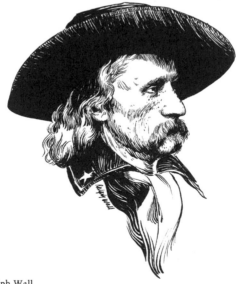

George A. Custer by Ralph Wall

124

Corcoran Gallery in Washington, D.C. to see the painting were moved by the power and high drama of the setting as well as the artistic qualities of the work. *Custer's Demand* was seen a number of times by President Theodore Roosevelt, the Widow Custer, Colonel John Schuyler Crosby (who had been with the colonel on the occasion of the painting), and many other military dignitaries. Among those, however, who disliked the painting were Colonel Frederick Benteen, members of the Reno Court of Inquiry (who testified that Custer disobeyed orders and acted irresponsibly at the Little Big Horn) and Frederic Remington. New York and Washington press critics were complimentary in their comments on the painting.

Charles Schreyvogel's temperament was moderate; he was a considerate man with accommodating ways. By nature, he was quiet, shy, and reticent but would become open and fun loving with friends. In this light, it may have been that he chose not to paint a Custer battle scene out of his respect for Mrs. Custer and the other widows and orphans of that ghastly day on the Little Big Horn in June of 1876. Ironically, it was Remington who made an attack on Schreyvogel and the painting. Remington wrote to the press denouncing the painting as being filled with flaws. "Half baked stuff," the big man called it, as well as "unhistorical."[4] The national press picked up the matter and played it up as controversy. Upon reading about it, old soldiers by the hundreds flocked to see the picture and, for the most part, nodded approval. The controversy grew in size and those who had opinions expressed them; soon the artist from Hoboken, New Jersey emerged the victor. The jabs that were thrown at Remington were well placed by important personages. Theodore Roosevelt took Schreyvogel's side, confiding to him that Remington "made a perfect jack of himself."[5] Only in the intimacy of a letter to his wife did Charles Schreyvogel repeat Roosevelt's opinion on the matter, and then he cautioned her not to tell anyone. Frederic Remington's role as the master painter of the Cavalry-Indian frontier had openly been challenged whether Charles Schreyvogel

liked it or not. Frederic Remington summed up his feelings in a letter to Colonel Crosby, in which he wrote tersely, "I despise Schreyvogel."[6] His accusations undoubtedly hurt the sensitive Schreyvogel, who praised Remington by saying, "He is the greatest of us all."[7]

It may be well to close the *Custer's Demand* incident with the words of Colonel Crosby when he wrote for publication regarding the matter:

> Now please, Mr. Editor, understand I have no feeling either way. I only know what Dr. Boteler once said of strawberries. Doubtless God could have made a better berry, but doubtless God never did. And so I, to be more gracious, say of the Schreyvogel painting, doubtless Remington could have made a better picture, but doubtless Remington never did.[8]

Schreyvogel's contributions in bronze were limited. He accomplished only two sculptures, *The Last Drop* and *Chief White Eagle*. The former work was the forerunner of a painting by the same title. Both pieces would be important acquisitions in a museum collection but only the National Cowboy Hall of Fame can boast of owning the two subjects cast under the artist's supervision. While both bronzes are technically well done, one can hardly classify Schreyvogel as an important sculptor.

As was the case with his sculptural ability, Schreyvogel virtually teased those who are devoted to his work in watercolor. While he had fine ability in this medium, he limited his output of western subjects to a few pieces. Because he was a good draughtsman and colorist, Charles Schreyvogel was proficient in all media, be it oil, watercolor, charcoal, or pencil. However, he obviously wanted to be remembered as an oil painter who captured the conflict on the high plains of the 1860s and 1870s.

Charles Schreyvogel was, in many respects, a painter's painter and a man's man. He was careful about his work and his reputation as a painter. Unlike several of his contemporaries, he did not leave a large body of miscellaneous work as part of his legacy. While he made drawings, sketches, and studies for his own

pleasure throughout his career, there is virtually no record as to the method or manner in which he worked. One can only speculate as to the pain and agony that may have possessed him in his striving for accuracy and perfection in his major works. He may have cleaned off several canvases and started over. At times, sheer hunger may have prevented such decisions. Nonetheless, it is obvious that he didn't want to be judged by his mistakes; as an artist he was totally incapable of sloppiness or professional neglect.

Schreyvogel worked slowly and compositions did not form easily. Unlike Remington or Russell, he had not lived in the military situation or marched with the column or worked on the roundup. While his travels to various posts and agencies were important, he did not become a part of the Western setting or environment. Photographs show him in the West sitting stiffly before his easel, formally clothed in a dark suit, white shirt, tie, fedora hat, and high-topped shoes. He was a kindly man to whom troopers, tiring of endless routine, may have spun ridiculous yarns and he was undoubtedly the butt of many barracks jokes. To the Indian, he was perhaps a curiosity—a white man who was a "shadow catcher." The night the Indians silently moved their entire camp away from the artist and Mrs. Schreyvogel is classic. When he awoke, his red brothers had vanished into the unknown. To Schreyvogel, this was a marvel. To the Indians, it was obviously hilarious—a story to be told and retold.

Remington, like C. M. Russell, had seen the raw, if not cutting, edge of the West. Both had lived in the West, and drank many a toast to it with rotgut whiskey. This was a life Charles S. Schreyvogel never understood. He looked at the West through the eyes of an Easterner, a sophisticate.

Charles Russell and Schreyvogel met when the Montanan came East in 1911 for an exhibition at the elite Folsom Galleries. The two undoubtedly got along very well, although there is no archival evidence that they communicated beyond that first meeting. But Russell, with his high heeled cowboy boots, showy red sash

around his waist, tilted hat, and shock of hair covering the side of his head was as vastly different from Charles Schreyvogel as was the aristocratic, often brutal Remington. Nonetheless, it is the great triumvirate of Russell, Remington, and Schreyvogel that has kept, and will continue to keep, the great and growing artistic image of the American West alive.

Charles Schreyvogel died of blood poisoning at the age of 52. Had fate given Schreyvogel another ten years of life, one can only speculate as to what he may have achieved. Certainly he would have gained greater popularity and the main body of his contribution may well have exceeded 150 works. Yet in the end, he achieved what he set out to do, and that was to recapture scenes of conflict that took place between the U. S. Cavalry and the Plains Indians over a brief span of years. For this alone he has earned a place of high rank among the West's most important historical painters.

My admiration for Charles Schreyvogel's talent began during my career at the Thomas Gilcrease Institute. There I saw great examples of his paintings for the first time, in works like *Fight for Water, Even Chances, The End, The Night Scout, Breaking Through the Lines, Standing Them Off, Attack at Dawn, The Scout* and *Custer's Demand.* Eight of the nine paintings at Gilcrease were acquired in 1944 with purchase of the huge collection of Western art from the estate of Dr. Philip G. Cole.[9] Philip Cole, medical man and millionaire-industrialist, was a native of Montana. Cole and his father, T. F. Cole (inventor of the automobile tire valve), knew Russell personally and bought some of his finest paintings. While the story of how and when Dr. Cole acquired the eight Schreyvogel paintings is not known, one must revere his memory for having done so. The Coles had the eye and the mind to choose quality plus the money and courage to buy. Philip Cole obviously inherited not only his father's wealth but also his love of the West and so he pursued his collecting with zest. The Philip Cole estate, Zeeview, located along the Hudson River at Tarrytown, New York, was filled with great Western art.

As great as the art holdings are which Thomas Gilcrease assembled, if the Cole collection was suddenly removed, the importance of Western art in the institute would be considerably reduced.

The Gilcrease collection unquestionably contains the most outstanding body of Schreyvogel's work in existence. I hoped to build a collection of Schreyvogels at the Cowboy Hall of Fame equal to Gilcrease's. In January of 1964 I attended an auction at Parke-Bernet Galleries in New York City that offered two fine Schreyvogel paintings, *A Sharp Encounter* and *The Lost Dispatches.* The two paintings fetched $20,000 each,[10] setting a new record for Schreyvogel sales. Since I was still wearing the mantle of Gilcrease's director, I was only mildly interested in the excitement and activity that surrounded their sale. Months later, I had resigned and, busily trying to ready the National Cowboy Hall of Fame for opening, found myself too preoccupied to show concern for another important Schreyvogel painting that was offered at Parke-Bernet. The title of the work was *Dead Sure*, purchased by my friend Robert Rockwell of Corning, New York. A search of auction records reveals that no major Schreyvogels came to public notice prior to the appearance of these paintings. Acquisitions or representations by art dealers were apparently offered privately. It wasn't until I was well into the problem of outlining goals for the Cowboy Hall of Fame's permanent art collection that I learned of the extreme scarcity of paintings by this artist.

One of the friendships that grew meaningful for me through my years as a museum director has been with New York City art dealer and bookman, Jack Bartfield. On each trip East, I would visit Jack and often joined him and other out-of-town guests who frequented his gallery at a sumptuous dinner. Table conversation usually revolved around Remington, Russell, Leigh, Henry Farny, H. W. Hansen, and Schreyvogel. These evenings were enjoyable and always spiced with laughter, fine food, and drink.

During a New York visit shortly after I came to the National Cowboy Hall of Fame, Jack displayed a sketch book of Charles

Schreyvogel that he had purchased from the artist's daughter. The book contained an assortment of fine drawings, including New Jersey landscapes, figures, pastoral scenes, cloud formations, and trees, but nothing that indicated his interest in the West. However, I was impressed with the book as an insight into the artist's drawing ability. The sketches whetted my interest and reminded me that soon the Cowboy Hall of Fame would have to actively but quietly seek a major painting by this artist.

After returning to Oklahoma, my thoughts continued to dwell on the sketch book, so I telephoned Jack and asked him to send it out on approval. A few days later I took the book to O. M. "Red" Mosier, then chairman of our Art Acquisitions Committee, who felt, as I did, that the sketches were not important enough to exhibit, especially since none of the drawings had any flavor of the West. In spite of the lack of interest at the board level, I was reluctant to part with the sketch book. Eventually, Jack gave the sketch book to me personally.

Although I didn't realize it at the time, what was to follow was one of the most extraordinary steps I have taken on behalf of our museum. I had made an intensive study of the artist and now I wanted to meet a flesh and blood Schreyvogel. I learned that Mr. and Mrs. Archie Carothers lived in Santa Ana, California; Mrs. Carothers (Ruth Elizabeth) was the Schreyvogels' only child. I wrote to them and within a few days received a telephone call from Archie Carothers. He acknowledged receipt of my letter and told me that he and Ruth had recently moved to Santa Fe, New Mexico. Before I realized it, I was telling Mr. and Mrs. Carothers that I would come to see them.

I arrived in Santa Fe on a beautiful October morning in 1968. It is always a treat for me to be in the clear, crisp air of mountain country. That day was especially exhilarating and promising; the foliage had turned to the beautiful golds and reds that I dearly love. The Sangre de Christo Mountains off to the east formed a beautiful backdrop for Santa Fe. Pecos, Baldy, and Lake Peaks had donned their caps of glistening snow. A scanning of the horizon

showed outlines of Wheeler Peak near Taos; to the south I could see the Sandias.

Soon after my arrival I was knocking on the door of a lovely Spanish-style home. I was ushered into a picturesque living room and began quickly chatting and shaking hands with two of the most affable people I had ever met. It was as if I had known them all my life.

Ruth had to be a carbon copy of her father, with an almost shy, reticent way—quiet and decidedly German. She was quick to laugh and her eyes shone, especially when talking about her father. Archie was the opposite of his wife: bold and talkative, then suddenly pensive, waiting for a reaction. His devotion to Charles Schreyvogel was instantly apparent even though fate had denied him an acquaintance with the artist. In fact, Ruth had been a small girl when her father died. "Oh, so many, many years ago," she would say.

We spent the entire day looking at their collection. It was great fun and a privilege for me to be able to touch and hold such items as Schreyvogel's guns, Hudson Bay knife, his palette, and to thumb through his drawings. We read his letters, laughed and hooted about a number of incidents.

During our conversations it became clear to me that their intention was to keep the collection together and eventually place it in a museum. They listed names of art dealers who had called on them repeatedly through the years, proposing an assortment of offers. Ruth's mother sold two paintings—*Fight for Water* and *The End*—shortly before her death and had regretted it. With the high cost of insurance and the rise in vandalism, it was evident that the Carothers were seriously thinking about the future of the collection.

"A number of things bother Ruth and me," Archie said. "We are getting old, and we hope to see the collection we have cared for so many years placed in a museum where everyone can appreciate it. We have thought of the Whitney Gallery of Western Art in Cody, Wyoming and of Gilcrease Institute in Tulsa, Oklahoma as

prospective buyers. Here in Santa Fe there has been interest. Until you wrote, we didn't know much about the National Cowboy Hall of Fame. But under no circumstances will we sell the collection to an art dealer."

In parting, the Carothers agreed to allow me to come back in a few weeks with our photographer, as I wanted to put together a prospectus. I had an idea.

Richard Muno, then assistant art director, accompanied me on my return trip to Santa Fe. We hauled lights, tripods, and camera equipment with us. Rich was in for a hard day's work, since we wanted a full pictorial record of the collection in color as well as black and white. While Rich and Archie (a photographer in his own right) worked and argued about settings and angles, I had an unusual opportunity to interview Ruth. From her I gained a memorable insight into the lives of her mother and father.

Ruth talked and I listened. She gave me good background on her family. "We were Germans to the core," she said. "Father wanted to teach me to speak German as well as English, but it confused me so he and mother dropped the idea. I remember my parents were very happy although they had some rough times. Father was 43 when I was born, but he had just really gotten started as a successful artist. So when I came along they were quite pleased, to say the least. My memories of father seem to be formed clearly in my mind now. I spent a lot of time with him in his studio. One time he brought me an Indian girl's beaded dress. I remember how happy it made me. I would parade up and down Garden Street in Hoboken, pretending I could speak Indian language. I was envied by all the other children. Father always enjoyed watching me squeeze the trigger of a gun, when mother wasn't around. He would take me up to the roof of our three story house where he had an easel set up and we spent hours there. It was a frightening experience as I thought it was the top of the world."

Ruth remembered her father as a kind, affectionate man. "He loved to dress well," she recalled, "and to see mother in beautiful

dresses. He was rather stylish and enjoyed taking her out to dine and listen to German music. They had been so poor that when he did become prosperous he wanted to make up for what he and mother had missed."

"Years after his death, mother used to talk about him. 'I remember when your father bought this or that,' she would say, pointing to some object in his studio. How he did love his guns. He would slip something into the house hoping mother wouldn't see it because she would scold him for being extravagant. Often mother would laugh at him or tease him in a firm way. She recalled that he would confess a new purchase by waking her up in the middle of the night, whispering softly the pet name he gave her, 'Schnuck, Schnuck, today I bought a rifle,' or, 'That Indian headdress came in the mail.' After he confessed, his conscience was clear and off to sleep he would go."

"A lot of things happened after his death," Ruth reminisced. "He was popular in Germany, so many of his guns and pieces of Indian costume were sold to a museum in Stuttgart. Later we heard the collection was destroyed during World War II."

"I remember Mrs. Custer,[11] too. I was named after her; the Elizabeth in my name honors her. She had a beautiful apartment with lovely furniture on Madison Avenue where mother used to take me. I would play with her dogs while the ladies enjoyed tea together. Mrs. Custer talked about the General incessantly and called him 'Artie.' Mrs. Custer stated that, of all the paintings of Artie, she preferred father's *Custer's Demand*. 'The General would have adored it,' she would say."

Ruth Schreyvogel Carothers continued, "As a painter father was very slow. Mother said he would spend days working on some detail. He seemed to know how he wanted it formed. He got most of his ideas out West and would pencil them in. He worked well on the train while traveling but did some of his finest work at our farm in Westkill, New Jersey.[12] He had horses there and used them. A man was hired to pose them and I recall father having this man pose hanging from a stirrup. I thought this was awfully

133

funny. Mother said he seldom destroyed a canvas. When he did, however, he would complain that he was a failure. But generally, he was very well controlled. Sometimes an idea would hit him at night, mother said, and he would jump out of the bed and stomp upstairs to the studio."

"We missed him when he went out West. It seemed like he was gone forever. Mother said that as the years went by he grew even more sympathetic toward the Indians. One time he told her he would like to be an Indian agent and mother replied that if he did he could marry a squaw because she wasn't going to leave Hoboken."

In summing up the years, Ruth Carothers said fate had denied her father a long life, but the years he was productive as an artist were enough to give him the fame he deserved. Yet at one time both she and her mother felt that his name would sink into oblivion. As time goes by, however, the Charles Schreyvogel reputation grows in stature and importance and for this she and Archie are justly proud.

Before we left, Archie and Ruth promised to come to the National Cowboy Hall of Fame in December. In the period between my visit and their coming to Oklahoma City, I had time to develop a purchase plan. I was at a disadvantage since I didn't know what the price or conditions would be. Two trips to Santa Fe, a set of color photographs, and an inventory of the collection merely enabled me to generalize about it.

While I felt the Schreyvogel Studio Collection was not an overly abundant representation of the artist's work, there was nothing more to be had. Percentage-wise it was a bonanza. Charles Schreyvogel was a major artist who died at the peak of his career and left less than one hundred finished paintings and a scattering of minor works. The collection contained his hallmarks, beginning with a superb self-portrait, a miniature oil portrait, and a large oil painting of the family farm. A small oil of Louise Walther Schreyvogel, painted on the couple's honeymoon, is one of the jewels in the collection. It has a transparent, landscape quality

134

about it that is suggestive of Winslow Homer. Another exquisite work is a charcoal drawing of the artist's wife. I felt then that the heart of the collection consisted of three oils painted during the great years of his life. Of medium size, they present Schreyvogel's interpretation of the frontier of the Cavalry and Plains Indian. The largest of the three works is *Going Into Action*. The first time I saw the painting in the Carothers' home, I felt it was an important work and might, in not too many years, appraise for as high as $100,000. *A Hot Trail* and *On Patrol* are well known paintings and were reproduced in the album titled *My Bunkie*, the only major publication issued during Schreyvogel's life. Two medium sized portraits of Indian Chiefs, one a Ute and the other a Northern Plains Indian, are included in the collection. While western landscape studies in oil by the artist are relatively rare, the collection contains six. One small sketch book containing thirty small but fine drawings represents Schreyvogel's work as a young man before he went to Munich for study. The drawings in the sketch book show his promise as a draughtsman. One of the miniature drawings is of his father.

The studio also contained fine castings of the only bronze subjects he sculptured, *The Last Drop* and *Chief White Eagle*. Both are rarities that few museums can boast of owning.

Among unusual items held by Mr. and Mrs. Carothers for so many years was a color print of *My Bunkie*. The print was taken from the original painting, in the Metropolitan Museum of Art in New York, that had won the Clarke Gold Medal and membership for Schreyvogel in the National Academy of Design in 1900. It was this recognition that started Charles Schreyvogel on the road to success and fame. The collection contains not only his coveted Clarke Medal but also medals he won at the St. Louis World's Fair in 1904 and Paris International Exposition.

Charles Schreyvogel remained an ardent admirer of Frederic Remington, even at the height of the *Custer's Demand* dispute. Schreyvogel was shocked when he learned of Remington's sudden death on Christmas day in 1909. According to Mrs. Carothers, her

Self Portrait by Frederic Remington

father brooded over the great painter's passing for weeks, regretting that they had not become friends. Even the compliment paid Schreyvogel by John A. Sleicher, editor of *Leslie's Weekly Magazine*, a few weeks later failed to cheer him up. "The death of Remington leaves you unquestionably the greatest artist in the line of work in which you both have achieved such great success," Sleicher wrote.[13]

Another interesting letter was from Buffalo Bill Cody. The two men were good friends and the old showman always wanted Schreyvogel to come to his ranch near Cody, Wyoming. Referring to the matter in a letter, Buffalo Bill wrote, "I will show you the life I love," and, in regard to a painting project, "I know you will make a great picture of the Battle of Summit Springs, and sometime I want you to paint some other fights I was in."

The studio offered the remnants of what had once been a superb gathering of Indian costumes, including a rare eagle feather war bonnet, a Hudson Bay hunting knife, beaded scabbard, and most unusual and assorted weapons. The military paraphernalia included such objects as guns, saddles, and a trunk used in traveling throughout the West; his art equipment—a paint chest, his Munich-made paint stand and easel, a field palette, and a handful of paint brushes—also were among the items.

136

Among Schreyvogel's papers we found a fascinating manuscript revealing his sincere efforts to learn to speak the Dakota Sioux language. With dignity, he could extend greetings, give his name, and tell what he wanted to do. A page from a faded tablet written in Schreyvogel's hand discussed bravery among the Dakota or Hidatsa Sioux. It read in part, "Each warrior shared honors with his dearest possession, his horse. His medicine bag or charm was often braided into the horse's forelock and feathers in the tail. Scars of battle were the horse's greatest honors and usually painted red. The black tip tail feather of the eagle was braided into its forelock and some tribes painted red spots on a white field, or the full feather dyed on earth red . . ."

The collection of clippings in the acquisition, as well as scrapbooks kept by Louise Schreyvogel, recount the artist's greatest achievements. One, however, edged in black and cut from the *New York Herald* dated January 28, 1912, records Charles Schreyvogel's untimely death:

> Mr. Charles Schreyvogel, the noted painter of Indian and frontier life, died yesterday at his residence and studio at number 1232 Garden Street, Hoboken, New Jersey. Born in New York City on January 4, 1861, Mr. Schreyvogel was educated in the public schools and then apprenticed to a gold engraver. Later he became a die sinker and finally a lithographer. His pictorial talent was noticed and encouraged by a fellow workman who aided in sending him to Europe for study. From 1886 to 1889 Mr. Schreyvogel studied in Munich under Frank Kirshback and Carl Marr. On his return to this country he went West and lived and painted among the plainsmen.
>
> When he returned here he supported himself by hack work for lithographing firms. It is a proof of his artistic sincerity that it was under such inspiration that the wonderful picture, *My Bunkie*, which made him famous, was produced.
>
> Luckily for him, the lithographer to whom he offered it found it too large for the use he had in view. Mr. Schreyvogel was downhearted over losing the small fee and hung the picture in an eastside restaurant he frequented.

Friends urged him to send it to the exhibition of the National Academy of Design. He yielded reluctantly. The judges unanimously awarded the Thomas B. Clarke prize to the unknown artist. No one knew him, and until he read the *Herald* the morning after the exhibition opened he had no idea fame had found him out.

After *My Bunkie, A Fight for Water* is most widely known of his spirited frontier scenes. Mr. Schreyvogel was awarded gold medals at the Paris Exposition, 1900; Buffalo, 1901, and St. Louis, 1904. He is survived by a widow and one small daughter.

After my visit to the Carothers home, I was more determined than ever to bring the studio collection to the National Cowboy Hall of Fame.

On January 13, 1969, I received a letter from John McCarthy, attorney for Mr. and Mrs. Carothers, offering terms of sale. The Carothers' terms, as stated in the letter, were as follows:

The sales price for the foregoing fine arts and other items is $160,000 plus interest and the terms set below:

A. Down payment of $16,000 on date of execution of bill of sale and other instruments.

B. Balance of $144,000, payable in six equal installments of $24,000 principal plus interest on the unpaid balance at 4%.

Appraisal of the collection was difficult to accomplish due to the small number of paintings that had come onto the market in the past through major galleries and public auction channels. After consulting a number of art dealers and collectors about market values, I came up with an appraisal format that assured me our purchase was fair and reasonable for both parties.

There were so few Schreyvogel paintings available that prices were on the increase. A major oil that I considered for the National Cowboy Hall of Fame prior to the studio acquisition had increased from $25,000 to $35,000, then $50,000, in comparatively quick transactions. Another factor that caused the dormant Schreyvogel market to suddenly come alive was the announcement that a widely known historian was preparing a manuscript

on Schreyvogel's life to be published under the imprint of a major New York publishing house.

Tension grew between the parties in Santa Fe and me, as the day and hour for expiration of the option rights drew near. In the meantime the content of the collection had been revealed in the East and Mr. and Mrs. Carothers were evidently experiencing new propositions and perhaps better deals. In all truthfulness, it was quite a dilemma for me. I was now down to the wire at the Hall, operating at minimums and much in debt with a sputtering economy. I would be hit hard in the coming weeks by other projects. We didn't have $16,000 for the down payment and I knew the Board would not approve a financial commitment that large. Without belaboring the purchase for long, I took the letter of agreement to the Hall's attorney, R. C. Jopling, Jr., for legal advice and at the same time reviewed the entire matter of appraisal versus cost with J. B. Saunders. J. B. quickly gave me the support I needed and said he would back me all the way in the matter. All that would be done, therefore, would take place outside the regular framework of the National Cowboy Hall of Fame. It was a nebulous situation.

It was now even more imperative that we incorporate our developmental division, Western Art Fund, so the Schreyvogel project could be pulled into that framework. I hoped it would work as a corporate entity and it did—more so than I expected—but at this time I had my doubts. In the meantime, I talked with Mr. Saunders as often as I could, feeling sure he would be elected to the board at the April meeting of the Trustees. This was as important as would be the reorganization of the Executive Committee.

My excuses for delay began to grow thinner and thinner in Santa Fe. Archie Carothers, I surmised, had a lot of time on his hands and apparently most of it was spent thinking about me and all that I wasn't able to do. I decided to go to Santa Fe on February 18. Archie was pleased when I phoned and said we could meet at their attorney's office.

I formulated my plan. I arrived in Santa Fe late the night before the meeting and checked in at LaFonda Hotel. The pressure I was under prevented me from enjoying the pleasant setting. The place was full of activity as the New Mexico State Legislature was in session. I left a call with the night clerk to get me up early so I could do some thinking.

The next morning Santa Fe was covered with a new layer of snow and it was still coming down. At breakfast I went over my presentation. Soon the Carothers came in and, after an exchange of greetings, we were wading through the snow on our way to what I hoped would be the first step toward an historic acquisition.

John McCarthy was a tall, typical Westerner with easy manners, possessing the sharp legal mind of one who had grown accustomed to listening more than talking. I liked John from the outset. As the meeting began, I stated that the purchaser for the National Cowboy Hall of Fame would be Western Art Fund, a development and acquisition agency for the museum, adding that papers of incorporation had been filed. I presented documents giving evidence of this intention and suggested that Mr. McCarthy might wish to contact our attorney. This was acceptable and I presented Western Art Fund's check for $10,000 as earnest money. I had raised the money from sales of Schreyvogel drawings cut from the sketch book given me by Jack Bartfield. I felt sheepish about selling Schreyvogels to buy Schreyvogels; the feeling, however, didn't last long. Upon execution of the papers I would give the balance of the down payment as required. We set the last day in April as our closing date.

Next, I offered an insurance certificate from our fine arts policy underwriters insuring the entire collection for the full amount, thus relieving the owners of the added expense and worry. The Schreyvogel collection was covered in Mr. and Mrs. Carothers' name in any eventuality. We were all in agreement. Within a short time we drank a toast to our relationship and to the future Charles S. Schreyvogel Studio Collection.

140

I was pleased about it all and a few hours later was flying back toward Oklahoma, feeling in a sense that I had a "piece of bacon" in my pocket. On my return, I called J. B. and told him of our progress. He, too, indicated satisfaction. I now had time to try to get something going in the way of fund raising. I considered several alternatives—one was the forming of the Schreyvogel Club.

During this time I conjured up a concept of how the studio should look and made a rough drawing of it with approximate dimensions. I got together with painter Jim Boren to describe my ideas and gave him the rough layout sketch. A few days later he brought in one of the finest watercolor renderings I have ever seen. It was beautiful; Jim had done it again. His paintings of the proposed Fraser Studio and *End of the Trail* had already become famous and helped me immensely in selling that project.

The matter of raising money was really plaguing me. We had already spent a considerable amount on "good deals." Many extra expenses, in addition to our growing overhead and payroll, were causing uneasiness. As usual I justified the acquisitions with the premise that if we didn't build our collections now it would never be done. Here, too, was another great one-shot project, so my answer to raising the needed $6,000 balance on the down payment was to market more of the Schreyvogel drawings Mr. Bartfield had given me.

By the middle of March I decided to present my concepts for an overall fund-raising project to board members in Colorado. Trustees in the state of my birth were extra special and it seemed a good place to try out an idea. I carried color photographs of the collection and other items that I thought would be good conversation pieces.

If the dinner in Denver was a flop, the one the following evening in Colorado Springs was worse. Both groups of trustees sensed that I was up to something. In each go around I must have said the wrong thing. Luckily I hadn't sent advance literature on my Schreyvogel Club fund-raising concept. In the solitude of my hotel room I consoled myself with the knowledge that timing and

141

mood were both important to any success. I had forgotten that just a few days before the meetings our accounting department had sent out our January and February profit and loss statement. We had losses in the amount of $80,000.

During this period I also began to feel the pressures of Eastern interests who apparently resented the fact that the Schreyvogel collection would never go on the market. The first indication was the notification that an important art collection on loan to our museum by dealers would be shipped elsewhere. Then a second notice came. These requests dove-tailed. Finally a third with-drawal came in.

Mr. Jopling was not able to get the papers drawn up for our Western Art Fund as quickly as we had hoped, and we realized it would take more time and frustration to obtain a tax exempt status. At any rate I felt another trip to Santa Fe was necessary and arranged to meet with Mr. and Mrs. Carothers and attorney John McCarthy on April 2nd.

On that day, Ruth and Archie joined me for breakfast. I highlighted our get-together by displaying Jim Boren's fine 20 x 30 inch rendering of the proposed Schreyvogel Memorial. They both were completely surprised yet their acceptance of it was almost instantaneous. Ruth exclaimed, "It's beautiful. If only Mother could have seen this!" We created quite a furor in the dining room as we discussed the installation, now being envisioned as thirty feet long, four feet wide, and eight feet high. I presented the rendering to them as a gift.

Our session with attorney McCarthy also went very well. He was in full sympathy with the delays in setting up Western Art Fund. To clarify this, I read a letter I had prepared outlining our problems and intentions. After a brief discussion I gave Archie and Ruth a second Western Art Fund check for $6,000. This amount, with the first check, totalled the down payment of $16,000, as required in their letter of January 13th.

At the Executive Committee and Trustee's Meeting scheduled for the latter part of April 1969, I expected to talk about the

collection to members of the board, especially those who were interested in Western art. However, our agenda was filled with a four-year fiscal history of the operation. Because of the large number of business matters and a full schedule of social events centered around the Western Heritage Awards program, it wasn't until late at night that I was able to get together with trustees of Western Art Fund and bring them up to date. They were half asleep and I was groggy from the day's activities. I considered the meeting important, even though a flop. At least they knew what I was into.

During the days following the Trustees' Meeting, I had sessions with attorney R. C. Jopling and we were able to get the promissory note and security agreement prepared. J. B. Saunders signed with me. These instruments and the Bill of Sale were sent to Santa Fe. All that remained, therefore, was to obtain Mr. and Mrs. Carothers' signatures.

In the meantime, the Carothers planned a short vacation trip to Florida and then on to New York City, where I knew they would be wined and dined by anxious dealers. In spite of having our down payment, Archie was growing impatient, to say the least. My problem was still one of getting Western Art Fund officially created so that all could be executed within that framework. Ironically, the instrument was officially filed[14] and accepted a couple of days before the Carothers' departure was planned. To expedite things, I needed the Bill of Sale signed by the Carothers to cover our investment. I also needed to take possession of the collection and prepare a financing sales plan, for our next payment of almost $30,000 would be due in less than eight months. To get things moving in a hurry, Richard Muno and I rented a plane, expecting to fly to Santa Fe but a gigantic thunderhead over Amarillo, Texas convinced us of the inadvisability of this. In the meantime, my office had a couple of telephone calls from Mr. Carothers. He was ready to leave for the East. I telephoned John McCarthy, who said it didn't make any difference to him if the Carothers were there or not. As long as the

Bill of Sale was signed and left with him, we could then take possession. I told him Muno and I would be there in time for breakfast and we promptly left the National Cowboy Hall of Fame in our station wagon at 5:00 P.M.

Sun-up saw us in Santa Fe. At 8:00 A.M., bleary-eyed, we drove up to the Carothers' home on Madrid Road only to discover that they had departed an hour or so earlier. The unhappy fact remained that the Bill of Sale had not been signed. In a decision that proved hasty in the after glow of a day, we decided to hire an airplane, locate the Carothers' car from the air, and have them sign the Bill of Sale.

Mr. McCarthy said he understood Mr. and Mrs. Carothers were driving toward Roswell. Soon the three of us and the pilot were wheels up and winging our way south. We flew in some of the most turbulent weather I have ever experienced as we circled, looked, and imagined their car, only to be disappointed. We even landed, rented a car, and waited beside the highway—but no sign of the Carothers was to be seen. It became apparent that they had not taken the Roswell Highway.

Late in the day we returned to Santa Fe, tired, still air-sick, dejected, and about $200 poorer. The whole trip, the all night drive, and the search with its harrowing moments were all to no avail. We were empty handed, to say the least.

The next time I talked with Mr. Carothers I told him if he would give us our $16,000 back, he could keep the collection and I hoped to hell he sold it to some art dealer and all would be scattered to the four winds. If he wasn't interested in a memorial to Charles Schreyvogel at the price we were willing to pay, I wasn't either. Not ever being at a loss for words, Carothers made an appropriate rebuttal.

I figured the whole thing was down the drain and gained some satisfaction from my anger. Suddenly events turned around. Archie telephoned to apologize and so did I. We never again had a harsh word during the six years the purchase plan was in effect.

I finally got my idea of a Schreyvogel Club going. It took shape

as the Winchester Schreyvogel Club,[15] a highly successful financing venture under the leadership of J. B. Saunders and Joel McCrea. We not only received a royalty from sales of regular Cowboy Commemorative Carbines manufactured by Winchester Western, but we sold 300 beautiful deluxe customized rifles in cases for $1,000 apiece. I am still extremely grateful to the Winchester Company for their vital role in putting the program together.

I will never forget J. B. Saunders' comment at the very beginning of the project when he said, "Hell Dean, if you think the collection is a good buy, I'll back you!"

Chapter 8

Wheeling and Dealing for Western Masterpieces

A FEW CHAPTERS back when discussing C. M. Russell, I related how the Cowboy Hall of Fame acquired *The Cinch Ring* and *Wild Man's Truce* from Knoedler's for $180,000. I also mentioned that the firm had a famous Remington oil, *Hunters' Camp in the Big Horns*, which I hoped we could some day purchase. These three paintings were part of a whopping package of sixty-five western works quietly offered to us. The entire lot had been assembled by my friend William F. Davidson, for many years executive vice-president of Knoedler's. But he had since then sold his interest in the more than one-hundred-year-old firm.[1] Had Mr. Davidson been in authority and in his prime, we wouldn't have had such an easy route to acquisition of the Russells. I'm

New York Skyline by David Blossom

convinced that in the beginning Bill would have made us take the entire collection or none, and his price would have been a flat $750,000. Certainly the Russells and Remington would have been the last to be sold.

My contact at Knoedler's now was Anthony Bower.[2] He was new in the firm and didn't have it made as far as his job was concerned. Pulling off the Russell sale would surely gain him attention with the front office. In one of our several telephone conversations, he filled in much of the picture there. Among other problems besetting Knoedler's was that fact they were going into a costly remodeling program at another location.

Bower told me that their entire western collection had been offered to *Reader's Digest* for $600,000. They were not responding so it was up to him to find another buyer, and I had been his only contact. However, news of the collection had been leaked and two works, a Charles Schreyvogel painting and a Remington bronze, had been sold "on the side." Purchaser of the Schreyvogel was my friend, Bob Rockwell, of Corning, New York. Public disclosure of all the holdings would have set art world wolves howling after the collection.

I wanted the Remington desperately but Bower told me that another party had first refusal rights. The price was $118,000, at that time the highest price asked for a Remington. A sporting scene by the artist had recently brought $105,000 at Parke-Bernet. *Hunters' Camp in the Big Horns* was a beautiful, 1908 fine art

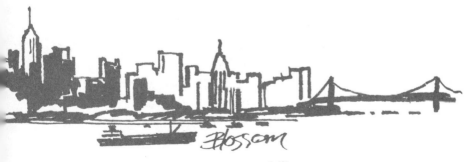

picture. The tabling of the Remington proved to be a fortunate break for me in the long run since it gave us a shot at the entire collection, but I kept worrying that we would lose the Remington jewel.

I scanned the list of paintings and bronzes and made up my mind as to which ones interested us. I telephoned Tony on October 23, 1970 and told him I could come to his office bright and early on the morning of November 9th. During the interim period I visited with Luther Dulaney, the most active member of our art committee.

By this time, our Western Art Fund had been set up by attorney R. C. Jopling to function as a non-profit, tax free corporation. The organization held meetings, took minutes, and made financial reports. Members were Luther, William G. Kerr, Jasper D. Ackerman, John E. Kirkpatrick, J. B. Saunders, and myself. Most of the activity of Western Art Fund was conducted by Dulaney, J. B., and myself with Mr. Jopling and our accountant, Hiram Turner. The big advantage was that we now had the authority to borrow money and buy and sell art, solely for the Hall's benefit.[3]

In spite of our care and caution during three years of operation, Western Art Fund ended up undergoing an intensive audit by the Internal Revenue Service. To avoid further criticism, I contracted for Wolfe and Company, auditors for the Cowboy Hall of Fame, to audit the fund. All came out well. We had succeeded, reckless as the scheme may have appeared, in tying down major art masterpieces for the Cowboy Hall of Fame. *The Cinch Ring* and *Wild Man's Truce* (valued at $185,000) were paintings that we put into Western Art Fund's assets; the Schreyvogel Studio Collection added another $160,000, thus relieving J. B. and me of two whopping notes.

At various times we had two or more Oklahoma City bankers pulling their hair out.[4] When we approached a banker, it was usually with a powerful man's blessing. I could say that Luther Dulaney, or J. B. Saunders, or John E. Kirkpatrick, or Jasper

Ackerman had sent me and we needed $100,000 or $250,000, whatever the case might be, at a preferred customer rate of interest. For this I was not destined to be popular, but I knew if I ever got out from behind the shield of these men, I ran the risk of a good goring. In time I became good friends with Oklahoma City's bankers. Most of them have grown to love the Cowboy Hall of Fame and to appreciate what we have been trying to accomplish.

In reviewing the Knoedler inventory with Mr. Dulaney, I suggested we could come out all right on the investment by gaining a number of works to sell in addition to those we would want to keep. Luther loved the thought of a big deal. Like J. B., he was an oil speculator and a horse trader. As I left his office heading for the airport to see Tony, he hollered, "Damn it, don't you go and spend more than $200,000!"

The next day I met Bower at Knoedler's. He wasted no time in taking me over to their warehouse where he had everything lined up against the wall. I gave the paintings a quick look. Staring directly at the beautiful Seth Eastman in the collection, I said, "Tony, I thought you said there was a Seth Eastman here." He was frustrated. I couldn't believe it—he didn't know. I began pressing him about other titles and he started running around, looking for names on paintings. I realized then that he knew very little about Western American Art; avant-garde was evidently the stuff he pursued.

After an hour and a half of examination and note taking, I told Bower I would think about what I had seen for the rest of the day and offered to meet him at his office the next morning with my proposal. We shook hands and took separate cabs. I returned alone to my hotel room to begin studying the inventory of art and reviewing photographs of the collection which Ed Muno had taken.

I had long ago learned to practice this solitary "one-to-one" approach when appealing to a potential donor or engaging in delicate negotiations for Western art. The incident that taught me

this lesson occurred several years ago and involved a good friend of mine, a department head on our staff who was a tall, handsome devil, a terrific artist and a good conversationalist. I shall call him "X." The purpose of our trip east, after weeks of planning, was to solicit money for the Hall that would enable us to purchase a great C. M. Russell painting for $85,000. At the crucial luncheon meeting with two officers of the foundation, "X," with his natural charm, dominated the conversation. The affair lasted over two hours.

In the end I never got a word in edgewise, much less time to make my pitch. The biggest blow to my pride came when the luncheon broke up and one of the foundation's trustees clasped my friend's arm, exclaiming, "Dear 'X', do call on us again next time you're in New York . . . and by all means bring Dean with you." As I paid the check, I concluded I would never take "X" on another business trip and didn't.

By mid-afternoon of that day in New York, I had narrowed down our selection to thirty-five of the items offered by Knoedler's. From the lot, I chose the following for the Cowboy Hall of Fame's permanent collection:

1. N. C. Wyeth, *A Word of Precaution to the Passengers*
 Oil on canvas, 24⅔ x 38 inches
2. W. Whittredge, *Mesas At Golden Colorado*
 Oil on paper, 15 x 11 inches, circa 1865
3. J. Walker, *Indian Taming Wild Horse*
 Oil on canvas, 16 x 12 inches, 1877
4. P. Goodwin, *When Things Are Quiet*
 Oil on canvas, 40 x 24¼ inches, 1910
5. A. Bierstadt, *Rams In Dunraven*
 Oil on panel, 9 5/16 x 7¼ inches, circa 1866
6. A. Bierstadt, *Jim Bridger, Scout*
 Oil on panel, 6¾ x 9 inches, circa 1866
7. J. D. Howland, *Bugling Elk*
 Oil on canvas, 22 x 17 inches
8. W. T. Ranney, *Boone's First View of Kentucky*
 Oil on canvas, 54 x 37½ inches, 1851
9. A. D. O. Browere, *Placerville Mining*
 Oil on canvas, 36 x 26 inches, 1855

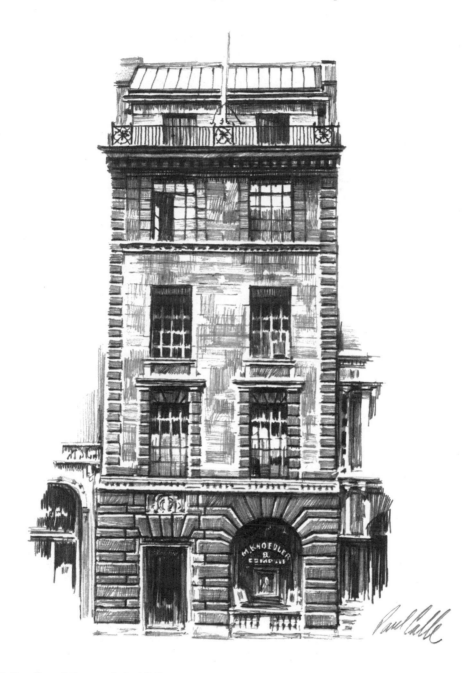

M. Knoedler and Company by Paul Calle

10. A. D. O. Browere, *The Lone Prospector*
 Oil on canvas, 25 x 30 inches, 1853
11. G. Catlin, *Buffalo Chase Upper Missouri*
 Oil on canvas, 25¾ x 32 inches, circa 1839
12. Seth Eastman, *Osceola as Captive in an Open Tent*
 Guarded by a Sentry
 Oil on canvas, 26 x 18 inches, 1837
13. P. Rindisbacher, *Assiniboine Family*
 Watercolor on paper, 7 x 10 inches, circa 1828
14. S. H. Borglum—*Lassoing Wild Horses*
 Bronze, cast by Roman Bronze Works, New York
 32 inches high, executed 1898

We would be fortunate, I thought, if we could save this group and sell the balance. There remained some fine, highly saleable pieces. Two Russell bronzes were beauties—duplicates of subjects we owned yet even better castings. My first thought was to trade, but I decided in the hotel I would not cross Western Art Fund lines with those of the National Cowboy Hall of Fame. The entire venture was becoming increasingly exciting. That night as I dined with Victor and Irene Hammer[5] in their lovely apartment filled with French Impressionist paintings, I had to restrain myself to keep from revealing the magnitude of the deal I was involved in. Ironically, the Hammers were to take over Knoedler's within a few months and Victor would then learn the details of our transaction.

Returning to the hotel, I figured the terms of my offer. Mr. Dulaney had set my limit at $200,000. Joking or not, it was a solid guideline for me. There were thirty-five works that I wanted, so I divided 35 into $200,000 as a trial figure and then settled on approximately $5,485 per item, for a total of $192,000. I speculated that we could sell the residue for not less than $150,000, and thus Western Art Fund, for only $42,000 would own a collection of fourteen works then worth what I would consider a fortune. The Seth Eastman was, by itself, worth the price difference.

I spent a restless night tossing and turning in bed, excited beyond belief. Nervous as I was, I tried to appear calm and

collected when I entered Bower's office the next morning. We greeted each other. He asked me if I cared for coffee. I said, "Nope. For what it's worth, I have an offer."

He said, "Shoot."

I began, "We are interested in 35 works in the collection. I'll give you $192,000 for them, payable within thirty days after arrival in Oklahoma City, seller pay the freight, we'll insure." Reviewing the overall proposition, I continued, "In the beginning, you asked $600,000 for the collection. I have this in your letter. I have already paid Knoedler's $180,000; add to it $192,000 and it becomes a total of $372,000. If you sell us the Remington for $118,000, you're only $110,000 away from your original sale price and there are 25 pieces left to sell. If the remaining pieces average $5,000 each, the total will be reached and you ought to get a raise. You know our trust in Oklahoma City, on my recommendation, bought the Charles S. Jones Collection through Knoedler's for $500,000. How many million dollar customers do you have?"

He shook his head and grinned, "Yes, Dean." Excusing himself, Bower said, "I'll run this by my bosses."

I was ready for coffee. I could hear muffled conversation and what sounded like laughter. Pretty soon a secretary asked me to come into the president's office. There were a couple of other men there. The president greeted me with "Bon Jour" and I answered with an Oklahoma "Howdy." Then he said, "We will take your deal if you pay in full within thirty days."

I said, "Maybe before."

I boldly replied that not only would we pay $192,000 within thirty days but also we wanted to buy the Remington for $118,000. We shook hands on our $192,000 sale. I would have to wait for the Remington.

On the way out of Knoedler's, I was surprised to see my old friend, Bill Davidson, sitting near the door waiting for his car. He was an unhappy sight, recovering from a stroke. I shook his hand cordially and told him how great it was to see him.

He said, "Rumor tells me you made a deal. Rumor, hell, Fred

told me you were at the warehouse yesterday morning."

I said, "That's true, Bill. We bought the Russells and thirty-five of the best in the collection. I believe we will also get *Hunters' Camp.*"

He smiled and said, "There's no place I'd rather see my paintings go to than the National Cowboy Hall of Fame."

The story ends well in spite of some mistakes. I regret having passed up a small Thomas Sully in the inventory, and I sold the Russell bronzes to a Tulsa banker too cheap. I had to hurry. I discovered that being an art dealer and seller was not as easy as buying; the National Finals Rodeo was on and I had a lot of other things to tend to.

We received the collection early in December as the nation's economy went into a slump during the winter of 1970-1971. By January 5, 1971, I had sold the pieces we were not keeping for a total of $148,000. Time was against me. I had to keep my word on the payment and, on the eighteenth, I mailed M. Knoedler and Company a Western Art Fund check in the amount of $192,000. The price difference was made up with a loan of $44,000 borrowed in the name of Western Art Fund.

My bid for the Remington was deferred; I had to sweat it out while Knoedler's moved into their new location. During the interim, I visited Tony Bower and he gave me a tour of their new gallery. It was indeed going to be plush when finished. Obviously building costs were becoming excessive. Bower confided that *Hunters' Camp in the Big Horns* would be ours in time and had not been offered to anyone else after the first buyer declined his option. "After all," he said, "the big boys like the idea of the Cowboy Hall of Fame's purchases reaching a million."

While I was waiting for *Hunters' Camp in the Big Horns* to become available, a New York dealer named Robert Osborne called me and said my name had been referred to him by Mitchell Wilder, director of Amon Carter Museum, as being someone who might be interested in purchasing a casting of the Frederic Remington bronze, *Coming Through the Rye*. The price quoted

was $85,000. I immediately dug into my files, searching for a letter sent to me while I was in Tulsa by the late Helen Card. I considered Miss Card authoritative on Remington bronzes. She had written:

> In regard to castings of 'Coming Through the Rye,' 1902, we used to sit around and tick off how many might exist. Someone would start, Gilcrease was number one, you know . . . and we'd count others; two in Chicago, one in Ogdensburg, three in Texas, and so forth, until we got to the Metropolitan Museum and the White House. But we could never count more than fifteen.[6]

The history of this bronze disclosed that it was purchased from Knoedler's during Remington's lifetime by Francis P. Garvin. Upon Garvin's demise, it was donated by his sister, Mrs. Nicholas Garvin Brady, to Mount St. Joseph's Academy, West Hartford, Connecticut, on behalf of her sister, Mother Angeline (nee Ellen Garvin) who was Mother Superior of the Academy from 1935-1939.

I took photographs of the bronze over to Luther, and we discussed the piece at length. To me, *Coming Through the Rye* was considered to be Remington's most important sculpture. The casting was excellent, having been in seclusion from the public since the 1930s and suffering no damage. In fact, Bob Osborne stated that the bronze had been in a closet most of the time. We decided to make the purchase, agreeing to pay Osborne $75,000 upon receipt and the balance of $10,000 by December 10, 1971. I was withholding the $10,000 as a hedge in case we discovered something about the bronze that would detract from its value and force us to litigate the matter. Luther thought this was a smart move; later on I came to regard it as stupid. Bob approved the terms and once again I was on my way to the First National Bank. On April 13, staff members Bryan Rayburn and Rich Muno went to New York City and took possession of *Coming Through the Rye*. Bob Osborne had proved an easy person to do business with.

Anything can happen in the Western Art business and I don't

think I have been denied any surprises. A few weeks after we had purchased *Coming Through the Rye,* I received a call from one of our directors. He said, "From all I can learn, you—or we—got royally screwed on the $85,000 Remington deal." He went on to explain that he became aware of this after telling some friends at a dinner in New York about our new acquisition. "First," he charged, "you paid too damn much. There was no precedence for such an outrageous price and secondly, according to a noted authority's book on Remington,[7] there are a damn sight more castings than fourteen or fifteen."

Our Cowboy Hall director was convinced now that I had used poor judgment, especially after reading the statement in the book declaring, "Forty or more of the original bronze castings [of *Coming Through the Rye*] were made and Tiffany & Company sold them for two thousand dollars each."[8]

The matter was duck soup for me to defend. It was a rewarding occasion when I pulled a sales catalog out of my file to show that a casting of *Coming Through the Rye* had sold at public auction for $125,000. The place of the sale was Astor Galleries; date of the sale was October 14, 1970, five months prior to our buy. As a matter of record, I had the head of one of America's most prestigious auction houses write a statement in reference to the number of castings. He agreed, as Helen Card had said, that there is no record of a cast number beyond fifteen. The matter was closed.

By this time it was mid-June and the Knoedler people were ready to sell the Remington. Their new building had been formally opened in a costly splash.[9] They needed cash. I had previously made a commitment to them to purchase the painting and was ready to stand behind it. The only drawback was that Mr. Dulaney was vacationing at his summer home in Michigan. I telephoned Luther there and explained the situation. He responded that he would be back in town about the first of July for a few days. "Issue the check," he suggested, "and see if they will hold it until the first, when I will sign a note at the bank." I agreed. I also reminded him that we now owed the bank over $700,000

and were servicing the debt with borrowed money.

He thundered, "How in the hell are we going to get this paid off?"

I suggested that we had several alternatives: one, an angel; two, to shift the debt over to the Hall's back; and three, to leave the country.

Luther countered, "Good Lord, I've already given you $200,000 worth of paintings, if not more."

I closed out the conversation with, "We're getting close—but we still need a major Farny and some Fechins."

"Cut it out," he replied. "Damn it, Dean, when I get back I'm going to make you take an oath on a stack of Bibles that you won't buy any more high priced art!"

I had a blank Western Art Fund check signed by Luther. All it needed was filling in and my signature. I telephoned Bower that I was sending Art Director Richard Muno to New York to bring back the painting and that he was bringing our check. When I explained the situation, Bower enthusiastically agreed to hold the check until July 1. The transaction was completed and a bill of sale issued without any apparent problems. We beamed over our new acquisition. The Hall had exhibited a number of minor Remingtons but nothing like *Hunters' Camp in the Big Horns.*

All was going well until a few days later when a First National Bank official telephoned and, obviously trying to exercise great control, said, "I hate to bother you, Krakel, but your Art Fund account is slightly overdrawn."

"No kidding," I replied. "How much?"

"It's only $118,000," he whispered. "But I thought you might like to know."

My first reaction was a string of mental cuss words, followed by a call to Tony. They had slipped up and a bookkeeper had sent the check through a full two weeks ahead of schedule.

I tried to get in touch with Dulaney in Michigan, but couldn't. He was in his boat in the middle of the lake. I told Mrs. Dulaney our problem. She thought the matter was terribly funny.

I telephoned J. B. Saunders and related my circumstances. He laughed and said, "You and Luther have really gotten your asses in a jam this time. Bring a bank note over."

J. B. was appointed to the presidency of our board after Luther T. Dulaney passed away in September, 1972, and was elected for another year beginning in April 1973. Today he holds the position of Past Chairman and has a seat on our all-important Finance Committee.

J. B.'s door has always been open to me, and he will always return a telephone call. Once I put in a call for him and learned he was not in the office. I asked his secretary to tell him please call me when convenient, since it was rather important. I wasn't told where he was. A few hours later, he telephoned from Zurich, Switzerland.

"What's on your mind that's important?" he asked.

J. B. Saunders by Lupas

"John Kirkpatrick wants to hold an Executive Committee Meeting next Thursday. Can you attend?"

"That's okay by me, I'll be there," he replied quickly and hung up.

Early in my career at the Hall, J. B. taught me a fundamental lesson, while giving an insight into the kind of businessman and employer he is. The time was 5:30 in the afternoon on December 31. I was at my desk when the phone rang. Since my secretary had gone for the day, I answered and it was J. B. He was in his office in Houston. We exchanged the usual greetings. "What are you doing working at 5:30? It's New Year's Eve." I said, "Working hours here are from 9:00 A.M. to 5:30. That includes me," I replied.

He said, "I like a man who stays on the job. I'm glad I didn't miss you because my accountant informed me this afternoon that I can give a sizable amount of money away this year. I've made a couple of calls around. One to a university; another to a symphony, but couldn't raise anyone. Since you're the only head man I've found on the job this time of day, I'll give the entire amount to the Hall of Fame—if you can use it."

When Thomas Eakins' great *Cowboys in the Badlands*[10] came up for sale at Parke-Bernet, I became quite excited about it. Once again I went to see J. B. Saunders, showed him a picture of it, and said, "This is a once in a lifetime chance." Unmoved by the once in a lifetime idea, J. B. asked, "How much do you think it will cost?"

"I believe $150,000 will get it," I replied.

"Have you talked to Luther Dulaney about it?" he asked.

"No," I said, "Luther made me swear that I will leave high priced art alone for awhile. And Jasper just bought a major collection, so I don't want to mention it to him."

J. B. said, "Okay; if you can get it for that, I'll come up with the money. I want you to know that I don't carry that much loose change with me."

I telephoned New York City and asked Tony Bower to bid it in at the sale. I was on pins and needles until we learned that it sold

for $210,000. A couple of days later I telephoned J. B. with the bad news and his comment was, "When in the hell did you let $60,000 stop you?" How I wanted that painting, as well as the distinction of having broken the $200,000 barrier. At that time it was the highest price paid for an American painting, much less one of western subject matter.

Another of the innumerable and unforgettable experiences I have had in my adventures in Western art also occurred with Mr. Dulaney. It put me in hot water in a hurry with the Internal Revenue Service. The story began with Luther's purchase of Thomas Moran's magnificent oil painting, *Ponce De Leon in Florida*. The painting was a classic offered by dealer James Khoury of Amarillo. We had been considering it for several months before I talked Luther into making an offer. When he did, it was below the price Khoury was asking. Khoury refused to come down; Mr. "D" refused to go up. After a couple of weeks, it looked as if there would be no deal. Khoury wanted money or his painting back. Then I had an idea. A day or two later I called Jim and said "I have your price. One check will come from Mr. Dulaney and the other will come from our Western Art Fund." I told Mr. Khoury to make out the Bill of Sale in Luther T. Dulaney's name. No one other than my bookkeeper, Hiram Turner, would be the wiser, yet he advised against it. "Hell, Hi," I said, "if we paid $20,000, it would be a good proposition for the Hall. In the end we will gain a painting worth over $100,000."

Several months later—the following year, actually—the Internal Revenue Service moved in on the Art Fund and one of the first items the examiner picked out was a $10,000 payment on a painting belonging to Mr. Luther T. Dulaney. The examiner spelled out the law: "money of tax free institutions could not be dispersed for benefit of a private citizen." It was a form of "endearment." The auditor, who was very nice about it, suggested a conference with Mr. Dulaney. "Jesus," I thought to myself, "I'm into it now." I recalled the many times that I had started to tell Luther the whole story of his painting and then backed down.

The next day I called Luther and asked him if I could come over to see him. I was determined to confess the whole business.

I sat staring at Luther as he lighted his pipe, brushed away the cloud of smoke that hung about his head, and then said, "Mrs. Dulaney and I have decided to give the Cowboy Hall of Fame our Moran painting this year. When can you draw up the papers?"

I said, "Today."

"Fine," he replied and went on to say how much he enjoyed the painting and thanked me for introducing him to Western art.

Once back in my office, I telephoned the IRS official and told him that within a few days he would receive Mr. and Mrs. Dulaney's proffer of *Ponce De Leon in Florida.* The agent answered, "In that case, we won't need a conference, will we?"

Nowhere else on earth could I have gotten away with such shenanigans. It took dealing with the kind of men who believed in the Cowboy Hall of Fame the way Luther Dulaney, J. B. Saunders, Jasper Ackerman, and Bill Kerr have. They believed that great Western art, once paid for, would insure the National Cowboy Hall of Fame's immortality, that it would always give us dignity and quality, and would attract people of stature and competence to the place.

Using Luther and J. B.'s strength with First National Bank, plus financial support from Jasper Ackerman and the Oklahoma City Industrial and Cultural Facilities Trust, the following year we were able to mortgage the collection under a bond issue and pay off notes totalling more than $1,000,000.

I mark the close of this chapter with a sad postscript. A few weeks after our last big deal with Knoedler's, my friend Tony Bower was murdered in cold blood.

161

Chapter 9

The Carl Link Windfall

NOT EVERYTHING I have done in my quest to bring great art to the National Cowboy Hall of Fame has been satisfying. As I look back on the Carl Link[1] episode, I shake my head with mixed emotions. My friend, the late Walter Brennan,[2] once philosophized, "You don't have to do good in this world but you better not do bad." Such words weigh heavily on me when my memory recalls Mr. Link's face. Did I do bad?

What bothers me now is that for $3,500 I purchased the remainder of Link's entire studio collection consisting of scores of drawings, studies, and finished oils and pastels paintings. I bought all this from his estate which had been bequeathed to Margarete (Gretel) Schirer, a niece who lived in Munich, Germany. Working with executor Robert L. Henry, I did snatch Link from unknown artistic oblivion. I placed his paintings in a nationally famous collection where millions would eventually come to appreciate his talent.

In time, we skimmed off paintings I thought were worthwhile for our Western Art Fund, found sponsors to buy them, and gave them to the Cowboy Hall of Fame.

Shortly after Link's death, I purchased from the estate a large painting of an Indian boy and his pony plus a quantity of other paintings and items thrown into the deal, including Carl's easel, chairs, and other studio furnishings which he had brought over from his parent's home in Germany. Included in this purchase

were library books rich in photographs, studio models, papers, personal letters, clippings, costumes—tons of it!

When negotiating for the studio furnishings, I at first had in mind creating the atmosphere of Link's studio within an area of the museum. This suggestion met with considerable enthusiasm from the executor and helped me clinch the bargain.

When I moved the collection, I did it with little care—scooping, shoving, and cramming the stacks of drawings and bits of paper into open boxes and cases alike. During the negotiations, two well known art dealers, whom the executor had asked to act as advisers, responded to my asking, "What do you think?" with, in effect, "Nickel a pound; so much scrap."

It's hard to look back on it and analyze my feelings. Maybe I wasn't really thinking—not of Link but of some other big deal, perhaps, or was I simply under the normal pressure of operation. 1968 at the Hall was a helluva hard year.

I sold almost all of the original Link purchase to the highest bidder, like so much war booty. I was cold blooded about it, indifferent and insensitive to his artistic provenance and integrity. Perhaps I had become used to dealing in big names too long—names like Remington, Russell, Leigh, Schreyvogel, and Fraser. I may have resented being involved with an unknown. I constantly had to explain who he was: "You mean you don't know Carl Link?" I didn't enter the Link project; I plunged into it. It was apparent I had bigger fish to fry than kindly, sweet old Mr. Link.

As time went on, Link's fabulous Indians brought more and more stature to his other efforts, and I became more and more conscious of the true value of his ability.

Now that I have confessed my sins, I will tell you of the unusual coincidences that led me to knock on Mr. Link's door. It was during my years at the Gilcrease Institute that I was introduced to Carl Link indirectly by reading Frank Bird Linderman's book, *Recollections of Charlie Russell.*[3] The year was 1963. The book was brought to my attention since it contained the story of a

Winchester rifle, model 1895, engraved by C. M. Russell and acquired by Mr. Linderman, a historian and writer of note. We had botched up the story of the rifle in Gilcrease's *American Scene*[4] magazine by incorrectly attributing the rifle's ownership to Russell. Actually, the rifle was owned by a third party and etched by Russell.

Mr. Linderman's daughter, Mrs. R. O. Waller, of Kalispell, Montana, wrote on August,[31] 1964 and straightened me out on the matter of ownership. She suggested I read her father's book and this I did. The story, as Frank tells it, is as follows:

> Charlie merely grunted and reached for my rifle, which had caught his eye. He fondled it, turning it slowly in the firelight. "You're a dead'center gun an a meat getter," he muttered to it. He held the rifle across his lap and rubbed its stock. "You roar like a cannon an' I bet ya kick like an army mule. Lemme cut some fresh meat on the old gal?" he asked across the fire.
>
> I nodded and he opened the small blade of his jackknife.
>
> I brightened the blaze with dry wood and went around the fire and sat beside him, watching the point of the blade bite into the steel of the rifle's frame without hesitation, without a slip, make the "fresh meat"—a buffalo bull, a buffalo cow and calf, a bull elk, a mountain sheep, and a grizzly bear. They seemed to walk out of the metal as though pricked into life by the blade. "C.M.R.—1913," the knife recorded, and then his mark, a buffalo skull.
>
> "There she is," he chuckled and handed me the rifle. "Now the old gal will always have fresh meat in sight."
>
> The engraving was unbelievably fine, marvelous when one considered the light and the instrument used. The animals were so sharply cut into the steel that prints might easily be taken from them.
>
> Unfortunately the rifle was not mine, had never been mine. It belonged to Montana's Territorial Governor, Sam T. Hauser of Helena. I had borrowed it several years before to go bear hunting and had never returned it because the Governor had asked me to keep it until he called for it. I knew that he would never want the rifle again, because his hunting days were over, but his son, Tom Hauser, might want it. I said

164

Self Portrait by Carl Link

nothing about this to Charley, who had given the rifle no particular attention until two years before when I had made a scratch shot that had surprised him. Now I was determined to get a clear title to the old gun. I succeeded the following spring.

"Have you father's bear rifle?" Tom Hauser asked, uncertainly.

"Yes. Want it?" I replied, wondering how to manage its purchase.

"Yes, I'm going to try for a bear next week."

"Should think it would be a little heavy for you, climbing mountains," I said.

" 'Tis," Tom admitted, "but it's the best I've got." He added in a moment, "It's got an awful wallop."

"You bet it has and at both ends," I laughed. Then I ventured, "Say, Tom, you go over to Holter's hardware store and pick out any rifle that pleases you and have them send me the bill. I love the old gun and I'd like to keep it. How about it?" I tried not to sound eager.

To my surprise, he agreed readily, and I have never paid a bill with more pleasure. The old gun is beside me now. I

looked at it to get the date of Charley's engraving, which is as sharp and clear as ever. I think maybe I should have confessed to Charley that what I did might be as crooked as his keeping the hundred dollars for the pictures when he was asking only fifty, for Tom didn't know about Charley's engraving on the gun and I didn't tell him.[5]

A number of interesting facts were gleaned from Linderman's book. Primarily it enriched my knowledge and regard for Russell. I wanted to see the rifle added to Gilcrease's already bountiful C.M.R. Collection, as it would contribute variety and a nice touch along with some of the sporting scenes in the collection. A Winchester 1895 model is held in the hunter's arms in some of his most thrilling action scenes.

I presented the matter to Gilcrease's Board of Directors on one of the few occasions in my years there when I ever suggested they might purchase a work of art. The price was $7,500. The rifle was owned by my friend, J. N. Bartfield, of New York City. At the meeting, I gave the rifle's history and outlined my reasons for wanting it. The idea of my suggesting such an outrageous expenditure was ridiculous, aside from the fact that I felt anything more was necessary to enhance their collection. To the board, the Institute's collections were perfect, the epitome, the undisputed. For them, when considering Western art, all roads led to Tulsa. At that time, I was considering coming to the National Cowboy Hall of Fame and this treatment and attitude further convinced me that I should resign. When I finally did leave Tulsa for Persimmon Hill, I took the Linderman-Russell rifle with me, with permission of the owner, Jack Bartfield. Historically, it was the first work of art purchased for the Cowboy Hall of Fame's collection. Today it is worth more than three times the nominal sum we paid for it.

The Linderman book contained a drawing of Frank by Carl Link. The sketch was one of the finest pieces of work I had ever seen. "Who is this man Link?" I asked myself, thinking, "My gosh, he's a master draughtsman." Curiosity (something I have never

166

been short of) led me to write to Mrs. Waller again, this time asking about Link. Her reply was full and illuminating. In part, it read:

He, Carl Link, came into our lives very briefly one fall day in 1937, driving down to Goose Bay, our home, with Winold Reiss and a Miss Erika Lohman. It was shortly before noon so I prepared lunch for them. Conversation was lively. My father and Mr. Link were instant friends. We had known Mr. Reiss for sometime. My father had far too little contact with people of the arts and it was an inspiring several hours for all of us. My father's Indian collection, which is now at the Museum of Plains Indians at Browning, Montana, hung on the walls of his study and Mr. Link was busy at once sketching the bead work designs. In the course of conversation, he told us one of his hobbies was going to the theater, or a concert or baseball game where he spent his time sketching the spectators. I recall Daddy asked him how long it took him to get what he wanted and he replied, "Oh, five minutes or so," and as conversation went on, Daddy told him no one had ever been able to sketch or paint him.

Mr. Link's reply was, "Come on, I'll get you in five minutes." He sat him down in the living room by a window and instructed him to "look into the woods and don't move."

It wasn't five minutes—it stretched into an hour and a half and he explained because of the long weather lines (we called them laugh lines) he couldn't move a fraction of an inch or his entire facial expression changed and that was why no one had ever been able to "catch" him in paint.

The result was indeed superior draughtsmanship. It is done in pencil and inside the frame mat measures 6¾ by 9½ inches. None of us had ever seen work like it and my children and I and my mother had the rare privilege of watching every stroke of his pencil. I had watched Charlie Russell paint many times, but this was something special and the result was the only real picture we'd ever had of Daddy.[6]

I wanted to learn more about Link's career and mailed several letters of inquiry to libraries, including the reference department of the New York Public Library. The New York library sent me an abundance of material on Carl Link.

One of the first things I discovered was that the Woolaroc Museum, near Bartlesville, Oklahoma, displayed a Carl Link Indian portrait. I promptly drove to Woolaroc to see it. Another discovery in Carl Link's colossal contribution to knowledge appeared in *World Book Encyclopedia*, published in 1947. He had researched and painted more than two hundred different national costumes for the encyclopedia, taking the artist almost three years to accomplish. Completed, they represented dress styles and costumes of all countries and ethnic groups around the world. Few would have undertaken such an artistic task with its seemingly impossible job of research.

On December 18, 1967, following one of my frequent meetings regarding the Fraser estate with Dr. Martin Bush,[7] he said, "Dean, there's a western artist in town you might like to meet. He has done some very good work; in fact, he's outstanding. His paintings are of Northern Indians. I visited him at the suggestion of sculptor Bryant Baker[8] and his name is Carl Link." I was stunned at Bush's comments and recommendations, although this was not the first coincidence that I have experienced in my Western art adventures.

We looked up Link's name in the telephone directory. Sure enough, he was there. I made an appointment to see him within a couple of hours. Interestingly, it was only a few minutes walk from my hotel on West 57th Street to Carl Link's place.

I found Mr. Link to be a tall, stooped gentleman of eighty-one. His apartment, on the fifteenth floor, was a typical bachelor layout consisting of a studio-type room with a kitchenette and bath. Beside a window admitting north light, Mr. Link had set up his easel. I noticed his major watercolor portraits of Northern Indians arrayed on the walls. They were absolutely beautiful and included *Bird Rattler* (25½ by 38½ inches), *Take the Gun Strong* (22½ by 31 inches), *Blackfoot Indian Girl* (22½ by 31 inches), *Shorty Young Man* (29½ by 21¼ inches), *Night Thunder-White Buffalo* (29½ by 21½ inches), *Miss Ramona Guitierez* (29½ by 21½ inches), *Spider* (38½ by 25½ inches) , *Well Off Man* (29½ by

21¼ inches), and *Shot on Both Sides* (30½ by 21½ inches).

I asked Mr. Link about his work in Montana and Canada. Briefly he told me the story of his friendship with artist Winold Reiss[9] and of their trips to the West together. Link verified his meeting with the Lindermans during the summer of 1937.

Link was enamored of the West. He later (after 1937) bought property at Lake Tahoe, California, set up his studio there, and during the summers gave art lessons. He patterned his program after that which his friends Winold and Hans Reiss had established at the Hotel Yergen, Glacier National Park. During the summer, Carl would spend a few days with the brothers in Montana. Winold Reiss and Link had been students together at the Royal Academy[10] in Munich, so theirs was a life-long friendship. When Reiss died in 1953, Link felt the loss deeply and in tribute made a superb drawing of his friend, hanging it in his living room.

I dined with Carl Link that evening and we continued our conversation. He reminisced freely of his life in America and Europe. If he had his years to live over, he would have gone west immediately upon coming to America. But as he reflected, "It's all hindsight. My life is about over." He went on, "You are the first museum man to ever do me the courtesy of paying a visit. I'm so pleased."

Upon my return to Oklahoma, I wrote Carl and thanked him for his kindness and mailed him a package of literature on our museum. A few days later, I received a Christmas card and a short letter; it was the only correspondence I ever received from Link.

From our visit and the collected biographical material, I was able to put together a capsule history of Carl Link's life. I learned that Link was born in Bad Toelz, Germany, in 1887. His education, beginning early in life, was in the classical tradition of academic learning and art discipline. He attended the royal academies in Dresden, Munich, and Berlin, studying under some of Europe's most respected teachers. Link learned to draw animals under the tutelage of the renowned Angelo Jank of the Munich Academy.

169

He began his professional career in art as a commercial illustrator in London. The coming of World War I saw the artist with his German accent regarded as an enemy of England. Within a short time, he was able to gain passage to New York. Not desiring to resume his career as an illustrator, Carl entered into theatrical design work and was successful from the outset. In his association with Morris Gest, the widely known playwright and producer, Link gained recognition for his work on *Chu Chin Chow*, *Aphrodite*, and *The Wanderer*.

The theater was only a part of Link's professional capability. During the 1920s and 1930s he contributed to illustration, portraiture, and art education. Memorable in the history of fashion illustration were Carl's "pinup girls" painted for William Randolph Hearst's *American Weekly*. Link's curvacious models were among the first of a daring type to appear in national publication. In 1922 he won international acclaim for his portraits of the Oberammergau Passion players. The paintings of the Austrian pageant players were reproduced in magazines and newspapers throughout Europe and America. Link always excelled in portraiture, and among his better known portrait subjects were actress Marian Davies, Lady Diana Manners of London, and Michel Fokine with the Ballet Russe.

Carl Link was a born teacher, and during his long life he instructed and inspired many art students. He taught at the Art Students' League in New York City, at Columbia, and New York University. While in Montana, he was taken with the color and picturesque quality of the Northern Indians, principally the Crow, Blackfoot, Piegan, and Gros Ventre. A number of important portraits resulted from those summers he spent in Montana.

Link's paintings and drawings are to be found in major museums throughout America. His portraits are in the Blackfoot Museum at Browning, Montana, and in Oklahoma's Woolaroc and Philbrook Museums. Carl is also represented in the art holdings of Radio City Music Hall.

Aside from his skill in portraiture, Carl enjoyed sketching

animals. As a lover of animals, Link, with pencil and pad in hand, enjoyed zoos the world over, particularly the Bronx Zoo in New York. While he often confined his attention to the sheer fun of sketching from life, he drew well and always with the emphasis on the eyes, facial expression, and character. Link likened the characteristics of animals to those of human beings, commenting that it was up to the artist to bring out as much personality as possible. Had Carl Link so desired, he could have been remembered as one of America's foremost animal painters.

The following January 1968 I visited him again. This time I noted a deterioration of both his health and attitude. He seemed confused about affairs. I thought he might have had a slight stroke. I tried to buy two of his Indian portraits but he brushed the matter aside, saying he would have to talk to his friend Bryant Baker. I had given a figure as a starting point and this meant our visit was less cordial than the first, for money had now entered into our relationship. Returning home a few days later, I wrote Mr. Link, reconfirming my offer. A few days later I received a neatly wrapped package. It contained a small landscape painting done in watercolor, dated and inscribed, "To my friend, Dean Krakel."

I never saw Link again. He died in May of that year. I felt disappointed that the Cowboy Hall of Fame would, in all probability, never acquire a Carl Link Indian portrait. I learned later, through the grapevine, that Bryant Baker had urged Link to sell his Indians elsewhere. Baker and I had disagreed on a matter a couple of years before when he had wanted us to buy a miniature model of his *Pioneer Woman*,[11] but the price was outrageously high in my mind and I refused to consider the matter further. I'm certain that Baker remembered this when Link mentioned my name.

My hopes were renewed in early August when I received a telephone call from a New York City attorney by the name of Robert Lee Henry. Mr. Henry had been appointed executor of Carl Link's estate. Going through Link's papers, he had run across

a copy of my purchase offer. Mr. Henry wanted to know if I wanted to buy the nine Indian portraits he had on hand in the studio. I wrote in reply as follows:

August 16, 1968

Mr. Robert Lee Henry
Counsellor at Law
60 East 42nd Street
New York, New York 10017
Dear Sir:

This is to confirm, in writing, the National Cowboy Hall of Fame's interest in acquiring the nine major paintings and the some thirty portfolios of drawings, sketches, letters and miscellaneous items of the late artist, Carl Link. Additionally, the Institution will be interested in acquiring photographs, books, papers, etc. relating to the artist.

This letter contains the offer of nine thousand dollars ($9,000.00) for this collection, payment to be made upon examination of the major paintings and related portfolio collection by the Managing Director of the National Cowboy Hall of Fame and acceptance after examination.

It is understood that upon consummation of this transaction, the National Cowboy Hall of Fame will hold full title to this collection, free and clear of any encumbrances.

Most sincerely,
Dean Krakel
Managing Director

Within a few days Mr. Henry replied:

Your bid has been heavily topped. I am now offered $1,500 each. However, I have explained your interest to the buyer and since he has no place to store them he might loan them to the Cowboy Hall of Fame for a considerable length of time. He would like to talk to you. Why not come to New York and perhaps you will find something else to buy.

Frankly, but inwardly, I was mad as hell. I felt that Mr. Henry had used our bid as a basis for offering the collection to other parties. In a sense he did, but I also recognized that he had an executor's duty to perform. The buyer, however, was none other than Edwin J. Beinecke, Jr.[12] For once I was glad that I had held my

172

tongue, as Mr. Henry assured me a loan of the paintings was all arranged; we were fortunate in having such a fine and auspicious friend as Mr. Beinecke.

Within a few days, I was in New York City with Mr. Henry. We went to Carl Link's apartment where I met with Chris Watson of the Country Art Gallery, Locust Valley, New York and an executive of the Kennedy Gallery. They had been called in by Henry as consultants or prospective buyers. In rummaging through the vast disarray of art work, supplies, empty coffee cans, worn draperies, carpets, books and furniture, we found, rolled up and tucked away, the Indian boy and horse and one unfinished Indian girl which were not included in Mr. Beinecke's acquisition. I quickly bought the boy and horse for $1,500 and negotiated for the unfinished Indian girl plus a collection of European, American, and classical style paintings—mostly watercolors and drawings—and Link's easel and hand carved furniture for $1,000 more. I intended to use the easel and furniture as a background for exhibiting the borrowed Indian portraits and other Link works, but this never could be worked out.

The tedious job of inventorying the collection was accomplished by our librarian, Esther Long, with her student assistants. The collection and furniture occupied a large part of the Cowboy Hall of Fame's limited storage area. Later, I acquired the remainder of the collection from Mr. Henry for $3,500.

Luther Dulaney and John Kirkpatrick, both members of the board of our Western Art Fund, stood in disbelief of all we had gained. After combing the collection for the few things we wanted (this took months), it was decided to sell the rest. This is the part of the narrative that chills me: the breaking up of the collection. Major paintings in the collection brought good prices. The bulk of the collection, primarily Link's European paintings and drawings, were sold to Mabel Owens of Owens Gallery, Oklahoma City. Our Art Fund gained an actual cash profit of more than $55,000 which was sorely needed to service bank notes. Shortly after the sale, three additional Link paintings came to us.

In 1974, Mr. Beinecke permanently presented his collection of nine splendid Link Indian portraits, adding a beautiful Steuben buffalo, etched in crystal, as a Christmas present to the Cowboy Hall of Fame. Thus the monetary worth of my association with this tall, stooped-shouldered, talented German assumes an imposing total. Aesthetically and psychologically, my experience with the project is unassessable. In the history of western artists, Carl Link, modest, unassuming, kindly, shy, ultimately landed on his feet right in the middle of one of America's most important museums.

Photo By Don Jurick

The author as Executive Director, Thomas Gilcrease Institute of American History and Art, September 1961.

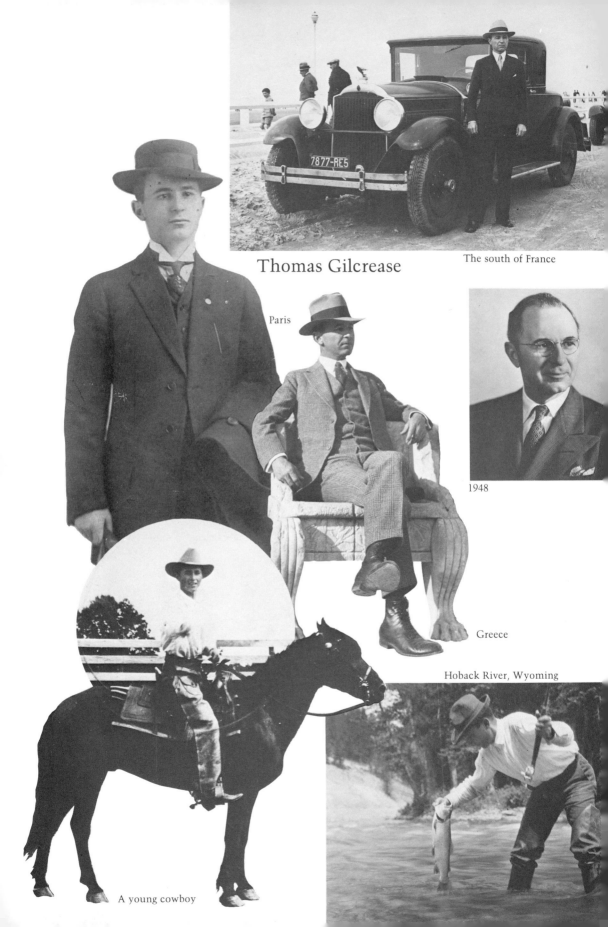

The south of France

Thomas Gilcrease

Paris

1948

Greece

Hoback River, Wyoming

A young cowboy

D.K. and T.G., first day on the job.

Thomas Eakins' masterpiece, *Frank Hamilton Cushing*.

Eudotia Teenor, secretary and loyal friend of T.G.

Barton and Gina Gilcrease; Des Cygne and Corwin Denney; Grace and Thomas Gilcrease, Jr.

Mr. Gilcrease and his friend, William S. Bailey, with the Foundation's massive artifacts collection.

William R. Leigh

Ethel Traphagen Leigh

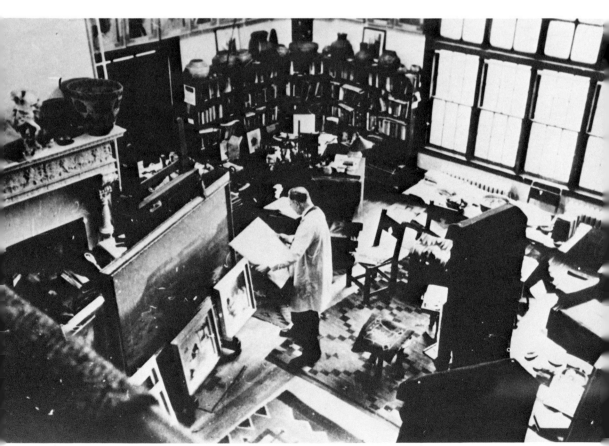

Leigh in his studio, eleven stories up at 200 West 57 Street, New York City.

John Traphagen, executor of the Leigh estate.

Leigh

Paul Rossi, Deputy Director, and later, Director of Gilcrease Institute.

Leigh Studio Collection, Gilcrease Institute.

Charles S. Jones: his great Russells came to the Hall.

Nancy and Jack Russell

C.M. Russell

Red Man's Wireless: Crown jewel of the Jones Russell collection.

Jasper D. Ackerman. He took the leadership in building the Hall's great art collection.

Paul B. Strasbaugh, Oklahoma City Chamber of Commerce. He worked out first financing of the Jones Russell Collection.

Joel and Frances McCrea. Joel teamed up with Jasper to solidify the million dollar Russell collection.

Lewis and Clark and Sacajawea: C.M.R.'s watercolor and the enigmatic bronze.

James Earle Fraser Laura Gardin Fraser

Fraser Studio, Eleven O'Clock Road, Westport, Connecticut

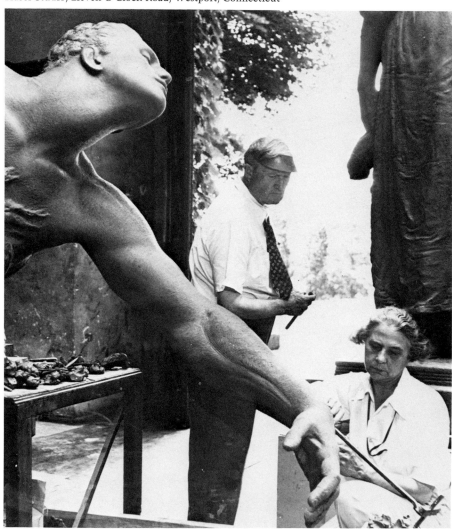

Laura with a section of the *Oklahoma Run* panel.

Jimmy designed the Navy Cross.

Original models for the
buffalo-Indian head nickel.

James Fraser and Mr. Lincoln: a national treasure.

Mrs. D.D. Payne, Mr. and Mrs. John E. Kirkpatrick at ground breaking for the Payne-Kirkpatrick Memorial.

Uncle Dave D. Payne, CHF honoree. His life epitomized the pioneer spirit.

Sculptor Leonard McMurry restoring *End of the Trail.*

Cesare Contini made the molds for the Visalia casting of *End of the Trail.*

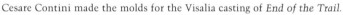

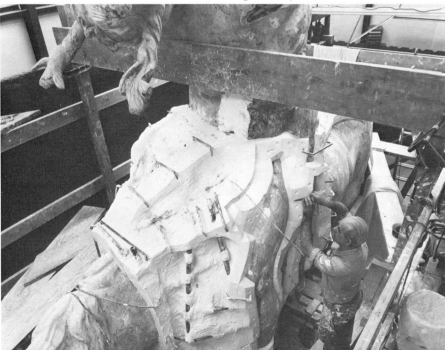

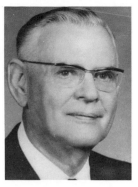

Joe W. Gordon, a great board president, wise counsel, and fellow adventure.

The end of an odyssey: Visalia's casting arrives.

Menchaca, Muno, Krakel, Dillehay, McMurry: the team that moved the aging statue 1500 miles.

Payne-Kirkpatrick Memorial Dedication, December 13, 1970. Left to right: Mayor James Norick, Joel McCrea, Senator John Tower (Texas), Dean Krakel, Congressman Bob Price, Jasper Ackerman, Mrs. Nona S. Payne, Mrs. John E. Kirkpatrick, Mrs. McGee and Dean McGee.

185

Louise Schreyvogel,
painted on ivory by C.S.

Charles in his studio, Hoboken, New Jersey.

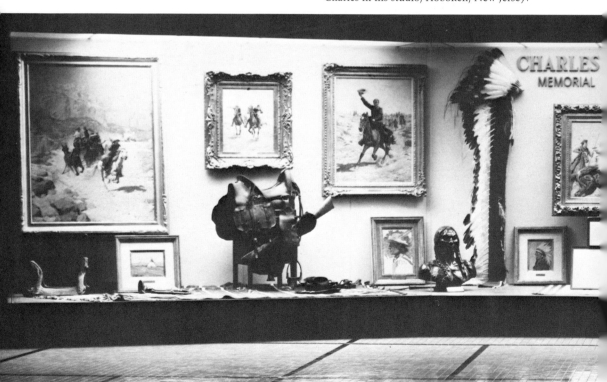

Charles Schreyvogel Studio Collection.—"*Winchester Western helped*"

186

Archie and Ruth Schreyvogel Carothers

Schreyvogel painting in Indian country
while Louise watches.

J.B. Saunders, 1925: he made possible the acquisition of the Schreyvogel collection.

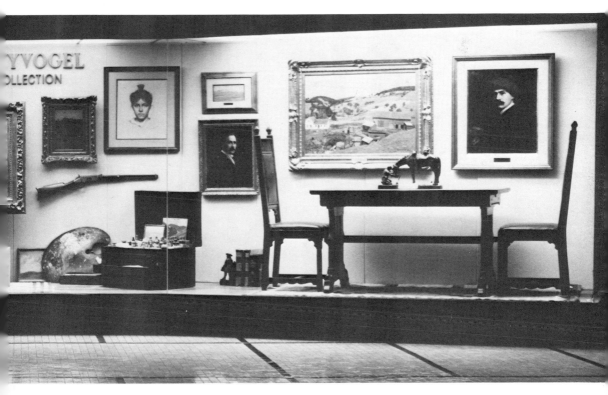

M. Knoedler and Company, 14 East 57 Street, New York City.

William F. Davidson, Executive Vice President, M. Knoedler and Co.—*"One of the art world's most dynamic leaders."*

Luther T. Dulaney, President, Western Art Fund—*"He loved the Cowboy Hall of Fame."*

188

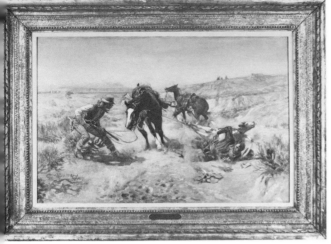

Cinch Ring, oil by C.M. Russell—*"Bower told me to bring back his two paintings or $180,000."*

Coming Through the Rye by Remington—*"A trustee said, 'You paid too damn much!'"*

Hunters' Camp in the Big Horns, oil by Frederic Remington—*"At the time, the highest price paid for a Remington—and our check almost bounced."*

Wildman's Truce, oil by C.M. Russell—*"Painted when Russell was at his peak as a colorist."*

J.B. Saunders—*"One of a kind."*

189

Carl Link as an aspiring artist in Munich.

Link with lady admirers in the Bavarian Alps.

Carl's portrait of his lifelong friend Winold Reiss.

Link, Linderman, Reiss—Kalispell, Montana, 1937.

Animal drawing by Link.

Spider by Carl Link, gift of Edwin Beinecke, Jr.

Wolf Tail by Carl Link: a masterpiece from the J.D. Ackerman collection.

Carl's drawing of Frank Bird Linderman—*"It caught my eye. . . ."*

Chester A. Reynolds, founder of the National Cowboy Hall of Fame.

"My first view of the Hall, November 1964."

Dean, Iris, Dean II, Jennie prior to opening of the CHF.

Cowboy Artists of America, 1966. Standing, left to right: Gordon Snidow, Darol Dickinson, Irvin "Shorty" Shope, George Marks, Wayne Hunt, Joe Beeler, Curtis Wingate (associate member), Charles Dye, Ted Long (associate member). Kneeling: Byron Wolfe, John Hampton, John Kittelson and Ernie Phippen, guest.

Richard Muno, Art Director, Cowboy Hall of Fame, 1971—"Unlimited talent and energy."

Mrs. Dean Krakel and Don Blair, NAWA dinner.

Fred and Ginger Renner. Fred received the Trustees' Gold Medal, June 1975.

Mrs. Grace Werner, great friend of the Hall.

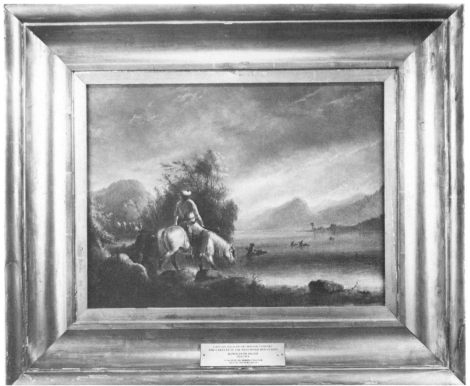

Alfred Jacob Miller, exhibited in honor of Mr. and Mrs. Herman Werner, Casper, Wyoming—"The painting had at least a hundred years' grime on it."

Self Portrait

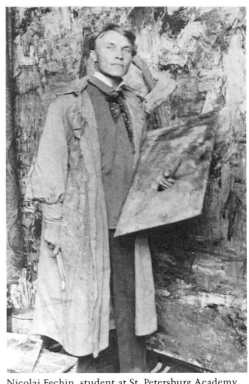

Fechin was also a talented wood sculptor.

Nicolai Fechin, student at St. Petersburg Academy, 1908, at work on *Bearing Away the Bride*.

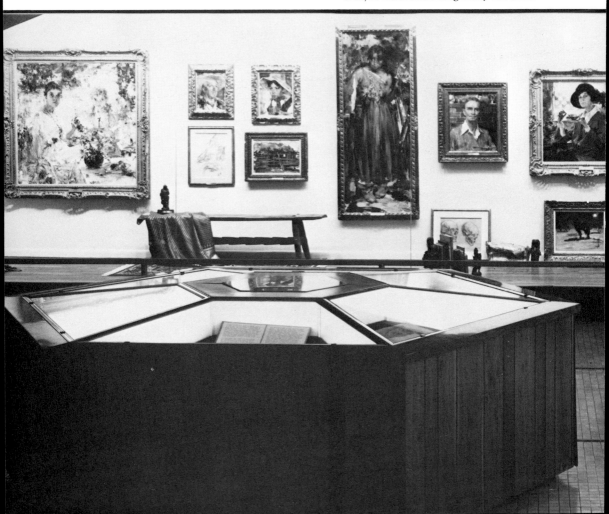

Fechin in his Santa Monica, California studio.

Dean, Eya Fechin Branham, Victor Hammer—*"Victor told me that what we had of Fechin was fine—but not enough."*

James Boren, Art Director, Cowboy Hall of Fame 1965-69—*"He hung our Fechin exhibition . . . it was important but no one came."*

William G. Kerr, Director—*"Modest, unassuming, intelligent, strong."*

The Fechin Studio Collection

Jasper D. Ackerman—*"He has the touch of greatness...."*

Miss Freda Hambrick, Director and
sponsor of our garden.

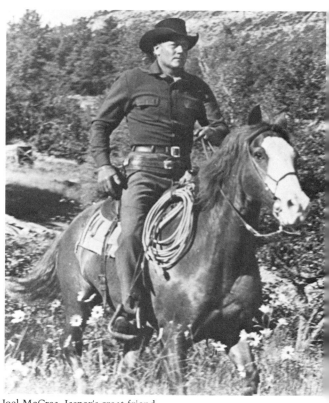

Joel McCrea, Jasper's great friend.

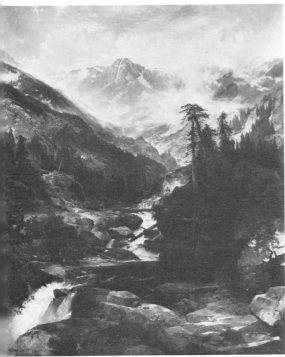

Mountain of the Holy Cross, 82″ x 64″ oil by Thomas Moran—"Sale number 3185 at Parke-Bernet and our bid was right."

Nearing the Fort by Charles Schreyvogel: non-violent Schreyvogel from Jasper's collection.

Emigrants Crossing the Plains, 60″ x 90″ oil by Albert Bierstadt: the classic of Jasper's collection.

Oklahoma City Times—Thursday, November 13, 1969

Two Russell Statues Stolen From 'Hall;' Director Riled

Two small bronze statues sculpted by cowboy artist C h a r l e s Russell

As a result of the theft, he said, all Russell bronz-

ered to be missing at 4 p.m. Wednesday w h e n

Until the theft, Krakel said, security officers did not wear uniforms. From

On Neenah

"Listen, you S.O.B., I have your bronzes!"—the thief.

Alert

The Bug Hunters

The Security Force at the Cowboy Hall of Fame.

The Scalp by Remington—*"Trying to help a friend put me in hot water."*

Cheyenne Buck, pastel by Frederic Remington.

The William Jacob Hays that was really an A.F. Tait. Gift of Mr. and Mrs. Thomas Lewis, Taos, New Mexico.

Victor J. Hammer: the art world's most colorful dealer.

Rudolf G. Wunderlich, President, Kennedy Galleries, Inc.: a leader in the Western art world.

Robert Rockwell, collector, sent his collection for the Cowboy Hall of Fame opening exhibition.

Jack N. Bartfield as a young man. A New York dealer; famous as a host.

James Khoury—"I told him to bring me masterpieces."

William F. Davidson, recipient of our Trustees' Gold Medal.

Erwin S. Barrie, Grand Central Galleries: Gentleman art dealer.

Fred and Frances Rosenstock, 1925—"Fred has been my lifelong friend and teacher."

National Academy of Western Art medal.

Luther T. Dulaney—*"He said to me, 'You don't have the guts!' "*

Prix de West cup, symbolizing the National Academy of Western Art's highest award.

Artists exhibiting in the first National Academy of Western Art, 1973. Left to right, front row: Edward Fraughton, Tom Lovell, John D. Free, Clark Hulings, Gary Carter and Harry Jackson. Standing: Willard Stone, Clark Bronson, William E. Sharer, Larry Toschik, Robert Scriver, Conrad Schwiering, John Clymer, John Stobart, Robert Rishell, Hahn Vidal, Nick Eggenhofer, Ned Jacob, Arthur Mitchell, Vladan Stiha, Otto Kuhler, Bettina Steinke, Brownell McGrew, Robert Lougheed and Donald Teague. Not in photo: Wilson Hurley, Robert Kuhn, Leonard McMurry, John Pike, Burt Procter, Kenneth P. Riley, William Arthur Smith, Oleg Stavrowsky and Robert E. Wood.

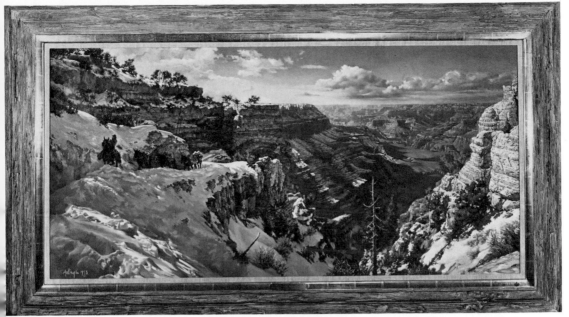

Grand Canyon, Kaibab Trail by Clark Hulings, winner of the NAWA Prix de West award 1973.

C.T. McLaughlin, first chairman of the NAWA.

John Clymer, Prix de West winner, 1976.

Tom Lovell, Prix de West winner, 1974.

Mae and Olaf Weighorst. Olaf received the Trustees' Gold Medal.

Robert Lougheed assisted in the founding of NAWA.

Albert K. Mitchell—*"A cattleman who had the eye and the mind to buy."*

Signing for the Mitchell Collection: Bryan Rayburn, Albert J. Mitchell, Dean Krakel.

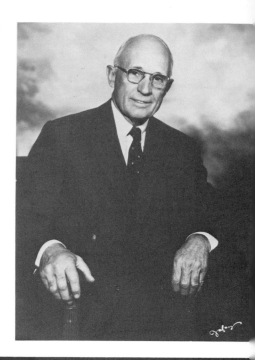

The Albert K. Mitchell Studio Collection

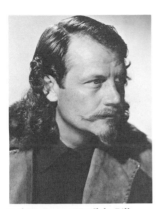

Joel McCrea as Buffalo Bill—
"*An inspiration on or off
the screen.*"

Buffalo Bill is fully assembled at foundry
in Italy.

Leonard McMurry—"*No job is
too big.*"

The Board of Directors and Trustees, Annual Meeting 1974. Front row, left to right: Glenn W. Faris, Rex Nicholson, Claude Olson, Jasper D. Ackerman, Mrs. Nona Payne, Harold Schafer, Joe H. Watt, Joel McCrea, C. T. McLaughlin, and Gene Autry. Center row: Dean Krakel, O. L. Bullock, John Baumgartner, Harry Blair, Brooks Park, Robert Rockwell, Robert C. Norris, Dave Stout, T. Ross Clement, and W. B. Ludwig. Back row: Willard Schnell, E. H. Shoemaker, John E. Kirkpatrick, Bill House, Fred Dressler, Manville Kendrick, Chauncey Flynn, and two guests. Present at the meeting, but not in photo: Albert Anderson, Joe Gordon, William Harmsen, Henry Hitch, William G. Kerr, Dean A. McGee, J. B. Saunders, and Mrs. Herman Werner.

National Cowboy Hall of Fame, Oklahoma City

Chapter 10

Nicolai Fechin

THE FIRST Nicolai Fechin[1] portraits I ever saw were in the fine arts collection at the United States Air Force Academy. They were portraits of Generals Ira Eaker and Joseph Cannon.[2] Both were painted from life; both were exquisite. Two years later, in the fall of 1958, Air Force Academy officials lent their portraits to Hammer Galleries, New York City, for a major Fechin retrospective exhibition. I had the pleasure of escorting the paintings to New York City, meeting Victor Hammer,[3] and seeing the exhibition. I remember how fascinated I was with the collection of about forty works. Fechin's talent was unlike anything I had ever seen. While I was always searching for Russells and Remingtons, feasting my eyes on this artist opened up new horizons. Where on earth could there be any art work that would surpass his genius?

Subsequently, my job at Gilcrease Institute (where we had only one Fechin)[4] enabled me to travel to New York frequently. In the course of visiting various galleries and looking at art, I met Erwin S. Barrie,[5] director of Grand Central Art Galleries. At one of our first meetings, I asked if his gallery offered any Fechins. While none were for sale, I was delighted to learn that he had met Fechin shortly after his arrival in New York in 1923. Grand Central was the first major New York gallery to give the artist an exhibition.

Barrie recalled Fechin as being a slightly built man with strong facial lines and very modest and humble in character. "In those days of the early 1920s," Barrie said, "Nicolai and Dean Cornwell,[6]

the muralist, were close friends who painted and studied to-
gether."

Mr. Barrie and Victor Hammer both gave me the name of Jack
Hunter[7] as being one of the men who helped the artist emigrate to
America from Russia. In time, I wrote Mr. Hunter and he
responded with long, interesting letters. On one occasion he sent
me a copy of a manuscript he had written giving details of the
Fechin family—Nicolai, his wife Alexandra, and young daughter
Eya—coming to America.

In his narrative, Hunter tells of their arrival and a glimpse of
their first days in America:

> The Fechins arrived August 1, 1923 and were met by Mr.
> Gorson, who found accommodations for them at a hotel and
> then located an apartment for them in his neighborhood. . . .
> As I recall, Mr. Stimmel [also a collector and friend from
> Pittsburgh] joined them and remained in New York several
> days, showing Mr. Fechin a number of points of interest and
> introducing him to several art dealers. After Mr. Stimmel
> returned to Pittsburgh, I went to New York for a visit of
> several days with friends and part of each day was spent with
> the Fechins. Mrs. Fechin did most of the talking as she had a
> little knowledge of English, but conversation was most
> difficult; however, we got along after a fashion. Mrs. Fechin
> told of their hardships in traveling in Russia and disappoint-
> ments experienced along the way. She said at times they were
> so discouraged they almost lost hope of reaching America . . .
>
> Fechin, I believe, brought few paintings with him. Howev-
> er, he showed me quite a number of interesting charcoal
> drawings which I greatly admired. Even before I arrived in
> New York, he had painted a Portrait of a Negress, and was
> working on a 32" x 34" canvas, a portrait of his daughter, Eya,
> sitting beside a table with a large assortment of fruit. I
> purchased that painting before it was finished. It still hangs in
> the living room of my apartment and is much admired by my
> friends.
>
> The first day I visited the family, Eya called me her only
> American Uncle and up to this time continues to address me
> as "Uncle Jack." I think it was on the second day I called that

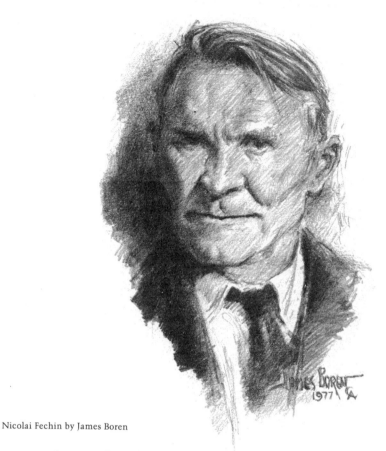

Nicolai Fechin by James Boren

Fechin produced a 16″ x 20″ canvas and said he wanted to paint my portrait. I protested, but to no avail. At that time, I was an inveterate cigar smoker and Fechin, having noticed this, insisted I should hold a burnt cigar in my right hand. I objected, but the mild mannered artist had his way—the cigar is still there. After so many years, it is difficult to remember how many hours I sat, but Fechin seemed very sure of himself and worked rapidly. When he observed the slightest indication that I was tiring, he would tell me to relax for a while. After the painting was finished, he asked me to accept it as a token of appreciation of my efforts in his family's behalf.

Through the years, I kept up my correspondence with Jack Hunter. In one of his letters, he sent me a snapshot of himself

standing near the portrait Nicolai had painted of him. Museum directors accrue many professional regrets through the years; the fact that I have not gone to Pittsburgh to visit Mr. Hunter is one of mine.

Each time I dined with Erwin Barrie in New York City, invariably he would begin reminiscing about Fechin. This artist and Walter Ufer were his favorites. Among the Grand Central Galleries publications he generously gave me was their annual catalog for 1937. The cover carried a color reproduction of one of the most beautiful women I had ever seen. The picture was simply titled *Mrs. Krag*, painted by Fechin. Ever so often in browsing through my Fechin files, I would take out the catalog and admire the attractive face of *Mrs. Krag*, never dreaming, years later, that I would have the opportunity of seeing her come to the National Cowboy Hall of Fame to hang in our permanent collection with an enchanting new title, *Tea in Santa Monica*.

In 1964, after taking over the concrete shell that was to become the Cowboy Hall of Fame, I began corresponding with Eya Fechin Branham, of Albuquerque. Three years later James Boren and Rich Muno, the Hall's art directors, and I spent an evening with Eya and her daughter, Nikki, in their home. We were there to look at paintings and drawings and to talk about the artist in relation to a Fechin exhibition we were to hold that spring. By combining the works Victor Hammer shipped to us with the ones from Eya's collection, we exhibited the best of Nicolai Fechin. It was a large show, consisting of both oils and drawings, and featured such prizes as the *Corn Dancer*, the *Patriarch*, *Carmelita* and *Joe With Drum*. While we were to acquire several works from this show years later, at that time our ability to purchase was non-existent. We were in a perpetual state of hard times.

It was during this period that Jim Boren, Rich Muno, and I learned to truly appreciate Fechin's talent. Such was not the case with the local press. Try as we did to get a feature story, we couldn't get even a tumble, yet public acceptance of the collection was unbelievable. The exhibition was up from February 17

through May 14, 1967. I wrote Eya often and reassured her of my enthusiasm for her father's talent.

In March of the following year, I visited Taos and had the great pleasure of meeting Alexandra Fechin.[8] It was indeed a thrill for

Alexandra by Nicolai Fechin

me to tour Fechin's studio and then sit briefly in his den, before a fireplace he built himself, listening to Alexandra. Dramatically rolling her r's, she told how great her man was as a painter (even though they had been divorced) and of her own aristocratic background. She talked of both W. S. Stimmel and J. R. Hunter, and the exhibitions at Carnegie Institute and the Chicago Art Institute. Mrs. Fechin lent me a book containing two of her published stories, which I read with a great deal of interest on my flight home. The title of the book was *March of the Past*.[9] I found her stories filled with simple beauty, charm, excitement, and suspense, giving a woman's insight into the harshness of Russian revolutionary times.

In the spring of 1971, the eternally exuberant Victor Hammer telephoned me and said, "You must come to New York. I want to show you one of the greatest pictures ever painted." He wouldn't tell me what it was but added, "My God, it's great!" At the first opportunity, I flew to New York and the next day met Victor at his gallery. Soon we were on our way to a midtown Manhattan office building. After a climb upstairs, we entered a large room and Victor exclaimed, "There it is!" It was Fechin's *Bearing Away the Bride*, done in 1908 and featuring forty-one figures in the composition. The owner was Mrs. A. S. Krebs, of Wilmington, Delaware. I was very excited by the picture and agreed with Victor as to its greatness.

In his unpublished memoirs, Fechin wrote about the picture. The idea for the composition and sketches began in 1908 during his second summer in Lipsha among the Cheremiss people. The composition was based on the wedding custom of allowing the groom to come unexpectedly to the bride's house, capture his woman, and take her to a pre-selected place to show her off to close friends and relatives. The occasion was cause for drinking, dancing, and much frivolity. Elements in this festivity are suggestive of the custom of the shivaree.

Nicolai had worked out the composition and characters in rough form. He stretched his canvas on a large frame in a small

room in a house belonging to his uncle. The canvas size (73 by 111 inches) was so large that it would only fit into the room diagonally. In his memoirs he relates, "The light from the low windows was so poor that the upper half of the painting was in perpetual dusk. In order to see the results of my work, I was obliged to lie flat on the floor and peer up."[10]

In spite of all these discomforts, the composition of the complex painting is successful, with an unusual relationship between leading characters. The bride is the central figure in the painting. She dominates because of the light color of her dress and the bright scarf which covers her head and face. In the foreground is a full length portrayal of a man with his back to the viewer. He is holding the hand of a small child. On the left side of the picture there is a very strong, heavy man who is holding a horse with his arm around its neck; a large Cheremiss woman, to the right of the bride, complements the canvas in a boisterous sort of way. The painting indeed captures the pageantry of the occasion.

Nicolai's Cheremiss figures are flesh and blood and strong-willed to the bone. The painting is not brilliant in color, yet it has a grace and dignity to it. It is a historical painting of a people and their passions.

The painting was an initial success in St. Petrograd and earned Fechin a prize of a thousand rubles. Later it was exhibited, along with his *Sketch of a Girl*, at the International Art Exhibition in Munich. There it attracted much comment, including these words from a critic:

> Among all the other pictures, there is one large painting which fully deserves consideration, namely *Bearing Away the Bride*, painted by Nicolai Fechin, of the city of Kazan. This is a real piece of deep Russia which is represented here in the form of a solitary village, the scene of which is submerged in mud and swine steam! Unbecoming truth, but the truth! The brisk and loud colors of some of the clothes and the way he has caught the spring light above the houses, against the commonplace, crude background, more fully emphasizes the poverty of the rest of the surroundings. The

peculiar and rough painting excellently matches the character of the entire picture. The persons are masterfully characterized.[11]

For this kind of foreign reaction, Fechin was rebuked by the Russian critics. One reporter wrote:

> They contended that the Russian patriots were insulted by that picture and gave as the reason that the picture portrayed not the Russians, but the foreigners within their midst, and well within their native customs. And in reference to the same picture, which had figured in the Munich exhibition, the critic Evseeff in his article writes as follows: 'Talented, but indiscreet Fechin had sent from Kazan his picture, *Bearing Away the Bride*. It is simply vexing that this man, possessing all the qualities of the artist, apparently spoils purposely the picture and exaggerating arrives at the ridiculous. On the whole, there is not even one figure resembling a human being. In this picture one can only see one monster after the other. Nothing more. And one should have seen how the venerable German families at the exhibition looked with some fright at the moujik (peasant) of animal appearance, standing by the wagon, at a woman painted with cinnabar, at a boy having a pumpkin instead of a head, at the face of the old orangutan and at the stomach almost touching the ground. Such a caricature of Russian life brings shame upon us. For no good reason at all we find an unfavorable atmosphere in foreign countries, and here, as if for spite, we are covered with shame before the eyes of all good people, at the International Exhibition. It is a grave offense, because the artist is not without talent. We find, however, at the same exhibition a picture by the same artist: *Sketch of a Girl*, of which it is possible to boast, even before foreigners.'[12]

Apparently undaunted, Fechin entered the painting in the Fifteenth Annual Exhibition at the Carnegie Institute in Pittsburgh in 1911. The *Chicago Daily Tribune* declared, "Among the foreign participators in the exhibition, it is worth taking notice of the Russian, Nicolai Fechin, who already had such wonderful success in the past year, and has strengthened the response this year through the exhibition of a small, but charming sketch of a

child and a large barbaric true-to-life picture of a Russian village group, known as *Bearing Away the Bride.*"[13]

Captivated by the painting that Victor Hammer discovered for me in New York, I began corresponding with Mrs. Krebs. Later that year, Victor, his wife, and I had dinner with her and we discussed the painting. She related how her late husband had purchased the painting by chance at a Parke-Bernet auction sale. Western artist Arthur Mitchell throws further light on the painting's history and Krebs' purchase. In a letter to me he wrote, "I once helped to carry this big, rolled up Fechin painting to Harvey Dunn's studio balcony in Tenafly, New Jersey. The man from Wilmington who had that day bought it at a Parke-Bernet auction in New York and had delivered to Dunn's studio was Harvey Dunn's brother-in-law, Sonnin Krebs. The three of us unrolled the picture on the floor, and after a lot of discussion, rolled it up and put it up on Dunn's balcony. I remember the whole thing as if it might have been last week and actually it was in the middle thirties."

Invariably, during my frequent trips to New York I would drop into Hammer Galleries and ask to look at the Fechins which Eya had placed there on consignment, secretly hoping of course that none had been sold since I had last been there.

During 1969, we acquired *Still Life* and the elegant *Tea In Santa Monica.* These two, along with *Corn Dancer,* became important additions to Mr. Ackerman's collection. Then I asked Victor to send Fechin's *Self Portrait,* with a bill. We now exhibited the four in an individualized grouping. Eya and Nikki came to see them. They liked what we had done. Victor Hammer, a frequent guest at the Cowboy Hall of Fame, with his customary enthusiasm would say, "What you have is great; but it's not enough, not of this master!"

By this time my admiration for Fechin had risen to a new pitch. I had to learn more about him. My files bulged with materials given to me by Eya, Alexandra, Victor, J. R. Hunter, Erwin Barrie, J. N. Bartfield, and others. I had to get something down on paper

215

about him even if it was fiction based on fact. Above all, I wanted to learn of his background and be able to generalize on his painting technique. I began a biography of the artist which I titled, *Nicolai Fechin—The Russian Years, 1881-1923*. I spent all my spare evenings during one entire winter researching and writing like fury, finally feeling that I had gained an insight into Fechin's life, discipline, and influences.

Under the heading, *Traveling Scholarship*, I wrote of his early career:

> The days following graduation from the Imperial Academy were exciting and rather hectic. Winning the traveling scholarship to Europe and Italy made Nicolai the envy of his classmates and instructors. A round of youthful celebrations filled with singing and drink followed the announcement. Nicolai wrote the good news to his father as well as his grandmother and brother, Paul, who was in the Army. It especially pleased him to write such exciting news to his uncle and aunt since they had shown so much faith in him.
>
> The trip was outlined by the director of the Imperial Academy. A tentative travel plan of where he would stay was recorded, as well as the museums he would see. Next, travel visas were arranged for. Letters of introduction were written and money checques issued for expenses. It almost made Nicolai dizzy to think of the museums he would see: the Pinakothek in Munich, the Louvre in Paris. In Berlin there were the Kaiser Frederich and Deutsches Museums and finally in Italy he would see art treasures in the Uffizi and Pitti in Florence and the treasures of Rome. The outer excitement of Nicolai was held in control by his inner feelings. There was much that even he did not understand about himself. After all, he was a man of twenty-seven. He disliked the pressures that officials had tried to place him under. When he returned, he must paint a great picture in order to retain his scholarship. Nicolai had had fifteen years of discipline and of being told what he must do, what he must not do and when. True, he was Russian from head to toe and loved Russia. At the same time, Nicolai felt that he was an individual. The fact that he owed the state something may have loomed over his life like a dark shadow.

216

Nonetheless, there began an epochal train trip for one so young at heart yet so old in life's experiences. One who had learned his lessons so well. The experiences from travel would teach him discrimination in art. The more he saw, the better he could judge. In the weeks to come, Nicolai Fechin would wander alone through gallery after gallery and corridor after corridor filled with masterpieces, stopping, contemplating, admiring, muttering to himself, sketching, and making notes.

The painters who were to stop Nicolai in his tracks were primarily Claude Monet and his crowd; particularly Camille Pizarro, Paul Cezanne, Edgar Degas, and Auguste Renoir. Their use of color and light was a startling revelation to Fechin. He spent hours feasting his eyes. Never had he seen such use of color as in Monet's *Water Lilies*. For Nicolai, the abstraction of light and color, transmuted into an idea, gave a

Hand Study by Nicolai Fechin

simple garden an unreal splendor. Years later Nicolai, with or without conclusive thought, was to recreate such scenes and duplicate Monet's effect of *Snow at Vethevil*. Renoir's *Nude in the Sun* opened up new thoughts about painting for Nicolai, as did Pizarro's *The Red Roofs*. In it, the Russian saw a representation of landscape that intrigued him. A screen of slender trees throughout which light passed separating the viewer from the mass of houses in the background, yet the village of red roof does not disappear.

Nicolai was startled by obvious use of live nude models— naked young women with men in everyday dress, and another, no less naked, in a bedroom—without mythological pretext. Fresh air had indeed come into European art. Nicolai memorized Monet's professed axiom: subject matter is secondary, the essential factor being the artist's own feelings.

The impact of what he saw and felt in Europe comes through in his own words on painting. "Beginners," he wrote, "especially should remember the limited palette, for where there is a smaller variety of colors, there is a greater need for brain work and inventiveness." He continued, "In order to preserve the intensity of the color, it should be remembered that it is not necessary, when coating the cloth, to use many colors in one combination; it is far better to adhere to singleness of color, confining yourself to one or two colors. A large number of paints and their thorough mixing on the palette only kills their force and purity."[14]

Nicolai Fechin was an extraordinary man, just as the National Cowboy Hall of Fame is an extraordinary place. As remote as he was from frontier life, Fechin was enthralled with the southwest from the outset of his arrival there in 1926. In Taos he found the crisp clear mountain air intoxicating to breathe and the ever-changing color schemes fulfilled his insatiable artistic temperament. The Indians, with whom he learned to communicate, were not unlike the nomadic tribes of Russia. Here Fechin found an abundance of freedoms, luxuries, and an exuberance for living— all undreamed of in his native land.

Nicolai's twenty-nine years as a painter in the southwest were

productive. As a portrait painter of singular style, he has no peer. His greatness as an artist seems unquestioned, yet his legacy remains unassessed and his prominence yet remains to be established nationally.

In September of 1971, Tom May,[15] of Dallas, telephoned me. "Dean," he said. "I wish you would come to our home and see the great Fechin which Eleanor and I have hanging in our living room. It's on consignment from Jim Khoury's[16] gallery in Amarillo." Of course I wanted to see it, so the date was set; Mr. Khoury also would be there and we would all have dinner together. Jim was a personal friend and had sold the Cowboy Hall of Fame a number of fine paintings.

What I saw in the May's home was no exception to Fechin's talent—a large oil titled *Summer*. The painting was of Alexandra and Eya, dated 1923, executed shortly after their arrival in America. The portraits were painted in a garden setting as beautiful in my mind as the creation of any French Impressionist. The price was high, but I felt the subject matter, size (50 by 50 inches), and quality justified it.

During dinner, Tom May relinquished their option on the painting. "In that case," I said to Jim, "if you will give me a year, I'll try to come up with the money for the painting." We shook hands on the prospective deal.

With Fechin's self portrait, a magnificent painting of the mother and daughter, and Mr. Ackerman's three works, we had the nucleus of a strong presentation. I began envisioning the power and glory that a whole galleryful of Fechins could create. After several days of contemplation, I asked Victor Hammer to send out eighteen additional works I had selected from photographs. He agreed; they would be sent on consignment. The collection included two sculptures and three drawings; the rest were oils. If we were successful in the acquisition, then Mrs. Krebs' loan of *Bearing Away The Bride* would round out a spectacular exhibition. My next step was to ask Rich Muno to design and build a scale model of the Fechin gallery-studio concept.

219

But time has a way of sneaking up, especially when bank notes and sums owed to art galleries are involved. We already had two substantial financial projects pending during the summer of 1972. The magnitude of problems facing us were formidable to say the least. Everyone on the board knew we had to raise $870,000 to regain our building's title; only a handful knew of Western Art Fund's million dollar plight. No one knew of my hopes for the Fechins. But everything we have accomplished at the Hall has involved a certain amount of blood-letting—the Fraser Collection, the Schreyvogel Studio, Charlie Jones' important collection of C. M. Russells, the great *End of the Trail* statue, and the Payne-Kirkpatrick building to house the Fraser work. Had we delayed on each occasion until we had our money in hand, the Cowboy Hall of Fame would have died waiting. The Fechin project was no exception, and again the right person appeared at the proper moment.

Bill Kerr is as much a gentleman as I have ever known. Tall and lean, the fourth child born of the late dynamic United States Senator Robert S. and Grayce Breene Kerr, Bill has served on the Cowboy Hall of Fame's Executive Committee Board since April, 1969. I have always been impressed with his quiet, strong ways and basic logic. One September afternoon, while talking over board matters, Bill and I browsed through our interim gallery containing the Fechins. Suddenly he changed the conversation and said, "These Fechins are great! Whose are they?"

I said, pointing, "These over here belong to Fechin's daughter, consigned to us by Hammer Gallery. The large one is Jim Khoury's; he is a dealer living in Amarillo. Upstairs we have the self-portrait which also belongs to Hammer."

Bill asked what our intentions were for the collection.

I quickly responded, "I have had an idea of creating a Gallery Studio setting for them, along with important loan additions. We have built a model of a proposed gallery but right now we have, as you know, many irons in the fire and so I may decide to return all of them."

220

"Do you want to do that?" Bill quietly asked.

I replied, "No. Frankly, I feel the collection could be vital to the Hall's future. Fechin is internationally important, especially in Russia, France, Southeast Asia, and Mexico. Once the paintings are gone, we will never have another opportunity to acquire a collection of such unique quality. The Fechin market, like prices for important Russells and Remingtons, is about to shoot sky high."

Then he said, "Do you mind if I present this matter to members of the Kerr Foundation? May I borrow your album of photographs and the model of the Gallery?"

I replied, "Sure!"

And so the Fechin Studio was formally dedicated on December 9, 1972.

To our great delight, Mrs. Krebs presented *Bearing Away the Bride* to the Cowboy Hall of Fame as a gift in 1975. I appraised it at $150,000.

Chapter II

A Touch of Greatness

To write about Jasper Ackerman[1] is to write about the lifeblood of the Hall. Without him, without his guts and financial strength and intelligence, we couldn't have survived. It was his hand in the dike that saved it all when we were battling for the Hall's life with members of the Trust.[2] He quietly put strength when and where it was needed and broke the stranglehold. He removed not only the clause but also the contract that gave others the right to manage as well as hold title to the C. M. Russell Collection.

The future of the National Cowboy Hall of Fame was at stake as an organization representing seventeen states versus a locally-controlled institution. It was a test by fire; a better analogy, perhaps, would be the chick pecking its way out from inside the egg shell. The pecking represented the museum's own life-strength. So it was with Jasper and me in those days of late 1966 and early 1967. There were those who believed in us but would not be counted. And men like Joel McCrea and J. B. Saunders were still in the future. Ours was not only a lonely but a deadly tussle.

As a man, Jasper Ackerman is a complex combination of traits: smart, tough, gentle, kind, a highly decorated hell-for-leather army combat veteran of two world wars, a rancher-cowman, and a banker for more than sixty years. He is always modest and grateful. Grateful for his pioneer heritage and that he was born in Buffalo, Wyoming. Grateful that he remembers riding on his

mother's lap in a covered wagon. And grateful for life's opportunities and the privilege of serving mankind.

In the lingo of the old time trail driver he is "one to ride the river with." There are a number of things he dislikes. Foremost is dishonesty and any man who does not willingly keep his word. Without knowing, or maybe without realizing it, he constantly tests men. Like Mr. Gilcrease, when Jasper Ackerman asks a question he usually knows the answer.

He believes in the axiom that if someone is misinformed he should be told the truth. If something is wrong, it should be righted. He believes that resistance or aggression and conversation in behalf of right and trust is the obligation of each man. He is very capable of telling off a deserving recipient without mincing his words.

His role in the National Cowboy Hall of Fame transcends self-interest. He has been treasurer, president, board chairman, and now past chairman. He was designated honorary chairman by acclamation and standing ovation of the board. I have always watched Jasper's conduct in board meetings with interest. As a rule he says very little, but sees all and hears everything. Yet, when called on to chair a meeting, he does it with considerable ease. As chairman and president of the Exchange National Bank for many years, as well as other financial and civic bodies, he knows when to speak and when to pound the gavel.

I have gained much from being at his side the past twelve years, even patterning my personal as well as administrative work habits after his as much as possible. He is an indefatigable worker who opens all his mail, reads virtually everything, and answers it all—often in longhand. From his letters, more than from personal conversation, one catches glimpses from time to time of the inner man. He is capable of writing high prose as well as the sharpest, most forthright communication one could ever receive.

My biggest thrills in Western art have come as a result of Mr. Ackerman. He saved the C. M. Russells for us in 1967. Then there was the purchase of an important collection, the result of Joel

Jasper Ackerman by Ned Jacob

McCrea's paying off the Russell debt. Yet in writing about him, one is confronted by elusiveness. His great reserve, his love of privacy, his self-effacement, and his extreme reticence about revealing his thoughts and personal life raise problems for the recorder. He is a composite of the Western man, a pioneer and contemporary at his best, honest and courageous.

Jasper was not slow to recognize the importance of Western art to the Cowboy Hall of Fame; rather, I was slow in going to him. Consequently I sold out, turned tail, and let a painting (now worth $175,000) get away.[3] The $25,000 I got for it was critically needed for the operation, and at the time I didn't realize I could knock on his door. When I told him about it later he shook his head and scolded, "Don't let it happen again." He still chuckles when he recalls how, when we were short on money, one of the trustees stood up in a board meeting and suggested we sell the *Leader's Downfall*, by William R. Leigh, and a rifle engraved by C.

224

M. Russell.[4] The money we could get for them, he figured, would "tide us over."

Jasper struck early in our art game by purchasing three superb Ed Borein pen and ink drawings for the Hall.[5] In size and quality, these Boreins were the best I had ever seen, and so I mentioned them to him while we were watching the Fat Stock Show and Rodeo in Fort Worth. Two weeks later I was in his office in Colorado Springs, when out of the clear blue he queried, "Do you still think those Boreins in Denver are the best you've ever seen?" "I haven't seen an awful lot of Boreins," I replied, "but those are the finest." He asked the price of the three and I told him. "Buy them," he said.

On March 16, 1971, Jasper, my wife Iris, and I were driving to Snyder, Texas to attend an event at the Diamond M Foundation, the museum owned and operated by C. T. McLaughlin,[6] a dear friend. It was a beautiful day. The pastures were green and Texas spring was in the air.

As we rode along I said, "There's going to be an interesting sale at Parke-Bernet next month. The one that catches my eye is Thomas Moran's *Mountain of the Holy Cross*." Iris read aloud the description from the catalog:

> Property of Huntington Hartford, New York, Thomas Moran N.A. *The Mountain of the Holy Cross*, Colorado. View from above the rocky torrent looking up through the mist-shrouded valley toward the distant peak. Signed and dated 1875. 80 x 63 inches.

I mentioned the fact that in New York I often visited Huntington Hartford's museum at Columbus Circle and paid the admission fee of two dollars just to see the great Moran. I recalled my friend Clarence Jackson, son of the pioneer photographer William H. Jackson, telling me about the painting. In fact, Clarence had published a book titled *Quest of the Snowy Cross*.[7] On page eleven of the introduction, Fritiof Fryxell gives a brief history of Moran and the painting, bemoaning the fact that it was in England:

> During the period of western exploration no one was more

Mountain of the Holy Cross by Juan Menchaca

zealous in seeking out and making known to the world at large the wonders of the Great West than the eminent artist, Thomas Moran. In 1873 he had been prevented from participating in the exploration just recounted since that season he was in company with John W. Powell in the Grand Canyon region. However, the summer of 1874 found him in Colorado, eager to paint the unique mountain which had

226

been so glowingly described by his colleagues on the Hayden Surveys. The work which resulted, *The Mount of the Holy Cross, Colorado*, is conceded to be one of Moran's greatest paintings and was awarded a medal and diploma at the Centennial of 1876. In view of the difficulties experienced by the 1873 party in reaching the Mount of the Holy Cross it was at first thought that Moran himself probably did not get to see the peak at close range and that he had depended solely upon Jackson's photographs for his interpretations of the peak itself. However, a letter has been discovered from Moran to his wife, written August 24, 1874, in which he recounts the difficult climb he and his men had just made up Notch Mountain to get the magnificent view of the Cross.

Moran's painting was subsequently purchased by a friend, Dr. William A. Bell, engineer with the D. & R. G. W. railroad, and it hung in Dr. Bell's home at Manitou, Colorado, up to about 1905 when the owner, at his retirement, took it with him to England. It is now in the family estate, Pendell Court, Bletchingly, Surrey, England. The removal of this painting, probably the most famous yet made of an American mountain, has naturally been a source of regret to many Americans.

I was excited about the painting being offered but didn't even suggest we buy it. So far, 1971 had been a devastating year for spending on Western art. Iris closed out the discussion with, "I'd rather have that painting than any Russell ever painted."

Jasper and I were together again in Sheridan, Wyoming three weeks after the Snyder meeting. I was speaking to the annual Sheridan County Library Convention. At the same time, we had planned a visit to Buffalo, the place of his birth, then to drive across the Big Horns to Cody to visit Dr. Harold McCracken[8] at the Whitney Gallery of Western Art. From there we would visit the Montana Historical Society and the Russell Gallery in Great Falls.

In crossing the Big Horns, we were engulfed in heavy snowfall. Breaking out on the summit we could see Mt. Cloud's peak. "Isn't it beautiful?" I said. Jasper asked, "Do you think this mountain is prettier than the Mountain of the Holy Cross?" I replied, "In my

opinion, there is no mountain in the West more beautiful than Holy Cross." That was the first indication to me that Jasper was even thinking about the painting.

In Cody that night at dinner with Dr. and Mrs. McCracken, we discussed the painting. Harold made some interesting comments about it, relating that he had been promised an opportunity to purchase the painting years ago by Bill Davidson of Knoedler's, when it was being sold by the Bell Estate in London. "Instead," Harold said, "Bill sold it to New York millionaire Huntington Hartford for $10,000." I said that we would not bid on it since we didn't have any money. Harold said, "We are definitely interested and one of our directors intends to be there."

The next morning Jasper and I drove to the Helena Museum and then to the Russell Gallery. Seeing the collections of Russells was a feast and the entire day was a lot of fun. Late in the afternoon I took Jasper to the airport at Great Falls. He had to catch a plane for Colorado Springs, as he had a bank meeting to attend the next day. My plan was to drive into the Judith Basin country for nostalgic reasons. I wanted to visit Utica and Stamford, Charlie Russell's old stomping grounds, and view the Belt Mountains as he had. Also, I was trying to locate the Jake Hoover log cabin,[9] site of the artist's first winter in Montana. Mr. Ackerman liked my plan and regretted he couldn't come along, too.

Standing at the ticket counter he asked, "Aren't you going to bid on *Holy Cross?*"

I answered, "I hadn't planned on it—should I?"

"Since it's an important painting," he replied, "why don't you use your judgment?"

I joked, "That can be dangerous."

"Worse than that," he laughed, and passed through the gate to his airplane. It was Sunday. The painting would come up Wednesday evening at Parke-Bernet.

I had two wonderful days in Judith Basin retracing Russell's trails. I visited the site of Hoffman's Saloon, the scene of the great

oil, *Bad Day In Utica*. In Stamford I walked the streets where he had sketched *In Without Knocking*.[10] I got a lead on Russell's cabin.

Tuesday night I had dinner with friends in Billings. Suddenly I realized the Moran would come up for sale in less than twenty-four hours. I was a long way from New York City, but Jasper had told me to use my judgment and I would! At midnight I called information in New York City and got Tony Bower's telephone number. When I called him it was after 2:00 A.M. in New York.

The phone rang and rang. Finally he answered with a feeble hello. "Tony," I said, "This is Dean Krakel. Are you going to the Parke-Bernet sale?"

"Not before daylight," he said.

I continued, "Will you do me a favor? Bid on Moran's *Mountain of the Holy Cross* for us."

"How serious are you?" he asked.

"$110,000 is our top bid. If we get it at that price it will be a good buy."

"I don't think you can get it," he said. "I know of two major museums that are interested, as well as a New York art syndicate." I told him I knew of the syndicate's interest. A member had telephoned about two weeks before to inform me that they were prepared to pay $150,000 for it and asking if we were interested in making an offer after they purchased it. I had told them we were broke.

I asked Bower to attend the sale representing Knoedler's and to make no mention of the Cowboy Hall of Fame. "If we happen to get it, cream off the publicity for yourself and the gallery. And Tony," I said, "sit in the front row and bid like you've got a million. Maybe with Knoedler's reputation you will scare some of the bastards off."

I gave him my number at the Great Northern Hotel in Billings and hung up.

About 6:00 A.M. my phone in the hotel rang. It was Bower. "Was that a dream I had about 2:00 A.M. this morning?"

Half awake, I said, "Hell no. I hope you buy the painting for us. I'm catching a plane out of here this morning for Oklahoma City. Call me tonight. Remember $110,000 is all we have—maybe."

Iris met me at the airport. Arriving home after 10:00 P.M., our daughter Jennie, greeted us at the door.

"Daddy," she said, "A Mr. Bower just called, and was very excited. He said, 'Tell your father we got it, we got it!' and hung up."

I had mixed emotions. According to Iris, I walked in a circle in our living room and kept muttering, "Jesus."

The next day I talked with Tony. He was ecstatic. The story of the sale of the painting for $110,000 had been carried in the *New York Times*, *Mirror*, and on radio and television. His bosses at Knoedler's were highly pleased with the publicity and said they would forgo the usual commission.

Just two days later Tony called and said, "You can make $20,000 on the deal if you want to sell *Holy Cross*." I replied, "Send me a wire to that effect, and I'll let you know."

Once I had the telegram in my hand I telephoned Jasper. "Mr. Ackerman," I began, "you can make $20,000 on your Moran painting if you wish. We have an offer. You paid $110,000," I said gingerly.

He was silent a moment and asked, "I paid how much?"

I replied, "$110,000." There was another pause in time.

Then he came back with, "The painting is important isn't it?"

"Yes," I said.

He asked, "It belongs in the National Cowboy Hall of Fame doesn't it?"

I gave another "Yes."

He snapped back, "Why would we want to sell it?"

"We don't, Jasper," I replied.

Purchase of the *Mountain of the Holy Cross*—more than any other single work—brought national attention to the Cowboy Hall of Fame's growing and great collection.

The next strike by Mr. Ackerman as a major collector of

Western art occurred on December 6, 1971, when he purchased Albert Bierstadt's famous oil painting, *Emigrants Crossing the Plains*[11] (*Sunset on the Oregon Trail*) dated 1867. The size of the painting is ten by seven feet. The original bill of sale, dated 1868 from the artist to Amanda Stone, was included in the transaction.

The whereabouts of the painting was brought to my attention by two art dealers. News of the painting's location was helpful, but I didn't think it would cost us $5,000. In the end, we paid it as a finder's fee, in spite of my kicking in the traces over it.

The painting was owned by the Automobile Club of Cleveland, Ohio. It had been presented at auction for the Club at Parke-Bernet three years before and the sellers turned down an offer of $125,000. Following the New York appearance, the painting was loaned to the Curator of the National Fine Arts Commission in Washington, D.C., and was hung in the outer office of the Secretary of State. If the owners wanted to give the painting dignity, they had made the right move. According to Curator Clement Conger, he tried to raise the money to buy it for the Fine Arts Commission and failed.

Our contact was Ralph Boland, secretary of the Cleveland Automobile Club. At the request of the art dealers, a provenance and photographs of the painting were mailed to me in October, 1971. I was familiar with the painting and showed the photographs and bill of sale to Ackerman. I began our conversation with, "This is one of the most important paintings of Western Americana." The artist had travelled in the West and sketched on the Oregon Trail in 1859, so the great work had a fine historical background that appealed to me. In other words, the painting was not just another wagon train heading west. Our collection needed a major Bierstadt to complement the fine 22 by 30 inch California landscape given by Mr. and Mrs. Luther T. Dulaney in 1970. Authorities on Bierstadt considered *Emigrants Crossing the Plains* one of the artist's most important works.

Jasper liked the painting from the outset. I did, too, but held back. Mr. Ackerman sounded decisive when he said, "This is an

important painting." I told him I thought the $175,000 price was high by at least $25,000. He replied, "We need it in our collection. Why don't you see what you can do about the price?"

Within the next two weeks, I talked to Mr. Boland a number of times. He seemed firm on the price. My persuasive powers failed, along with our pitch about it coming to the Cowboy Hall of Fame, bringing national recognition to him and the Cleveland Automobile Club. He knew how to deal. In our last phone conversation he said unyieldingly, "If you want the painting, you know the price. If you don't want to pay our price, forget it."

I reported to Jasper by phone of Boland's determination and he said, "Figure out what you think you want to do and try him out."

Late that afternoon I sent a wire stating, "$153,000 is all we can come up with. Will you sell *Emigrants Crossing the Plains?*"

The next morning my secretary got a call from Boland's office conveying the following message: "Sale no dice." Discouraged, I talked to Jasper again. I just didn't think it was worth the asking price. He sounded cheerful enough and asked where the painting was hanging. I replied that it was in the outer office of the Secretary of State. After that he hung up on me brusquely, as he often did.

The next time I talked with Mr. Ackerman, he had already been to Washington, D.C. to look at the painting. He said he liked it even more. He authorized me to go to Bill McDonald, chief executive officer of the First National Bank and Trust Company, to make arrangements for a cashier's check to be issued in the amount of $175,000 and sent to the Cleveland Automobile Club. Then I talked with Mr. Boland, who was surprised and happy about the pending sale. By the time I got to the bank, Jasper's transfer of funds from his bank in Colorado Springs to the First National in Oklahoma City had already been made. Except for signing the bill of sale, the deal was made. Bryan Rayburn and Rich Muno flew to Washington to make arrangements for shipment of the painting.

In buying *Emigrants Crossing the Plains*, Jasper revealed some

of his own personality, courage, and love of the pioneer spirit. His desire for the painting had nothing to do with his affluence or any need to possess; simply, he saw in it the fundamental lesson of pioneering. He wanted it to hang in our museum for that basic reason and no other. He wanted to share with others all that he saw in the painting.

His role in our history could perhaps have ended here, but instead it does anything but that. Aside from cash amounting to perhaps $150,000 and his recent matching of Mrs. Nona Payne's gift of $75,000 for our heroic Buffalo Bill statue, he bought $900,000 worth of the $1,000,000 art fund bonds issued. In the end, after all that Luther Dulaney, J. B. Saunders, and I had done—our purchases made with blood, sweat, and tears—it was Jasper Ackerman who made most of the biggest sacrifices.

The highlight of our National Academy of Western Art Exhibition each year is the presentation of our Trustees' Gold Medal to the person who, in the opinion of the directors, has done the most for Western art. At the 1974 event on the evening of June 6, before a crowd of more than six hundred guests, artists, and trustees of the National Academy of Western Art, Dean A. McGee, a member of our Board of Directors, called Jasper to the platform and read the following citation:

> The man chosen tonight to receive the Trustees' Gold Medal for outstanding contribution to Western Art, would, I'm sure, not have been with us tonight had he the slightest hint that he would receive this deserving tribute. He's a gentleman ever so modest and humble.
>
> To know his life is to know the pioneer spirit. A true westerner born in Buffalo, Wyoming, of pioneer parents, he grew to manhood caring for his mother and large family of brothers and sisters, after the early demise of his father.
>
> He had three careers in his life, being a cowboy-cattleman, then a banker, and above all being a friend of his fellow man. This man is a patriot, a highly decorated infantry soldier and officer, serving in two World Wars, fighting for his country both times in France and Germany.
>
> His fourth love, beyond his profession and country, has

233

been the National Cowboy Hall of Fame. He has been involved, if not instigator, of every significant development of this Institution. More than 25 great works of Western art have the wonderful, clean, clear brand of Jasper D. Ackerman of Colorado Springs on them.

Jasper, on behalf of the Board of Directors and Board of Trustees, everyone here tonight, and hundreds of your friends, those who know you personally, and tens of thousands who know you by reputation, it's my pleasure to present you this Medal.

Chapter 12

Dealers I Have Known and Liked

As LONG AS there are artists who create and collectors who buy, there will be dealers[1] who sell. Dealers are the art world's middlemen, the promoters and entrepreneurs. Behind every great collection there is at least one important art dealer, and the National Cowboy Hall of Fame has been blessed with great dealer relationships since the initial stages of our collection's development. Similarly, behind every collection of junk, there is the poor judgment of the collector and an array of peddlers and dealers who often operate out of station wagons and car trunks. I have seen a few good works in the parking lot, but they can be counted on the fingers of one hand.

I have met most of America's Western art dealers and would-be dealers. I have met dealers of all shapes, all sizes, from all stations in life. I have been exposed to the high brow and the low brow, the shrewd, good, pious, the honest, the dishonest, and virtually all the heels. Size, location, longevity, and the amount of quality art that a commercial gallery offers are hallmarks of a good reputation and lasting success.

I have had interesting tricks played on me by a number of lesser art dealers, and, though I was born and raised in a small town, I never regarded myself as being a "country boy." To have been beaten openly and honestly in an art proposition is not a satisfying experience but at least it's memorable. I remember what the late O. M. "Red" Mosier, first chairman of the Cowboy Hall of

235

Fame's Art Committee, told me after it had been put to me over some drawings from a picture peddler. "Kid," he said, "if you're going to play with horse manure you're bound to get it on your hands."

After I became a museum director, I had to be careful about my relationships or else I would end up either being misquoted or getting blasted. In actuality, a museum director should be one of God's most wary and suspicious beings.

There is a possibility of embarrassment when a director goes into a gallery and shows even the slightest interest in a painting. The dealer or his agent might say to a subsequent customer (and this has been the case more than once), "If you're interested in this work you better act now. Krakel was in here a while ago . . . and showed a lot of interest in that particular work."

Once a dealer telephoned that she had a large number of Borein drawings and invited me to come and see them. I told her I'd drop by and look at them since I planned on being in her city within the next two weeks. Only a few days later one of our directors phoned and exclaimed, "My God, are you really planning to buy all those drawings?"

Initiation of the Tenderfoot by C. M. Russell

On another occasion a dealer telephoned me about a Schreyvo-
gel painting he had for sale. I cut him off half way through his
pitch by saying, "We have several fine Schreyvogel oils. We don't
need any more. Besides, I don't happen to have that kind of
money right now." A few days later I was talking to a collector
friend. He commented, "Say, the other day I bought that
Schreyvogel you wanted from dealer X. He confided to me, 'Too
bad the Hall's so broke; Krakel really wanted it.' "

Once I wrote an appraisal on some drawings for the sweetest,
most innocent appearing little lady, who was wearing the prover-
bial tennis shoes. "How sweet she is," I thought to myself. "I'll
help her sell her pictures to supplement her pension." She was a
female wolf in disguise. My letter and generous appraisal were
duplicated by the hundreds for the dealer she was in with.

My career in Western history and art formally began when I
enrolled in Colorado State College of Education at Greeley. At
that time, and on through graduate school, I began collecting
Western Americana, books, brochures, biographical data, repro-
ductions of Western paintings, dealers' catalogs, and auction
records.

Early in my career I had several unforgettable experiences
which helped to hone my trading instincts and sense of values.
Once I found a gun maker's catalog at a rummage sale. It was
pre-Civil war and outlined repeating mechanisms for a rifle.
While the manufacturer had not succeeded, the catalog was in
excellent condition—in spite of being in paper covers. I took it to a
famous bookman. I was filled with high hopes, and I needed
money. He searched his reference library and found a volume
titled, *The Ten Rarest Gun Manufacturers' Catalogs*. My find
was not listed. Nor was it among the second ten rarest gun catalogs
ever printed. My bookman friend concluded that my catalog
obviously had little or no value. I picked the catalog up off the
counter and, disappointed and tired, walked toward the front of
the store. It was already midnight, so I bid my host good night,
thanking him for the bowl of chili and hamburger we had enjoyed
earlier in the evening.

As I reached the front door he said, "You're a nice guy, Dean, and I want to help you. I'll give you thirty-five dollars for the catalog." My face brightened; in those days that was a sizeable sum. Driving home, I smiled. I had paid a quarter for it, and now I had seven crisp, new, five-dollar bills in my pocket. I was an undergraduate in college then—newly married and counting every dime.

Two days later an airmail letter arrived from a New York bookman. He had been out of town for a couple of weeks and had, upon returning, just opened his mail. "My God," he exclaimed. "If the catalog is as you describe, it's virtually unknown! Certainly it isn't listed among the top twenty rarities!" His offer, pending examination, was fifteen times the price I had received.

I was able to gain a measure of revenge months after the gun catalog episode. This time, I warily approached the same dealer with three large, beautifully framed Currier and Ives prints. Two were of western subjects—very famous, in fact. The third was a nautical scene. Taking the prints on consignment for a commission of twenty-five percent, I was able to gain insight into their value through research at a public library.

When my mentor saw them, his face lit up. Then he became downcast and sorrowful and said, "Too bad this is not the 1930s when such prints were popular. But before we talk business, why don't we go out and have dinner." The meal was splendid—steak with all the trimmings, wine, and more wine. We laughed and talked. My host was most entertaining. Then, subtly he brought up the subject of the prints.

"Since we are together, why don't we talk?" He coolly suggested that I give him a price. Laughing and mellow from too much wine, I shook my head. Finally he said he would do something that he would not ordinarily do. In fact, he had not ever done it before and probably would never do it again. He was going to make me a cash offer. It was a one-time proposition and he would surprise me by being able to pay cash, then and there, giving a bill of sale—providing I would accept his offer.

His price was two-hundred dollars each for the western subjects and a reluctant fifty for the maritime scene. Had he offered five hundred for the three (as I had estimated their worth to the nice people who had consigned them to me), it would have been a deal. "Nope," I said firmly, "Five hundred for the lot."

I shook my head, even though the thought of the commission was tempting. I was unswerving. He put on a good show, adding that he had already invested almost eight dollars in the meal and wine.

"My God!" he said. "I don't think I could sell that marine scene in a hundred years."

I said I would sleep on it and come by his store in the morning. With that, we parted. He went to his store, as he was a night worker. As for me, I wobbled back to my hotel lugging the Currier and Ives in an awkward, oblong bundle.

The next morning I telephoned an art collector, whose name I had heard by chance, and was soon describing what I had for sale. I didn't mention the maritime scene. He invited me over and very shortly he was drooling over the two western Currier and Ives. After showing him my letter of consignment indicating their origin, he said, "I will give you a thousand apiece. How's that?" I was so dumbfounded he couldn't tell whether I was happy or sad.

Later that day I returned to my friend's gallery. "Gee," he said. "I'm glad to see you. I lost my head last night and now I don't think I want the maritime scene."

With a big smile I replied, "Fine," and took the check for two thousand out of my billfold. I held it up close to his face. "Will you have dinner with me tonight? I'm buying."

The lessons I had learned within those few months were far more important than the money earned or lost. I became impressed with the maxim that the person with superior knowledge of the wares, be he buyer or seller, has the decided advantage.

My experience in the field of collecting, buying, selling and trading of art, and working with art dealers—combined with administrative experience and exposure to a number of great art

collections—has given me a unique background, a background many museum directors and curators lack in this wonderful, rough and tumble art world. Without this varied career, I am sure that the National Cowboy Hall of Fame would not have its great collection of Western art. Had I not been a trader, the *End of the Trail* might still be rotting in a park in California.

Before I get on with dealers I have known and liked, I want to tell of an incident concerning a dealer I didn't like. For obvious reasons, everyone involved in this incident will go unnamed. I will compromise and state that this attempted bit of chicanery originated in the Southwest.

The work of art involved was a Frederic Remington pastel, his famous *Cheyenne Buck*. This was one of the original pastels done by the artist to be reproduced as a lithograph in the portfolio *A Bunch of Buckskins*, published in 1901 by the R. H. Russell Company. Aside from Remington's great name, the portfolio was historically important for being one of the first ventures of its kind in Western art.

For years, collectors speculated as to where all of the originals might be. The *Cheyenne Buck* had been missing from the public eye for almost a half century. The other drawings were: *A Sioux Chief, A Breed, Old Ramon, A Cavalry Officer, An Army Officer, An Army Packer, An Arizona Cowboy, Commanche Warrior,* and *A Trapper.*

It began for me in June 1973, when a collector phoned to say that he and three associates were considering purchase of the drawing *Cheyenne Buck* from a dealer source in New York City. He added that the drawing had been pronounced a phoney by a widely known dealer in the Southwest. The collector was rather distraught over the matter and asked if I would look at the piece. He added, "If you think it's all right, I'll buy it."

I asked the price; he answered sixty thousand. This surprised me, knowing of the drawing's rarity and that we had insured two other drawings from the series—*Commanche Warrior* and *Arizona Cowboy* for seventy-five thousand each when they were

240

loaned to us for exhibit by the Sid Richardson and Rockwell Foundation collections. "If the pastel is right," I told him, "you can make a good buy."

In the meantime, the dealer who pronounced the work a phoney sent it to a museum for an opinion. Their art curator, a respected authority on Remington, declared the work to be authentic. In the face of this evidence, the dealer (without telling the collector about the curator's affirmative opinion) asked to be included in the ownership of the picture and then phoned the New York City gallery to ask that the price be reduced to fifty thousand. The New York dealer reported back hours later that the price of fifty thousand was acceptable to his client. The Southwest dealer gathered his buyer friends in his office and told of his new price deal.

The collector was, by this time, confused. In his mind the painting was still a fake, yet why had the dealer gone ahead with the negotiations? The Southwest dealer again, without the collector's consent, called the New York gallery to say his party could now give only forty thousand for the *Cheyenne Buck*. By this time, the New York gallery owner, having been insulted in every possible way, demanded that the pastel be returned to him immediately and announced the sale was off.

In the meantime, the collector and his friends visited me at the Cowboy Hall and, in fragments, discussed what had happened. At that time I intimated that I would be interested in the picture, if it was genuine, for the Hall. The group suggested that I telephone the New York Gallery and have the painting sent to us. As I did this, the gallery owner told me of the painting's origin— principally that it had been in the family of William Rockefeller. In the course of our conversation, he mentioned that the painting had been authenticated by a museum curator and consented to ship the *Cheyenne Buck* to the Cowboy Hall of Fame. It was agreed between us that, if I passed favorably on the painting, the collector's group could still buy the pastel if they wished. In the meantime, to assure myself, I called the curator and asked his

241

opinion of the painting. He said it was unquestionably good and added that he would send me a copy of his letter of authentication.

Within a couple of days, the *Cheyenne Buck* arrived at the Cowboy Hall of Fame. There was no doubt in my mind about it being genuine after comparing it under a magnifying glass with prints. Now I was doubly convinced. I telephoned the good news to the collector. He planned a flight to Oklahoma City on the next day.

Next, I visited my friend Gaylord Jones at Stock Yards Bank to borrow $60,000 for purchase of the pastel. He consented. Until I could find a sponsor to buy it for the Cowboy Hall of Fame, the bank note would be issued in my name.

My meeting with the collector was cordial. Much of his enthusiasm for the painting had obviously been dissipated. I assured him that his experience was the exception and not the rule in art dealings. Still, he indicated a desire to give up the picture. I proposed, "If I can buy the painting for fifty thousand, I will give you ten thousand." "No," he said, "if you can get it for fifty thousand, do it. My only request is that you loan it to us at our country club sometime for a few months. Also, bring some good Western art there from time to time." I agreed.

The gallery owner in New York agreed to sell the painting for fifty thousand and, within a matter of hours, I had a cashier's check issued in my name for payment. Shortly after, the *Cheyenne Buck* was hanging on our gallery wall. A couple days later, I telephoned a collector friend in the East and told him about the famous painting.

He immediately replied, "If you get stuck, let me know. To own that painting, I'll give the Hall a $25,000 gift and pay off your note." A few weeks later, my good friend Joe Gordon paid off my personal note. Today the *Cheyenne Buck* has a prominent place in the Cowboy Hall of Fame gallery and carries the names of Mr. and Mrs. Joe Gordon, donors.

When I think of the classic manner of selling art, I'm reminded

of the first time I met the late Bill Davidson[2], vice-president of M. Knoedler and Company[3], New York City. As the new director of Gilcrease, I called on Mr. Davidson in July 1961 at Thomas Gilcrease's suggestion.

Bill gave me a tour of their gallery at 14 East 57th Street. One velvet-lined sales room in particular held special meaning for Mr. Davidson. For a few minutes he relived memorable sales sessions with Mr. Gilcrease.

"T. G. sat here," he said, becoming excited. "Mrs. Teenor here. I was in the center. I had some of our finest things brought in—the Winslow Homer, Charles Willson Peale's portrait of James Madison, John Vanderlyns. We'd try all kinds of lighting. I would talk about them for a while. Sometimes T. G. bought them so fast it made my head swim."

If Western art ever had a super salesman, it was Bill. He began his career with Knoedler's as an errand boy and served in virtually every capacity. Tutored by Roland Knoedler, then Charles R. Henschel and Carmen Messmore, Davidson rose in the firm's ranks, ultimately becoming executive vice-president. Bill knew American art from A to Z; when he applied his mind to art of the American West, he became one of its greatest proponents. He was always able to see things in a broader framework than just single pictures. He loved to form collections, put things together, make big deals, and see museum buildings go up.

Davidson assisted Amon Carter of Fort Worth in assembling his great collection of Russell, Remington, Schreyvogel, and Frank Tenney Johnson. Bill was instrumental in selling Carter the famous C. M. Russell Mint Saloon Collection of Sid Willis. He had an important role, not only in developing the Whitney Gallery of Western Art facility, but in furnishing important paintings and bronzes for the museum's opening in May of 1959.

On June 12, 1971, the National Cowboy Hall of Fame Board of Directors voted to present Bill Davidson their Trustees' Medal. The citation recounts briefly a few of his achievements:

> Mr. Davidson, it is with pleasure that I bestow this honor

243

upon you for your outstanding contributions to Western art.

Your life long dedication to your profession, rising from an errand boy, up through the ranks, to become vice-president of the great M. Knoedler and Company is full testimony to your will. The role you have exercised in forming, holding, and then placing great collections in major western museums is unparalleled. The Frederic Remington Studio Collections in the Whitney Gallery of Western Art, Cody, Wyoming; the extensive American holdings as well as a myriad of great works in the Thomas Gilcrease Institute, Tulsa, Oklahoma; the great Russell Collection of Amon Carter Museum, Fort Worth, Texas; the Karl Bodmer, Alfred Jacob Miller, and George Catlin priceless groupings in the Joslyn Museum, Omaha, Nebraska; the large C. M. Russell Collection in the National Cowboy Hall of Fame and Western Heritage Center, Oklahoma City, Oklahoma, all reside in these institutions for the public good because of your foresight and ability.

The foregoing is but a brief accounting of highlights of your intelligence, energy, courage, and devotion to purpose. By the authority invested in me by Trustees of the National Cowboy Hall of Fame and Western Heritage Center representing the Seventeen Western States, I present you with the Trustees' Gold Medal, which is but a symbol of our pride and gratitude.

Jasper D. Ackerman
President, Board of Trustees
National Cowboy Hall of Fame

Another dealer, Jack Bartfield, is a remarkable person. Of average size, he has a round face set behind thick glasses and owlish eyes that can sparkle at the slightest suggestion of humor. Jack has a deep voice made husky by the ever present cigar. Educated in law, he developed a deep love of books early in life—so consuming an interest, in fact, that he turned from a promising career as an attorney to the field of Western Americana.

When I would be in New York City on a weekend, Jack and I would often take in a Broadway play or movie or go to the top of one of New York's skyscrapers for a breathtaking view of the city.

On other occasions we would ride the sightseeing boat around Manhattan Island. I often kidded Jack that if I came to his town often enough, he would finally get to see it. Once Jack, Jim Boren, our collector friend Robert Rockwell, and I drove to Ogdensburg in upstate New York to visit the Remington Art Memorial. Following our tour of the museum, we drove to the nearby cemetery to pause for a moment of respect at the great artist's grave.

Few social activities, however, equal my pleasure in browsing among the books and paintings at the J. N. Bartfield Gallery at 45 West 57th Street. Jack is considered an authority in the field of Western art, particularly on the works of Remington, Russell, Schreyvogel, Farny, and H. W. Hansen. During his many years in the art business, he has owned several important pieces including Remington's pastel, *The Arizona Cowboy*, and his bronze, *The Horse Thief*, and C. M. Russell's oil, *Roundup On the Musselshell*. I purchased one of Henry Farny's finest paintings from Jack—the only major museum quality painting we have acquired from him.

Erwin S. Barrie,[4] director of Grand Central Gallery located in New York's Biltmore Hotel, has had a strong influence on my Western art life in a quiet sort of way. Barrie was a great friend of artist William R. Leigh and his wife, Ethel Traphagen Leigh. During the months I was negotiating for the Leigh Studio Collection on behalf of Gilcrease Institute, Mr. Barrie was fully in support of the transaction. Erwin Barrie has a long history of devotion to Western art and is decidedly no "Johnny-come-lately." In one of Grand Central Gallery's catalogs, Barrie comments briefly on his life:

> When I left Cornell, I became a Jack London hobo and rode the rods and slept with wandering cowboys through the West. Later I got a job as manager of an art department in a Chicago department store where we sold pictures, hand painted in oil, for $5.00 and $10.00 with gorgeous gold frames. I finally persuaded a young painter named Walter Ufer,

whom no one had ever heard of, to have a one-man show in our galleries. He painted Indians of the Southwest. I knew he was good and we sold every canvas in the show.

From then on, in both Chicago and New York, in the Grand Central Art Galleries, I was able to handle the finest cowboy-Indian painters in the country, including Russell, Frank Tenney Johnson, William R. Leigh, Charlie Dye, and many, many others. In fact, Nancy Russell and I put on an impressive memorial show of Charlie Russell's work shortly after his death.

Some of the National Cowboy Hall of Fame's most important paintings have at one time or another been in the hands of Barrie and his able assistant, Ruth Raile. Among such works are two of Leigh's greatest, *The Leader's Downfall* and *The Buffalo Hunt;* also, Moran's *Mountain of the Holy Cross;* and Frank Tenney Johnson's *Rough Riding Rancheros.*

A dealer who is as widely known and respected in the Western art field is Rudolf Wunderlich[5] of Kennedy Galleries, New York. I first met Rudy when I was at Gilcrease Institute. Mr. Gilcrease was very fond of Rudy and bought heavily from him. In the Cowboy Hall of Fame's first two or three years of operation, Kennedy Galleries lent several fine works to help line our walls.

Few families in the commercial art world have had as long a history in American art circles as the Wunderlichs. In 1874, Herman Wunderlich opened his print import business in Room Three, Number Three John Street in lower Manhattan. During a century of history, the firm's reins went from the grandfather to his son, Herman Wunderlich, and from Herman's wife, Margaret Cronau Wunderlich, to Rudy, increasing in importance with each change in ownership and location. In 1959, after almost sixty years, the business was incorporated as Kennedy Galleries, Inc., and is presently located at 40 West 57th Street, New York City.

In 1960, Wunderlich began publication of *The Kennedy Quarterly,* now regarded as one of the finest and most authoritative sales periodicals in American and Western art. Issues of the

periodical, including price lists, have become invaluable as guides to understanding the development and pricing structure in Western art. Rudolf Wunderlich and his mother have used their great influence with integrity.

At the National Academy of Western Art awards banquet held on June 7, 1975, Vice Chairman of the Academy William G. Kerr surprised Rudy by announcing that the Cowboy Hall of Fame Trustees had selected him as the year's recipient of their Gold Medal for outstanding contribution to Western art. In presenting the award, Kerr not only cited Rudy's contribution to his field, but also his generosity in lending the Hall several high value paintings and sculptures during our formative years. The audience of more than seven hundred gave Mr. Wunderlich a standing ovation.

The first time I talked with Victor Hammer,[6] was by telephone in the late 1950s. I was on the staff at the Air Force Academy and Victor wanted to borrow our fine portraits of Generals Ira Eaker and Joe Canon by Nicolai Fechin. I have been talking to Victor almost continuously since then, and we still talk about Nicolai Fechin. Through the wisdom and friendship of Victor Hammer and Fechin's daughter, Mrs. Eya Branham, the National Cowboy Hall of Fame exhibits the most important collection of this great Russian-born artist's work in existence—twenty-six paintings in all.

Few art dealers living today have had a life as interesting as Victor Hammer. The youngest of the three famous Hammer brothers, Victor began his career as a dealer in Russia during the 1920s, when he and his brother, Armand, sold their pencil factory to the government at Lenin's suggestion. Terms of the sale were simple: the Hammers were permitted by the Kremlin to keep all the art they had purchased over a period of several years, so they came back to the United States with several millions of dollars' worth of art, including a portion of the Russian crown jewels. Such was the basis of the Hammer art fortune.

In 1922, Victor, who always had an ambition to become an

actor (and for which he had a natural born talent) joined his brother Armand in Russia where he studied at the Moscow Art Theater. However, by the time he learned the language, he was completely involved in Armand's business enterprises. He specialized in buying objects of Russian Imperial origin that were being sold by the government and those found in commission shops consigned by private individuals. The Hammers' twenty-four room palace, rented to them by the government, was furnished completely with such objects. When Stalin came to power, he was anxious to rid the country of foreign concession-aires. Armand agreed to sell out the last five years of his very profitable business if they would permit him to export the art collection. After long and difficult haggling, a deal was made in 1928 and thus was founded the Hammer Galleries in New York. They managed and publicized exhibitions and sales in leading department stores throughout the country, such as Marshall Field in Chicago, Scruggs in St. Louis, Halle Brothers in Cleveland, Bullocks in Los Angeles, and Lord and Taylor in New York. After observing what sold best, Victor went back to Russia several times to buy such items with dollars, which the government welcomed. Their ability to sell, even during the great depression, finally was brought to the attention of the William Randolph Hearst companies. The Hammers were appointed agents to sell the Hearst collection in a history-making promotion which they set up at Gimbel Brothers on Fifth Avenue. This in turn led to their entrance into a gigantic whiskey business which included the hundred year old firm of J. W. Dant. After selling J. W. Dant in 1954 to Schenleys for over six million dollars, Armand went into a small oil company, Occidental Petroleum Company, whose total assets then were less than $150,000. As chairman of that company, Armand built up the assets to about two billion dollars. The Hammer Galleries grew, majoring in Western art as well as other fields, and they subsequently acquired M. Knoedler and Company.

One of the most unusual art dealers I have known is James

Khoury[7] of Amarillo, Texas. Jim has a trading sense as uncanny as an Arab's. While operating a comparatively small art business, he has turned up exciting and important works of art for the National Cowboy Hall of Fame. Jim Khoury's purchase terms have always been fair and he has allowed sufficient time for me to find a sponsor or raise the money to buy.

Our purchase relationship with Khoury began with Charles Schreyvogel's fine painting, *Nearing the Fort*. This picture had bounced around the country for quite a while before I took a serious look and bought it, breaking the fifty thousand dollar price barrier for important Schreyvogels. The next important painting Khoury showed me was Thomas Moran's *Ponce de Leon in Florida, 1513*. Luther Dulaney bought the painting and gave it to the Hall two years later. The appraised value of this gift was in excess of $100,000.

Next came *The Sand Painter* by E. Irving Couse, a truly fine work. Until I saw this painting, I had developed a mental block against Couse's works, thinking they all looked alike. *The Sand Painter*, however, is a beautiful study in the use of various shades of black.

Jim had a role as a finder in calling our attention to Albert Bierstadt's great work, *Emigrants Crossing the Plains*, followed by Taos artist Joseph Henry Sharp's *Green Corn Ceremony*.

Another important painting purchased from Khoury was a Nicolai Fechin masterpiece, *Summer*, a sizable portrait of the artist's wife and daughter. This superb painting, in my opinion, is as great as any Fechin ever created. It took almost a year to the day from the time Jim gave me an option on the painting to come up with full payment.

If I have had a mentor in the rare book and Western art field, it has been Fred Rosenstock[8] of Denver, Colorado. While a graduate student at the University of Denver, I used to browse in Fred's fascinating store on Fifteenth Street. He quickly observed that my associates (usually Paul Rossi and Martin Wenger) and I were too broke to buy; admittedly, we didn't exude much promise as

Fred Rosenstock by Ned Jacob

paying customers. On one occasion he pointed to us and said loudly to an assistant, "They're just looking—but keep an eye on them."

Later, a few years after graduate school when I was a junior professor on the faculty at the University of Wyoming, Fred and I became good friends. Occasionally he would take me into his inner sanctum at the Fifteenth Street store where I could examine many of his rare books and paintings. There, under Fred's appreciative eye, I browsed and listened to his marvelous adventures in acquiring his treasures. It was during one of these sessions that Fred allowed me my first chance to not only see but actually hold a small C. M. Russell watercolor painting.

In time I became familiar with all of Fred's Russells. His collection consisted of three oil paintings, twenty-two watercolors, two pen and ink drawings, eight bronzes, and several illustrated letters. Fred knew Russell bibliography and gave freely of his knowledge.

I have always enjoyed watching Fred handle customers. He can size up a person after only a few minutes' conversation, evaluating how much the customer knows and the general range of his purchase potential. After more than fifty years of seeing people of all shapes and sizes, from all walks of life, he has developed an uncanny, intuitive ability. Fred is a master seller and can handle three or four customers successfully at one time, talking and moving back and forth among them. I have seen him in top form many times.

The state of Fred's disposition can usually be ascertained by whether he is buying or selling. As a buyer Fred is brusque and cutting; as a seller he is cordial and charming. The quality of the work or the dollar amount of a purchase does not especially insure gaining Fred's friendship, but it's a good start. He has a great knowledge of history and can immediately place a painting or a book in its proper historical perspective. He was one of the first dealers to talk to me about the color periods in Russell's life. Fred has handled practically all of the great guide books (Wagner-

Camp) and narratives; some of them he has had three and four times. He is an authority on various editions of the West's rarest Americana.

Fred has a twinkle in his eye when satisfied with a book. When I was at the University of Wyoming, I would drive down to see Fred to try to sell or trade him something, I did so with great anticipation—but not necessarily with any expectation of financial gain.

Until I got to know Fred's habits of work, I thought he was perpetually tired. He works three-quarters of the night through and sleeps late each day. He will doze off momentarily in the middle of a conversation or a meal. He can appear to be in a deep sleep yet not miss a spoken word. Almost chronically, business has been bad for Fred, "all month yet," and he doesn't feel well. When Fred is puzzled by a customer or situation, he will put his hands in his back pockets and walk back and forth in small circles.

On some matters—especially purchasing—Fred would consult his late wife, Frances. He would look at me and say, "I'll ask Frances—you know, my wife. She has generations of bargaining character in her blood. My wife knows. If I had listened to her years ago, I'd be a rich man today." Fred and Frances could communicate by merely glancing at one another or by an unnoticed nodding of heads. Seeing the box of stubby pencils, piles of cardboard boxes, and rolls of string bits tied together on the shipping counter always delights me and heightens my appreciation of Rosenstock's business acumen.

Unlike some Western Americana specialists, Fred knows his subject well. His sense and knowledge of history have been of inestimable value to him in placing books and paintings in historical sequence and setting. He has known and often generously befriends the descendants of many of the West's outstanding pioneers. His love of history transcends buying and selling and it has made him an important force in the field of Western Americana. His personal attention to people and busi-

ness has been one of the hallmarks of his success. Those who go to Denver to Rosenstock's always want to see Fred.

To watch him browse in his stacks of books is like watching an experienced sheep counter at a stockyard. He apparently sees everything almost at once. He will tip his head back, look through his bifocals at the books, then lick the end of his index finger before pulling a book out. All of this is done quickly and without hesitation. He knows books by sight, color, height, width, and perhaps smell. A few books can give him a key to the value of a collection or a library. His estimates are uncanny. He can find an item among his 150,000 or more books by concentrating a minute or two and then walking directly to it.

As a buyer, Fred has always had adequate cash reserves. He will buy heavily if he likes the looks of something. He will buy large lots, rapidly calculating the amount that must be sold to regain his investment. It has been in the last fifteen years that he entered the Western art business on a full scale, applying the same eye, mind, and business sense to paintings that he has to books. I enjoy both buying or selling with Fred. With him, you can get down to the hard facts of the subject in a hurry.

Occasionally I would spend most of the night talking and looking at books and paintings with Fred. We would usually close out our session with a glass of beer, corned beef sandwiches, and pickles at Salemans, across from the store on Fifteenth Street. I loved every minute of each night.

There was one evening I especially enjoy recalling. It was about 3:30 in the morning. We were having a wonderful time but finally decided to call it quits. Fred gently shook Frances who had fallen asleep in a nearby chair. She awoke startled, checked the time, and exclaimed, "Fred, I love you. But when you're with Dean, you're crazy as hell."

Chapter 13

Fraud, Horror, and the Checkbook

T HERE ARE several ways of committing fraud or misrepresentation in Western art. The simplest is for an artist to paint a picture and sign someone else's name to it—like C.M. Russell or Frederic Remington. Another approach is to take a "well painted picture," paint out the original artist's name, and fill in another's signature. The most common method is simply to copy an artist's work, including the signature. Fraud and misrepresentation in bronze casting is far more difficult to detect than in painting.[1]

To understand fraud in art, one must determine what is the motive for deception. In most cases, the motive is simply money. There are cases, however, where both paintings and bronzes were produced or copied for purposes of appreciation, without any thought of monetary gain. I know of instances where bronzes were recast from originals by mutual understanding of all parties involved to fill out collections, or a casting was produced to preserve a work that had not ever been set in bronze. In reproducing bronzes, each work should be visibly identified on the base as a copy, inscribed as to foundry, and dated.

In the National Cowboy Hall of Fame collection, there are seven original models by the Montana sculptor, Earle Heikka.[2] The set was among the last sculptured by the artist. These models in clay were bought from the artist by C. R. Smith and years later presented to O. M. Mosier. Mr. Mosier, a former vice president of American Airlines and the first chairman of the Art Committee at

the Cowboy Hall of Fame, had the models electroplated to preserve them. The Heikkas were given to the Hall by Mrs. Mosier in memory of her husband after his death.

While the models appear now to be in good condition, eventually they will deteriorate and fall apart; therefore, a decision will have to be made by officials to some day have molds made from the models and cast into bronze. Done properly, with identifying base marks, there can be no misunderstanding or misrepresentation.

There are countless stories and incidents in the art world of fraud on a grand scale. There is the story of the art collector who made it known that he was interested in buying European and preferably French paintings, but only from families or heirs of families that had assembled the collection. A "smart" New York dealer outfitted an apartment in a swank hotel with expensive rented furniture, installed a roomful of phony paintings and drawings, domiciled an attractive middle-aged female accomplice with the right accent to her voice, and beckoned his client to come and see. The European old masters market often is ridden with fraud, crooked sellers, and their authenticators.

I know of an instance where a dealer reproduced or made facsimiles of a vintage art sales catalog, substituting a photograph on identical, aged stock of a fraudulent masterpiece they were offering. That is, the size, title, and subject of the work copied were identical, the original painting having gone to a major museum. The new owners believed implicitly in the provenance of their painting. They had the catalog to prove it!

There are dealers and galleries that will knowingly trade in fraudulent art with no conscience at all. The sole goal is money. The axiom "buyer beware" applies to the art game more so than others because of the ease with which fakes can be created by the unscrupulous.

I once owned a drawing of *Sitting Bull* by Henry Farny. I was proud to possess such a prize, paying $5,000 for it. I researched the relationship of Farny and Sitting Bull and knew the approximate

255

date and place of their meeting. Yet something about the picture bothered me. Maybe it was that the price was too low for one of America's most notable Indian figures painted by an important artist. On a hunch, I sent the painting to New York and had a number of experienced art authorities look at it. Victor Hammer suggested that it be examined under the powerful microscopes at the Morgan Library. Sure enough, my *Sitting Bull* picture was a lithograph with a watercolor wash painted over it. This raised the question: Did the original exist? Who put on the watercolor wash? Could Farny have done it? All in all, it was exquisite, even though it was not what had been advertised.

A reproduction, mounted on canvas, has been made of a Remington oil showing a well painted, standing Indian figure holding a rifle in a decorated buckskin scabbard. The size of the reproduction is 17½ by 11¾ inches, a tip-off to students of Remington since the artist didn't ordinarily paint on a canvas that small. Through the years I have been offered three of these interesting reproductions. The quality of the print is unbelievably realistic, down to revealing brush strokes. I first took one of the reproductions to a Gilcrease board meeting, thinking it was an

The Shell Game by C. M. Russell

256

authentic Remington oil. It caused considerable discussion. After the meeting one of the directors literally beat a path to the widow's door in an attempt to make a fast deal. Had it been authentic, the painting would have easily been worth several thousands of dollars. I remember sitting on Mr. Gilcrease's front porch, visiting with him one evening when he asked, "Tell me, did so-and-so buy that Remington you showed me the other day?"

"Yes, he did," I replied. "He stole it."

Mr. Gilcrease chuckled quietly, "I'm so glad he has it!"

A few years ago Helen Card,[3] who was a leading authority on Remington art, wrote me an illuminating letter about these reproductions. They had been printed in Austria.

One of the strangest cases in my career involved a fine painting of a deer given to the National Cowboy Hall of Fame by a good friend who happened to be an art dealer. The painting was signed "William Jacob Hays",[4] a fine artist who painted in the West in the mid-1800s. The painting disturbed me. While I have little or no background on the work of A. F. Tait,[5] the Hays painting looked very similar to another work I had seen by artist Tait. I brooded over the matter for weeks. Finally I had the painting sent off to New York to our conservator for examination.

A week or so later, he telephoned me and exclaimed, "Your painting is a Tait, not a Hays! Under the examination light it reveals the first signature. The Hays signature is of a different chemistry." We had him fully restore A. F. Tait's signature. This is the only time I know of where a forgery worked in reverse.

There was a Harold Von Schmidt[6] painting once that had the signature changed to W. R. Leigh. Of course, upon learning of it, the matter infuriated Von Schmidt.

One of the toughest situations I ever became involved in concerned a Remington bronze titled *The Scalp*.[7] The work turned up in a collection at a bankruptcy sale. The collection, while large, was pretty much of a grab bag of art but contained two Remington bronzes, *Coming Through the Rye* and *The Scalp*. The former work, Remington's most formidable, was an obvious

phony. The workmanship was poor, the patina was vague in comparison with Remington's traditionally fine black finish, and it was not numbered. Remington authorities have concluded that there were not more than fifteen of this sculpture cast and numbered. This is logical when considering the technical problems in casting a bronze of this size and complexity.

The Scalp, however, had the unmistakable workmanship of the artist and of Roman Bronze Works,[8] under the skill and craftsmanship of Riccardo Bertelli. The casting was a low number. After thorough examination, I signed my name to a letter stating that, in my opinion, the bronze was authentic and had been cast under Frederic Remington's watchful eye.

A few days later the dealer who was handling the dispersal telephoned me to say that he had offered the bronze to a banker; the banker had, in turn, telephoned a well-known dealer. The dealer asked for the bronze's measurements and, upon hearing them, stated emphatically that the bronze was a phony. Both the seller and the banker were going at me, especially the art dealer. I had gotten into the mess as a favor and was now involved in the matter up to my neck and without fee.

In talking with the banker over the telephone, I pulled out of him information that the dealer, after shooting our *Scalp* out of the saddle, offered "a good casting." His price was $35,000. The motive became clear to me.

The first thing I did was retrieve the bronze at my expense to make tracings of the base and take height measurements. Next I wrote the Remington Art Memorial,[9] home of the Remington Studio Collection, and asked for a sheet containing an exact tracing of their *Scalp's* base and also the height measurements as their casting was unquestionably done by Roman Bronze Works. The measurements of a recast are bound to be smaller. Within a few days, I received the tracings and height measurements. Luckily for me, they precisely matched the piece I had authenticated.

Another set of base drawings came from a collector friend. His

Scalp tracings also compared favorably with the disputed bronze's measurements. It is interesting to note that it was the same dealer, critical of this bronze, who had also sold the *Scalp* to my collector friend. I bundled up the facts of my case and sent them to the banker. Even though he was convinced of the soundness of my opinion and subsequent findings, the banker declined purchase.

In recent times I have received numerous letters from persons in a western state who are casting Remington bronzes from originals and offering them for sale at cut-rate prices. I do not condone projects of this kind under any circumstances.

In evaluating a Remington bronze, it should be noted that Remington's widow had all the original models destroyed. Also, castings from the Henry Bonnard foundry are valued much higher than those from Roman Bronze Works. I recommend that, before purchasing a Remington bronze, the potential buyer have the piece examined by an expert.

There is a large and famous collection of Remington bronzes, impeccable in provenance, but containing one puzzle for me. It concerns their casting of the famous *Stampede*,[10] on which Remington's first name is spelled with a "k"—"Frederick." Artists do not ordinarily have a habit of misspelling their own names. On the other hand, this casting was produced after his death; the misspelling could have been done by a foundry worker or the persons paying for the casting. And then I recall one time when I denounced a portrait attributed to Charles Schreyvogel because the last two letters in the artist's name were transposed—reversed to "le" instead of the "el". This same painting now hangs in the home of a prominent collector.

Fake Schreyvogels have been a personal nemesis. There is a large Schreyvogel action painting that has been offered to the Cowboy Hall of Fame by various sellers a number of times. Each new dealer who buys the painting obviously thinks he has gotten the best of his fellow seller; with each transaction the provenance becomes a little more "blue ribbon." The first time I was offered the painting I had it photographed and sent the photo to

Schreyvogel's daughter and son-in-law, Mr. and Mrs. Archie Carothers. They said emphatically that it was *not* done by Charles Schreyvogel. Three years later the story circulated that the painting had been purchased from the daughter and son-in-law. "It came out of the studio collection," claimed the voice on the other end of the telephone. I knew this was completely false. In addition to the Carothers' denouncement of the painting, the Cowboy Hall of Fame had purchased the studio collection from the daughter and son-in-law. On another occasion, rather than personally condemning the painting again, I had a three-way telephone conversation set up between the seller's agent, myself, and Schreyvogel's son-in-law. I let Mr. Carothers do the talking. A month later still another caller said, "I know you don't believe in that Schreyvogel . . . but I have some new and convincing evidence. Do you want to hear it?" I replied, "My God, yes!"

Difficult circumstances often result when an expert, usually a museum director, condemns a painting or bronze but will not qualify his judgment. Unless the case goes to court and the expert is subpoenaed into testifying, bedlam can result. A case I recall involved a Schreyvogel portrait. After receiving the guilty verdict from a museum director, the collector immediately turned on the seller, who in turn threatened to sue the person he bought it from and so on, down the line. Four transactions were involved. No one would budge. The source of the problem, the expert, refused to talk about the matter and resisted acceptance of the summons. I entered the case of my own free will and expense. After thorough examination of the painting, I was neither convinced the painting was a Schreyvogel nor could I prove it wasn't. The outcome of the case was that the museum director rescinded his initial opinion.

Art appraisals can be dangerous in more ways than one. I recently became involved in an estate settlement in the East that held two fine Schreyvogel oils. I appraised the paintings at $75,000 and $60,000, respectively. They were large in size, contained several action figures, and were in good condition. When I submitted my appraisal to the widow and her attorney, they were

stunned. An eastern appraiser, who boasted up-to-date knowledge of the market, had quoted $12,000 and $8,000. I asked if this appraiser had tried to buy the paintings.

"Yes," replied the widow. "Every day for the past two weeks he has offered $15,000 for the pair."

A couple of years ago a wealthy friend bought a large Thomas Moran seascape, titled *On The Maine Coast*, at auction. He spent over $50,000 at the auction acquiring art that I considered nearly worthless. The amount at stake in the Moran seascape was $21,000.

Five days after the auction, my friend invited my wife and me over to see the new art. The Moran was a flagrant phony. An artist as great as Moran is incapable of such sloppy work, particularly in the foreground of the painting. Moran is famous for his rocks and exquisite detail; this work was crude in every respect. I suggested sending the painting to New York to have it examined as to paint pigment, age, overpainting, and signature stability, and then have an authority on Moran study it. I softened my opinion with, "If your painting gets a clean bill of health, you've made a terrific buy. If not, you are entitled to recover $21,000." According to the agreement listed in the terms of sale, the buyer had ten days to return the art for refund.

The next day I telephoned the dealer who sponsored the auction and requested a copy of the painting's provenance—that is, any information as to who had previously owned the Moran, where and when it was exhibited, listings in catalogs, letters in which the artist might have mentioned it, and any other information. The entrepreneur said that the owner, a New Mexico dealer, had said he would supply such information to the buyer, but somehow he had overlooked the matter. No provenance was ever forthcoming.

Rich Muno, art director at the Cowboy Hall of Fame, accompanied me to New York to witness the examination. The painting showed overpainting under ultra-violet light. The signature was weak. The Moran authority, at first glance, exclaimed, "I

261

wouldn't touch this painting. It's not a Moran." Then he carefully outlined reasons why he felt the painting had not been painted by Thomas Moran. In the meantime, the sponsor of the auction became uneasy and, on his own, returned my friend's check for $21,000.

Aside from the quality of a painting and the reputation of the seller, the first thing required before consummating a purchase is to find out who has owned the painting—a succession of previous owners, if possible—and when and where. Also important is how close the work can be documented as to the artist and his dealers. Many artists signed the back of canvases or frames. Some wrote letters or made notes regarding their works. Dealer identification or labels are often to be found on important works. Many paintings have been reproduced in books, magazines, and art catalogs through the years. Forging Moran's work is not new and occurred during his lifetime so often that he began the practice of impressing his thumb print on the canvas while still wet, usually near the signature.

The foregoing incident reinforces my feelings that local auction sales are not ordinarily the best place to buy expensive art. It is often for auctions that dealers clean out "attics" full of works that won't sell or works they don't wish to be identified with. Auctions often attract the disreputable, who will try to slip in phony wares. The best place, in my opinion, to buy art of any kind is from a reputable art dealer.

An unforgettable experience happened to a good friend of mine at an auction. My friend had two fine western paintings he wanted to sell and there were two paintings in the auction that he wanted to buy. He made the mistake of telling the auction dealer of his intentions. This is what happened: when my friend's pictures came up, they sold surprisingly well and quick. My friend, in turn, had to fight and bid higher and higher to get the paintings he wanted to buy. Thinking of the good prices his pictures had brought and the money he would have available, he felt more relaxed about his purchases.

After the sale, when adding up the bills, the dealer said, "You owe us $11,600 for the two paintings."

My friend said, "That's all right. My pictures brought $9,550. I will write you a check for the difference, figuring in your auction commission."

The dealer explained, "My agents in the crowd bid your paintings up, each thinking the other was a legitimate buyer. Sorry, old boy—they were not sold. I'll hold your check for a few days if you wish—but not too long."

Another incident I was involved in pertains to an Indian portrait by Robert Henri. I doubted that it was his but told no one of my feelings; I was curious about it since the workmanship was so poor. After several letters and telephone calls, I was able to trace the painting through several owners and, to my amazement, ultimately back to the Henri estate.

A number of years ago, a dealer brought in a Charles M. Russell painting titled *The Buffalo Hunt*. It was signed, but undated. The signature was strong yet the work was wretched—weak in drawing, poor and varied in coloring. The dealer offering the Russell displayed a letter from an expert authenticating the painting "beyond a doubt." I told my friend that we wouldn't hang the painting in the National Cowboy Hall of Fame's collection even if he gave it to us. Eventually, a series of collectors and dealers were to buy and sell the painting. The last time around it sold for $80,000 to an uninformed collector. All the while I harbored a feeling that the Russell wasn't genuine. One day I was browsing in the book store of a friend. He said, "Here's a book, Krakel, that might interest you. It's got four plates in it of Russell's work." The first plate I turned to was a reproduction of the picture I had discredited!

Years ago I saw a collection of reproductions of Charles M. Russell's oil paintings, about forty in number, covering the Montanan's greatest subjects. They were owned by a man named Fred Barton,[11] a cowboy friend of the artist. The paintings were copied at Barton's expense by an artist named E. L. Boone. Boone

had copied each painting in an exacting manner but the copies were smaller than Russell's originals. Mr. Barton was delighted with his collection and felt he had paid great tribute to Russell. His hope was that the National Cowboy Hall of Fame would buy the entire collection for $50,000. After seeing them, I wanted the collection for one reason—so that each canvas could be destroyed, removing the possibility that some day an unethical person would represent them as authentic by replacing Boone's signature with Russell's.

As a matter of fact, Barton sold a number of his Boone copies, unsigned, to a San Francisco book dealer in the 1930s. A few years later some of these same paintings, with a forged Russell signature added, were offered for sale in a brochure describing them as "original Russells."

A Pueblo, Colorado banker telephoned me one time to announce that he had just bought Russell's great 1909 oil, *The Wagon Boss*. I said, "That's interesting because we have one here in the Gilcrease collection." I asked him how much he had given for it. The reply was $900. I asked him to describe any printing that might be on his painting. This he did, and soon he heard himself reading, "Aaron Ashley Print Makers." Without further comment, the banker hung up.

I have heard that there are literally dozens of fraudulent black and white Remington illustrations floating about. Rumor has it that a large percentage of these works originated in Chicago. They are in all medias: oil, watercolor, gouache, pen and ink, and pencil. Virtually all of Remington's illustrations can be traced to a published appearance. In my research files on Remington, I have more than 600 printed illustrations. Ordinarily, if everything matches between the original illustration and the published version, it's a safe bet the work is all right. In a case where the painting was reproduced as an engraving, chances for a difference in detail exist since the work is sometimes transferred to the plate by an engraver and not the artist.

Recently an Oklahoma City dealer came to me with two pen

and ink drawings signed "Frederic Remington." The dealer wanted to know what I thought of them. Were they authentic? I recognized both immediately as resembling *Bronco Busters Saddling* and *Cowboy Fun*. The drawings were untitled and each had a figure missing from its composition. In the saddling composition, the copier had deleted the cowboy holding the cinch strap with a light rope and the second rider (also a distant figure) from *Cowboy Fun*. Since the original drawings had appeared as illustrations, a few minutes of research in my personal files produced full blown evidence from *Century Magazine* and some recently published citations. My findings convinced the dealer he should return the drawings to the seller without explanation.

There are many ways of getting into trouble in art. Again, make sure the person you are dealing with is honorable. Years ago I bought a fine painting for the Cowboy Hall of Fame from an art peddler. He had, unbeknownst to me, taken the painting on consignment from the artist's widow, sold it to us, and kept the money. Fortunately we had a bill of sale from the peddler attesting that the painting was clear as to title. When the owner learned the Cowboy Hall of Fame had the painting, she had her attorney write to inform me of her ownership and to demand details of the acquisition. I promptly mailed a copy of our bill of sale describing the transaction. Luckily for us, the widow was a sweet, genteel lady. She paid us our cost and we promptly returned her painting, air freight prepaid.

The stickiest of all Western art subjects is the matter of bronzes. It would be hard to estimate the amount of money that has been made from the sale of recasts of bronzes from such artists as Frederic Remington, Charles Russell, James Earle Fraser, Cyrus Dalin, Henry Shrady, and others. The National Cowboy Hall of Fame, at one time, owned 92 Russell subjects in bronze. However, close to forty of these bronzes were cast from models created by Russell and found in his studio collection after his death. Many of the models served as props for figures in paintings. This is particularly true with his animal subjects and, in all probability,

the artist never intended to cast them. If at all possible, the potential buyer should find out if the work was cast during Russell's lifetime.

Russell authority Frederic G. Renner lists four criteria for judging the value of a bronze: (1) the artistic merits of the piece itself (including its size and whether it has been faithfully reproduced in bronze); (2) whether it was, in fact, cast from a mold of the original model or is a recast from another bronze; (3) the number of authorized casts; and (4) whether the original model is still in existence and, if so, whether it is in a museum with a binding prohibition against any further casting or is in private hands with the possibility of additional castings being made.[12] Each authentic Remington bronze carries a copyright notice, and the cast number is stamped on the underside. A Russell bronze cast today has little or no value in my opinion, since recasts and later castings lack precise detail. In recent times we have been slowly weeding out the Cowboy Hall of Fame's Russell bronze collection. Ultimately we will reduce it to the original fifty-two subjects which were cast during the artist's lifetime.

When the Cowboy Hall of Fame became co-sponsor of the National Finals Rodeo, we wanted to present a grand trophy to the All Around World Champion Cowboy. I thought of the idea of having castings made of Russell's *Bronc Twister*. I took the matter to the Board of Trustees for consideration and recommended that, since we had purchased the C. S. Jones' Collection and it had been a part of the Russell Estate, we in all probability inherited reproduction rights. In support of the matter, I could not find a copyright date on any casting of the bronze listed in a catalog, nor could I gain information from the Copyright Division of the Library of Congress. At our board meeting, I displayed circulars showing Russell bronzes for sale by the Montana Historical Society. In fact, Russells were even being offered cast in silver. The precedence for recasting was in evidence all over the country. Our bronzes were to be trophies and not offered for sale. The Board

allowed that five should be issued. I then brought up a personal matter, asking trustees to allow two additional copies to be made for James Boren, then art director of the Hall, and myself. I said that we had worked hard in getting the Cowboy Hall of Fame open and such a copy would be a bonus for our efforts. The trustees agreed to the idea and thus seven *Bronc Twisters* would be cast in all. They would be properly marked, carrying on the base the name of the National Cowboy Hall of Fame and date of casting; Boren and I were to pay foundry costs for our castings.

The first shock Jim Boren and I had regarding the matter, aside from the inscription on the base, was the fact that we could not, from a distance, tell our original *Bronc Twister* from the casting we received from the foundry.

In time the *Twisters* were presented to All Around World Champion rodeo cowboys Dean Oliver in 1966 and Larry Mahan in 1967. Then suddenly a problem developed. Two art dealers and one Russell expert began raising hell about our trophies. The heat was put on me. I conferred at length with Los Angeles attorney Earl Adams, counsel for the Nancy Russell estate, and learned of our wrongdoing.

The practice of giving *Bronc Twisters* as trophies was stopped. Mr. Adams asked that the mold be broken; he also asked that all the bronzes issued be called in and destroyed.

In our casting venture at the National Cowboy Hall of Fame the motive was not to deceive, nor were the works intended for the public market. However, the lesson regrettably learned was not a happy one.

Recently a friend telephoned, "There are two Remington and two Russell paintings that belong to Mr. _____, now living in New Jersey. Would you go up this weekend and look at them? If they are good and priced right, I will buy the lot and give the Cowboy Hall of Fame the pick of the four." The paintings had been purchased by a once-famous show business celebrity who had been a mind-reader and magician.

The agents for the old fellow were as strange looking a couple as

267

I ever set eyes upon. The pair literally fought and argued about how the Remington-Russell sales melon was going to be split from the time they met me at the airport until we crossed the bridge into Jersey. They knew I had a blank check with me and authority to buy. Glances and signals between them were hilarious. After riding a while, I settled them down considerably by asking if the paintings were oils or watercolors, what were the dates, and the approximate sizes. They didn't know about oils or watercolors. They didn't even know that was important. Before we arrived at our destination, the melon was going to be split three ways, they insisted.

The house of the owner was three stories high, ghastly looking, in disrepair, and badly in need of painting. It had a mysterious look about it. With my two companions, I reluctantly entered. I met the celebrity, a man in his eighties who was obviously very sick and confined to a wheel chair. He was likeable, though, and occasionally conjured up a glint of the charm that had earned him millions of dollars. His wife, who had been a chorus girl, smoked constantly and carried a glass of whiskey as she talked of the good old days in the theater. All floors of the house were filled with cats, books, paintings, statues, bronzes, theatrical memorabilia, and a strong smell. Too many cats and dogs roved at will throughout the house.

The library was filled with Oriental erotica. There were at least 20,000 books, undoubtedly worth two or three hundred thousand dollars, if not more. It was an appalling sight.

The Russells and Remingtons turned out to be among the worst fakes I have ever seen. A large oil, purported to be a Remington, was a copy of the famous *Bell Mare* that hangs in Gilcrease Institute. The back of the painting bore a letter of authentication signed by the son of poet Eugene Field. The owner boasted that he had bought all his paintings from Field in the early 1930s. For years I had heard rumors about fakes attributed to the collection of Eugene Field II; now I was face to face with four of them, with signed bills of sale and one letter. Had the old gentlemen been able

to read my thoughts, he would have told me to get out.

My solution to this predicament was to take pictures of the four paintings and indicate that we would have to study the matter before making an offer—if we did. This was unlikely, I added, since the subjects were unsuited to my friend's requirements. I chose to call a cab for my expensive but nonetheless solitary and comfortable ride back to Kennedy Airport.

Other horrors lurk in the museum world and I have experienced two of them—mutilation and theft of art works—during my career. At Gilcrease, an important Thomas Moran painting was slashed around the edges in an apparent attempt to steal. At the Cowboy Hall, Mr. Ackerman's great Henri, *La Trinidad*, was jabbed with a pencil. Restoration in both instances was expensive but happily paid for.

My story of theft begins in a terrifying manner with the loss of three C. M. Russell bronzes. Deputy Director Bryan Rayburn and I were in California on museum business with Joel McCrea, then vice-president of the board, when I telephoned my office in my usual "how's it going" manner. Jim Phelan, who was chief of security, blurted out, "Boss, someone's stolen two Russell bronzes—one a mule deer titled *Alert*; another, *The Bug Hunters*, of a mother bear and her cub." I couldn't believe my ears. Jim filled me in with the details. Bryan and I concluded our business with Mr. McCrea quickly and headed for the Los Angeles Airport.

The following afternoon we were reviewing the facts of the theft with Phelan in the front part of the museum when a guard rushed up to us and shouted, "Another bronze is missing!" It was *On Neenah*, one of C. M. Russell's horses. Several staff members ran through the museum visually searching each visitor, but to no avail. I telephoned the police. In checking all bronzes on display, we discovered that several others had been pried loose from their wooden bases by some sharp instrument.

In reconstructing the theft with ticket personnel and guards (our force was then limited to five), it was determined that the thefts were pulled off by two young men and a young woman. The

guard had been pulled off to the side repeatedly while the other two worked the collection over, taking what they wanted. The bronzes were obviously dropped into a large handbag carried by the woman.

Bad news travels fast. We made the front page of more of Oklahoma's newspapers than ever before and wire services sent the story nationwide. For the first time millions of people knew that a Cowboy Hall of Fame existed.

A couple of days after the theft, I received a late-at-night telephone call. The voice asked if this was Krakel of the Cowboy Hall of Fame. I said it was.

The voice laughed and then said, "Listen, you sonofabitch. I got your Russells. I want $25,000 or I'll throw them into a river."

I replied, "They're fully insured; do what you want with them."

The person at the other end of the line started to tell me when and where to meet him. I hung up on the voice and telephoned the police.

Our insurance underwriter, Stan Deardeuff, of Ancel Earp McEldowney and Associates, offered a $5,000 reward for information leading to recovery of the bronzes. Mr. Deardeuff repeatedly asked if we didn't want to file a claim. I declined. We had photographs and bulletins announcing our loss widely distributed to art galleries, museums, collectors, and law enforcement agencies. I felt certain sometime and someplace at least one of the bronzes would turn up. Sure enough, about six months later an F.B.I. agent spotted the Russells in a Las Vegas, Nevada narcotics raid. The agent was a Montanan and prided himself on his knowledge of the artist.

We overhauled our security and protective format after the thefts, yet this wasn't the incident that chilled my blood the most. That was to come years later from groups who bombed the museum's west window walls, threatened to blow the head off the *End of the Trail* . . . and sent a message to my secretary that read, "Tell Krakel he dies tonight."

270

Chapter 14

Zeroing in on Values

IN APPROACHING this subject,[1] I am reminded of an incident I witnessed while at Gilcrease Institute. Thomas Gilcrease was serving as guide and lecturer for a group of out-of-town visitors. The situation was normally one T.G. thoroughly relished, since he loved many paintings in his collection as if they were beloved friends. The group being hosted soon proved to be not as attentive as Mr. Gilcrease would have liked. One individual became most irritating and would interrupt T. G. with, "Hey mister, what'd ja pay for this one?" or, "How much would this one bring today?" Followed by a "What is the highest priced picture in the place?"

Those of us who knew Mr. Gilcrease could see his annoyance mounting. Pretty soon his black eyes were flashing mood signals. Finally, he stopped talking and sent a guard for his hat. Once his hat was in hand, he excused himself, stating that he had other business. Then, turning to the irksome individual, he said, "My friend, with your love of money, you should not visit art museums—only the United States Mint." With that, he turned and walked out of the building.

A favorite painting of Thomas Gilcrease's, as mentioned in an earlier chapter, was John James Audubon's large oil, *The Wild Turkey*.[2] Gilcrease loved the painting for many reasons. First of all, he could see in it the superb technique of the artist, particularly Audubon's draughtmanship and his pure genius as a painter. In addition, he admired the artist for his knowledge of

271

birds and wildlife, especially the wild turkey. There are painters today who may be able to paint a wild turkey with skill equal to Audubon's, but the fact remains that this artist devoted his life to the study and painting of wild birds and animals during an important period in America's frontier history when game was a vital source of food. The significance, therefore, of an Audubon work is greater.

In recent times, a trustee of the National Cowboy Hall of Fame told me I had been extravagant in advising a prominent director to purchase Albert Bierstadt's magnificent *Emigrants Crossing the Plains*.[3] The price was among the highest ever paid for a western painting. My critic stated that we could have commissioned a painting, maybe not as big, but of important size and similar subject matter, for one-tenth of the cost. Such an allegation is perhaps true, but a painting of this nature would have had no provenance and no historical value if done by someone who may not survive as an institutionally-sought artist. Albert Bierstadt's reputation as an academician and important painter has been well established. His works are found in all nationally important collections. He traveled the Oregon Trail and sketched scenes for the composition from life. Furthermore, the painting was in its original frame, and the bill of sale from the artist to the first purchaser accompanied the painting provenance. Such factors have been of the utmost importance in building our permanent Western art collection at the National Cowboy Hall of Fame.

I must, however, add a note of caution. Some of the worst fakes are often accompanied by detailed, carefully written statements of provenance that turn out to be equally as spurious as the work of art.

Also mentioned previously as a great treasure at Gilcrease is Charles Willson Peale's portrait of James Madison.[4] Undoubtedly there are other paintings of President Madison that are well executed, but none can touch Peale's, which was painted from life.

Many will argue that the value I place on historical involve-

ment is unwarranted, citing that Emanuel Leutze[5] did not actually see George Washington crossing the Delaware in a rowboat, nor was C. M. Russell witness to the meeting of Lewis and Clark and Sacajawea and the Flathead Indians.[6] Frederic Remington was not a spectator at the massacre at the Little Big Horn. A roster of similar examples could run into the thousands. My point is that Leutze is at least a hundred years closer to the Washington incident than painters of today. Certainly Russell was on the frontier and lived with descendants of Indians who had seen Lewis and Clark. He sketched from life, as did Remington. They were, for the most part, contemporaries of the times and subjects they painted and sculptured.

The distance in time between the subject and the painter's hand contributes greatly to establishing real value. For this reason, many of today's so-called historical paintings have illustrative rather than historical value. They depict scenes. What artist of today has seen a trail drive? Or a gunfight in Tombstone? Or Indians hunting buffalo?

Artists can often be careless and exert almost no effort toward research. I can cite instances where artists have violated history, displaying details in equipment and costume that couldn't have existed at that time in history. This produces unforgiveable errors, such as the wrong number of spokes in a particular kind of wheel or an Indian costume typical of Northern Plains people found in Pueblo scenes. Saddles of various kinds are often misplaced by painters. For example, swell forks in saddles came into use well after the turn of the century, yet I know of paintings of 1880s trail drives that include swell fork saddles.

There are, of course, artists who are exceptions and have become keen students of history, going far beyond ordinary research. One of the finest contemporary examples is Nick Eggenhofer[7] in his study of frontier transportation vehicles and equipment; Nick's book, *Wagons, Mules and Men,*[8] is a classic. A habit of field sketching and research capability are, in my opinion, hallmarks of the artist's integrity. If the artist can't be a

witness to his historical scenes and actually know the personalities, he can at least search out and experience the real terrain, because the geography exists today.

The ability to generalize about an artist's life as well as his work provides a foundation for determining quality and value. Knowledge of the period during which the artist worked is important. One has to know where the artist's work is hanging, be it in a museum or in the collection of an individual. An historical view of the artist's sales as well as his current value is significant. These facts are available from libraries and museums. When I'm asked to appraise a painting, my first step—if I don't already know the artist—is to look him up in a biographical dictionary, then I go to the various art market records. These two sources give me a vital basis. If there are no entries, the omission usually tells me all I need to know.

It is important to learn when and where an artist studied and with whom. There are rare exceptions of the successful artist being "self-taught," but if we delve into such a life, usually there exists a source of inspiration with periods of study or analysis of another's work. I have always felt that C. M. Russell, while in England, was exposed to J. M. W. Turner, the great landscapist and colorist. Certainly Russell's use of color became much brighter from that time on.

It is important to survey the artist's career—to discover what kind of work he was doing at different periods of his life. The seller should be able to determine the period in the artist's life during which the picture was painted. If the painting is dated, a need exists to relate the painting to its creator's situation in life.

Just knowing the bare essentials of the artist's life, however, is not really enough. It has not been for me. In the case of James Earle and Laura Fraser, I researched their lives thoroughly to determine the Cowboy Hall of Fame's course of action. Did the Frasers warrant a memorial? Eventually, my research was published in a book titled, *End of the Trail: The Odyssey of a Statue*.

In the past ten years, I have delved deeply into the talent of

several artists to determine the extent of the National Cowboy Hall of Fame's interest as a collector. My findings were favorable in the case of the Frasers, Charles Schreyvogel, and Nicolai Fechin but unfavorable in regard to other widely known artists. Since I wanted to solicit major works and their studio collections, we had to be sure of the enduring quality of the artists' talent. What if I had asked the Board of Directors for commitments to acquire an artist's work and then later found that his life and talent did not deserve such recognition in the National Cowboy Hall of Fame.

Next to the artist's life and authenticity of subject matter, I consider the manner and quality of the painting itself. Is the basic draughtsmanship sound? Are the figures well drawn and in balance with one another? The matter of perspective is vital. Do the foreground and background figures properly recede with distance? However, in our collection of contemporary works, there are some interesting, successful examples of head sizes on both men and animals that violate the conventional rules of perspective.

I strongly believe that drawing is fundamental to art. Without that ability, an artist is hamstrung. Too often the young artist wants to make it big and skips the years of basic discipline that drawing and sketching can provide. Invariably, when I evaluate the work of a second-rate artist, the problem lies simply in his lack of drawing ability. Where there is a weakness in this skill, it will often be compounded by a poor sense of color values.

When assessing a painting's worth, color values can be equal to drawing ability in importance. In fact, superb color can substitute for poor draughtsmanship and many artists, especially among today's crop who are not able to draw the human figure well, survive on the use of color. Color values depend on the skill with which the artist applies oil paint, watercolor, or whatever the chosen medium. Thus the brush strokes are the paintings' skin, its vitality, and nerve system; the applied paint invokes the living qualities.

Raw or uncontrolled color is usually the tipoff that a work was

not painted by a skilled artist. In most cases, the painting is by a beginner or an amateur. The technique of application is, of course, the hallmark of each artist, and many artists have attempted to duplicate the technique or style of a successful and talented artist. An artist's ability with color should grow with experience and the development of his palette.

The quality of a work of art is determined by many factors. The complexity of the composition, number of figures, what the figures are doing, and the kind of figures shown are to be considered. Certainly it should be easier for an artist to paint horses tied to a fence or a still figure in a landscape than to show complex horse action or physical dilemmas. A painting can be a challenge to an artist because of the number of figures, what they are doing, and the variety of their anatomical positions as well as the setting they are superimposed upon.

There are artists who are simply copyists. I recall visiting a painter in the Southwest who is popular by today's standards. Since my knock at his door was unannounced, I was innocently ushered into the studio by his wife. There stood my artist-friend, bending over a number of Russell prints, "doing his sketching." Copying the work of another artist solves the problem of composition and color values, to say the least. It is easy to take a Will James *Bronc and Rider* and superimpose it on a C. M. Russell background or vice versa. Copy by photographic projection is

Easel by Phil Young

sometimes practiced, but with the experienced eye it is not too difficult to detect.

In looking back down the trail at the "old boys"—say the Taos School of Painters[9] (principally Joseph Henry Sharp, Ernest L. Blumenshein, Oscar E. Berninghaus, Bert Phillips, Nicolai Fechin, Walter Ufer, and Victor Higgins)—one cannot help but admire them and yet have feelings of pity. What tremendous talent they had and yet so little support. They were victims of a harsh art environment. They poured every ounce of talent, skill, and literally their souls into each work, hoping against hope that it would be accepted in the art world. What painters today can match Ufer and his *Sleep*, or Fechin's *Corn Dancer?* How many artists today would tackle a huge canvas with a myriad of figures?

And I'm sure members of the Taos School would stand aghast at some of today's Western art spectacles, where hundreds push into the exhibition area with money in hand, ready to buy! Consider the amount of effort one of today's artists will put into a painting when he knows it will sell in a few minutes. What amount of creativity is really involved in an offering of twenty or thirty works in a one-man show? Research, care, and sincerity are often tossed out the window when the artist is painting for dollars and riding a crest of popularity to the saturation point. Artists can be mishandled by grasping and demanding dealers. The lust for money can damage an artist's sense of values—and can pump his ego up to the point of his believing the lines from his own brochure: "Yes, I am the greatest!"

Thus the supply of paintings, the artist's yield, is to be considered in determining real value. In other words, if the artist has repeated one composition over and over with only slight variations, the worth of your purchase is diminished. Soon the word is going around. Everyone who wants one of so-and-so's paintings has three or four, and they all look alike.

An incident I can recall involved a contemporary painter. He did an oil of a longhorn steer on the trail. The painting was horrible—colors raw, the drawing poor. He confessed that it was

277

one of his worst. I suggested that he paint over it. He replied, "Naw, dealer so-and-so wants one of my paintings. I think I'll send it to him and see what happens." A few days later, I saw him again and he showed me a check for $3,500—four times more than he ordinarily got for paintings of this size, along with a plea from the dealer that he "send another one just like it." The dealer didn't know how to determine real value—or more likely didn't care. So the painting went to an unknowledgeable collector.

It is also helpful to learn who is collecting what. If an artist's work is cataloged in a major museum's collection, it is a fair indication of artistic worth, especially if the painting is on exhibition or travels with the institution's shows. Dealers can advise collectors on works, and frequently do, but half the fun of it is learning for yourself. By collecting prints and color photographs, or by studying plates in books and catalogues, the collector can gain considerable knowledge of an artist's ability. However, many books about artists have been written by historians who have little or no knowledge of art, and thus critical facets of artistic influences and development are sadly ignored.

A study of Charlie Russell's career would show that during his career his ability to paint improved enormously. In his early years, prior to 1900, his works—the majority of which were watercolors—were poorly painted. Figures were usually stiff and amateurish. After the turn of the century, his talent improved and he began painting very well, using darker colors with less bright reds, yellows, oranges, and purple hues. From 1911 on, one notes a decided change in his work. He splashed color—purples, pinks, reds, the golds of sunlight—all over his paintings. Toward the end of Russell's career (he died in 1926), his color values weakened and often became unreal. This may have been due to poor health and failing eyesight. I know of a contemporary painter, now deceased, whose sight problems caused his paintings to run to an over-use of yellows.

One can gain insight into the spectrum of Charlie Russell's work from studying the National Cowboy Hall of Fame's collec-

tion of both oils and watercolors, beginning with some of his earliest works up to those painted shortly before his death. Much can be learned by comparison and study of a lifetime of work.

If everything about a selection of paintings is equal, including provenance, period or date painted, skill, and quality of color, then size is the next important factor. The size and complexity of composition most often determines the amount of work that has gone into a painting.

In collecting for the National Cowboy Hall of Fame, the term "museum quality" becomes significant. That is, a very large painting, because of its size (and assuming it was painted at the height of the artist's career) speaks of value and importance. Works smaller in size may be considered "collector quality." Artists' works vary as much in size as in technique. The larger canvas is a positive commitment to his or her art by virtue of the weeks and months and even years that go into its completion. It becomes a favorite or memorable work. This is not meant to put undue emphasis on large size paintings. Again, quality is the key, and a small painting can be a jewel. Several collections that I have studied in both public and private museums generally lack large-scale compositions, and this weakens the overall presentation.

For example, I know a collection of a famous artist's work, twenty-five or thirty paintings in number, that are all virtually the same size and of the same general subject matter. In viewing the collection, one begins to become bored half-way through—simply from the sameness and the repetition.

To illustrate the contrast achieved with variety of size and theme, in the National Cowboy Hall of Fame's collection of Fechin's works, we have his small self portrait and a large 50 by 50 inch painting of his wife and daughter. Also included is a major work created when he was a student at the Imperial Academy in Russia, significantly titled *Bearing Away the Bride*. Two more comparatively large oils give balance to our collection. Many collectors and museums make the mistake of not seeking variety

in size as well as in subject matter.

It is, of course, a matter of individual taste, but as a rule of thumb I would rather have one fine example of the artist's talent than a bushel of run-of-the-mill works.

I feel it is a mistake to mix contemporary works with historical works in a museum gallery. I see little validity in hanging a contemporary painter's buffalo hunt with a Carl Wimar,[10] dated 1860; or to arrange Seth Eastman's[11] *Osceola As A Captive*, painted in 1836, beside a contemporary artist's hostage scene. The greatest narratives are those constructed at the time by the hand of the eyewitness or participant. Mixing the two together, in the same gallery, is like mixing oil and water. They are not one and the same, nor are they of the same values. If the contemporary artist's quality surpasses the skill of the artist of long ago, then it will equalize itself in demand and pricing.

As Mr. Gilcrease used to say, "No amount of conversation or writing can add or detract from a work of art's original worth."

Author Willa Cather said it all when she compared painting with writing:

> Art, it seems to me, should simplify. That indeed is very nearly the whole of the higher artistic process; finding what conventions of form and what detail one can do without and yet preserve the spirit of the whole so that all that one has supressed and cut away is there to the reader's consciousness as much as if it were in type on the page. Millet had done hundreds of sketches of peasants sowing grain, some of them very complicated and interesting, but when he came to paint the spirit of them all into one picture, *The Sower*, the composition is so simple that it seemed inevitable. All the discarded sketches that went before made the picture what it finally became and the process was all the time one of simplifying, of sacrificing many conceptions, good in them- selves, for one that was better and more universal.[12]

Chapter 15

The Oath

THE WESTERN ART scene at the National Cowboy Hall of Fame in the spring of 1972 should have been peaceful. After all, Jasper had bailed us out when he agreed to purchase $900,000 worth of the million dollar art bond issue. The Kerr Foundation had taken title to the Nicolai Fechin collection of paintings for an amount of $456,000, also paying for construction of the elegant cases and installation of the studio exhibit. Our permanent art collection was growing in importance, and we had successfully launched a number of educational programs.

In addition, I felt somewhat liberated from my obsession with Western art because my friend Luther Dulaney[1] persuaded me to sign an oath pledging that I would not commit the Hall to further high value art acquisitions. While we laughed and joked about it, Luther was serious. Later I became regretful at having signed and sworn to such an oath—if I was to live up to this commitment, a major driving force in my life would cease to function. The chase was what really made me tick. Luther's logic was right, but could I hold myself to it?

I owed the same vow to Mr. Ackerman, who had become the real hero of my art plight. I shall never forget the startled look on Jasper's face that day in Oklahoma City when I first told him that the total owed by Western Art Fund for all the paintings, bronzes, loans, and interest was almost a million dollars. I had delayed telling him for as long as I could, and at the time we were alone in

the elevator on our way to have lunch and discuss the entire matter with Mr. C. A. Vose, the First National Bank's board chairman. The elevator was my last chance to briefly review our problem before we got down to the facts of the case.

Aside from negotiating for major Western art acquisitions, there was the day to day operation of the museum: making ends meet financially, co-sponsorship of the National Finals Rodeo, our Western Heritage Awards and numerous contemporary art programs, not to overlook my working relationship with the board.

The subject dearest to my heart (on the job) is Western art. In my mind, the Cowboy Hall of Fame's collection had a strong beginning, but we had no representation from the Taos or Hudson River Schools. We were weak in items of major sculpture. We needed works by masters George Caleb Bingham, Thomas Eakins, Eastman Johnson, and prestigious names like Winslow Homer, James McNeill Whistler, and others. Even so, I lived up to my oath with Luther that summer and in doing so, we lost two crown jewels. One was Frederic Remington's rare bronze, *The Old Dragoons of 1850*[2], and the other a buffalo hunt scene painted by the renowned Rosa Bonheur.

I had first gained contact with the Bonheur painting when browsing through an old 1908 catalogue of the collection owned by the great art patron, George A. Hearn.[3] At that time, Mr. Hearn owned such notable European works as *The Blue Boy* by Thomas Gainsborough and Peter Paul Rubens' *Christ Giving the Keys to Peter*. Within a few weeks after I acquired the Hearn catalogue, the Bonheur buffalo hunt painting surprisingly appeared for sale in *Kennedy Galleries Quarterly*. Upon seeing it, I telephoned my friend Rudolf Wunderlich and asked the price. It was $50,000.

There was no question about passing up the *Dragoons* bronze and the Bonheur painting, but it meant we had lost two quality items. The next work to rear its beautiful head and gain my attention was an Alfred Jacob Miller oil. A telephone call about the Miller from Baltimore art dealer James McCloskey threw me completely off my art diet. If it was authentic, the price was right.

McCloskey told me the painting had never been cleaned.

"It has a hundred years' grime on it and you can barely make out the figures," he said.

"Send it out," I replied hastily, "it won't take me long to make up my mind."

Sure enough, the painting was a fine Miller. Having been closely attached to the Gilcrease Millers[4] during my years there, I knew what one looked like. Baltimore had been the artist's home, site of his studio for years. Such a find as McCloskey had made was indeed plausible.

I could barely make out the horses' heads in the painting but what was visible convinced me. Miller's horses have a distinct look about them—overly romantic with an unmistakable Arabian head. The central figure on the horse was Sir William Drummond Stewart,[5] of Murthly Castle, Scotland, who was the expedition's sponsor and patron saint. The Wind River mountains formed the backdrop for the composition with what was later to be named Fremont Lake in the foreground. Stewart made a number of trips into the unspoiled West in the 1830s. On his last expedition in 1837, while in New Orleans, he hired Miller to accompany him.

Stewart, his entourage of frontiersmen, and Alfred Jacob Miller witnessed one of the last grand rendezvous in the trade fair between Indians, fur trappers, and company traders. Few frontier events equalled it for color and pageantry. Miller was first to paint in this remote part of the unsettled West, while Catlin and Bodmer painted Indians and upper Missouri River scenes in the 1830s. Like theirs, Miller's contribution in this pre-photographic period was historically valuable. After several weeks' work, the artist created a large reservoir of sketches, drawings, rough draughts, and notes from which he would paint not only for Stewart but to sell intermittently during the rest of his life.

The painting offered to us was a beautiful presentation. Without hesitation and forgetting my pledge to Luther, I negotiated a bank loan in the name of the National Cowboy Hall of Fame for the amount of the painting and wired it to McCloskey.

The next thing we did was to ship the painting by air freight to the firm of Raymond Lowey in New York to have it cleaned and examined. My friend Hilly Shar, an outstanding conservator, would do the work. Within a few days Hilly called to tell me what I knew had to be: purple and pink mountains, a caravan of figures, carts, horsemen in the distance, a lake and, of course, in the foreground, Sir William Drummond Stewart in buckskin astride his horse. This was not just any Miller painting.

A year or so later I was able to repay the loan for the painting out of a sizeable gift from Mrs. Grace Werner of Casper, Wyoming. The bequest was in memory of her late husband, Herman,[6] who was a trustee and had been active in the Hall's operation. The fact that Mr. and Mrs. Werner were residents of the state depicted in the painting gave it added sentimental value. Discovery of the painting, labeled with the Werners' name as donors, during a social event at the Hall was a pleasant surprise for Mrs. Werner.

No one—not even Luther—could quarrel with my belief that the Cowboy Hall of Fame should have at least one good Oscar Berninghaus[7] oil as well as an important painting by Joseph Henry Sharp, both of the Taos School. During the summer of 1972, works by these artists came through our portals.

The Berninghaus, titled *Forgotten*, shows snow-covered horses at a hitching post in front of a western saloon—a fine mood painting. Frederic Remington had painted a similar scene. The Sharp was a superior painting with finely drawn Taos Indians participating in the green corn fertility ceremony.

On the first go around to acquire the paintings, I floated personal loans. The Berninghaus was bought from Fred Rosenstock of Denver and the Sharp from Jim Khoury of Amarillo. The prices may have set records at the time but both were of the quality I wanted, especially the Sharp. I felt we owed Jim Khoury an "extra" five grand in the price for the good deal he had given us on our Couse painting years before. When I felt the moon was in the right position, so to speak, I took up the matter with the Board

Luther T. Dulaney by Clark Hulings

of Directors. I showed photographs of the paintings, bills of sale, and my cancelled checks, then was given authority to pay off my loans and place both the debt and the paintings on the Hall's books as assets, working out a payment plan through the bank. In my mind this was buying paintings the hard way, especially when I recalled acquiring the entire Leigh studio for Gilcrease Museum—hundreds of paintings, drawings, sketches—all free! But that was in 1963. In fact, Mr. Gilcrease had acquired his entire J. H. Sharp collection of more than 150 paintings for less than $50,000.

In the coming years I was to fish for some more art dandies. But during 1972 I found myself spending a great deal of time thinking about the annual Cowboy Artists of America[8] exhibition and our association with these artists. We had sponsored their first exhibition during the fall of 1966. In a sense, the Hall and the organization's twenty-five or so members had grown up together. But now our relationship was festering.

It appeared to me, even during the early years of the show, that the Cowboy Artists of America organization was somewhat inflexible. Each show of paintings and bronzes was virtually a carbon copy of the previous year, with a large percentage of the winners coming from the same group. The case was one of a certain amount of inbreeding, with the Cowboy Hall of Fame putting its stamp on the entire affair as if we recommended each work exhibited.

Jim Boren and I frequently discussed the question of the show's overall quality. In fact it was a favorite topic whenever I met with leading CAA members. Charlie Dye and I often talked about it and corresponded on the subject. On February 14, 1968, Charlie wrote to me concerning the 1967 exhibition:

> I was not pleased with many of the pieces shown, both paintings and sculpture. Going on the angle that a few rotten apples will spoil the whole barrcl, it is my idea that something should be done to improve the overall quality of the show. In getting the organization started by using transparencies to judge quality was a basic mistake. By the present method of accepting members we will not repeat that boner. We sure

> can't get rid of those members that we originally accepted. The only way we can assure that the annual exhibit is of top quality would be to jury the entries.

The matter of prejurying the show was touchy to say the least, and it could seem that at least one-fourth of the CAA members didn't measure up in basic talent. In the end, Dye was to blast me with, "It's one for all and all for one and to hell with any sonofabitch who tries to break us up."

I had first conceived of the specific idea of a National Academy of Western Art in December 1968, when I presented a paper and film on James Earle and Laura Fraser before a national art society. Disappointed in the society from an organizational standpoint, I concluded that if American art depends upon groups like this, there is little hope. My next thought was to form a strong art organization for the West. This idea dovetailed with my feelings about the Cowboy Artists of America.

In making plans for the 1970 show, I asked for a meeting in Albuquerque with officers of Cowboy Artists of America. Rich Muno and I flew over for the meeting. Our plans for the show were well received but any thought of introducing added talent or an academy idea into the show met with opposition. Doing the only tactful thing I could, I backed the idea out of the meeting. The plans were finalized and our arrangements pleased the CAA's president. The judges would be Fred Rosenstock, Harold McCracken, Senator Barry Goldwater, and Robert Rockwell [9]

A major addition to the exhibition was the inauguration of a seminar program, billed as the "first national convention recognizing art of the American West". The seminars would be scheduled from Friday morning until 3:30 on Saturday, with the art exhibition opening at 6:30 that evening. Sunday was to be highlighted with a breakfast, ground breaking for the Payne-Kirkpatrick Memorial housing the *End of the Trail* and the Frasers' collection, then followed by a bus trip to Woolaroc Museum near Bartlesville, Oklahoma.

The program, therefore, was to be broader than just the art

show. An addition to the awards program was the recognition of outstanding writing and publishing which featured Western art. Additionally, it gave us the chance to spotlight personalities in the art field.

I laid two eggs during that weekend. One was an attempt to establish an organization of Western art dealers and the second was my idea for a national academy. I could wait for another day to gain acceptance of the national academy idea—and did. As far as trying to organize dealers who specialized in Western art, I would never try anything so foolish again.

The exhibition, seminars, and trip to Woolaroc came off very well.

The *Sunday Oklahoman*, June 14, 1970, reviewed the awards banquet in detail:

> Top honors in the field of western art were presented Saturday night at a banquet climaxing the two-day meeting of the Cowboy Artists of America in Oklahoma City.
>
> Awards to western art patrons U.S. Senator Barry Goldwater of Arizona and Dr. Harold McCracken of Cody, Wyo. were a high point in the presentations to nine top Western artists and three Western publications at the National Cowboy Hall of Fame and Western Heritage Center.
>
> Dr. McCracken, director of the Whitney Gallery of Western Art in Cody, received the Center Trustees' annual Gold Medal Award for a lifetime of devotion to the West and its art.
>
> Sen. Goldwater, a long-time collector of Western art, received a custom-made Winchester Cowboy commemorative carbine.
>
> Some $16,000 in prizes, honorariums and medals were presented to the top nine art entries in the exhibit, a display of 120 Western works which were previewed by the 500 guests before the banquet.
>
> Making the presentations were the judges, Sen. Goldwater; Dr. McCracken; Fred Rosenstock, the noted Americana book dealer and publisher of Denver, Colo.; and Robert Rockwell, a gallery owner of Corning, New York.
>
> Paul Weaver, owner of Northland Press, Flagstaff, Arizona

received a special medal for his firm's book, *Olaf Wieghorst*, a biography of the famous El Cajon, Calif. artist.

Jerry Mason, editor in chief of *American Sportsman* magazine published by the Ridge Publishing Co. and American Broadcasting Publications of Chicago received the special medal for outstanding periodical article about western art, the magazine's spring 1969 article, "John Clymer's West."

Red Fenwick, Denver Post columnist, accepted a special medal for the paper's outstanding coverage of western art.

Winner of the best oil painting award of $5,000 was John Clymer of Teton Village, Wyo., who painted *Land of Plenty*.

Best sculpture award of $4,000 went to Robert Scriver, of Browning, Mont., for *An Honest Try*. James Boren, of Oklahoma City won $3,000 for the best watercolor, *When Saddles Creak*, and Brownell McGrew, Cottonwood, Ariz., won $2,000 for the best drawing, *Sam Billie, A Navajo*.

Second place winners, presented with silver medals and $500 honorariums each, were: Oil painting, *In the Valley* by Brownell McGrew; sculpture, *Thanks for the Rain*, by Joe Beeler, Sedona, Arizona; watercolor, *Way Station-Morning Stop*, by Byron Wolfe, Leawood, Kansas; and drawing, *Night Horse*, by Tom Ryan, Lubbock, Texas.

Luckily, I don't spend time reflecting or brooding because the fifth annual summer art show had its share of back lash and gossip. Little did I realize at the time of the exhibition how, in the eyes of some, I had been thoroughly trounced. Charlie Dye was to take credit for stopping the academy concept, writing to a widely-known art dealer:

I am enclosing the original program. I have underlined when Krakel intended to toss his bomb. Well, I pulled every fighting trick I knew and later on Friday he changed the program and stated that "_____, _____, _____, _____, and Charlie Dye would discuss the Academy of Western Art." This really gave me the opening for a right hook. I let it be known that I sure as hell was going to shoot his idea full of holes when I got up to talk and to hell with the Trustees. Anyhow, somebody told Krakel that I was really going to raise hell in general. He wilted on the stalk from then on . . .[10]

By this time, my relationship with several of the artists was strained to say the least. From then on it seemed that no matter what I said, it was distorted. Among the jabs that came my way I remember, for example, "How famous can the CA's make the Hall?" Failure of several artists to attend our "Meet the Winners" cocktail party after the awards banquet further caused my hackles to rise.

A few days later, I had a hard time fully justifying to members of the Art Committee almost $20,000 worth of bills relating to art purchases and expenses for the weekend. Chairman Luther Dulaney declared he was "fed up with the whole damn mess." My report to our directors on the overall sales volume of the exhibition helped blow things higher than a kite. Many artists' prices had doubled since 1966. The board really stuck their spurs in me over the fact that the Hall didn't get even a slight operating commission from sales—a beef I felt was fully justified.

Early the following spring, plans for the 1971 Annual Summer Exhibition and Seminars were again completed. By this time, our staff was highly seasoned; each knew their job. We moved the seminars to the Hall with emphasis on papers by the next of kin of great Western artists. During the day and a half session, speakers talked about Frank Tenney Johnson, Ed Borein, W.H.D. Koerner, Nicolai Fechin, Solon Borglum, Winold Reiss, Harvey Dunn, and Phimister Proctor. This was perhaps one of the most successful and interesting seminars ever held on Western art. More than 350 registrants listened intently to each speaker. We were giving the weekend more depth than just an exhibition; the value of the seminars, followed by a tour of Gilcrease Museum the following Sunday, gave our friends a full measure of Western art.

The Sixth Annual Show featured 103 works averaging $2,964 each. Judges were Paul Rossi, then director of Gilcrease Institute; Albert K. Mitchell, former board chairman of the National Cowboy Hall of Fame; Eugene Kingman, associate director exhibits design and curator of art for the museum at Texas Technological University in Lubbock; and Mrs. John Kieckhefer, chairman

of the Phoenix Art Museum's Western Art Association. Paul B. Strasbaugh, Oklahoma City Chamber of Commerce executive, and Mrs. Strasbaugh hosted the judges.

More than 550 artists, writers, historians, gallery owners, museum curators and directors, collectors, and Western art lovers were crowded into the large exhibit hall for the ceremony. It was an evening charged with excitement and expectation. Board Chairman C. T. McLaughlin of Snyder, Texas was emcee for the evening. The program opened with presentation of silver medals for outstanding contributions to Western art through publication. The book award was given to Robert Karolevitz for his biography of Harvey Dunn, *Where Your Heart Is*.[11] Joe Stacey,[12] associate editor of *Arizona Highways* magazine, received a medal for publishing an article titled, "The American Cowboy."

The art competition awards were presented by members of the jury. First place winners received gold medals and purchase prizes with the work of art becoming a part of the Hall's permanent collection. Second place winners received silver medals and honorariums of $300.

The winning entries were:

> First Place, oil ($5,000): *The Good Life*, James Reynolds
> Second Place, oil: *Old Blue Heading Home*, Charlie Dye
> First Place, sculpture: ($4,000): *Pay Window*, Robert Scriver
> Second Place, sculpture: *Algonquin Chief and Warrior*, Harry Jackson
> First Place, watercolor: ($3,000): *Beneath the Cliffs of Acoma*, James Boren
> Second Place, watercolor: *The Posse*, Donald Teague
> First Place, drawing: ($2,000): *The Heritage*, Tom Ryan
> Second Place, drawing: *Boss of the Rough String*, James Boren

The Trustees' Gold Medal for an outstanding contribution to Western art was presented to my friend William F. Davidson, executive vice-president of M. Knoedler & Co., by Board President Jasper D. Ackerman.

The summer was a hot and long one, with more than the usual amount of gossip in the air. A meeting of the Board of Directors and Trustees held in Colorado Springs took up much of my time. In addition, we had some exciting plans underway at the Hall.

A sort of lull in our art world prevailed. During the first weekend of the National Finals Rodeo held in December, we invited officers and board members of the Cowboy Artists to a luncheon at the Hall to discuss our relationship. Artists present were William Moyers,[13] president; George Marks, vice-president; Ned Jacob, secretary-treasurer; and Joe Beeler, past president and board member. Representing the National Cowboy Hall of Fame were Jasper Ackerman, C. T. McLaughlin, Chope Phillips, Robert Norris, William D. Harmsen, Bryan Rayburn, Richard Muno, and myself. The meeting was held to discuss the forthcoming 1972 exhibition, and a number of matters were talked about openly and cheerfully. The artists were laudatory about past exhibitions and our relationship. I suggested the possibility of inviting a few other artists to exhibit with the CA organization but the matter was not favorably received. Mr. McLaughlin asked President Moyers what he thought of the Hall getting a ten per cent commission from the show's sales. Moyers replied that such an arrangement would be contrary to the organization's by-laws; therefore, a matter of this nature would have to be referred to CA's membership. The meeting, while sociable and pleasant, resolved nothing as far as our future together was concerned. From my point of view, it was good to have our directors talk with the artists. The artists' attitudes on issues vital to us were no longer my own interpretations.

On March 24, Rich Muno, Bryan Rayburn, and I drove to Albuquerque to meet with Moyers, Marks, Jacob and Gordon Snidow.[14] Details for the 1972 exhibition were laid out with no notable changes. The artists agreed to appoint a business manager to take charge of their sales; since the Hall received no commission, there was no point in running sales through our accounting department. We reviewed the judges with the officers, recom-

mending Earl Adams, Arthur Mitchell, Joe Stacey, Thomas Buechner,[15] Michael S. Kennedy,[16] Robert Rockwell, and Bill Harmsen. Hosts would again be Mr. and Mrs. Paul Strasbaugh.

The seminars and activities were outlined as part of our plan. Under Bill Moyers' fine leadership, things went smoothly. We responded well to him and he to us. Promotion of the exhibition was so effective that, in spite of efforts to hold banquet ticket sales down, we gave in, one table at a time, until we were soon near our seating maximum of 650.

The seminars opened on June 9 with about four hundred participants registered for the ten sessions. The entire program was outstanding, beginning with a talk by Thomas Buechner on Norman Rockwell; Earl C. Adams offered a revealing study of the casting of C. M. Russell bronzes. Arthur Mitchell presented an unforgettable talk on, "The Painting Game As I Remember It."

The awards banquet held the usual excitement and suspense. John Clymer gained his second first prize award with his oil *Moving Camp*, while Donald Teague won the first prize for watercolor with *Waiting for Trouble*. Bill Moyers earned his second gold medal in the bronze category for *The Price of a Herd*, and Robert Lougheed took his third gold medal in mixed media with an acrylic titled *Wearing the Bell Brand*. As winner of the drawing category, Brownell McGrew, another familiar face, came to the rostrum for his charcoal, *Hosti in Chischille*.

The second place winners were Jim Reynolds, oil; James Boren, watercolor; Joe Beeler, sculpture; Melvin Warren, mixed media; and Ned Jacob, drawing.

The Trustees' Gold Medal was presented to our great friend Robert Rockwell, with the citation signed by President of the Board Joel McCrea.

While the show ended on a successful note, it was obvious to Rich Muno and me that most of CAA's membership felt their independence stoutly.

True, the Cowboy Art Show was a big summer attraction, but polls revealed that less than three per cent of our summer

293

attendance could identify with the Cowboy Artists organization, as contrasted to twenty-two per cent who knew C. M. Russell and nineteen per cent Remington. A whopping seventy-six per cent could identify with the *End of the Trail.* During the seven years we had sponsored the exhibition, the Hall and our friends purchased more than $125,000 worth of art, while we spent more than $85,000 on the banquet and seminars. Promotional costs for public relations alone were in excess of $12,000.

We had pulled the Cowboy Art Show together and started it rolling to success. The honors awarded bore our image engraved onto our medals. We worked hard at promoting the CA program and membership the year round, mailing out news releases with photographs and featuring the show in our new magazine, *Persimmon Hill.*[17] In addition we absorbed the extensive cost of sending a travelling contemporary Western art show long distances throughout the West.

There is no easy way out of some relationships. But if we were going to sustain quality, stabilize finances, and create a vital, growing organization that was broad in its interpretation of the West and not just a cowboy-oriented group, it was apparent that we had to cut the knot. Once the knot was cut, the newly-established organization might not necessarily insure quality. How many good Western artists were there in the country? Who would paint landscapes? How many CAA members would stick with us? How about the art dealers and collectors? What would their attitudes be? The magazines and newspapers—how would they react? There were those on the board who collected CAA paintings and sculpture. Some made speeches and, in effect, said, "If you have a winner, why change?" Another, "To hell with principles." A friend cautioned, "Lose the show and you will lose your summer art exhibit momentum."

The decision to break came about in a rather strange manner. I would have called for another meeting with the officers in CAA, or at least a telephone meeting with those whom I thought were still my friends. But again I had to hark back to the unsuccessful

meeting held in December 1971 with CA's officers. The situation came to a boiling point for me after going through the catalogue for the Post, Texas show,[18] a combined steer roping and art exhibition held September 30 and October 15, 1972. I counted twenty-three Cowboy Artists members participating in a showing of thirty-one artists. In many respects it *was* a CAA show, with over two-thirds of their membership entered. There had been other exhibitions in which CA's participated that needled me; in fact, a show held the previous spring saw nine CA's among forty-four artists. Such participation was in direct violation of the agreement we made with the organization, spelled out to the membership in a June 19, 1970 letter by then President Tom Ryan. The terms were as follows:

> The Agreement:
> 1. An annual exhibition of the voting membership shall be held at the National Cowboy Hall of Fame in 1971. Details of said exhibition such as display of art, judging of art, the awards, and general conduct of the exhibition shall be the responsibility of the Cowboy Hall of Fame as sponsors of the exhibition. The membership may advise if asked, but final authority belongs to the sponsor of the exhibition.
> 2. A pre-jurying of the art entered into annual exhibit will be made by a panel of judges who will be selected from the membership of CAA. We will pre-jury our show with a firm hand.
> 3. No more than 4 or 5 members may exhibit as a group at a museum, or public institution, and/or gallery outside the National Cowboy Hall of Fame. We may not exhibit as the Cowboy Artists of America in these groups shows. We may be referred to as members of the Cowboy Artists of America in this type of group show.
> 4. The annual CAA exhibit at the National Cowboy Hall of Fame will be our only official exhibit of the Cowboy Artists of America.
> 5. The National Cowboy Hall of Fame will have catalogue rights.

I met with Luther Dulaney to show him the O. S. Ranch catalogue and the list of exhibiting artists and then read a copy of

Tom Ryan's letter containing our agreement. Added injury lay in the fact that the artists were giving the ranch a commission on sales. The Hall drew no commission from sales during our shows and this had become an increasingly touchy subject among board members in light of the kind of awards banquet we held to honor the artists, the medals we had designed and struck, the cash purchase prizes, and promotional costs. Mr. Dulaney grew mad as hell and, openly challenging me to terminate our relationship, snapped, "You don't have the guts!"

Our board members met September 19 in Mr. Dulaney's office with Joel McCrea presiding. The facts of the 1972 show were reviewed, then Luther talked about the O. S. Ranch affair at Post, Texas. Considerable discussion followed. A motion was made by C. T. McLaughlin and passed unanimously to dissolve the National Cowboy Hall of Fame's relationship with the Cowboy Artists of America via letter. Dulaney said, "Dean, when you get your letter drafted, I want you to call and read it to me." This I did.

My letter, dated September 28, 1972, read in full:

> Mr. U. Grant Speed, President
> Cowboy Artists of America
> 245 North 300 West
> Provo, Utah 84601
>
> Dear Grant:
>
> At the Board of Directors Meeting held here recently, members voted to dissolve our relationship with the Cowboy Artists of America, and replace it with an annual exhibition, titled, The National Academy of Western Art. A great amount of discussion, study, and contemplation has gone into this.
>
> The National Academy of Western Art will broaden the basis of the annual summer show. I don't see how we, or quality Western art, can grow under the present arrangement. Directors and Trustees feel that we must transcend the membership of CAA's group.
>
> Gold Medal first prize winners of the past exhibitions will be individually invited to this exhibition as well as many of

CAA's members who have not won medals. The recommendation is that medal winners will be elected acadamicians by the National Academy of Western Art Board of Trustees. A Medal for the Academy will be struck. The Academy's Board will be made up of those who have made outstanding contribution to Western art as well as Directors and Trustees of the National Cowboy Hall of Fame.

We hope that this will prove to be an important step in the elevation of Western art to a new and higher plane. Whatever the reaction among CAA members I know we are committed to this new format. We have worked for and with CAA officers these past seven years and jointly produced outstanding programs and great exhibitions. More than one million visitors have seen these exhibitions through the years and tens of thousands have viewed the road shows. Our role has been devoted to contemporary Western art, devoid of commissions.

We feel that the seminars have become an important part of our role as an Institution. There has to be more substance for the National Cowboy Hall of Fame than an art show. More seed has to be put in the Western arts soil than has been in the past, if it is to survive with character. Artists look at things from a personal basis, which is all right. Here we at the National Cowboy Hall of Fame look at the broader framework and try to think what might be down the road for Western art.

The show at Post caused us to review our line of thinking more than any other factor. With 23 of CAA's members showing there, the luster of the once a year meet-them-all exhibition here is obviously gone. We would not have thought of holding a winter show inviting 23 non-CAA members . . . in competition with the CAA Exhibition "presented" here, thus helping to keep the show here unique. That is, of course, another matter. A policy statement, however, was issued, I assume by direction of the Board or Membership of CAA (Summer 1970) that assured us no more than four or five CAA members would show together at any one time.

Should you wish to talk to Mr. McLaughlin, Chairman of the Art Committee, me, or members of the Board about the National Academy of Western Art, I know it can be arranged

at a mutually convenient time. I thank you for what you have
done these past months.

Sincerely,
Dean Krakel
Managing Director

I had misgivings about the manner in which we terminated our
relationship with the Cowboy Artists, but never regrets—though I
knew there would be much hell to pay. If nothing else, we had set
the Western art world buzzing. The mail poured in, some of it
from notable citizens and mostly critical. Among the stacks
received each week were some amusing letters—one lady even
accused me of booting the Cowboy Artists from the Hall show for
trying to help orphan boys. I tried to maintain a low profile;
admittedly, there were a lot of talented critics in the woods.

Even though I had talked of an academy for years, I was not
comfortable with the face to face reality of it. While experience
was on our side, my definitions of an academy were still vague. I
didn't want to see policies and hard lines drawn in the beginning;
during the formative months or even years, our new organization
would be on a pragmatic basis.

The first step needed would be to create the National Academy
of Western Art organization. Trustees of the academy, I felt,
should consist of representatives of the art world, collectors,
dealers, artists, critics, and publishers meeting with the Hall's
committee and staff. Trustees of the academy were to be
appointed by the Board of Directors; terms were set at two, four,
and six years. In theory, one-third of the Board would be up for
re-election every two years. The Hall's art director would serve in
a major capacity while our business manager would be ex-officio.

This structure would formulate programs and provide repre-
sentatives to meet with artists who were elected academicians.
Ultimately, it would be a committee of academy trustees and
artists who would determine such matters as who would exhibit.
This committee in turn would also recommend to the Board of
Directors names to be considered for election as life academi-
cians.[19]

298

The question foremost in many minds concerned the nature of our relationship with the artists. We planned on developing an equitable, give-and-take cordial relationship of reasonable people working together for the betterment of Western art. I was convinced that a mixture of artists and knowledgeable laymen was needed—in fact, imperative. Strong businessmen-collectors— authorities like Luther Dulaney, Jasper Ackerman, William G. Kerr, Harrison Eiteljorg, Robert Rockwell, Malcolm Mackay, Rudolf Wunderlich, and C. T. McLaughlin—could only enhance any organization.

The proof of this working concept of collective judgment is seen in the quality of the National Cowboy Hall of Fame's permanent collection and particularly in those outstanding works chosen from CAA exhibits. The heat to accept unworthy art has been put on us many times. Our holdings, our exhibits, stand as open verification of the axiom of quality.

Quality and talent, I believe, have reigned at the Cowboy Hall of Fame in art, rodeo, western films, literature, or whatever. Whether an artist who competed in our exhibitions was an actual cowboy or not is of no consequence. Gary Cooper was not a real-life cowboy, but he acted well in cowboy roles and thus was elected to the Hall of Fame of Great Western Motion Picture Performers. Allowing the show to continue as our annual competitive summer event would be like picking thirty rodeo cowboys and saying, "You thirty will be in the National Finals each year from now on . . ." Our concern with the level of quality had been discussed around our place from the beginning. In fact, along with the question of prejurying exhibitions, it was the most frequent topic of art conversation.

In our NAWA show we wanted a professional organization and competition—competition that would clearly emphasize talent by offering the highest and most thrilling art award ever, an award that would literally turn the Western art world inside out. The Prix de West[20] offering was announced more fully after selecting artists. It carried $18,000 in cash, a trip to see Europe's great art

museums (worth several thousand dollars), and a $1,000 western clothing gift certificate. To our knowledge, there had never been an award like it. We were returning much of the sales' commission money (twenty per cent) from the show back into the program. This was to be the most professional Western art show ever held.

In my personal files, I have folders on more than nineteen hundred artists. From this number, we picked about seventy-five to consider—not necessarily artists who had used western subject matter, but who might, in terms of talent, qualify for the exhibition. With the assistance and recommendations of several friends, we mailed invitations to this list of artists, under Joel McCrea's signature. We would try out a few of the artists for maybe one or two years at the exhibition. Among the first invitations mailed were those to Cowboy Artists who had won our gold medal or first prize during the past seven years. We limited ourselves to the top winners. From the Cowboy Artists membership, painters Robert Lougheed, John Clymer, Ned Jacob, Brownell McGrew, and Donald Teague responded favorably; also, sculptors Harry Jackson, Bob Scriver, and John Free accepted invitations, as did Nick Eggenhofer.

In assembling the first group for the National Academy we took a broad look at art as well as the Western art field. We wanted to exhibit not less than thirty artists, with a variety of subject matter, predominately western.

Robert Lougheed's experience and knowledge of art and artists was of inestimable value to Richard Muno and me; we were frequently on the telephone discussing this or that artist, with Bob constantly stressing quality. I felt that there should be a mixture of professionalism as well as younger talent. From more than seventy-five applications, we accepted twenty-four.[21] Our first piece of literature was a large color folder announcing the Prix de West and our Western Art Seminars. With such exciting painters in our National Academy of Western Art show as Clark Hulings, Tom Lovell, Bob Kuhn, Morris Rippel, Robert Rishell, Conrad

Schwiering, Bettina Steinke, and John Stobart along with Robert Lougheed, John Clymer, Nick Eggenhofer, Brownell McGrew, and John Free, how could we miss?

Bettina Steinke wrote she was so nervous that she could hardly paint. Clark Hulings said he was walking the floor over it; Tom Lovell wrote that his shoulder was to the wheel. Modest, unassuming Robert Lougheed telephoned, "Gee, Dean, I'm terribly excited." A young artist not in the show said he intended not only to be invited but dreamed of someday winning the coveted Prix de West.

Two weeks before the opening, we issued our first academy newsletter, "The National Academician," which was to become the written voice of NAWA. In the first issue we attempted to summarize the talents of all the exhibiting artists. It is hard to describe the deep excitement we all felt as the date of the exhibition drew near and the sheer pleasure we experienced in working with this fine group of artists.

To parallel the development of the exhibition plans and Western art seminars, we devoted an entire issue of *Persimmon Hill* magazine to the academy. Ed Muno, our associate editor and designer, had only six weeks to get the issue out. It had to be outstanding and it was. In this issue I wrote of the basic goals of our new venture.

A week before curtain time the exhibition was a sellout. Hoping for 500 guests, we had to shut off the sales at 550 and could have sold a hundred or more tickets. We were seeking guests who were genuine art enthusiasts rather than crowds herded together by civic booster clubs dangling offers of drinks and food as the incentive to come.

The seminars were a big hit, starting off on the morning of June 7 with John Clymer, Bob Lougheed, and Ned Jacob sketching out of doors. More than four hundred onlookers were given a first-hand opportunity to see three fine artists at work.

Arthur Mitchell, veteran illustrator, lifelong exponent of the West, and museum administrator, said that few scenes in his life

thrilled him like the setting for the awards banquet that evening. "It had the sound, thrill, and look of class." Mitch said, adding, "My God, the West lives tonight." It was indeed a star-studded evening.

The judges were Paul Strasbaugh, Mrs. Kay Haley, Walt Reed, Harold Von Schmidt, Joe Stacey, Robert Rockwell, Bill Harmsen, and Olaf Wieghorst.

The results of the show were capably recorded by Jon Denton, fine arts critic for the *Daily Oklahoman:*

New Mexico Painter Takes Prix de West.
500 Cheer Word of Winning Work at Dinner.

A snow-slogging trail packer skirting the wintery edge of Grand Canyon won New Mexico artist Clark Hulings the Prix de West Saturday at the Cowboy Hall of Fame.

Hulings' panoramic oil painting became the first such prize in the National Academy of Western Art competition sponsored by the cowboy shrine. Applause from 500 greeted the announcement ending a banquet, a western art seminar and gathering of western art enthusiasts.

The top prize carries with it an $18,000 cash award, western clothes for two and a museum tour of Europe. Cowboy Hall keeps the painting.

Hulings' "Grand Canyon, Kaibab Trail" competed with 92 works by 34 artists.

Other excited winners: Robert Lougheed, Santa Fe, New Mexico, a gold medal for his oil, "On the Edge of the Sangre de Cristos"; Edward Fraughton, Salt Lake City, Utah, gold medal for his sculpture, "Where Trails End"; Donald Teague of Carmel, Calif., a gold medal for his watercolor, "Appointment in Town", and Brownell McGrew of Cottonwood, Ariz., for his gold medal drawing, "Head Study of a Young Navajo."

Silver medal winners were Wilson Hurley of Albuquerque, New Mexico, for his oil "Grand Canyon"; Robert Scriver of Browning, Mont., sculpture, "Laying the Trap"; Robert Lougheed watercolor, "At the Arroyo Hondo Cutoff" and Ned Jacob of Denver, Colo. for his drawing "Sutsi Man."

302

The final event of the evening was the awarding of our Trustees' Medal to Nick Eggenhofer of Cody, Wyoming. Jasper Ackerman, honorary chairman of the Board of Directors, made the presentation. We had taken a gigantic step. The National Academy of Western Art had a highly successful launching. The wire services covered the awards, as had several national magazines.

It was satisfying to realize that, whereas ten years ago there had been no art organization, only a few galleries promoting Western art, and no museums serious about the contemporary western artist, there now were numerous organizations, museums, and literally dozens of galleries vying for exhibitions.

The NAWA exhibitions represented the balance of subject matter that we sought. The ninety-two works submitted included landscapes and historical subjects, trains and ships, big game animals, western cactus and flowers, cowboys and Indian camps. There were awesome portrayals of Grand Canyon and other works featuring mountains, the great plains, arid deserts, and roaring rivers. This was it! Variety, quality, and motivation. Bob Lougheed wrote, "So many paintings here would not have been painted, nor the great sculpture done, had it not been for the desire to excell created by NAWA."

In addition to the Prix de West winner, we bought six works from the exhibitions: *Windswept*, a 40 x 30 inch oil by John Clymer; Robert Lougheed's *On the Edge of the Sangre De Cristos*, (48 x 36 inch oil); *The Hand Warmer* by Tom Lovell, (36 x 26 inch oil); *Variation and Theme* by Brownell McGrew, (48 x 36 inch oil); Robert Rishell's *The Idle Hour*, (38 x 28 inch oil); and *Ever Changing*, (48 x 36 inch oil) by Conrad Schwiering. These seven paintings, along with past award winning works by Robert Scriver, Ned Jacob, Robert Lougheed, Brownell McGrew, and John Clymer, would give us the basis for a stunning new travelling exhibition. In all, we had laid out over $100,000 for Academy art.

The next step of importance was a discussion of those to be elected to the Academy as life members. NAWA Academicians

elected in 1973 were:

Clark Bronson	R. Brownell McGrew
John Clymer	Arthur Mitchell
Nick Eggenhofer	Kenneth P. Riley
Edward J. Fraughton	Conrad Schwiering
John D. Free	Robert Scriver
Clark Hulings	William E. Sharer
Wilson Hurley	Bettina Steinke
Harry Jackson	John Stobart
Ned Jacob	Donald Teague
Robert Kuhn	Harold Von Schmidt
Robert Lougheed	Olaf Wieghorst
Tom Lovell	

The Cowboy Hall of Fame's stalwart art-oriented directors Luther Dulaney, Jasper Ackerman, J. B. Saunders, Bill Kerr, Joel McCrea, and C. T. McLaughlin were pleased to say the least.

The summer season following the NAWA Awards came off very well. More than 150,000 visitors flocked in from all over the country to see the Hall and the show. The skeptics on the Board conceded that creation of NAWA had been for the better.

In late September, Mr. Dulaney returned from his summer home in Michigan. He called me to his office a few days after his return. We talked about the exhibition and I told him of our plans for the coming year. The NAWA Screening Committee would meet in November and Luther excitedly planned to sit in. We talked at length but avoided any conversation about acquisition of high value art.

Then enthusiastically he said, "I want to raise a million dollars to help erase the Hall's building debt. I want to match what Jasper and Joel McCrea have done. After all, I'm President of the Board of Directors and I want to do something worthy while I'm in office. With the help of J. B. Saunders and you, we'll do it." His excitement was infectious.

That evening about 7:30, Luther's secretary, Miss Billie Tull, telephoned me and blurted out through a face that I'm sure was

tear stained, "Dean, we just lost Mr. Dulaney. He died at 7:15."

I was stunned by his death. His raspy voice, unusual laugh, the twinkle in his eyes, the smell of pipe smoke, his classy appearance, and the ability to make quick decisions would be gone—forever. Many fond memories of Luther came to my mind that evening. Like the time I left his office for New York City to wheel and deal for western masterpieces and he called out, "Don't you go and spend more'n $200,000—y' hear?" Or the time our $118,000 check, bearing his signature, in payment for Remington's *Hunters Camp in the Big Horns*, almost bounced. He thought it was terribly funny. Nor will I forget the oath he made me sign, pledging that I wouldn't buy any more high priced Western art.

We flew all our flags at half mast in tribute. We flew them for seven days—a day for each year he was with us.

Chapter 16

In From the Night Herd

THE NATIONAL COWBOY HALL OF FAME has introduced the West to millions who would not otherwise have appreciated it. No other museum has made as strong a commitment to Western art. We have worked for the contemporary painter and sculptor of western subject matter day in and day out since opening.[1] Western art has come into its own during the past decade; the market has skyrocketed. A number of exhibitions and seminars have been patterned after our NAWA events; we have become the tastemakers. Books and magazines about Western art and artists have become more popular than ever and many western artists have become famous and rich. The Hall has accumulated the greatest collection of contemporary western works in existence—more than fifty paintings and bronzes representing medal winners or outstanding pieces purchased from the seven Cowboy Artist exhibitions[2] we sponsored or our own National Academy of Western Art[3] shows. In addition, though of short duration, we started the Royal Western Watercolor Show[4] held in February and ended our art year with the Solon Borglum Memorial Sculpture Exhibition.[5] These shows were sources for more fine additions to our collection.

Outstanding works in our collection are Charlie Dye's *Through the Aspens*; Joe Beeler's bronze, *The Navajo Man*; a James Boren watercolor, *Afternoon in New Mexico*; Olaf Wieghorst's *Letter From Home*; Tom Ryan's *Sharing an Apple*; James Reynolds' *The*

Good Life; and Robert Lougheed's *The Bell Remuda.* An important painting acquired during 1974 is Tom Lovell's strong Prix de West winner, *The Wolf Men,* a super companion piece to his immortal *The Handwarmer,* from the first NAWA exhibition. Robert Lougheed's *Deer of Sangre de Cristo* is another classic of recent years added to our collection, along with Robert Rishell's *Idle Hour* and Clark Hulings great painting, the first Prix de West winner, *Grand Canyon, Kaibab Trail.* The latter is undoubtedly the most popular contemporary painting to hang in the National Cowboy Hall of Fame. We have had dozens of requests for prints. George Carlson's sculpture *Courtship Flight* is done in the style of the old masters. John Clymer has always scored heavily at the Cowboy Hall of Fame, as has Brownell McGrew; Clymer's *Out of the Silence* has a serenity that few other contemporary artists have achieved. Ned Jacob, Bettina Steinke, and Wilson Hurley are important contemporary artists. Sculptors Robert Scriver, Harry Jackson, Richard Greeves, Ed Fraughton, and George Carlson are super stars, while in the art of wood sculpture, no artist in my opinion can touch Willard Stone. There is no doubt in my mind that the twentieth century, at its three-quarter mark, has established some of the masters of western subject matter in all media.

In addition to recognizing artists, trustees of the Academy have shown concern for art in literature by recognizing excellence in publishing through magazine and books. Successive NAWA exhibitions were further enhanced by awarding trustees medals to each of those who have made outstanding contributions to Western art.[6] Major contemporary artists the trustees have singled out, not only to honor with one man shows but also to award gold medals to, have been Nick Eggenhofer, Olaf Wieghorst, and Clark Hulings. All three have had long, distinguished careers in Western art.

Even though the Cowboy Hall has indeed fulfilled its role as a major museum of Western art by encouraging and collecting the contemporary artist, I still set other goals in my unrelenting drive

307

to collect major historical art. These yearned for acquisitions were mingled with thoughts about heroic sized statues and memorials for our grounds. In no way would I submit to the idea that the National Cowboy Hall of Fame would be anything but number one. Not the largest but the most forceful and imposing western museum and shrine in America—the world, in fact.

Yet I was aware of and guarded against ideas and concepts that from time to time threatened to divert us from our goals. I was always careful to disengage the institution from such bramble bushes. The historian in me was constantly thinking and reappraising our position—where had we been and in which direction should we be headed, what would be our course in light of our financial capability. One serious default could, in fact, defeat or virtually bankrupt the future and throw a cloud over the past achievements.

Among the propositions that came before us was a major collection of antique automobiles, $5 million worth of Winchester Westerns' weapons, and a major turquoise and Indian jewelry grouping. The Quarter Horse Hall of Fame considered a site near ours. In other instances we declined large displays of Indian artifacts and coins. We backed away from world championship fast draw competitions, arm wrestling, and the glamorous Miss Rodeo America pageant. The life of a progressive institution, like that of the individual, is filled with temptation, but above all, we did not want our institution to be a historical junk house filled with unrelated collections and programs.

Our major thrust is to give the cowboy and cattleman, the great westerner immortality through programs and exhibits that include historic and contemporary Western art, films, literature, and education—enriched with the vitality and color of the National Finals Rodeo. The program that most promises to promote our goals in the long run is the publication of *Persimmon Hill* magazine, supported by its books division.

Time, timing, misfortune, and even tragedy constantly haunt the museum director. My sense of time has perhaps always been

out of balance with the cadence of everyday life because of the nature of a museum's own fundamental goals and the sense of timelessness that rises and falls in spite of human tides. Yet how much time did I really have? Death cut short the life of Chester A. Reynolds, the dreamer and founder of the Cowboy Hall of Fame concept. His passing crippled the project initially as he came on the scene in 1954 and was gone, winked out of the picture in 1960. And how was I to follow Glenn Faris, who walked in Reynolds' footsteps?

The spectre of death, like taxes, hovers over all stations in life, not just museums. Death is always just around the corner with taxes on top of it. In most instances, it takes away or causes a cessation, but in a few instances death can give new life with infusions of wealth. In the case of the Cowboy Hall of Fame, so far there have been more losses, more stoppages than gains. With the passing of Reynolds, there was defeat and the near death of the institution. The thing I looked upon in November, 1964 was but a shell, a lifeless skeleton. But slowly we saw the infusion of life, the pumping in of financial oxygen, the arousing of a human institution from a deep sleep as if the fires of life had been temporarily banked by winter's snow. The idea had lived in spite of years of inaction.

One of the few benefits of passing years is a sharpening of life's values as to the relevant and the irrelevant, an awareness of what is worthwhile and what is not. Time becomes more precious as life and tenure ebb away. The days, weeks, and months—back to days, hours, and minutes—haunt us as the ticking of a clock. Time is the hunter supreme.

As I zoomed passed my fiftieth birthday, I had definite ideas for our future. In terms of museum management experience, I had long ago arrived, yet I felt we should accomplish a number of major goals in the coming years. If at all possible, we should do fewer things but do them well.

First of all, we needed to continue to reinforce our masterpiece collection of Western art, to finish and give balance to what we

had achieved. I had long wanted to start a heroic piece of statuary for our grounds, namely a colossal Buffalo Bill equestrian statue at least three stories high. And I hoped to develop a concept that had danced around in my head for a number of years: a tomb to the unknown pioneer. This I envisioned as being a small scale Washington monument, paying tribute to those who had died going west. I wanted the remains from an unmarked grave exhumed from some lonely outpost along the Oregon Trail and placed as a focal point to be ringed by crypts for such great westerners as Frederic Remington, Eugene Manlove Rhodes, rodeo hand Bill Pickett, Jim Bridger, and Charley Goodnight. The tomb, the Buffalo Bill Statue, and graves of great western animals would all be united by beautifully landscaped grounds, a mall, fountains, cascading streams, and crystal clear pools. Could I do these things, or would I find myself, like the proverbial salmon, hopelessly swimming upstream?

My idea for the colossal-size Buffalo Bill, also named the *Legend of the Westerner*, jelled after thinking about it for a number of years. The idea for the subject was finalized after watching my friend Joel McCrea one night in a rerun of the popular film, *Buffalo Bill.*[7] No figure represented so well the spirit of the West around the world as did this dashing, exciting, and gallant figure. Cody beckoning from the saddle, his horse rearing up on its hind legs, was indeed the personification of the opening of the West. Thus Joel reinforced himself as my hero and became the embodiment and star of a long and thrilling aspiration.

The artist I looked toward once again to interpret this concept was the talented, easy to work with genius, Leonard McMurry. I drew out on paper roughly what I had in mind and gave it to Mac. Only a few days later, Leonard telephoned that he had a model in clay. I was amazed in one way and yet not in another because McMurry has great talent. What he had created was remarkably close to what I envisioned.

I had the model brought to my office and asked fellow workers to critique it. To my surprise, I found opposition. Some felt the

Buffalo Bill idea corny and inappropriate for the Cowboy Hall of Fame. I was accused of copying what others had done. "Buffalo Bill belongs to all America," I pleaded, "the world in fact! He was one of our first honorees." A simple cowboy was suggested, as were other subjects. The entire episode caused me to retest my own thinking and values. After a period of study and soul searching, I came out of it more convinced of the subject than ever, sure of the merit of a Buffalo Bill. Surprisingly enough, there has been opposition to most of my projects at the staff level. Through the years, we have had our share of doubting Thomases, though I never wanted to be surrounded by "yes" men. I had asked for criticism and got it. The next thing I did was to ask Juan Menchaca to design the base, with a pool and rock plaza surrounding the setting.

A few weeks later at the first NAWA exhibition in June 1973, I displayed a striking 30-inch model in plaster with Menchaca's beautiful base setup. I showed it to board members Jasper Ackerman and Arthur Mitchell[8] and waited for their reaction. Both approved. The next day I had my first nibble on the entire project. I had quietly cast my trout fly on the water and sure as the world, I had a solid bite. A tugging on my line. One, then another. We would need no less than $150,000. The cost figure was then fifteen percent over my first casting estimate to include building the base, fountain, and adjacent plaza. Construction estimates for the base and pool were made by Afton Gille, who had designed the Payne-Kirkpatrick Memorial.

Together with the statue, I felt we should develop our grounds into a maze of walks, lawns, shrubs, pools, and gardens. The man we turned to was a young landscape architect, Bill Renner. Renner's work would be the first phase of a three phase landscape plan. Within a few weeks, he came up with a blue print that I considered outstanding.

For all construction and walks, I wanted to use native granite and sandstone. I remembered another axiom Thomas Gilcrease bequeathed to me. "If you build it so it looks old, when completed

311

it won't grow old—in fact, it becomes ageless," he advised. As in many of my projects, I turned to my associate Bryan Rayburn to carry forward a myriad of details. The entire project—statue, base, pool, and landscaping—now totaled about $275,000.

In the weeks following the NAWA art show, we refined the statue concept, as well as the garden and grounds setting. I had all that I needed for a presentation.

The Board of Directors annual summer meeting was to be held in Colorado Springs in August, in conjunction with the Pikes Peak or Bust Rodeo. Mr. Ackerman was our host.

We needed to display the model and gain the Board's ideas regarding these projects. Hopefully, we would then receive approval to proceed. I could happily relate that we had a solid prospect to pay for the statue. Cash in hand always helps convince and so the Board heartily approved the whole project.

Half way through Juan Menchaca's presentation of the plan for the base and fountains, Mrs. Nona Payne arose and asked to speak. To our surprise, she said she wanted to underwrite half the project and hoped Mr. Ackerman would be her partner. Mr. Ackerman, never slow in responding, replied that Buffalo Bill, an idol of his home state of Wyoming, was also a personal hero and that he would consider it an honor to share in the project with our "beloved Aunt Nona." Members of the Board (the meeting was chaired by Vice-President Rex Nicholson) gave the two patrons a standing ovation. It was indeed an hour of joy.

For me, solidifying of funds was a thrill. As usual, I immediately began to think in terms of money, hoping that our cost estimates were correct. I had another immediate problem: how to tell my first potential donor that he was out of the picture. For help, I would turn to Joe Gordon of Pampa, Texas, Mrs. Payne's counsel and good friend. Before I told Joe of my problem, I had to also relate what his client had offered to sponsor. All went well in our conversation. My friendship with Gordon had grown in importance. I found him easy to talk to.

My relationship with Joe Gordon has always been out in the

Joe W. Gordon by Bettina Steinke

open, as it has been with all directors and trustees. Together we have literally travelled the four corners of America. No thrill has been greater or more breathtaking than circling Alaska's mighty snow-covered Mount McKinley in Joe's tiny twin engine airplane. From that petrifying experience, I realized how awesome nature can be and how insignificant is man.

I have been free to telephone Joe at all hours of the night. Our talks are often long. He always closes his conversations with a resonant, "Mighty fine, see you." It has been my pleasure to watch this warm, highly intelligent businessman climb the ladder to become president of the Board of Directors, the titular head of what I consider to be the most powerful museum board in America.

Our problems with the Buffalo Bill statue were primarily technical, dealing with time and scheduling, but delays were exasperating. At times I even wondered if the seemingly small base would hold such a colossal size work. After a while, my concern got the best of me and I hired engineering consultants to look at it. They assured me all was well. It took Leonard McMurry months to complete the working model. We had planned on weeks.

The garden project was beautiful from start to finish. It was financed by Miss Freda Hambrick[9] of Colorado Springs, an associate of Jasper Ackerman. Few projects have proceeded with such ease and grace under the eye of the talented landscape designer Bill Renner. Dedication of Freda Hambrick Garden was held on a beautiful June morning during our third National Academy of Western Art festivities.

Eventually, Bryan Rayburn and Leonard McMurry were sent to Italy to look at prospective foundries to enlarge and cast the Buffalo Bill into bronze. Their recommendation, after touring the country, was to do business with my friend and often adversary in the *End of the Trail* project, Bernhard Zuckerman. I agreed.

As was the case with the *End of the Trail*, there were long delays, and inflation shot the price up almost twenty percent. The

months passed into years; two tentative dedication dates came and went. Eventually the matter became a sensitive subject at the board table, although Mrs. Payne and Mr. Ackerman were extremely understanding.

With news of a February shipping date from Italy reported by Zuckerman, I was able to rest easier regarding the project. Several days later, Jasper and I met with Aunt Nona at her home and we set June 12, 1977 as the date for dedication. The event would be the climax of our National Academy of Western Art weekend.

Projects like the *End of the Trail* bronze, the Payne-Kirkpatrick Memorial, Buffalo Bill and the disasterous "last bunch" of pictures I tried to buy have made me wary—gun shy. Projects and ambition have often steered my career-ship dangerously close to devastating rocks.

On the other hand, the difficulty I ran into with the "Tomb of the Unknown Pioneer" was enormously philosophical. The first time I tossed the concept out on the board table, members virtually riddled it with shots. It tumbled and rolled about like the proverbial tin can with the sharp shooters blazing away. I never brought the matter to the board again.

Another happier event brought us closer to completing our collection of Western art masterpieces. It was rewarding in another sense, too, since it reflected a growing confidence in our operation; it meant we had finally earned the trust of a cautious man. I had long dreamed of acquiring the Albert K. Mitchell collection, but at times, especially during the early years, our relationship was brittle. Few established museums are strife-free and stable, much less a comparative fledgling museum like the National Cowboy Hall of Fame. Albert Mitchell had been with the institution since its inception, serving as its first president. Even under his strong leadership, the place had its differences of opinions, some ups and downs. I'm sure at times he had his doubts, but in the long run we made great strides in developing forceful programs and accomplishing goals without government aid of any kind. Albert's decision to place his art in the Cowboy

Hall of Fame was in all probability not an easy one, aside from sentimental reasons.

The arrival of Mr. Mitchell's letter was indeed exciting; it was one of the most important I have received in my career as a museum director. His collection, after it was signed and delivered, boosted our assets over the fifteen million dollar mark.

"Dean," he wrote in his usual short and to the point manner, "I intend to give the National Cowboy Hall of Fame and Western Heritage Center my Western art collection when you can work out some sort of a plan for transferring it from the Lovelace Clinic in Albuquerque. Also, let me know ideas you might have for displaying them."

The Mitchell collection is superb, containing twenty-one oils, watercolors, and bronzes by Charles M. Russell and Frederic Remington. Mitchell told me in a conversation prior to receiving his letter that he had received an offer of $2 million from an art dealer for the works. Such news, of course, heightened the acquisition's value.

More than monetary value, I was captivated by the four Remington oils in the gift. Few of his works could match *In From the Night Herd* for quality and sheer artistry in the use of a limited color spectrum. The painting, a rare cowboy night scene showing changing of the guard, had been in demand as a print and illustration from the date of its debut in 1907. *The Quarrel*, is a light and colorful dramatic scene—another widely known work that was acquired from the Remington Studio Collection at Ogdensburg, New York. This painting depicted the kind of men the artist admired—"men with bark on," ready to do battle at the drop of a hat. The large black and white oil, *Ray's Troop*, is a vertical composition that had been reproduced as the frontispiece in Charles Bird King's novel, *Daughter of the Sioux*, published in 1903. When it came to Mr. Mitchell's hands and on to us it was dramatically renamed *The Seventh Cavalry*. The *Sign of the Buffalo Scout* shows Remington as a fine art painter, and the work demonstrates a fusion of colors typical of the Southwest. Few

316

Indians are more haughty or typical of the plainsman. Remington's mastery of bone structure is much in evidence in this superb painting, one of several in the artists' series on hunting buffalo.

The Russell oils and watercolors in the collection attest to Albert K. Mitchell's keen artistic eye as a cowman and cowboy, as do his Remingtons. The Russell paintings, ten in all, are led in quality and importance by *Call of the Law*, a 24¼ by 36 inch oil. The painting, done in 1911, depicts a Royal Mounted Policeman arresting two characters who obviously are suspected of horse stealing. Like Remington, Charles M. Russell had his favorite subjects and *Call of the Law* ranks with *The Queen's War Hounds* and *Single Handed*, his other famous mountie subjects.

In talking about *The Fatal Loop*, Albert said enthusiastically, "By golly, that's some painting. It's a darn good trick, roping a wolf. I've known chaps who tried it. Notice how the roper has thrown a perfect loop. And the wrist action—only a skilled painter like Russell who had seen such sights could draw and then paint from memory."

In the field of bronzes, the collection of Russells is strongly led by early castings of *The Bucker and the Buckaroo, The Buffalo Hunt, Counting Coup* or *When Sioux and Blackfeet Meet, Enemy Tracks*, and *Where the Best of Riders Quit*.

Mr. Mitchell, prominent New Mexico rancher and graduate of Cornell, is one of the few cattlemen I have known who successfully collected Western art with a tutored eye. As a collector, he appreciated more than historical values.

In pointing out features of Russell's *When Wagon Trails Were Dim*, he says: "Notice the balance to this painting, the composition, the way the trail fronts in the picture, the sky with the mountains to the left and the covered wagons to the center and right. The wagon boss is a frontiersman of the Kit Carson period. You can tell by the way he is dressed in buckskin. See that buffalo carcass in the foreground. Notice the green grass sprouting around and through the bones, when the rest of the vegetation is in a later state of growth or drought. Only Charles Russell would have

Albert K. Mitchell by Tom Phillips

known that the carcass fertilized the ground in that manner."

Discovering the watercolor painting *Custer Battle* in the Lovelace Clinic in Albuquerque, where the collection was exhibited several years ago, was a treat. There is a black and white Custer painting of approximately the same size in the Gilcrease collection. In adding the painting to his collection, Albert Mitchell again demonstrated his knowledge and love of history. The subject is an important one.

Son Albert J. Mitchell[10] recalls, "My sister and I grew up loving these Russells and Remingtons. I remember many of the acquisitions. Each time daddy would bring a painting or a bronze home, it was always a big event for us, too. It was years before I fully realized the importance of our collection. I also recall some that were rejected. When a dealer would either send photographs or bring a painting to the ranch, dad would promptly pick out the good and bad points—especially the flaws—saying, 'that's not right—that horse's leg is wrong,' or some such comment."

And so on April 8, 1975, Bryan Rayburn, Richard Muno, Tom English, and Staff Photographer Steve Davis, met Albert J. Mitchell at the Lovelace Clinic to transfer the collection and responsibility. Albert J., a member of the Hall's Board of Directors, represented his father. Dr. E. Kilgore, Jr., president of Lovelace Clinic, signed the release. Sometime after midnight on April 9, the collection was safe in the vaults on Persimmon Hill.

The Hall's outstanding art director, Richard Muno, designed the setting for the collection. Since the collection came from the Mitchells, one of the West's more widely known ranch families, our idea was to show the art in that manner. Muno and his assistant, Tom English, worked nights building the case. When completed, the twenty-one works were displayed in a stunning setting, complete with Persian rugs and Louis XIV parlor furniture uniquely lighted behind glass. The exhibit was unveiled on May 2, 1975, with more than three hundred guests in attendance. President Joe H. Watt, of Sheridan, Wyoming, presided over the monumental occasion. Robert Rockwell, member of the Board of

Directors and noted collector and authority on Western art, spoke on the importance of the gift. Both Rich Muno and I added our two bits worth.

In presenting the collection, Mr. Mitchell explained, "We have loved our collection for many years. I bought my first painting in 1928. In placing it here in the National Cowboy Hall of Fame, we can now share it with the hundreds of thousands of visitors who come here each year. There is no better place than the National Cowboy Hall of Fame."

The main thrust of my story has dealt with the acquisition of great art the hard way, and so I must comment on the last gathering of art I had in tow. Small though it was in comparison to some deals, it was not without bloodshed—mine. By this time, I had developed strong lines of credit with banks, and among them I could borrow whatever we needed. The problem, of course, was paying off.

One work I sought for my encore with Western art was *The Scouting Party* by William T. Ranney, an 1851 beauty that was both artistically and educationally important to our collection. I had it around for years trying to land it.

Next I tackled a splendid Thomas Moran titled, *Green River Crossing*, dated 1901. Painted by Moran at the peak of his career, the painting contains a rare usage of blue that helps mark Moran as a master colorist. I thought it superb as a companion piece for *Mountain of the Holy Cross* and *Ponce de Leon in Florida, 1513*. The painting was brought to me from Newhouse Gallery of New York by art dealer Charles Tyler of Los Angeles. The price was high and I sweated over whether to buy or not for weeks. But in the face of a sputtering national economy, I sent a wire asking for a year to raise the money to buy.

The next painting was *Buffalo Hunt* by Carl Wimar, dated 1860. I saw the pastel work at Hammer Galleries and asked Victor to see what he could do in the way of time and price. During the balance of 1974 and early winter of 1975, I took on a Carl Runguis painting, *A Moose*, that probably originated as a sketch in the

320

Wind River country of Wyoming some fifty years after Miller had been there, and Solon Borglum's *One in a Thousand*. The Borglum piece originated with the artist's daughter, Mrs. Monica Borglum Davies, and was offered by Sandra Wilson's Gallery in Denver. "Send it out," I told Sandra. "I'm putting together a small collection," but I cautioned her that I would need time to pay.

Two works to come our way which I enjoyed fully were Remington's epochal watercolor, *The Medicine Man*, with seven figures, and contemporary artist John Stobart's dramatic night scene, *San Francisco Vallejo St. Wharf in 1863*.

Some of the foregoing I was able to find sponsors for, others I had to sell at cost and accrued interest pricing. The interest alone on such works can be staggering. Once again, Jasper, J. B. Saunders, and Bill Kerr came to the front and we saved valuable pieces. In the end, I lost the Moran, then the Ranney. Maybe it was the economy, maybe the times, maybe it was me. Had I lost my touch? Somehow I couldn't shrug off the loss of these two great paintings. In all it was a tough pill for me to swallow.

However, a number of very special gifts bolstered my sagging art courage during this period. All were first rate art contributions that didn't require laying my life on the line, going to a bank, or appealing to some close friend. Mr. and Mrs. Gerald Hopkins of Tucson, Arizona gave us a version of Frederic Remington's watercolor drawing, *Lin McLean*; Doc and Lottie Ludwig (friends from my days at the University of Wyoming) presented us with an important Fechin portrait titled *Mr. Gorson*; and Verne and Shirley Hawn of Shreveport, Louisiana added a great E. L. Blumenschein to our collection. The summer of 1976 ended with a gift by Dr. Violet Sturgeon of a small but important portrait of Comanche Chief *Quanah Parker*, circa 1890, painted by Julian Scott.

My hopes of developing an important Taos collection were heightened immensely in the fall by Joe Singer of Oklahoma City when he telephoned and asked if I liked artist Walter Ufer, and what did I think of the Taos School of Painters? What resulted

from that simple phone call was the building of a beautiful exhibit case for us to house a Taos collection. Mr. and Mrs. Singer started their collection with a gift of two magnificent Ufers titled *At Rest* and *Jim and His Daughter* in memory of their son Norman, who was killed in Vietnam.

Completion of our Taos unit ends for now my drive to acquire great Western art for the National Cowboy Hall of Fame. I wanted us to exhibit nothing but quality and western masterpieces. Now we had them, together with the prestige of ownership and the intrinsic joy of looking at beauty. I could reflect back on more than twelve years of fun and struggles and suspense and a handful of wonderful, generous people who made my adventures possible. It was the challenge of Western art that brought me to Persimmon Hill. It is the achievement of it that has kept me here.

At the time of the formal opening of the Albert K. Mitchell Collection, it had been more than three years since my friend Luther Dulaney had made me take the oath that I would not solicit any more great Western art. Since that time, we had caused a stream of great Western works to come to the Hall. I wonder what his comments would be if he could see our galleries today. Certainly he would have gotten a chuckle out of a remark made to me following the Mitchell dedication. A Hall of Fame trustee sidled up to me and looked around to make sure we were alone. Then he whispered, "Dean, don't you think you've overdone this damned Western Art thing!"

Sources and Notes

Chapter 1
THOMAS GILCREASE

1. What was to become the Thomas Gilcrease Institute of American History and Art, Tulsa, Oklahoma, had its beginnings in San Antonio, Texas, through incorporation of "The Thomas Gilcrease Collection." The charter was filed December 18, 1939. Goals of this entity were essentially to collect and display artifacts and "to provide education and proper environment for Indian boys and girls." The home for the foundation was in Tulsa.

The organizers or subscribers were: Lena Gilcrease Logan (sister of Thomas Gilcrease), Frank Burton Logan (her husband), Eudotia Teenor (secretary to Thomas Gilcrease), and Thomas Gilcrease, Jr. and Barton Gilcrease (sons).

The Thomas Gilcrease Foundation came into being on the twenty-first day of September 1942. Thomas Gilcrease was one of the original incorporators. Other incorporators were: Frank Walling, Tulsa; G.B. Bancroft, San Antonio; C.H. Lamb and Pierce Larkin, Tulsa; Thomas Gilcrease, Jr., Lester Whipple, and Gene Ames, San Antonio. The articles of incorporation were filed with the Office of Secretary of State, State of Oklahoma, November 17, 1942. Thomas Gilcrease was elected president and Thomas Gilcrease, Jr. secretary. This body became the structure from which the world famous institute was to grow.

In 1943, the Foundation formally opened its museum to the public. Site of the museum was in the Milam Building (Gilcrease Building) in San Antonio. Public support was lukewarm, according to Mr. Gilcrease, who was to draw the conclusion that San Antonians did not care for Indians or their artifacts. An article in the *San Antonio Evening News*, June 22, 1949, tells of the demise of the museum under the heading, "San Antonio Loses Valuable Collection of Indian Lore." Because of this experience, Mr. Gilcrease thought in terms of Tulsa, location of the home which he bought in 1913, as the place to build a building to house his collections. By the time he began actual construction on a building in 1944, Gilcrease owned a large tract of land adjoining his home in Blackdog Township, Osage County, about two miles northwest of downtown Tulsa. Prior to completion of the building (the first portion was a

converted barn), collections were stored in San Antonio. Mr. Gilcrease was secretive about his acquisitions.

Information is scant regarding the physical growth of the building and collections during those early years in the 1940's. An article published in the *Tulsa World*, July 7, 1947, announced the appointment of Lester Hargrett as director. He was to resign two years later. The *Tulsa World* of April 26, 1949 announced that the Gilcrease Foundation would open seven museum galleries to the public on May 3, 1949. With the opening to the public, the museum's holdings were to become known—if not state-wide—at least to the Tulsa community.

2. A biography of Thomas Gilcrease is given in *Who's Who in America*, v. IV, 1961-1968, as follows:

> Oil producer, b. Robeline, La., Feb. 18, 1890; s. William L. and Elizabeth (Vowell) G.; student Bacone College, Muskogee, Okla., Teachers College, Emporia, Kans.; m. Belle Harlow, 1908; children: Thomas, Eugene Barton; m. 2d Norma Smallwood 1928; one daughter Des Cygne; farmer; rancher; banker; oil producer; real estate, San Antonio; founder Gilcrease Oil Company, 1922; founder Thomas Gilcrease Institute, 1942. Home: Osage and Ozark Rd., Tulsa. Died May 6, 1962.

A full length biography of Mr. Gilcrease was researched and written by his close friend, David R. Milsten. The work, titled *Thomas Gilcrease*, was published in 1969 by the Naylor Company of San Antonio and is a veritable goldmine of information and archives from the life of Thomas Gilcrease. Nothing can surpass it in historical competence. *The Proud Possessors* by Aline Saarinen (New York: Random House, 1958) contains a superficial chapter on T.G.; he is mentioned in Ruth Sheldon Knowles' *The Greatest Gamblers*, (New York: McGraw-Hill, 1959). *Rosenbach* by John F. Fleming and Edwin Wolfe (Cleveland: World Publishing Company, 1960) describes some of Gilcrease's great literary and manuscript purchases.

Dozens of periodicals have printed stories about Thomas Gilcrease. Of national importance, none surpasses "Saving a Vanishing Frontier," *Life* Magazine, March 8, 1954, pp. 72-79; an article in *Art in America*, no. 3, 1964, is comprehensive; also Martin Wenger, "Thomas Gilcrease," *The Chronicles of Oklahoma*, Summer 1962. The files of both the *Tulsa World* and *Tulsa Tribune* chronicle Gilcrease's life; a valuable source regarding the collections is found in issues of the Institute's own quarterly, *American Scene*.

3,4,5. While there are many standard references that contain biographies of Karl Bodmer, George Catlin, and Alfred Jacob Miller, one secondary source I recommend is *Artists of the Old West* by John Ewers, published by Doubleday, Chanticleer Press Edition, 1973. Mr. Gilcrease was especially fond of these three artists' achievements. A number of times he spoke at length about them, declaring how historically important they were in leaving behind such invaluable pictorial records. Another factor that impressed T.G. was that they painted primarily non-violent scenes.

6. For material on Frederic Remington, I recommend the work *Frederic Remington* by

Peter Hassrick published by Abrams (New York, 1973); Harold McCracken's first book on the artist, *Frederic Remington; Artist of the Old West* (Philadelphia: Lippincott, 1947) is a landmark work with excellent bibliography. Writings by Helen Card on Remington are authoritative. Much of my own knowledge has come from an extensive personal collection of Remington illustrations, *Harper's* and *Collier's* magazines, etc.

7. Concerning C. M. Russell, Frederic Renner reigns supreme in the field; any standard library will have Renner's books. Harold McCracken's C. M. Russell book is undoubtedly the most popular. For enjoyable reading of Russell's own writings, I like *Trails Plowed Under* and *Good Medicine*.

8. Martin Wenger is a native of Colorado; he was born at Telluride. A historian and librarian, he graduated from the University of Denver and earned his library degree from the University of Oklahoma. Martin served as the first librarian at Gilcrease Institute in 1955 and was also the editor of the Institute's quarterly publication, *American Scene*.

9. I attended graduate school at the University of Denver, 1950-51, earning a master's degree in history. During graduate school, I enrolled in a course on Historical Archives at the Colorado State Historical Society. Following graduation, I worked at the Society for about one year. In March 1952, I received an appointment to the faculty of the University of Wyoming in Laramie. I was assistant professor of the Archives and Western History Division of the Library. In April 1956, I resigned to become curator of the Air Force Academy museum developmental program. Later I assisted the Chief of Staff in various public relations programs. In June 1961, I resigned to become the director of the Thomas Gilcrease Institute of American History and Art, Tulsa. For biographical sketch see *Who's Who in the South and Southwest*, eleventh edition.

10. *Life* Magazine, March 8, 1954.

11. Gilcrease Institute was under the authority of the Park and Recreation Board of the city of Tulsa; actual operation was directed by a citizens board of directors. It was a joint management plan and the Citizens Board during my tenure was the ruling body.

12,13,14,15. Gordon T. Hicks, a banker, was chairman of the Tulsa Park Board and active in Institute management. Alfred Aaronson, an oil producer and influential Tulsa citizen, was a leader in the movement to keep Gilcrease Museum in Tulsa. Otha Grimes and William S. Bailey, both widely respected Tulsa businessmen, were also instrumental in maintaining the stability of Gilcrease as an operating institution.

16. Mrs. Eudotia Teenor, native Oklahoman of Cherokee descent, was Mr. Gilcrease's efficient secretary and associate until his death. Mrs. Teenor is widely respected and serves as a member of the Board of Trustees of the Gilcrease Foundation.

17. See note 2 for bibliographic reference.

18. For Cephas Stout, see *American Scene*, 5, no. 2 (1963), containing a tribute to Stout and his recollections of Mr. Gilcrease.

325

19. Popular Tulsa banker and civic leader, Mr. Johnson was chairman of the Board of Directors of the Fourth National Bank and a longtime friend of Thomas Gilcrease.

20. Letter on file in Gilcrease Institute library reads:

28th May, 1959.

Dear Mr. Gilcrease,

Catlin Gallery

I am proud to be able to offer you the original correspondence of George Catlin with Sir Thomas Phillipps. This correspondence refers to the Catlin Gallery now at the Gilcrease Foundation and, included with it, are other rare items relating to Catlin's pictures.

I offer you the collection for $5,500 and, although I know you are not buying much at present, I feel it an opportunity which should not be missed.

Of course, I have not the slightest hesitation in recommending the purchase to you. The correspondence is essential to the Gallery which, we have always thought, the finest purchase you ever made from us. A description of the collection is given on the attached sheets, and I would appreciate an early reply from you.

We hope you keep well, and with our kindest regards,

Yours sincerely,

Philip Robinson

21. Paul A. Rossi, a native of Denver, Colorado, attended North Denver High School and graduated from Denver University with a major in art. Rossi was a staff member of the Colorado Historical Society and then joined me at Gilcrease as deputy director in November 1961. He became director shortly after my resignation in 1964. Paul is co-author with David C. Hunt of the Gilcrease book, *Art of the Old West*, (New York: Alfred Knopf, 1971). He is now a widely known artist and historian.

22. Bruce Wear, Gilcrease Institute's first art curator, served the Institute for almost fifteen years. He is an authority on Western art, specializing in Remington bronzes.

23. I was fortunate, during my association with Thomas Gilcrease, to share many conversations with him. These times were very special to me, so I would return to my office and record his comments in a private journal. This journal is the source for my personal recollections of conversations with T.G. included in this book.

24. Letter from Thomas Gilcrease to his sister Bessie, in author's files.

25. Ibid.

26. Drawn from various records and the library at Gilcrease. At times articles about books, manuscripts, documents, etc., in the collection have appeared in *American Scene* magazine. Lester Hargrett's publications are invaluable, as is *A Catalog of Hispanic Documents in the Thomas Gilcrease Institute* (Tulsa, 1962) compiled by Dr.

Clevy Lloyd Strout, professor at Tulsa University. Also see *Rosenbach* and David Milsten's book cited in note 2.

27. The most important source used to build my knowledge of works of art in the collection was the inventory prepared by Bruce Wear. Secondly, I studied the appraisal inventories made at various times in the Institute's history. *American Scene* files give insight into the holdings as do other publications. Rossi and Hunt's *Art of the Old West* shows important holdings pictorially.

28. From the will of Dr. Philip G. Cole, Tarrytown, New York; appraisals prepared by P. J. Curry Company, 82 Wall Street, New York City. A copy of an inventory of paintings, sculpture, and library of books is on file at Gilcrease Institute. For an article on Dr. Cole, see "The Old West Revisited," *American Scene*, v. 8, no. 4.

29. See "Audubon's Wild Turkey," *American Scene*, v. 1 (Fall 1958) p. 6.

30. Cleve Gray and Francine du Plessix, "Thomas Gilcrease and Tulsa," *Art In America* 52 (June 1964) pp. 64-73.

31. "Saving a Vanishing Frontier," *Life*, 1954.

32. Collections of ethnology, archaeology, Spiro mounds, artifacts, pottery, and Eskimo items were uncataloged at the time I was at Gilcrease.

Chapter 2
A PILE OF NICKELS

1. Mr. Gilcrease was to have said, in effect, that "a man should leave a track in life and, in his footsteps of achievement, his work would live on after death." Several writers have used this theme, including Milsten in his biography of Thomas Gilcrease and Saarinen in *The Proud Possessors*. David Milsten, in high tribute, spoke of these "tracks" at the funeral services for Gilcrease.

2, 3. For L. Karlton Mosteller and Judge Lester Whipple, see Milsten's biography, *Thomas Gilcrease, op. cit.*

4. Thomas and Belle Harlow Gilcrease were married in August, 1908. See also Milsten, *op. cit.*, pp. 33-40.

5. *The New York Times*, January 16, 1973, noted Bill Davidson's death with a biographical article written by Sandra Knox. It read in part:

> William Francis Davidson, a dealer who pioneered in the placing of Western American art in specialized museums, died yesterday. He was 68 years old.
>
> A connoisseur with a penetrating eye for art of his day as well as of the past, Mr. Davidson was for many years an officer of M. Knoedler & Co. before his retirement in 1971.
>
> He joined Knoedler's in 1920 and he was still little more than a youth when he was sent abroad to buy frames for the famous collection of

paintings, the Alba Madonna included, which the gallery had purchased from the Russian Government for Andrew Mellon. The collection became the nucleus of the National Gallery.

Mr. Davidson was also a super-salesman, with faith in his wares and the acumen to enlist the support of oil and cattlemen and others endowed with means and regional pride.

Bought Russell Collection

Mr. Davidson, New Yorker, went to far corners of the country for art quarry that no one else seemed to want.

It was in the Mint Bar in Great Falls, Mont. that he located and bought a huge collection of paintings and sculpture by Charles Russell that the artist had left there years before. This became the treasure of the Amon Carter Museum in Fort Worth, one of five great Western collections directly attributable to Mr. Davidson's expertise.

Then, there was the enormous collection of Frederic Remington sculptures, paintings, sketches and memorabilia, which the art dealer swooped up from a studio in Ogdensburg, N.Y., where the artist had worked for some time.

The Remington collection went to the Whitney Gallery of Western Art, one of the museums in the Buffalo Bill Historical Center in Cody, Wyo. The Gilcrease Collection of Tulsa, Okla. bought not only cowboy and Indian art from Mr. Davidson but also works in other genres.

Noted for Purchases

The art dealer, who was first secretary-treasurer at Knoedler's, then in 1958 vice president, a director and finally executive vice president in 1964, became noted for his large-scale purchases and sales.

Mr. Davidson dealt as surely with French Impressionists, American historical portraits and 19th-century landscapes. He was responsible for landmark exhibitions, including one on Thomas Eakins, another on William Sidney Mount and still another of a collection of life masks of noted Americans, fashioned by John H. L. Browere in 1825, which preserved such likenesses as John Adams, Dolly Madison and Thomas Jefferson.

6. Thomas Eakins (1844-1916) is listed in *Dictionary of American Biography*. His works are in most major museums and any noteworthy history of American art chronicles Thomas Eakins' contribution.

7. For George de Forest Brush, consult *Mantle Fielding's Dictionary of American Painters, Sculptors and Engravers*, (New York, James F. Carr, 1965) p. 47.

8. For Andrew Melrose, see G. C. Groce, and D. H. Wallace, *New York Historical Society's Dictionary of Artists in America 1564-1860*, (New Haven: Yale University Press, 1957) p. 438.

9. Ralph Earle Blakelock is found in Fielding, *op. cit.*, p. 31.

10. For Edward Troye, see Fielding, *op. cit.*, p. 521.

11. For information on Thomas Moran, see Fielding, *op. cit.*, p. 246; also Thurman Wilkins, *Thomas Moran; Artist of the Mountains* (Norman: University of Oklahoma Press, 1966); Fritiof Fryxell, *Thomas Moran; Explorer in Search of Beauty* (East Hampton, N.Y., 1958); Amy O. Bassfield and Fritiof Fryxell, *Letters of Thomas Moran to Mary Nimmo Moran* (East Hampton Free Library, East Hampton, N.Y., 1969). There are 692 Moran oils, watercolors, and sketches in the Gilcrease collection.

12. Again I have referred to my personal journal as source for the rich conversations between Davidson and Gilcrease, recalled for me by Davidson during our many meetings.

13. For Albert Bierstadt, consult Fielding, *op. cit.*, p. 28, and Gordon Hendricks, *Albert Bierstadt, Painter of the American West*, published in association with the Amon Carter Museum of Western Art, 1974.

14. *American Scene*, v. 4, no. 3 (1962) is devoted to the Gilcrease Miller collection, with an essay on the collection written by librarian Martin Wenger. Noteworthy in the issue is an article on Miller by John Francis McDermott.

15. Walter Shirlaw was one of a small group of artists picked to do field paintings to illustrate the U.S. government volume, *Report on Indians Taxed and Indians Not Taxed* (Wash. D.C., 1894). Shirlaw's paintings, *Omaha Dance* and *The Race*, appear between pages 262 and 263. For further comment on this project, begun in 1890, see Robert Taft, *Artists and Illustrators of the Old West* (New York: Scribner's, 1953), p. 215, and Frank Getlein, *The Lure of the Great West* (Country Beautiful, 1973). A biographical reference on Shirlaw is found in Fielding, *op. cit*, p. 311.

16. Gilbert Gaul was a little known artist who painted on the frontier as an illustrator more than a fine arts painter. He painted Sitting Bull's portrait for the Census Bureau, 1890, in *Report on Indians Taxed and Indians Not Taxed*. See Fielding, *op. cit.*, p. 134.

17. Biographical information on General Alfred Sully appears in Groce and Wallace, *op. cit.*, p. 613.

18. Thomas Sully (1783-1872) was a great English portrait and figure painter. An abundance of references on Sully may be found in standard reference works on English artists.

19. The collection was extremely important historically but also had great value because it was done by an important military personage. The paintings were accomplished in the prehostile period of frontier relationships. The acquisition again testifies to Gilcrease's astute judgment and to his sense and love of history.

20. Black Hawk was a subordinate chief of the Sauk and Fox Indians and leader in the Black Hawk War of 1832. For biographical reference see F. W. Hodge, ed., *Handbook of American Indians, Part I* (Washington, D. C., Government Printing Office, 1912), pp. 151-152. Black Hawk was also painted by George Catlin. See "The Obscure Path To

Glory," *American Scene*, 1 (Fall 1958), p. 5, for account of Jackson and Black Hawk.

21. John Wesley Jarvis was one of America's finest portrait painters. The author considers his *Black Hawk and Whirling Thunder* one of the masterpieces of Indian portraiture. The author has visited the New York Historical Society for the specific purpose of viewing Jarvis' portraits there. Recommended reading is Harold E. Dickson, *John Wesley Jarvis: American Painter, 1780-1840, with Checklist of His Work* (New York Historical Society, 1949).

22. "Obscure Path to Glory," p. 6.

23. Jackson, Andrew (Mar. 15, 1767-June 8, 1845), seventh president of the
 United States, was born in the lean backwoods settlement of the Waxhaw
 in South Carolina (Bassett, *Life*, 1911, pp. 5-7). His father, for whom he was
 named, his mother, Elizabeth Hutchinson, and two brothers had migrated
 from the neighborhood of Carrickfergus in the north of Ireland in 1765.
 Two years later, shortly before the birth of Andrew, the father died. Mrs.
 Jackson, being left a dependent widow, took up residence with relatives,
 and her little son started life under the most discouraging circumstances.
 He was sent to an oldfield school, and developed into a tall, slender,
 sandy-haired, tempestuous stripling. When he had attained the age of nine
 years, the Revolution broke upon the country and its horrors later visited
 the Waxhaw settlement. His brother Hugh was killed in 1779; he and his
 brother Robert, though mere lads, took part in the battle of Hanging Rock,
 and afterward were captured by the British. The boy troopers were thrown
 in prison, where they contracted smallpox. Their mother secured their
 release, but Robert died from either the effects of the disease or neglected
 wounds. During 1781 Mrs. Jackson went to Charleston to nurse sick, and
 here she died of prison fever. Bereaved of the last member of his family,
 Andrew at the age of fourteen was now alone in the world. (*Dictionary of
 American Biography*, v. 5, p. 526).

Thomas Gilcrease read and studied the life of Andrew Jackson and credited him for his raw frontier background as the foregoing indicates. However, in an interview with the author, Mr. Gilcrease said, "At no time in our history did America need a man like Jackson, because he lacked understanding and care for the human being and particularly the American Indian. Had Jackson not been president, this country would have had less to be ashamed of regarding the treatment of the Southeastern Indian than it has . . ."

24. For basic reference I again refer the reader to Hodge's *Handbook of the American Indian*, 2 vols., 1912. While the accounts of these important five civilized tribes are short, they are basic and this is a source with which any careful researcher on the subject of the Indian would want to become familiar. No account surpasses Grant Foreman's *Indian Removal; the Emigration of the Five Civilized Tribes of Indians* (Norman: University of Oklahoma Press, 1932). Murial Wright's writings on the subject in the *Chronicles of Oklahoma* are also important.

25. William De La Montagne Cary (1840-1922), an important documentary artist, accompanied the Northern Boundary surveying party. One of the most comprehensive pieces on this artist is by James T. Forrest, "What a Sight It Was!" *American Heritage* (February 1961), pp. 46-55. W. H. Schiefflin, traveling west up the Missouri, recorded "Crossing the Plains in '61," with illustrations by Cary in color and black and white, *Recreation* (June, July, August, September 1895). Cary was a favorite artist of Thomas Gilcrease; also see *American Scene*, v. 1, n. 4. Art Director Bruce Wear featured a showing of Cary's paintings at Gilcrease during the summer of 1961. Twenty-three major paintings of the artist were exhibited. The designers of *Art of the Old West* drew heavily on the collection in presenting their artistic layout.

26. Joseph Henry Sharp (1859-1953) was one of the few artists Mr. Gilcrease actually took the time to visit. He visited the artist in his studio in Taos in 1947, an important event because Mr. Gilcrease ended up buying Sharp's tremendous collection of oil paintings. He purchased Sharp's easel, paint box, and old hat and gave him a major exhibition. Margaret Teague, writing for the *Tulsa World*, September 29, 1949, exclaimed, "One Man Show Honors the Living." The article is the most informative to date that I have seen on the Gilcrease Sharp collection. It describes Phoebe Hearst's relationship with the artist and Sharp's great work in painting the survivors of the Custer battle. The museum issued a catalog for the show.

A quote from Teague's article gives an insight into the nature of T. G.:

> The assembling of this collection has been a process of mature selection over a long period of years, both by artist Sharp and collector Gilcrease. Each recognized the ideal background of the other man's efforts: one to produce and the other to preserve. Sharp feels the Gilcrease Museum is the only place where his life's work can be preserved safely. Knowing of the idea in Gilcrease's mind for the creation of such a museum as it stands today long before it was realized, Sharp saved his best work for this collection and deliberately included certain paintings in the Gilcrease purchases. Some of his very earliest paintings, and what he calls his "swan song," *The Green Corn Dance*, are included.

An intimate associate of Mr. Gilcrease at the time of the Sharp purchase confided in me years later, "Tom bought it all—over 160 paintings—from Sharp for less than $30,000. The old man wanted a good home for his paintings, not money."

Mr. Gilcrease already had a fine and important collection of sixty-four Sharp paintings from the Dr. Philip Cole estate before he made his deal with Joseph Henry. Many of the portraits in the Cole collection were done of participants in the Custer battle on the Crow agency in Montana after the turn of the century.

27. Robert Lee Humber was a native of North Carolina who received a law degree from Lake Forest College in 1921. He became a Rhodes scholar in 1923, earning a Bachelor of Literature from Oxford. Dr. Humber was an advocate of world government. The lives of Mr. Gilcrease and Dr. Humber were entwined for more than forty years, during which Dr. Humber was on the payroll of Gilcrease Oil Company and became a cultural adviser to Thomas Gilcrease. David Milsten goes into considerable detail on the

relationship between the two men.

I met Dr. Humber twice in my career at Gilcrease, the second time taking place at Thomas Gilcrease's funeral. The first time occurred in the fall of 1961, prior to our bond election attempting to raise $600,000 to expand the museum by approximately 25,000 square feet. Mr. Gilcrease asked me to show Dr. Humber and himself the model of our proposed expansion and I made arrangements to do so. Upon meeting me, Dr. Humber recognized me as "Boy," then proceeded to tell Mr. Gilcrease what an "unimportant, near meaningless structural addition" we had come up with. In my presence he said, "Tom, give the State of North Carolina your second collection [which was about 400 paintings and sculptures and 50,000 or more artifacts; it was at that time a $4,000,000 deal] and I guarantee you we will build a million dollar edifice to house it and name it in your honor."

A couple of days later, Mr. Gilcrease asked me in for coffee and confronted me with Dr. Humber's proposition, reminding me that I had heard it. I thought a moment and replied, "Mr. Gilcrease, whatever you do with your second collection is entirely your business. My only hope is that it never goes east of the Misssssippi River. I think parts of the East are decadent." Mr. Gilcrease chuckled and said, "That may be—and there's no telling how bad it will get in years to come."

28. While my chapter on Thomas Gilcrease concludes with the opening of his museum in May 1949, his relationship with Bill Davidson did not end; in fact, it grew more important and purchases were frequent. In the end, the friendship was strained over the amount owed Knoedler Company. The following is a record of Mr. Gilcrease's purchases from Davidson beginning March 31, 1953:

11/10/53

Ptg. by Remington, *The Discovery*
Ptg. by Remington, *Un I Was Yell Terrible*
Ptg. by Remington, *The Rabbit Hunter*
Ptg. by Remington, *The Arrest of the Scout*

the four: $15,000.00

Ptg. by Stanley, *Indians Outside Camp Playing Cards*
Ptg. by Stanley, *View on Milk River, Minn. Territory*

$12,000.00

Ptg. by Ira C. Cassidy, *Mountain Man* 2,500.00
Ptg. by S. N. Carvalho, *Portrait of Wakar,*
 Later Chief of the Utah Indians 650.00
Ptg. by American School, *Indian Chief* 375.00
Ptg. by Charles Schreyvogel, *Custer's Demand* 19,593.75
Ptg. by Eastman Johnson, *Portrait of an Indian Family* 1,000.00

1/31/55

125 ptgs. by H. H. Cross, ports. of Indians and frontier characters
7 ptgs. by Carl Boeckman from T. B. Walker collection

the group: $25,000.00

Ptg. by Thomas Sully, *Alfred Sully*
Ptg. by Alfred Sully, *Battle of White Stone Hill*

332

Ptg. by Alfred Sully, *Indian Maidens*
Ptg. by Alfred Sully, *Buffalo Attacked*
Ptg. by Alfred Sully, *Self Portrait*
Ptg. by Alfred Sully, *Indians Spearing Salmon*

the group: $7,817.50

Ptg. by Winslow Homer, *Watching the Breakers*
Ptg. by Thomas Sully, *Portrait of Charles Carroll*
Marble bust by Clark Mills, *Andrew Jackson*
Marble bust by Mills, *John C. Calhoun*
Ptg. by John Smibert, *Portrait of John Cotton*
Ptg. by Robert Feke, *Portrait of John Rowe*
Marble bust by Gusseppo Cerrachi, *Alexander Hamilton*
Ptg. by Geo. Peter Alexander Healy, *Portrait of Stephen Douglas*
Ptg. by John Singer Sargent, *Beach Scene*
Ptg. by John Singleton Copley, *Hannah Greenleaf, Wife of John Apthorp*
Ptg. by James Abbott McNeill Whistler, *Nocturne, the Solent*
Ptg. by James Bogle, *Portrait of John Calhoun*
Bronze by Augustus St. Gaudens, *The Puritan*
Bronze by Daniel Chester French, *Ralph Waldo Emerson*

the lot: $125,000.00

Ptg. by Jules Travernier, *Prairie Indian Encampment*
Ptg. by Thomas Hill, *Yosemite Valley*
Ptg. by Hill, *Early Morning on the Hills*
Ptg. by Hill, *Shasta Mountains and Castle Lake*
Ptg. by Hill, *Illillante Falls, Yosemite*
Ptg. by Hill, *Squaw Valley*
Ptg. by Hill, *Chinooahue Falls*
Ptg. by Hill, *Donver Lake*
Ptg. by Hill, *Mountain Landscape*
Ptg. by Hill, *Mount Hood*
Ptg. by John Mix Stanley, *Buffalo Hunt*
Ptg. by Thomas Moran, *Acoma*
Ptg. by Emanual Leutz, *Indians Hauling Boat with Bound Captive*
Ptg. by Thomas Moran, *Landscape with Indians*

the lot: $16,600.00

11/10/58
Ptg. by Benjamin West, *Penn's Treaty with the Indians*
Ptg. by Charles Wilson Peale, *Portrait of James Madison*
Ptg. by George Catlin, *Flamingoes Breeding Place*
Ptg. by Catlin, *Two Buffalos*
Ptg. by Catlin, *Snow Landscape with Buffalo*

the lot: $100,000.00

Set of 8 panels of Columbus' Discovery of America
Ptg. by Sir Joshua Reynolds, *Cherokee Indian Chief*
Ptg. by John Trumbull, *Portrait of Thomas Wilkes*
Bronze by Frederick W. Macmonines, *Nathan Hale*
Marble bust by Hiram Powers, *Benjamin Franklin*
Ptg. by Ralph Earl, *Portrait of Matthew Clarkson*
Watercolor by Seth Eastman, *Buffalo Chase*
Watercolor by Eastman, *Indians Playing LaCrosse*
Watercolor by Eastman, *Indian Chief Addressing Circle of Indians*
Bronze by Frederic Remington, *Bronco Buster*
Bronze by James Earle Fraser, *End of the Trail*
Bronze by John Boyle, *Indian Mother and Children*
Bronze by Charles M. Russell, *Mountain Mother*
Ptg. by Thomas Moran, *Cortez Tower: Mexico*
Watercolor by Moran, *Blue Spring: Idaho*
Ptg. by Moran, *Church: Moravitio, Mexico*
Watercolor by Moran, *On the Lookout*
Watercolor by Charles Deas, *Indian Brave*
Watercolor by Deas, *River Man*
Ptg. by E. Lehman, *Scene of a Hanging at Sacramento*
Ptg. by Rosa Bonheur, *Indian Encampment*
Ptg. by Newell Convers Wyeth, *The James Brothers in Missouri*
Ptg. by George Inness, *Sconset, Nantucket: a Windy Day*
Ptg. by Remington, *Father Lacombe Leading the Indians*
Ptg. by Paul Kane, *Sault Sainte Marie: American Side*
Ptg. by Kane, *White Mud Portage: Winnepeg River*
Ptg. by James Walker, *Horse Corral and Gauchos*
Ptg. by Walker, *Men Lassoing a Bear*
Bronze by Jo Davidson, *Will Rogers*
Ptg. by Alfred Jacob Miller, *The Good Samaritan*
Watercolor by Miller, *Indian Girls Making Toilet*
Watercolor by Miller, *Indian Woman with Papoose*
Watercolor by Miller, *The Trapper's Bride*
Watercolor by Miller, *Indian on White Horse*
Watercolor by Miller, *Threatened Attack on the Caravan*
Ptg. by Chas. Willson Peale, *Portrait of George Washington*
Ptg. by Maria Cosway, *Portrait of the Artist in the Style of Rubens'*
 Chapeau de Paille
Ptg. by Benjamin Wilson, *Portrait of Benjamin Franklin*
Ptg. by Gilbert Stuart, *Portrait of William Temple Franklin*
Ptg. by John Wesley Jarvis, *Portrait of Chief Justice John Marshall*
Ptg. by William Ranney, *Boone's First View of Kentucky*
Ptg. by Seth Eastman, *Indian Burial*

the collection: $258,300.00

Ptg. by Rudolfo Friedrich Kurz, *Clearing in the American Forest*
Watercolor by Kurz, *Group of Indians*
Watercolor by Kurz, *The Waterfall*
Watercolor by Kurz, *Man on Horse and Dead Buffalo*
Watercolor by Kurz, *Winter Landscape*
Watercolor by Kurz, *Bear in a Case*
Watercolor by Kurz, *Indian Beauty*
Watercolor by Kurz, *Indians and Horses Crossing River*
Watercolor by Kurz, *Fox Caught in Trap*
Watercolor by Kurz, *Bisons Crossing River*
Watercolor by Kurz, *Three Indians on Horseback*
Watercolor by Kurz, *Two Indian Women Crossing a River*
Watercolor by Kurz, *Two Crying Mourners*
Watercolor by Kurz, *Fort Berthold*
Watercolor by Kurz, *Training Horses*
Watercolor by Kurz, *Stag Near River*

the group: $7,500.00

Drawing by Carl Bodmer, *Interior of Mandan Hut* $2,000.00
2/15/62
Ptg. by Thomas Moran, *On the Lookout* No chg.
Ptg. by Alfred Miller, *Indians Crossing a Stream* No chg.

29. J. Frank Dobie and Thomas Gilcrease were close personal friends and visited each other quite often; they also corresponded frequently.

30. Mr. Gilcrease had known Will Rogers quite well. In later years Tom also became friends with Will, Jr. Mr. Rogers visited the museum quite frequently.

31. Sid Richardson and Amon Carter, Sr. were Texas millionaires who, like Gilcrease, formed great collections of Russell and Remington. At one time, Mr. Carter hoped to buy the Gilcrease collection.

32. C. R. Smith, founder of American Airlines and pioneer Western art collector, influenced men like Sid Richardson, Amon Carter, and Charles S. Jones to begin collecting. Smith purchased the Nancy Russell estate and was a longtime friend and admirer of T.G. For biography of Smith see *Who's Who in World Aviation*, Volume I, 1955; *Time*, November 17, 1958; *Business Week*, September 22, 1973.

33. Earl Stendahl, Los Angeles art dealer, sold Mr. Gilcrease a number of costly pieces. Noteworthy was his sale of an important pre-Columbian gold collection to Gilcrease Institute.

34. *Time*, December 23, 1953; *Life*, March 8, 1954.

35. The actual acquisition of the museum and the collection titled "The Thomas Gilcrease Institute of American History and Art" by the city of Tulsa was begun on August 6, 1954. The acquisition instruments, *Deed of Gift and Conveyance, Assignment of Oil and Gas Mineral Interests Special Election and Bonds* is on file at the

Institute. Total cost of the municipal bonds was $2,957,308.75. The *Trust Indenture* was amended on January 27, 1955. The first meeting of the Board of Directors was held May 26, 1956 and by-laws were adopted.

Chapter 3
WILLIAM R. LEIGH'S STUDIO: FIRST COUP

1. Ethel Traphagen Leigh was a dynamic person in her own right; she became a highly creative force in her profession of fashion design. Aside from her personal ambition and busy schedule, one of her major goals was the promotion of her artist-husband, William Robinson Leigh, and she did this with great skill and persuasion. No artist could have had a better press agent; features on Leigh were to appear at one time or another in virtually every national magazine, art directory and reference book, and in *Who's Who in America*. Leigh and Ethel Traphagen were married June 4, 1921, and from that date Leigh's career moved in higher artistic circles. Ethel worked closely with Erwin Barrie, director of Grand Central Gallery, New York City. She was able to do things for Leigh's career—to meet with and sell his paintings to the great and near-great of America's cultural and industrial world. No other artist that I know of could boast of a more sophisticated clientele.

2. Letter in author's possession.

3. Author's interview with Lindley Eberstadt of Edward Eberstadt & Sons, 888 Madison Avenue, N.Y.C. Their Catalog 139, *A Distinguished Collection of Western Paintings*, listed items 67: *Bear Hunt in Wyoming* (titled *Bear Fight in the Rockies*), priced at $7,500, and *Up Where the Big Wind Blew*—two of Gilcrease's most important Leighs. According to Mr. Eberstadt, he often would send Mr. Gilcrease proofs of a catalog and Tom would respond immediately with a sizable order.

4. Throughout this chapter, biographical material on Leigh has been drawn from Leigh's unpublished memoirs; Gilcrease Institute Library; William R. Leigh, "My America," *Arizona Highways*, February 1948; and author's interviews with Ethel Traphagen Leigh.

5. "William R. Leigh," *The Mentor*, 3 (1915), no. 9, serial no. 85.

6. *Scribner's Magazine*, 25 (June 1899), pp. 717-728.

7. William R. Leigh, *The Western Pony* (N.Y.: Huntington Press, 1933) pp. 18-19.

8. Leigh's unpublished memoirs.

9. For a fine overall description of Leigh in Africa, see his *Frontier of Enchantment: An Artist's Adventures in Africa* (New York: Simon and Schuster, 1940).

10. Ibid.

11. An interesting footnote to the history of fashion stems from the Leighs' African adventures and appears in Mrs. Leigh's obituary: "It was she who introduced shorts and slacks to American women's sportswear in 1929 when she returned from Safari in

Africa where she accompanied her husband, the late W. R. Leigh, N.A., on the famous Carlisle-Clarke expedition for the Museum of Natural History." (*Fashion Digest*, Summer 1963).

12. The May 24, 1937 issue of *Life* magazine featured these great displays, paying tribute to the man who conceived and carried out the project to its last stages. Three of the background murals Leigh painted were reproduced in full color.

The November-December 1937 issue of *The Journal*, published by the American Museum of Natural History, is devoted to the African expedition. Each of the major participants wrote articles for the publication. Mr. Leigh's article is titled "Backgrounds for the African Hall Groups."

13. *Clipt Wings* (N.Y.: Thornton Allen, 1930); *The Western Pony* (N.Y.: Huntington Press, 1933); *The Painted Desert* (New York: Salmagundi Club, 1949); "A Day With a Navaho Shepherd," *Scribner's Magazine*, v. 72 (March 1922) pp. 334-42. Also published in *Scribner's* was his story, "Coward," v. 72 (Dec. 1922) pp 738-48.

14. Leigh, *The Western Pony*, pp 113-114.

15. I based this study on a collection of eight albums (in private library) containing a photographic record of many of Leigh's paintings. This author also surveyed fifteen volumes of the *Kennedy Quarterly*; records of Parke-Bernet auctions; Eberstadt catalogues of Americana 1935-1956, four volumes; exhibition records of National Academy of Design 1861-1900, two vols.; *American Artist Annual*, 1903-1938; *International Art Market*, 1961-1975; photographs of June DuBois collection; and Jeff Dykes, *Fifty Great Western Illustrators: A Bibliographic Checklist* (Flagstaff, Ariz.: Northland Press, 1975).

16. Huntington Hartford, of New York City, is heir to A & P food chain fortune and patron of the arts. He has spent a lifetime of activity in museums and the performing arts. The Cowboy Hall of Fame was able to acquire two of Hartford's finest American paintings: William R. Leigh's *The Leader's Downfall*, a 78 x 126 inch masterpiece (actually one of the first major paintings in the collection) and *Mountain of the Holy Cross* by Thomas Moran.

On two occasions, the author visited Mr. Hartford at his invitation. The purpose of both meetings was to discuss the idea of assembling Western Art exhibitions for his museum (now defunct) at Columbus Circle in New York City.

17. Alfred E. Clegg is a San Francisco shipping executive. Interestingly enough, two of his fine Leighs were to come our way. One is *The Buffalo*, the only subject the artist ever had cast in bronze. The bronze was the model for the dominant figure in our second acquisition, the oil painting *The Buffalo Hunt* (72 x 122 inches). These two works had been purchased by Clegg and placed in the library at Stanford University, his alma mater.

In May 1968, I contacted an official of the university art department after receiving a tip that they were considering selling both the painting and the bronze. I made an exploratory phone call and was soon talking to the right person. He told me works of

this nature were not in "vogue" at the university and he had been given permission to sell them. The price quoted was $12,500 for the painting and $1,000 for the bronze. I gulped at the news and agreed to buy both.

As usual, the Hall didn't have the money so I resold the painting to my friend Robert Rockwell of Corning, N.Y. for $25,000 and the bronze to Jasper Ackerman for $5,000. We needed the profit. Today I estimate the painting, which hangs in Corning, N.Y., is worth at least $175,000 and the bronze $18,000.

18. For C. R. Smith see chap. 2, note 32. During my visit to New York in November 1961 to see Mrs. Leigh, I also called on Mr. Smith. He had known Leigh and in fact owned several of his paintings. I told him of my enthusiasm for the studio collection and he was most complimentary.

19. Dr. Philip Cole owned the following W. R. Leigh oil paintings: *Badlands at Night* (28½ x 31½ inches); *The Roundup* (30 x 37½ inches); *The Buffalo Mother* (36¼ x 47½ inches); and *Argument With the Sheriff* (39½ x 59 inches).

20. Frank Phillips (1873-1950); see *Who's Who in America*, vol 26. A wealthy oil man and art collector from Bartlesville, Okla., he established Woolaroc Museum near Bartlesville in 1929. Phillips purchased some of Leigh's finest titles: *The Lookout, Navaho Fire Dance, Pocahontas, Westward Ho, Custer's Last Fight,* and *Visions of Yesterday* (as listed in *Woolaroc Museum Guide Book*, prepared by Patrick Paterson, director).

21. A copy of this compilation is in author's collection. From the time I first corresponded with Mrs. Leigh until her death, she would frequently mail me articles, brochures, folders, clippings, books (new or old), and any printed matter that mentioned her husband.

22. Mr. Gilcrease once told me how badly he wanted to purchase Leigh's *Midnight Ride of Paul Revere* but couldn't afford it. It was offered for sale at the time of his financial crisis. He felt the painting would have made a nice companion piece to the original document he owned authorizing Paul Revere to make his ride.

23. Among important bits of nationwide publicity the artist received was a short film done by Pathe News for national distribution. The documentary film showed Leigh working in his studio. *Collier's* magazine, in November 1950, did a feature on Leigh and his studio titled "Sagebrush Rembrandt." *The Saturday Evening Post*, April 1951, displayed "Old Time Longhorn Roundup" in color.

24. I am referring to Leigh's *The Leader's Downfall*.

25. Minutes of December 18, 1967 Board of Directors Meeting, Directors' Room, Fourth National Bank Building; Mr. E. Fred Johnson, presiding. The Leigh project came up for lengthy discussion. One director proposed that a Leigh room be set up and a separate admission be charged as a possible means of financing the acquisition. The idea received little or no support. (From author's copy of the minutes.)

26. An article noting Mrs. Leigh's death appeared in *The New York Times*, May 30, 1963:

> Mrs. Ethel Traphagen Leigh, founder and director of the Traphagen School of Fashion, 1680 Broadway, died yesterday in her studio at 200 West 57th Street. Her age was 80. She was the widow of William Robinson Leigh, noted painter of the old West, who died in 1955.
>
> Ethel Traphagen established the Traphagen School in 1923. She was responsible for a number of original styles in women's clothes that started trends in the fashion world. Her designs did much to bring recognition to the United States as a fashion center.
>
> A native New Yorker, she studied at the National Academy of Design and later at Cooper Union, where in 1904 she was awarded a bronze medal for a drawing from life. She also attended the Chase School of Fine and Applied Art.
>
> In 1910 Miss Traphagen formulated for the Board of Education a method of instructing students in fashion design. She became an instructor at evening high school, and in 1912 a lecturer at Cooper Union.
>
> She remained at Cooper Union for 20 years. Meantime she had been distinguishing herself in other ways. She won first prize in a New York Times fashion design competition in 1913, and later went to work for the *Ladies' Home Journal*, traveling in search of original motifs from American Indian costumes and in Europe.
>
> After her marriage to Mr. Leigh in 1921, she accompanied him on an American Museum of Natural History expedition to Africa, where she collected African dolls, jewels and ornaments, as well as costume data, which were to serve as the inspiration for new designs used in the textile industry.
>
> Miss Traphagen wrote "Costume Design and Illustration" (1918), and beginning in 1937 served as editor and publisher of Fashion Digest magazine. Her "Fashion Work as a Career" was published in the Book of Knowledge.
>
> She belonged to the Metropolitan Museum of Art, the Daughters of the American Revolution, and the National Geographic Society.
>
> She leaves a brother, John, of Nyack, N.Y.

27. Appraisal made by Art Curator Bruce Wear after consulting with Rudolf Wunderlich, president of Kennedy Galleries, N.Y.

28. Leigh, *Western Pony, op. cit.*, p. 70.

29. Eugene Neuhaus, *The History and Ideals of American Art* (Palo Alto: Stanford University, 1931), p. 324.

30. It is interesting to note that the Leigh studio collection was formally dedicated on the evening of November 7, 1964, almost three years to the day since my first letter to Mrs. Leigh exploring the possibility of Gilcrease Institute acquiring this great

asset—now worth perhaps more than a million dollars. It was of some concern to me that the editors of *American Scene* magazine devoted two issues to Leigh, his talent, and studio (vol. VII, no. 1 and vol. IX, no. 4) but made no mention of the years of effort that went into acquiring the collection.

<div align="center">

Chapter 4
ON THE TRAIL OF C. M. RUSSELL

</div>

1. The National Cowboy Hall of Fame and Western Heritage Center was the idea of Chester A. Reynolds of Kansas City, Mo., an executive of the H. D. Lee Company. He conceived of the idea for a cowboy hall of fame after visiting the Will Rogers Memorial at Claremore, Okla. Reynolds envisioned a shrine to the men and women who pioneered the American West. This was in the early 1950s.

In July 1954, at Cheyenne, Wyoming, Mr. Reynolds announced his plan for a national rodeo hall of fame. Several cities responded enthusiastically to the announcement by indicating they were interested in becoming the site for the cowboy shrine. Cheyenne made a strong bid, as did Dodge City, Kansas, and Prescott, Arizona.

An organizational meeting was held in Denver in January 1955 during the national Western Livestock Show. Those present were: Fred Porter, Jr. and Louis T. Horrell, Ariz.; Jasper Ackerman and Judge Wilson McCarthy, Colo.; Dodge City Mayor Gordon Morgan representing Kansas Gov. Fred Hall, and Harry Jameson representing former Sen. Harry Darby, Kansas; C. A. Reynolds, Missouri; Frank L. Spencer and K. Ross Toole, Mont. and Bill Browning representing Mont. Gov. Hugo Aronson; Chester Paxton and E. H. Shoemaker, Nebr.; Fred H. Dressler, Nev.; Albert K. Mitchell, New Mex.; Ray Schnell, N. Dak.; Lee V. Sneed, Okla.; Ernest Ham and Bert L. Hall, S. Dak.; A.M.G. Swenson, Texas; John D. Lewis, Utah; R. J. Hofmann and Dr. W. J. Ryan, Wyo.; and James McQueeny, public relations counselor.

At this time the name was changed from National Rodeo Hall of Fame to National Cowboy Hall of Fame and Museum. The name change may have been beneficial in the long run, but the immediate effect was an estrangement between the Rodeo Cowboys Association and many of their members. Under the leadership of Albert K. Mitchell, the Hall's role was slanted toward memorializing the cattleman rather than the cowboy.

At the Denver meeting, various committees were selected and plans formed to incorporate. An important committee was the Site Selection Committee, composed of Albert K. Mitchell, Fred H. Dressler, Ray Schnell and S. M. (Swede) Swenson. Site choices had been narrowed down to ten cities. The committee, on tour in the spring of 1955, further narrowed the selection to three possibilities: Colorado Springs, Dodge City, and Oklahoma City.

The final selection from the three sites was held in Denver in July 1955. The competition was especially keen and the outcome suspenseful. A huge delegation appeared from Dodge City, Kansas, headed by the state's governor. Oklahoma City's strong points were its wealth, a transcontinental highway, and the fact that it was a major city without a major museum. Persimmon Hill was dramatic and located along U. S. Highway 66. Furthermore, the site was forty acres in size and steeped in the

history of Indian territory and cattle trail driving days.

The building design was picked from more than 100 designs submitted in a national architectural competition with a first prize of $5,000. The firm of Jack Begrow and Jack Brown of Birmingham, Mich. won the competition. Construction of the building started in November 1958. After a few months it became apparent that drives were not yielding adequate funds to complete the construction, and work on the building stopped. At one point, trustees signed a note for $100,000 to complete the roof, but the loan was not enough incentive. Thus the incomplete building sat for years while the concept floundered. In 1964, the Oklahoma City Chamber of Commerce (under the leadership of executives Paul B. Strasbaugh and Stanley Draper, Sr.) and trustees of the Hall raised $1.2 million by surrendering title to the building and land to the Oklahoma City Cultural Facilities Trust. Revenue bonds were issued and construction resumed in August. The building was completed and formal dedication held on June 6, 1965.

On November 1, 1964, the author was employed as director, with the responsibility of staffing, integrating themes, acquiring collections, operation, and maintenance of fiscal responsibility.

During the first ten years of operation, more than three million visitors from throughout the world came to the Hall. One hundred eighty-nine names have been elected to the Hall of Fame of Great Westerners, thirty-four to the Rodeo Hall of Fame, and fourteen to the Great Western Motion Picture Hall. Unlike most museum-type institutions, the Cowboy Hall of Fame pursues *active* programs. It co-sponsors the National Finals Rodeo each December and sponsors the Western Heritage Awards, which recognize excellence in Western motion pictures and literature. The Hall mounts outstanding art shows each year, principally the National Academy of Western Art in June.

Major staff divisions are: administration, membership, education, rodeo, exhibits, library, public relations, art, Persimmon Hill magazine, book publishing, and security. Today there are forty-one staff members and the institution is open seven days a week.

In 1971, directors of the Hall were able to recover title to the building and grounds. In 1975 the institution showed assets over debits in excess of $15,000,000.

In concept, the National Cowboy Hall of Fame and Western Heritage Center is much like the old West, in that it has no government affiliations or subsidization. The Hall has not sought tax money from any level—federal, state, county or city.

2. Persimmon Hill is named for the numerous Chinese persimmon trees on the site.

3. The Amon Carter Museum was established in 1961 under the will of the late Amon G. Carter for the study and documentation of westering North America. The program of the museum, expressed in publications exhibitions, and permanent collections, reflects many aspects of American culture, both historic and contemporary. (Frederic Renner, *C. M. Russell Paintings and Sculpture in the Amon Carter Museum*, Harry N. Abrams, 1974, p. 6). For a colorful biographical sketch of Amon G. Carter see the foreword of the above book, written by Ruth Carter Johnson.

4. Perusal of various action records from Parke-Bernet and Eberstadts verify this

341

statement. The two single-most important collections bought by Carter and Gilcrease were the *Mint Saloon* and Philip G. Cole collections. At the time, total purchase prices were less than $500,000. Current worth today is perhaps twenty million dollars.

5. Charles S. Jones was an organizer of the Richfield Oil Company. For autobiographical material, see his history of the Richfield Oil Company, *From the Rio Grande to the Arctic*, published in 1972 by University of Oklahoma Press.

6. The National Cowboy Hall of Fame published an inventory of the Jones-Russell collection for the formal opening of its exhibit in December 1965. Frederic Renner has catalogued correct titles for a number of works named in the collection: *Happy Cowboy* is correctly titled *In For Christmas; Indians Attack on Stagecoach* is *The Stagecoach's Attack; Attack by Indians* is correctly titled *Battle of the Bear Paws; Indian Attack* is *Battle Between Crows and Blackfeet*. Regarding Russell's bronzes, the *Bronc Twister* is correctly titled *A Bronc Twister; The Buffalo Hunt* is *Buffalo Hunt* and *The Night Herder* is *The Horse Wrangler*.

7. For Luther T. Dulaney, see Dean Krakel, *End of the Trail: the Odyssey of a Statue* (Norman: University of Oklahoma Press, 1973), pp. 185-6, and chapter 15, note 1.

8. Oklahoma City Industrial and Cultural Facilities Trust is an Oklahoma state-chartered entity, with authority to aid industrial and cultural financial development through the issuance of long-range revenue bonds.

9. Paul B. Strasbaugh is a native of York County, Pa. and graduate of Dickinson College. He joined the Oklahoma City Chamber in 1946 and moved up through the ranks, becoming general manager in 1968. Paul is a specialist in industrial financing, and the success in locating the National Finals Rodeo in Oklahoma City is due largely to his skill. He is active in the Cowboy Hall of Fame's various programs.

10. Stanley C. Draper, Sr. (1889-1976) was a native of Lasker, North Carolina. He joined the Oklahoma City Chamber of Commerce in 1919 and became nationally famous for his organizational ability, having developed numerous projects that gave Oklahoma City stability and leadership in the southwest. He served the Chamber for more than 48 years and retired as its top executive in January 1968. Mr. Draper also took the leadership in securing the National Cowboy Hall of Fame for Oklahoma City.

11. James Boren, a widely known Western painter, was born in Waxahachie, Texas. He joined our National Cowboy Hall of Fame staff as first art director in March 1965 and resigned May 1969. Jim has long been active in the Cowboy Artists of America organization and is a rancher in Texas. For biography, see *James Boren: A Study in Discipline* by Dean Krakel (Flagstaff, Ariz.: Northland Press, 1968).

12. John Pogzeba, conservator of art, was born in Poland and educated in private European schools. He served a long apprenticeship at the Vatican in conservation and restoration of masterpiece art; he served as a consultant to many European muscum directors. Held prisoner at Dachau prison camp, he came to America after World War II. Mr. Pogzeba has operated his own art conservators business and was conservator at

Gilcrease Institute for many years.

13. This statement is in error, as the Nancy Russell estate was purchased by C. R. Smith. According to authority Frederic Renner, "After selecting a complete set of the Russell bronzes for himself, Smith essentially then sold the remaining half of the collection to Homer E. Britzman. Britzman, in turn, and over a period of several years, sold some of the Russell items to Mr. Jones."

14. See Krakel, *End of Trail*, p. 186. For a fuller tribute to Ackerman, see chapter 11, "A Touch of Greatness."

15. For John E. Kirkpatrick, see Krakel, *End of Trail*, p. 184.

16. National Finals Rodeo is the rodeo which climaxes the competitive year for members of the Rodeo Cowboys Association. World titles are often decided at the National Finals. Championship rodeo cowboy titles in major events are based on money earned—a point for each dollar. Before coming to Oklahoma in 1965, the Finals were held in Denver and Los Angeles.

17. Robert Henri (1865-1929) is mentioned in practically every book written on American art. The best book on Henri's philosophy was compiled by Margery Ryerson, *The Art Spirit* (Lippincott, 1960); also William I. Homer, *Robert Henri and His Circle* (Cornell University Press, 1969). I bought the Henri painting *La Trinidad* after seeing it in the Henri exhibition at the Huntington Hartford Museum, N.Y.C. I went straight from the exhibit to the Chapellier Gallery, where I told Robert Chapellier that I was interested in the painting. He quoted $32,000 as the price. I replied that it was too rich for our blood and for him to think it over and let me know. On February 26, 1970 he wrote, "Our asking price for the painting is $32,000. As a special private offering to you and your museum we could make the price to you $24,000. This could be paid over a period of eighteen months with a token down payment of $4,000. This offer is made primarily to please you and have something from our gallery at the National Cowboy Hall of Fame."

18. Walter Ufer (1876-1936) was born in Louisville, Ky. See *American Art Annual*; *Fielding's Dictionary of American Painters*; *Who's Who in America*; D. J. Mallot, *Index of Artists*, 2 vols. (New York, 1948); and Dorothy Harmsen, *Harmsen's Western Americana* (Flagstaff, Ariz.: Northland Press, 1971).

19. Eanger Irving Couse (1866-1936) is included in *American Art Annual*; *Fielding's Dictionary of American Painters*; *Who's Who in America*; *Thieme-Becker Lexikon*; and Harmsen, *op. cit*. For additional mention of Couse, see text on J. M. Khoury in chapter 12, "Dealers I Have Known and Liked."

20. Remington's *Wild, Wild East* appeared as an illustration for the cover of *Harper's Weekly* magazine, Oct. 21, 1893. This painting was purchased from Oklahoma City art dealers Willard Johnson and Richard Seis.

21. This painting of a big horn sheep, dated 1914, was obviously painted while Leigh

343

was in the mountains near Cody, Wyoming.

22. Russell's *Wolves Attacking In Blizzard* was purchased in 1969 while I was on my summer vacation. I was visiting Fred Rosenstock's Book Store and Western Art Gallery in Denver. The painting was owned by Raymond Brown of the Country Store Art Gallery, Austin, Texas. I felt the painting was terribly important and immediately snapped it up.

23. For more on Carl Link, see chapter 9.

24. Hammer Galleries is discussed in chapter 12, "Dealers I Have Known and Liked."

25. In 1969, I began visiting Chapellier Galleries (located at 22 East 80th Street and Madison Avenue at 75th St.) when in New York City. I first made the acquaintance of George Chapellier, then Robert. George Chapellier had established his first gallery in New York in 1916. I was intrigued when he told me how he would drive to Tulsa in the early days and sell paintings from his hotel room to Thomas Gilcrease. The Chapelliers were advocates of the American School of Art. What endeared them to me was their sale to us of Robert Henri's great painting *La Trinidad* (see note 17).

26. Fred Rosenstock is profiled in chapter 12.

27. Country Store Art Gallery, Austin, Texas, is owned and operated by Raymond Brown. It is one of the forceful commercial art galleries in Texas and the Southwest.

28. For J. M. Khoury, see chapter 12.

29. The Biltmore Gallery in Los Angeles was formed in 1924 as the Biltmore Salon, representing seven Western artists. Nancy Russell was involved with the group and Alex Cowie served as the first director.

30. Joel McCrea is the famous motion picture actor and a California rancher. See Krakel, *End of the Trail*, p. 188.

31. Hubbard Russell (1885-1963) was elected an honoree in the Hall of Great Westerners, National Cowboy Hall of Fame, in 1970.

32. Ernest N. Corneau, *The Hall of Fame of Western Film Stars* (Quincy, Mass.: Christopher Publishing House, 1969) p. 154.

33. Earl Adams is the author of an informative article titled "The Russell Estate," *Persimmon Hill*, vol. 3, no. 2. A short biography and photo of Mr. Adams appears on page 56 of that issue.

34. Edward Muno was born in 1942 on a farm near Clinton, Okla. and was educated in the Arapaho Schools. He attended Okmulgee Tech. and then worked as a photographer for Gilcrease Institute. Ed became staff photographer, NCHF, in 1969 and was promoted to design and associate editor of *Persimmon Hill* in 1971.

35. Don Hedgpeth, born in Agua Dulce, Texas, is an educator and writer; he earned a

M.A. in history. He was editor of *Oklahoma Cowman* and the first editor of *Persimmon Hill*. Don was director, Whitney Gallery of Western Art, Cody, Wyoming, 1972-1975 and is presently director, Haley Library and Foundation, Midland, Texas.

36. Rex L. Nicholson (1902-1974), a California rancher, was born in New Mexico. He was owner of Nicholson Enterprises (primarily construction) and served as advisor to Presidents Roosevelt and Truman during World War II. Rex was a member and officer of the National Cowboy Hall of Fame Board of Directors.

37. William G. Kerr is included in detail in chapter 10 and in Krakel, *End of Trail*, p. 187.

38. For more on J. B. Saunders, see Krakel, *End of Trail*, p. 187. An excellent full-length biography is *The Professional* by Otto J. Scott (New York: Atheneum, 1976). J. B. is also included in chapter 8, "Wheeling and Dealing for Western Masterpieces."

39. Robert Rockwell was born in Bradford, Pennsylvania and is now a resident of Corning, N.Y. He is a rancher, department store owner, and creator of the Rockwell Foundation. Bob is the owner of a large, important collection of Western art; his Rockwell Foundation lent extensive collections to the NCHF during our formative years. Mr. Rockwell is a member of the Hall's Board of Directors.

40. Mitchell Wilder has been director of Amon Carter Museum since 1961. For biographical sketch of Mr. Wilder, see *Who's Who In The Southwest*, 11th ed., p. 1089.

41. Bryan B. Rayburn was formerly deputy director of the NCHF. He now operates the Hall's gift shop, The Sutlery.

42. Homer Britzman was born in Colorado; his law degree is from the University of Colorado. He became associated with Charles S. Jones of Richfield Oil Co. and, through Mr. Jones, became interested in C. M. Russell and Western art. Britzman bought a portion of the Nancy Russell estate from C. R. Smith. Many of the later castings of Russell bronzes were unauthorized and are attributed to Britzman. Britzman's own writings and publications under the Trail's End imprint helped to publicize Russell and improve the market at a comparatively early date in the promotion of Western art. See Ramon F. Adams and Homer E. Britzman, *Charles M. Russell, the Cowboy Artist; a Biography* (Pasadena: Trail's End 1948); and Karl Yost, *Charles M. Russell, the Cowboy Artist, a Bibliography*, 2 v. (Pasadena: Trail's End, 1948); Homer Britzman, "The West in Bronze," *The Westerners Brand* Book (Los Angeles Westerners, 1945); Homer Britzman, "Charles M. Russell, Friend of the Indian," *Arizona Highways*, vol. 29, no. 8 (August 1953).

Chapter 5
THE FRASER PROJECT

1. James Earle Fraser (1876-1953) was born in Winona, Minn. He studied at the Chicago Art Institute and at the École des Beaux Arts, Julien Academy, and Colarossis in Paris. Full biographical information can be found in *Fielding; Who Was Who in America; American Art Annual*, Isham's *History of American Painting;* and Joseph F. Morris,

ed., *James Earle Fraser* (University of Georgia Press and National Sculpture Society, 1955). Aline B. Lochheim interviewed the artist shortly before his death for her article, "Most Famous Unknown Sculptor," *The New York Times Magazine*, May 13, 1951.

Laura Gardin Fraser (1889-1966) was born in Chicago. She attended Columbia University briefly and then went to the Art Students' League, where she met, studied under, and married James Earle Fraser. Laura is listed in *American Art Annual*, *Who's Who in America*, *Fielding*, and *Who's Who of American Women*. Her personal papers, letters, and diaries are in the Syracuse University library.

2. Fraser first exhibited the full-scale *End of the Trail* statue at the Panama-Pacific International Exhibition held in San Francisco in 1915. *End of the Trail* was awarded the gold medal for sculpture. After the close of the Exposition, the work was ultimately removed to Mooney Grove Park near Visalia, California.

3. Dr. Martin H. Bush was then assistant to the chancellor of Syracuse University. At present, he is vice president for Academic Resource Development, Wichita State University.

4. Major works of James and Laura Fraser are chronologically listed in the author's *End of the Trail: the Odyssey of a Statue* (Norman, Univ. of Oklahoma Press, 1973) pp. 169-177.

5. Glenn W. Faris served the Oklahoma Chamber of Commerce for forty-nine years and played a role in bringing the National Cowboy Hall of Fame to Oklahoma City. He was the Hall's first general manager. Also see Krakel, *End of the Trail*, p. 186.

6. Juan Menchaca has been chief curator of exhibits at the National Cowboy Hall of Fame since its beginning. He was born in Fort Worth, Texas and, before coming to the Hall, was a staff member of the Colorado Historical Society. See Krakel, *End of the Trail*, p. 184.

7. Rich C. Muno, native Oklahoman, is a talented sculptor as well as staff member of the Cowboy Hall of Fame. He first served as curator, then assistant art director, and is now art director.

8. Merle Fisher Harp, though born in Kansas, grew up and was educated in Oklahoma. He graduated from Oklahoma State University with a degree in agricultural administration and later became superintendent of parks of Tulare County, Calif. and curator of their county museum. In 1971 he was awarded the Calif. Bicentennial Commission Medal for his efforts in developing the museum and for his part in the *End of the Trail* project.

9. Leonard McMurry, a native of Texas, attended West Texas State College and Washington University, St. Louis. He received the Prix de Rome and other sculpture awards before serving in the armed forces during World War II. Later he studied with Ivan Mestrovic at Syracuse University. In 1952, his massive bronze of St. John the Evangelist was entered in a national competition sponsored by the National Sculptors Society of New York, and in the same year he won the McMillinken Foreign

Scholarship at Washington University.

10. Gene Dillehay was born in Texas but schooled in Oklahoma. He has worked in radio and television in Oklahoma City for many years. Currently he produces music albums and commercials at his Producers' Workshop.

Chapter 6
A MILLION DOLLAR MEMORIAL

1. Bernhard Zuckerman was born in New York City in 1912. There he studied at the National Academy of Design, Beaux Arts Institute, and Columbia University, as well as the Academy of Fine Arts in Florence, Italy. He is a fellow of the National Sculpture Society and a member of the Salmagundi Club, the American Artists Professional League, Burr Artists, and the Architectural League. Zuckerman's projects include a mural for the Catholic Chapel, Air Force Academy, Colorado Springs, Colo.; the Kennedy Memorial Fountain in Tampa, Florida; and a heroic-sized bronze of Columbus for Scott Park, Elizabeth, New Jersey.

2. Cesare Contini was born and raised in New York City where he, his father, and brothers were professional moldmakers. The Continis worked with the Frasers for more than forty years and with other prominent American artists as well.

3. Dean A. McGee is chairman of the board of directors and chief executive officer of Kerr-McGee Corporation. Born in Humboldt, Kansas, March 20, 1904, he earned a degree in mining engineering at Univ. of Kansas. Mr. McGee has been awarded several honorary degrees and is an officer or director of numerous business, professional, scientific, educational and community organizations.

4. Mrs. Nona S. Payne was born in Bloomfield, Iowa and married the late David D. Payne on May 4, 1940. Mrs. Payne is a member of the Business and Professional Women's Club; a life-member of the Panhandle Plains Historical Society; a life-member of the Texas Panhandle Heritage Foundation, Inc., a member of the Pampa, Texas Knife and Fork Club, and a life-member of Cal Farley's Boy's Ranch. She is a trustee of the Board of Directors of the National Cowboy Hall of Fame and is the first elected honorary life member of the Board of Directors.

5. Joe Gordon was born in Miami, Texas. He received a B.A. from Texas Tech University in 1930 and an L.L.B. from University of Texas the following year. Joe is active in local and national bar associations, served as county attorney of Gray County (1937-44), and has been a director of Texas Tech University Foundation. Mr. Gordon was elected president of the Board of Directors of the National Cowboy Hall of Fame in April 1976.

6. Dr. Leland Case was born in Wesley, Iowa. He holds a B.A. from Macalester College, an M.A. from Northwestern University, and a Ph.D. from the University of Chicago. Dr. Case has long been active in publishing and has authored and edited a number of books, including: *Guidebook to the Black Hills* (1949); *Around the Copydesk* (1933); *A World to Live In* (1942); *Peace Requires Action* (1946); and *Reader's Choice*

347

Treasury (1964). He has received numerous awards, citations, and honorary degrees and served with the U. S. Dept. of State at the United Nations Conference in San Francisco, 1945.

7. For more on Albert K. Mitchell, see chapter 16, "In From the Night Herd."

Chapter 7
CHARLES SCHREYVOGEL: BUGLES IN SANTA FE

1. A basic source has been my own collection of Schreyvogelana accumulated since 1950, the year I entered graduate school at the University of Denver and purchased my first four-drawer file cabinet with the idea of "filing things." A friendship, now in its eighth year, with the artist's daughter, Ruth Schreyvogel Carothers, and her husband, Archie, has yielded many written interviews. Ruth draws on what her mother told her since she was a small child when her father died. I also interviewed several others who had either a near or distant kinship with the artist. Clippings and letters in my files are important, but as to specific dates and places of his western travels, there is virtually nothing. The bulk of my material pertaining to paintings is ephemeral; yet, in the collecting of such material over a twenty-five year period, interesting profiles take form.

The Schreyvogel paintings referred to in my summary are virtually all identified as to recent owners in James Horan's *The Life and Art of Charles Schreyvogel, Painter-Historian of the Indian-Fighting Army of the American West* (New York: Crown Publishers, Inc., 1969).

Valuable insights into Schreyvogel's life and work are found in his own publication, *My Bunkie and Others* (New York: Moffat, Yard & Co., 1909). Also, *Souvenir Album of Paintings by Charles Schreyvogel* (Hoboken, New Jersey: Charles F. Kaegebehn, 1907), containing 28 reproductions, photograph of the artist and biographical sketch; Gustav Kobbe, "A Painter of the Western Frontier," *The Cosmopolitan*, v. 31, no. 6, October 1901. In all there appeared no more than ten feature articles about Schreyvogel in major newspapers and magazines during the zenith of his career and at best they are reporters' accounts. Kobbe's article is the better. Robert Taft's *Artists and Illustrators of the Old West*, (New York: Scribner's, 1953), remains for me the best and most stimulating source on the artist. Jefferson Dykes biographic contribution in *American Book Collector*, Volume XVII, (1966) No. 4, was timely and immensely helpful in my pursuit of the artist.

A full-length, in-depth biography of the artist during the time he travelled in the West needs to be produced. I spent the greater part of six months, with the help of a research assistant, trying to track down Schreyvogel's life in the West. At best the evidence gained was scattered. Both Taft and Horan are vague on the subject as is Schreyvogel in his own writings. I did succeed in dating him at Fort Robinson, Nebraska; Fort Yates, North Dakota; and Browning, Montana, but certainly this is not enough on which to develop a solid research framework. I succeeded in uncovering two caches of Schreyvogel's Indian Territory letters concerning the purchase of artifacts and costumes. In only one letter did he indicate that he might be going to Fort

Sill. Schreyvogel's trip to Ignacio, Colorado and the Ute agency in 1893 is still somewhat a riddle.

2. Letter from Schreyvogel to his wife, in author's collection.

3. *Saving the Mail* (48 x 35¼ inches) is in the National Cowboy Hall of Fame's permanent collection, gift of Mrs. Sanford Brown, East Orange, New Jersey.

4. New York *Herald*, April 28, 1903, p. 3.

5. Letter from Charles Schreyvogel to his wife, dated November 25, 1903, in the collection of the National Cowboy Hall of Fame.

6. Remington letter dated May 6, 1903, on exhibit at the National Cowboy Hall of Fame.

7. Gustav Boehm, "Painter of Western Realism," *Junior Munsey*, New York (1900), v. 8, pp. 432-38.

8. New York *Herald*, May 2, 1903, p. 7.

9. Dr. Philip G. Cole; see chapter 1, note 28. Davidson-Knoedler records show that Thomas Gilcrease purchased Schreyvogel's most important painting, *Custer's Demand*, on November 10, 1953 at a price of $19,593. For further information on this painting see Taft, *Artists and Illustrators of the Old West*, page 228-230.

10. Parke Bernet public auction, January, 1964; sale number 2251, items 56 and 72.

11. Elizabeth Bacon Custer (1844-1933), widow of George Armstrong Custer, is mentioned in *Who's Who in America*, Volume I. She was the author of *Boots and Saddles, or Life in Dakota with General Custer* (New York: Harper & Bros., 1885); *Tenting on the Plains* (New York: Charles Webster, 1889); and *Following the Guidon* (New York: Harper & Bros., 1890).

12. His *The Schreyvogel Farm* (25 x 34 oil) is in the studio collection at the National Cowboy Hall of Fame.

13. A copy of this letter, dated January 11, 1910, is on exhibit at the National Cowboy Hall of Fame.

14. Papers for Western Art Fund were formally filed with the Internal Revenue Service and Oklahoma State Corporation Commission on May 15, 1969.

15. We prepared an elaborate and colorful brochure on the joint venture between the National Cowboy Hall of Fame and Winchester Western Gun Co., containing a color photograph of the Schreyvogel studio as well as an inventory of the studio collection. Membership in the "Schreyvogel Club" carried with it the commemorative rifle in walnut case, a distinctive commemorative medallion, and a replica of Schreyvogel's bronze, *The Last Drop*.

Chapter 8
WHEELING AND DEALING FOR WESTERN MASTERPIECES

1. *New York Times* reporter Grace Glueck wrote on Thursday, December 9, 1971, "It is understood that the gallery [Knoedler's] which moved early this year from East 57th Street to its present quarters at 21 East 70th Street, ran into trouble over unexpected remodeling expenses, amounting to $1.4 million . . ." In the same article, new owner Dr. Armand Hammer is quoted as saying, "I foresee that Knoedler's, on a sound business basis, will become again the institution it has been."

2. Anthony Bower, born in the United States and educated at Oxford, was a well-known personality in the art world. From 1957 to 1970 he was managing editor of *Art in America*, then moved to Knoedler's as head of their American department. Shortly before his death he had opened his own gallery in New York City.

3. Western Art Fund, Inc., 1520 First National Center West, Oklahoma City, was incorporated as a non-profit, educational organization on May 15, 1969. The author used Western Art Fund to expedite the Cowboy Hall of Fame's financial operation, which was at that time rather inflexible. The board would not give me borrowing authority and prior to the organization of Western Art Fund the Hall was, in my opinion, headed toward bankruptcy and collapse. Working closely with Luther Dulaney and J.B. Saunders, I was thus able to operate in a financially fluid manner. For example, at the time of phasing out, the December 31, 1972 audit report revealed that Western Art Fund had assumed National Cowboy Hall of Fame notes in the amount of $120,031.64, had made payments on National Cowboy Hall of Fame notes for $158,915.60 and interest payments of $59,980.60.

4. This statement is in a sense a misstatement. As a matter of fact, the Oklahoma City bankers with whom I did business became dedicated to the Hall and all that we were attempting to achieve. Throughout the years, we have received strong support from Liberty National Bank, vice-presidents William Robertson and Homer Paul; First National Bank and Trust Company, C. A. Vose, chairman, and Bill McDonald, chief executive officer; Stockyards, Robert Empie, president and Gaylord Jones, senior vice-president; Fidelity, Keith May and J. W. Michael, vice-presidents; Republic, N. L. McClain, president and Bill Eddy and Don Bateman, vice-presidents. Exchange National Bank of Colorado Springs, Jasper Ackerman, chairman and chief executive officer and Hal Littrell, senior vice-president.

5. Victor Hammer is described more fully in chapter 12, "Dealers I Have Known and Liked."

6. Letter from Helen (Teri) Card to author, July 18, 1963.

7. Harold McCracken, *The Frederic Remington Book; a Pictorial History of the West* (New York: Doubleday, 1966).

8. Ibid., p. 262.

9. For Knoedler's formal opening we loaned *The Cinch Ring* by C. M. Russell and

Remington's *Hunters' Camp in the Big Horns.*

10. Thomas Eakins' *Cowboys in the Badlands* is a 35½ x 45½ inch oil dated '88, with two figures in the left foreground, one astride his horse, gazing out over an extensive valley. The painting was sold at Parke-Bernet Galleries, Inc., December 10, 1970.

Chapter 9
THE CARL LINK WINDFALL

1. A biography of Carl Link is difficult to prepare because of the lack of published professional material. He is mentioned in *Mallett's Index of Artists* (New York, 1948), p. 257.

The summary in this chapter is the result of original research coming from Link's papers. The author has completed a seventy-eight page preliminary biography of the artist, containing six chapters. Tentative title is: *Carl Link: Sixty Years a Painter.*

2. Walter Brennan (1894-1974), the famous movie actor, was elected an honoree in the National Cowboy Hall of Fame's Hall of Great Western Performers in 1971. Walter was as delightful a person off the screen as he was on and very philosophical, too. One of the most unforgettable experiences I have had was accompanying Walter to Stockbridge, Massachusetts, to visit Norman Rockwell, the famed illustrator, preliminary to Rockwell painting Brennan's portrait. See *Persimmon Hill*, vol. II, no. 4. Also "The New Life of Norman Rockwell," *Saturday Evening Post*, Fall 1972. The Brennan portrait is reproduced on page 76 of this article.

3. Frank Bird Linderman, *Recollections of Charlie Russell* (Norman: University of Oklahoma Press, 1963).

4. Russell-Remington issue, *American Scene*, vol. V, no. 4, p. 61.

5. Linderman, *op. cit.*, pp. 8-10.

6. Letter from Mrs. R. O. Waller to author, dated October 9, 1968.

7. For Dr. Martin Bush see chapter 5, note 3.

8. Bryant P. Baker, sculptor, is included in Fielding, *op. cit.*, p. 15. Also, Beatrice G. Proske, *Brookgreen Gardens Sculpture* (South Carolina: Brookgreen Gardens, 1966), contains a biographical sketch of Baker, pp. 236-238.

9. Biographical information on Winold Reiss was sent to the author by Tjark Reiss, the artist's son; I also referred to numerous brochures, folders, and clippings in my collection. Recommended reading: John C. Ewers, "Winold Reiss: His Portraits and Photos," *Montana, the Magazine of Western History*, vol. XXI, no. 3 (July 1971); and "Portfolio: 24 Color Prints from Original Portraits of Blackfeet Indians Drawn From Life by the Late Winold Reiss in Glacier National Park in Montana, from the Great Northern Railway's Collection and Dr. Claude E. Schaffer's story of the Blackfeet Nation."

10. A Royal Academy class photograph in the Link Collection, National Cowboy Hall of Fame, shows Reiss and Link together. The two corresponded frequently with each other, most of the time writing in German. Mrs. Waller verified the friendship between the two artists in her letter of October 9, 1968.

11. The commission for *Pioneer Woman* was won by Baker in a nationwide competition sponsored by oilman E. W. Marland of Ponca City, Oklahoma. The colossal work was dedicated in 1930; Will Rogers was featured speaker at the ceremonies. James Earle Fraser entered the competition, as did ten other artists. This may well have been Baker's most famous composition even though the figure has been somewhat controversial.

12. Edwin J. Beinecke, Jr. is a member of the famous Beinecke family and is an executive with the Sperry-Hutchinson Corp. His associations are many in industry and the arts and he is an important collector of Western art and Americana. Mr. Beinecke is widely known for his philanthropic activities.

Chapter 10
NICOLAI FECHIN

1. For biographical background, see the following books: Mary N. Balcomb, *Nicolai Fechin*, foreword by Eya Fechin Branham (Flagstaff, Ariz.: Northland Press, 1975); Harold McCracken, *Nicolai Fechin*, (New York: Hammer Galleries, 1961); Ed Ainsworth, *Cowboy In Art* (World Publishing Company, 1968); Dorothy Harmsen, *Harmsen's Western Americana* (Northland Press, 1971). Also several articles: Ed Ainsworth, "Nicolai Fechin, the Man Who Painted the Desert's Soul," *Palm Springs Villager*, v. 11, no. 8 (March, 1957); Frank Waters, "Nicolai Fechin," *Arizona Highways*, v. 28, no. 2 (February, 1952), pp. 14-27; Dean Krakel, "Faces of Fechin," *Persimmon Hill*, v. 4, no. 3, pp. 44-54.

2. Information on these portraits and biographical materials on Eaker and Cannon are available from United States Air Force Academy, Colorado Springs, Colorado.

3. For more on Victor Hammer, see chapter 12, "Dealers I Have Known and Liked."

4. The Fechin in Gilcrease Institute is titled *Old Tower*.

5. For Erwin S. Barrie, see chapter 3 on William R. Leigh and chapter 12.

6. Dean Cornwell is listed in *Fielding, op cit.*, p. 77.

7. Jack R. Hunter, of Pittsburgh, was an early collector of Fechin's work. He was instrumental in the lengthy efforts required to obtain permission for the Fechin family to emigrate from Russia to America.

8. Alexandra Fechin is described in McCracken, *Nicolai Fechin* and Balcomb, *Nicolai Fechin*. The Balcomb book includes photographs and several portraits that Fechin painted of his wife.

9. Alexandra Fechin, *March of the Past* (Santa Fe, N.M.: Writers' Editions, 1937).

10. McCracken, *Nicolai Fechin*, p. 8.

11. Peter Dulsky, *Nicolai Fechin*, brochure (Kazan: Library of Illustrated Monographs, Kazan Section, 1921), p. 9.

12. Ibid.

13. *Chicago Daily Tribune*, April 27, 1911.

14. Dulsky, *Nicolai Fechin, op. cit.*, p. 16.

15. The C. Thomas May, Jr. family has assembled a noted collection of Eastern and Western Americana paintings. Tom, a graduate of the U. S. Naval Academy, is a Dallas financier.

16. James Khoury is further described in chapter 12, "Dealers I Have Known and Liked."

Chapter 11
A TOUCH OF GREATNESS

1. Jasper D. Ackerman is a banker and rancher in Colorado Springs, Colorado. He was born into a pioneer family in Buffalo, Wyoming and attended high school in Colorado Springs. As a 2d Lt. in World War I and Lt. Col. in World War II, Jasper received many decorations, including five battle stars. Mr. Ackerman has been the guiding force behind Colorado Springs' successful "Pikes Peak or Bust Rodeo." He operates the ten-thousand-acre Turkey Track Ranch and is active in many horse and cattlemen's associations. Mr. Ackerman is one of the original trustees of the National Cowboy Hall of Fame and has served as treasurer since 1954; he has also been a member of the Executive Board, serving as president and as chairman.

2. The Oklahoma City Cultural Facilities Industrial Trust of Oklahoma City.

3. William R. Leigh's *The Buffalo Hunt*. See chapter 3, note 17.

4. The story of the rifle is told in chapter 9, "The Carl Link Windfall."

5. Ed Borein's *The Free Trappers* (21½" x 27½"); *Ute Camp* (21½" x 27½"); *California Cattle Herd* (19" x 28"). All three india ink drawings are reproduced in Harold Davidson's book, *Ed Borein, Cowboy Artist* (Garden City, N.Y.: Doubleday, 1974).

6. Clarence T. McLaughlin (1897-1975), born in Arthurs, Pennsylvania, was an oilman and rancher in Snyder, Texas. In 1964, Clarence created his own Diamond M Museum in Snyder to house his extensive collection of Western art. The collection is described in detail by Alice Miller, "C. T. McLaughlin and His Diamond M Foundation," *Persimmon Hill*, v. 5, no. 1.

7. Clarence Jackson was living in Denver, Colorado at the time I knew him during the early 1950s. We frequently had dinner together, and he often visited me at the

University of Wyoming. Details of his life can be researched through the Western History Division of Denver Public Library.

Quest of the Snowy Cross was written by Jackson and Lawrence W. Marshall (Denver, University of Denver Press, 1952).

8. Dr. Harold McCracken, widely known historian, author, and museum director, was the first director of the Whitney Gallery of Western Art, Cody, Wyoming. He is a recognized authority on the art of C. M. Russell and Frederic Remington. McCracken's autobiography is *Roughnecks and Gentlemen* (Garden City, N.Y.: Doubleday, 1968).

9. This was the cabin where the hunter and trapper Jake Hoover lived in the mountains near Utica Basin, Montana. Hoover befriended C. M. Russell. For insight into the lives of Hoover and Russell, see *Persimmon Hill* magazine, v. 3, no. 2.

10. *Bad Day in Utica* and *In Without Knocking* both hang in the Amon Carter Museum, Fort Worth, Texas.

11. *Emigrants Crossing the Plains, (Sunset on the Oregon Trail)* by Albert Bierstadt (1830-1902), oil size 60" x 90", signed and dated 1867. In the spring of 1863, Bierstadt, together with the journalist Fitzhugh Ludlow, left New York City for an extensive expedition west which would finally end in California. While traveling near the Platte River in Nebraska, they came upon a scene which the artist wrote of as "a picturesque party of Germans going to Oregon . . . the whole picture of the train was such a delight in form, color, and spirit that I could have lingered near it all the way to Fort Kearny." The painting was done from sketches made on the spot and was purchased directly from the artist in 1868 by Amanda Stone, of Cleveland, for $15,000.

Emigrants Crossing the Plains is considered by many as the artist's most important work because of the rich color values, particularly the use of reds, yellows and gold colors in the sunset, along with the animation and life given the painting by the caravan heading west. Both the color and action qualities are unusual for this famous artist who is known primarily for his quiet and magnificent mountain scenes. While the painting has led a life sheltered from exhibitions, it has appeared frequently in major publications featuring the American West.

Chapter 12
DEALERS I HAVE KNOWN AND LIKED

1. There are a number of books regarding art dealers that I found entertaining: James Brough, *Auction* (Indianapolis: Bobbs-Merrill, 1963); Sophy Burnham, *The Art Crowd* (New York: David McKay Company, 1973); James Henry Duveen, *The Rise of the House of Duveen* (New York: Alfred A. Knopf, 1957); S. N. Behrman, *Duveen* (New York: Random House, 1952); Germain Seligman, *Merchants of Art: 1860-1960, Eighty Years Professional Collecting* (New York: Appleton-Century-Crofts, Inc., 1961); John Russell Taylor and Brian Brooke, *The Art Dealers* (New York: Charles Scribner's Sons, 1969); Calvin Tomkins, *Merchants and Masterpieces* (New York: E. P. Dutton Company, 1970); Wesley Towner, *The Elegant Auctioneers* (New York: Hill & Wang, 1970); and Robert Wraight, *The Art Game* (London: Leslie Frewin, 1965).

2. William F. Davidson also appears in chapters 1, 2, 3, and 4. An obituary appears in chapter 2, note 5.

3. Knoedler Galleries is an important commercial art firm dating back to 1846. In 1946, "on the occasion of Knoedler's one hundred years, 1846-1946," a short history of the firm was written by Charles R. Henschell, grandson of the founder Michel Knoedler, and privately published. One does not have to search extensively in the catalogues of major museums before finding examples of masterpieces that have come through the firm's sales galleries.

4. Erwin S. Barrie is listed in *Who's Who In American Art* (New York: Booker Publishers, 1976), p. 29.

5. Rudolf Wunderlich is listed in *Who's Who In American Art*, p. 617.

6. Victor Hammer is mentioned in chapter 10, "Nicolai Fechin." For exploits of Victor and Armand Hammer, see James Brough, *Auction* (Indianapolis: Bobbs-Merrill, 1963). More recent is *The Remarkable Life of Dr. Armand Hammer*, written by Bob Considine and published by Harper & Row, 1975.

7. James Khoury is mentioned in chapters 4, 8, 10, and 11. Jim's partner for many years was Boyd Hinton.

8. An abundance of biographical information is available on the career of Fred Rosenstock in the clipping files of both the *Denver Post* and *Rocky Mountain News*. A choice item is "Small Miracles In My Life As A Book Hunter," a paper he delivered to the Denver Westerners at their Christmas rendezvous on December 18, 1965. A full-length biography has recently been published: *Fred Rosenstock: a Legend in Books and Art*, by Donald Bower (Flagstaff, Ariz.: Northland Press, 1976).

Chapter 13
FRAUD, HORROR, AND THE CHECKBOOK

1. There are several good books on fraud in art. The most interesting to me are: Harry Hahn, *The Rape of LaBelle* (Kansas City, Mo.: Frank Glenn Publ. Co., 1946) with an introduction by Thomas Hart Benton; and Frank Arnau, *The Art of the Faker; 3,000 Years of Deception* (New York: Little, Brown and Company, 1959). Arnau's chapter, "Twentieth Century Vermeers," is the fascinating story of Han Van Meegeren. Also, John Kilbracken's book *Master Art Forger* (New York: Wilfred Funk, 1951) which goes into Han Van Meegeren's life and art fraud; and *Fake: the Story of Elmyr de Hory, the Greatest Art Forger of Our Time* by Clifford Irving (New York: McGraw-Hill Book Company, 1969).

The most important article written on C. M. Russell frauds is by authority Frederic G. Renner in *Montana Magazine*, v. 6, no. 2 (April 1956) titled "Bad Pennies," a Study of Forgeries of Charles M. Russell Art." Rudolf G. Wunderlich of the Kennedy

Galleries in New York City is an authority on Frederic Remington fakes and has prepared an informative paper on the subject.

2. Earle Erik Heikka was born in Belt, Montana, but shortly thereafter his family moved to Great Falls. At the age of four his father died; five years later his inherent ability as a sculptor became clearly evident. As a child Heikka would spend hours modeling animals from laurel gumbo. Whenever the opportunity arose, Heikka ventured off to Charles Russell's studio and there he would watch Russell at work. By the time he was eighteen Heikka was turning out his own sculptures. In 1929 Heikka accepted film star Gary Cooper's offer to spend a summer modeling ranch hands at the Cooper ranch. That same year, William Andrews Clark III, scion of a family famed as art patrons, learned of Heikka's talent. Clark was convinced of the young artist's genius; within an hour after meeting Heikka, Clark had commissioned the artist. Later that year Clark presented Heikka's work at the Stendahl Galleries in the Ambassador Hotel, Los Angeles. In every detail his sculpturing was amazingly real, depicting the fast-disappearing wild and woolly West.

Heikka's maturing sense of form, ideas, and technical understanding, as displayed in his first showing, gathered the attention of critics and laymen alike, who proclaimed him a great artist. Like Remington and Russell, Heikka lived his art. Working as a ranch hand, he shared in the common suffering known to the American cowboy.

In 1932, after exhibiting at the World's Fair in Chicago, Heikka's genuis became known to Marshall Field. Field offered him a studio in which to continue his historic account of the old West. Heikka refused, returning to the Montana he loved and felt an affinity for. 1939 brought Heikka added fame when exhibiting in another sellout show at Treasure Island's San Francisco Fair.

Among the early art patrons who recognized Heikka's ability as a sculptor was Cornelius F. Kelly, Anaconda Copper Mining official. Kelly purchased two of Heikka's early works—one depicting an ore wagon drawn by six mules, the other of a miner working the face of a mine tunnel. Other early collectors included C. R. Smith, American Airlines official; Alvin Adams, Western Airlines official; and Thomas Wolfe, a trustee of the Los Angeles County Art Museum.

3. Helen (Teri) Card (d. 1972) was my friend and I often visited her at the Walter Latendorf Bookshop on Madison Avenue in New York. In 1968, Teri served on the jury at our annual summer exhibition and it was with a great deal of pride that I gave her a tour of the fledgling National Cowboy Hall of Fame. If I could only repeat it now with Helen.

One of the finest tributes to Miss Card came from the pen of J. Frank Dobie:

> The most knowledgeable person alive on Remington is probably Miss Helen L. Card, proprietor of the Latendorf Bookshop (containing more art than books), 714 Madison Avenue, New York. She does not publish enough, but her two pamphlets, privately printed at Woonsocket, Rhode Island, 1946, on *A Collector's Remington* (I: "Notes on Him; Books Illustrated by Him; and Books Which Gossip About Him;" II: "The Story of His Bronzes, with a Complete Descriptive List" contain as much

rces and Notes

at germ. (Dobie's introduction to *Pony* [Norman: University of Oklahoma Press,

found in *Fielding's Dictionary*, p. 163, and Taft, *st.*

905) see *Fielding's Dictionary*, p. 359.

old Von Schmidt and Walt Reed, *Harold Von* *est* (Flagstaff, Arizona: Northland Press, 1972).

ssed by Helen Card in her article "Frederic *e*, v. 5, no. 4:

he Triumph, but not many; and I do not *The Scalp*, in which Remington changed ommon at all) and was cast by Roman s. The Bonnard foundry closed forever castings are considered most desirable, l very well the magic of the "lost wax" on, I like the Bonnard castings as well. ain the difference, because in the 1961 *n Scene*, v. 4, no. 2 this was done very f the Gilcrease Museum.

Riccardo Bertelli in Greenpoint, New York at the turn of the century and continues in operation today. Roman Bronze Works introduced the Cire-Perdue or lost wax casting process to the United States and Remington was one of the first sculptors to employ this method of casting bronze sculpture.

9. The Remington Art Memorial building in Ogdensburg, New York was originally the home of the David Parish family, followed by the Hon. George Hall in 1890. When Mrs. Frederic Remington died in the fall of 1918, leaving to the city the valuable works of her late husband, Mr. Hall expressed a wish that his house might sometime be used to receive the gifts. His daughter, Mrs. Walter Guest Kellogg, carried out his wishes and in the settlement of his estate, the old Parish mansion was given to the Public Library for use as a museum. Subsequently, certain changes were made in partitions, fireproof arrangements were completed, and the main rooms converted into art galleries which were opened to the public July 19, 1923.

10. "Remington's last bronze, *The Stampede*, first copyrighted in November 1909, once more proves Mr. Gilcrease to have been lucky. The Remingtons apparently cast only three, and Mr. Gilcrease got number two. One is at Ogdensburg. Evidently an edition of ten was planned in 1947 (the royalties to go to the Remington Art Memorial) but how many got cast I do not know. I can count up only seven *Stampedes* in all that I know about. The truth, as in the day of Diogenes, is elusive." (Helen Card, "Frederic

Remington's Bronzes," *American Scene* v. 5, no. 4.)

11. Fred Barton wrote and published a booklet titled *Charles M. Russell; an Old-time Cowman Discusses the Life of Charles M. Russell* (Los Angeles, Calif.: privately printed, 1961). I visited with Mr. Barton a number of times in Los Angeles and we discussed Russell.

12. Renner letter to author dated April 3, 1976.

Chapter 14
ZEROING IN ON VALUES

1. Through the years many books have been informative and helpful in my study of art history and values. Among them I'd like to recommend: Axel von Saldern, *Triumph of Realism; an Exhibition of European and American Realist Paintings, 1850-1910* (Brooklyn, N.Y.: Brooklyn Museum, 1967); Edgar Preston Richardson, *Painting in America; the Story of 450 Years* (New York: Crowell, 1956); John Walker, *Self-Portrait, With Donors; Confessions of an Art Collector* (Boston: Little, Brown & Co., 1974); Richard H. Rush, *Art As An Investment* (Englewood Cliffs, N.J.: Prentice-Hall Inc., 1961); Frank Herrmann, ed., *The English as Collectors, a Documentary Chrestomathy* (New York: W. W. Norton, 1972); Madeleine Hours [Director of the Laboratory of the Louvre], *Secrets of the Great Masters; a Study in Artistic Techniques* (New York: G. P. Putnam's Sons, 1968); and Robert Henri, *The Art Spirit* (Philadelphia: J. B. Lippincott Company, 1951). Also, Charles H. Caffin, *The Story of American Painting; the Evolution of Painting in America From Colonial Times to the Present* (New York: Frederic A. Stokes Company, 1907); Max Nordau, *On Art and Artists* (Philadelphia: George W. Jacobs & Co., n.d.); F. W. Ruckstill, *Great Works of Art and What Makes Them Great* (Garden City, N.Y.: Garden City Publ. Co., 1925); Malvina Hoffman, *Sculpture Inside and Out* (New York: Bonanza Books, 1939); Gerd Muehsam, comp., *French Painters and Paintings from the Fourteenth Century to Post Impressionism* (New York: Frederik Ungar Publ. Co., 1970); Jean Selz, *XIXth Century Watercolors and Drawings* (New York: Crown Publishers, Inc., 1968); and Richard Muther, *The History of Modern Painting*, 3v. (London: Henry & Company, 1915).

2. The story of Tom Gilcrease's purchase of Audubon's *Wild Turkey* is told in chapter 2.

3. For detail on Bierstadt's *Emigrants Crossing the Plains*, see chapter 11, note 11.

4. The Charles Willson Peale portrait of James Madison is inventoried in the list of acquisitions from Knoedler's by William F. Davidson, chapter 2.

5. For Emanuel Leutze, see Groce and Wallace, *Dictionary of Artists In America 1564-1860*, p. 395-396; J. D. Champlin and Charles Perkins, eds., *Cyclopedia of Painters and Paintings* (New York, 1886-87); Henry Tuckerman, *Book of the Artists* (New York: Carr, 1966); and Charles Lanman, *Haphazard Personalities* (Boston: Lee and Shepard, 1886).

6. The Lewis and Clark mural by C. M. Russell is located in the Montana State Capitol

building in Helena.

7. Nick Eggenhofer (b. 1897) is included in Dorothy Harmsen, *Harmsen's Western Americana*, p. 72. Also see John M. Carroll, *Eggenhofer: The Pulp Years* with introduction by Jeff Dykes. (Fort Collins, Colo.: Old Army Press, 1973); Ed Ainsworth, *The Cowboy In Art* (New York: World Publ. Co., 1968).

8. Nick Eggenhofer, *Wagons, Mules and Men: How the Frontier Moved West* (N.Y.: Hastings House, 1961).

9. The Taos School of Painters consists of a group of talented artists who came to Taos, New Mexico during the turn of the century to paint for art's sake and not for illustration or assignment. According to Laura Bickerstaff in her book *Pioneer Artists of Taos* (Denver: Sage Books, 1955), the six men who came first were Oscar E. Berninghaus, Ernest L. Blumenschein, E. Irving Couse, W. Herbert Dunton, Bert G. Phillips, and Joseph Henry Sharp; joining them later were Walter Ufer and Victor Higgins.

10. Carl Wimar's (1828-1862) biographical sketch in Groce and Wallace's *Dictionary of Artists in America* reads:

> Painter of the Western Indians and buffalo; also portrait and historical painter. Born February 20, 1828, in Siegburg, near Bonn (Germany), he came to America at the age of 15, settling with his parents in St. Louis. About 1846 he became a pupil and assistant of Leon Pomarede and in 1849 he accompanied his master on a trip up the Mississippi. After leaving Pomarede in 1851, he opened a painting shop in St. Louis, but a year later he was able to go to Dusseldorf, where he stayed four years and studied under Emanuel Leutze. Wimar returned to St. Louis in 1856 and devoted himself mainly to paintings of the Indians and buffalo herds of the Great Plains. He made at least three trips to the headwaters of the Missouri in search of material. He also did some portrait painting and in 1861 executed the mural decorations in the rotunda of the St. Louis Court House. He died in St. Louis, of consumption, on November 28, 1862. (Rathbone, "Charles Wimar," biographical sketch, bibliography, and illustrated catalogue of an exhibition at the City Art Museum of St. Louis in 1946).

11. For more on Eastman, see John Francis McDermott, *Seth Eastman, Pictorial Historian of the Indian* (Norman: University of Oklahoma Press, 1961).

12. Willa Cather, *On Writing: Critical Studies on Writing as an Art*, with a foreword by Stephen Tennant (New York: Alfred A. Knopf, 1968).

Chapter 15
THE OATH

1. Luther T. Dulaney was born April 5, 1902 at Cornish, Indian Terr. His parents, Thomas Jefferson and Jane Slaughter Dulaney both came from families which settled

359

in America in pre-Revolutionary War days. Luther attended public schools in Ardmore and the University of Okla. He married Virginia Piersol in 1935 and established Dulaney's, Inc. (furniture manufacturers & household appliance distributors) in 1938. Among his many civic and philanthropic activities, Luther was a Director of Okla. Natural Gas Co., First Okla. Bankcorporation, Inc.; a Director and Chairman of the Executive Committee of Oklahoma City University; a director of Boy Scouts of America; and a Trustee of National Cowboy Hall of Fame and member of the Executive Committee of the Board of Directors. Mr. Dulaney died September 13, 1973.

My pledge to Luther read:

April 17, 1972

To Luther T. Dulaney:

I, Dean Krakel, on this 17th day of April, 1972, do state that I am sound of mind and feel very definitely that the National Cowboy Hall of Fame has achieved an art collection and status desired.

I personally have no desire to purchase additional art other than is now hanging in the Cowboy Hall of Fame.

Signed,

Dean Krakel

Witness: Billy Tull

2. Peter Hassrick, in his *Frederic Remington* (New York: Abrams, 1973) describes *The Old Dragoons of 1850:*

Remington could catch the drama of battle in bronze as well as in paint. The twisting of contours, stretching of muscles, and headlong plunges of horses were perfect subjects to be depicted three-dimensionally. In sculpture the artist could mass groups of figures without losing the individuality of any one. Each figure embodies its own impression of action, and as the viewer moves around the bronze, the figures take life.

This is especially true of the large bronze Remington copyrighted in December of 1905, *The Old Dragoons of 1850.* Because of the size and complexity of the work, probably fewer than ten castings were ever made.

Harold McCracken estimates, in *Frederic Remington, Artist of the Old West* (Philadelphia: Lippincott, 1947) that five or six castings of this sculpture were made.

3. Catalogue of the collection of foreign and American paintings owned by Mr. George A. Hearn. (New York: privately printed, 1908.)

4. *American Scene*, v. 4, no. 3 is devoted to the Thomas Gilcrease collection of Alfred Jacob Miller Paintings.

5. For biographical information on Sir William Drummond Stewart see: *Scotsman in Buckskin: Sir William Drummond Stewart and the Rocky Mountain Fur Trade,* by Mae Reed Porter and Odessa Davenport (New York: Hastings House, 1963); Bernard Devoto, *Across the Wide Missouri,* (Boston, Houghton Mifflin, 1947); *The West of Alfred Jacob Miller* by Marvin C. Ross (Norman: University of Oklahoma Press, 1968).

6. Herman Werner, of Casper, Wyoming, was born in 1892 at Fort Fetterman. Beginning in 1924, he and his family operated the largest sheep breeding operation in the U.S. and became the largest land owners and cattle raisers in Wyoming. Werner was a director of the Wyoming Nat'l. Bank, a stockholder of Cherry Creek Inn, on the Advisory Board of Directors of Big Horn Life Insurance Co., and a trustee of the National Cowboy Hall of Fame. Mr. Werner died on August 6, 1973 of injuries sustained in a two-car auto collision July 31, 1973, in Rawlins, Wyoming.

During the summer of 1971, the eagle controversy erupted nationally and Mr. Werner was charged with killing and sponsoring the killing of eagles on his ranches. Major magazines covered the story: "Sheepmen vs. Eagles—Slaughter in the Sky," (*Life*, August 20, 1971, p. 36-38). We sent Dean Krakel II to Wyoming in July 1973 to interview Mr. Werner for a *Persimmon Hill* story, "The Wyoming Eagle Controversy," which appeared in v. 3, no. 4. Our story was one of the few that contained the facts of the case and defended Mr. Werner

In April of 1974, Mrs. Grace Werner was elected to succeed her late husband on the Board of Directors of the Cowboy Hall of Fame.

7. For Oscar Berninghaus, see Laura M. Bickerstaff, *Pioneer Artists of Taos* (Denver: Sage Books, 1955); Van Deren Coke, *Taos and Santa Fe: The Artists Environment, 1882-1942* (Albuquerque: University of New Mexico Press, 1963).

8. James Howard, in his *Ten Years With the Cowboy Artists* (Flagstaff, Ariz.: Northland Press, 1976), relates the founding of the organization, its growth, and development. A rare bit of CAA memorabilia is a four page, salmon-colored pamphlet titled, "Cowboy Artists of America, Inc., organized June 23, 1965 at Bird's Creek Tavern, Sedona, Arizona." The pamphlet, listing members George A. Phippen, J. W. Hampton, Fred Harman, Joe Beeler, Charlie Dye, and Robert MacLeod, states the purpose of the CAA:

> To perpetuate the memory and culture of the Old West as typified in the works of the late Frederic Remington, Charles Russell, and others; to insure authentic representation of the life of the West as it was and is; to maintain standards of quality in contemporary Western painting and sculpture; to help guide collectors of Western art; to give mutual assistance; to hold a joint exhibition once a year; to hold a trail ride and campout in some locality of special interest at least once a year—these were the CA's stated aims at the organizational meeting, June 23, 1965, at the Oak Creek Tavern, Sedona, Arizona. "We chose Bird's Bar because of its Old West atmosphere. It seemed an appropriate place in which to get going," said a charter member. And, for the future, "We'll be a bunch of guys with the same interests, aims, and problems, getting together for mutual benefit, to have fun, and to talk things over."

The Cowboy Hall of Fame's relationship with the organization was the result of a meeting held at the Hall with artist John Hampton, Art Director James Boren, and Dean Krakel in July 1966. We agreed to hold an exhibition, and the first was held September 9 through October 16, 1966. The following artists participated: George

Phippen, Joe Beeler, Charlie Dye, John Hampton, Fred Harman, Darol Dickinson, Wayne Hunt, Harvey W. Johnson, John H. Kittelson, George B. Marks, Irvin Shope, Gordon Snidow, U. Grant Speed, and Byron B. Wolfe. The second exhibition was held May 27 through September 9, 1967.

The 1968 exhibition was significant in that we began the awards banquet and moved the exhibition into the forepart of the museum. We awarded our 1968 trustees medal for the outstanding contribution to Western art to Harold Von Schmidt. For the first time we began our cash purchase awards: $1,500 for watercolor, $2,000 for sculpture and $3,000 for oil. Medals accompanied the winning works. The jury was composed of three outstanding authorities: Helen Card, Robert Rockwell, and Harold Von Schmidt.

The 1969 exhibition of CAA art, our fourth, marked a certain amount of growth and maturity for the staff at the Hall. We began the practice of giving first and second place medals in the drawing category. We continued the cash prizes, adding a cash honorarium for the second place winner. C. R. Smith received our trustees gold medal. The jury consisted of Norman Kent, Ramon Adams, Walter Bimson, and C. R. Smith. The following winter we published a catalogue of the exhibition containing a brief history of CAA written by Charlie Dye.

9. One of the strengths of our exhibitions has been the quality of the judges. We have always given the matter careful consideration. Paul B. Strasbaugh, an outstanding Oklahoma City Chamber of Commerce executive, has been active in either hosting or presenting our judges since 1968.

10. The Charlie Dye letter, two pages in length, came to me through the mail unsolicited and without a cover letter. The contents were most revealing and helped me determine our course of action. Dye exaggerated my feelings by quoting me as saying I hated his guts.

11. Robert F. Karolevitz, *Where Your Heart Is . . . The Story of Harvey Dunn, Artist* (Aberdeen, South Dakota: North Plains Press, 1970).

12. Joe Stacey, an author specializing in Arizona subjects, succeeded Raymond Carlson as editor of *Arizona Highways* magazine. He recently resigned from that post.

13. The National Cowboy Hall of Fame held a major retrospective showing of Moyers paintings and sculpture March 4-May 6, 1973. This followed our split with the Cowboy Artists organization.

Bill and I exchanged letters on the subject of the National Academy of Western Art concept. He felt that any art organization should be controlled solely by the artists. In spite of our differing opinions, we remain friends.

14. Gordon Snidow, who followed Ryan as president of the Cowboy Artists in June of 1971, discussed NAWA and the CAA relationship in a three-page letter issued shortly after he became president. Included in his letter are numbered terms of our agreement with the artists as set forth by Ryan, limiting the number of artists who would exhibit in shows other than ours.

15. Thomas Buechner is a widely known art authority, author, and former director of the Brooklyn Museum. Buechner is currently president of the Corning Glass Company, Corning, New York. Buechner's book on Norman Rockwell was popular nationally *(Norman Rockwell, Artist and Illustrator* [New York: Abrams, 1970]).

16. Museum Administrator Michael S. Kennedy is the former Director of the Montana Historical Society and Editor of *Montana, the Magazine of Western History.* In recent years, Kennedy has been associated with museum programs in the state of Alaska.

17. *Persimmon Hill*, the quarterly publication of the National Cowboy Hall of Fame, was launched during the summer of 1970 with Don Hedgpeth as editor. He guided the publication of the first seven issues.

18. The catalogue for the O S Ranch steer roping and art exhibit included introductory statements by Don Hedgpeth and Tom Ryan. The eighty-four page catalogue contained short biographical sketches of both artists and ropers.

19. This recommendation was submitted to the National Cowboy Hall of Fame Board of Directors meeting held December 1972. The selection process for electing academicians was a frequent topic of discussion with art director Richard Muno, board members, and artists (primarily Robert Lougheed and Bettina Steinke).

20. I discussed the Prix de West concept at length with Luther T. Dulaney, William G. Kerr, and Jasper Ackerman. They each agreed with the basic idea and prize concept, and so the program was adopted at the annual meeting of the Board of Trustees held April 1973.

21. All correspondence regarding applications to the first exhibitions favorable or unfavorable remains in the files of the National Academy of Western Art.

Chapter 16
IN FROM THE NIGHT HERD

1. The following exhibitions and special openings have been held at the National Cowboy Hall of Fame and Western Heritage Center:

Inaugural Exhibition featuring collections from the Sid Richardson Foundation, William R. Coe Foundation, Robert Rockwell Foundation; and art from the Knoedler, Kennedy, and Bartfield Galleries. Contemporary artists Joe Beeler and Willard Stone (June 25, 1965-October 10, 1965).
Harry Jackson Exhibition (April 29-Summer 1966).
First Annual Exhibition Cowboy Artists of America (September 9-October 16, 1966).
Paintings of the Southwest from the Santa Fe Railway Collection (October 21, 1966-February 28, 1967).
Nicolai Fechin Exhibition (February 17-May 14, 1967).
Second Annual Exhibition Cowboy Artists of America (May 27-September 9, 1967).
Frank Hoffman Exhibition (November 29-December 8, 1967).
Albert K. Mitchell Collection (January 24-April 30, 1968).
Third Annual Exhibition Cowboy Artists of America (June 14-September 2, 1968).

Tom Ryan-James Boren Exhibition (March 14-April 14, 1969).

Fourth Annual Exhibition Cowboy Artists of America (June 13-September 1, 1969).

Fred Harman-Andy Anderson Exhibition (November 14-January 31, 1970).

Robert Lougheed-Gordon Snidow Exhibition (March 8-May 17, 1970).

Fifth Annual Exhibition Cowboy Artists of America (June 14-September 5, 1970).

Melvin Warren Exhibition (December 7-January 31, 1971).

John D. Free Exhibition (February 7-March 14, 1971).

Nick Eggenhofer Exhibition (March 21-May 16, 1971).

Sixth Annual Exhibition Cowboy Artists of America (June 12-September 10, 1971).

W.H.D. Koerner Exhibition (October 30, 1971-January 30, 1972).

Ned Jacob Exhibition (March 4-May 14, 1972).

Seventh Annual Exhibition Cowboy Artists of America (June 10-September 5, 1972).

Harold Von Schmidt Exhibition (October 21-January 31, 1973).

William Moyers Exhibition (March 4-May 6, 1973).

First Annual Exhibition National Academy of Western Art (June 9-September 9, 1973).

Royal Western Watercolor Competition (February 23-May 5, 1974).

Second Annual Exhibition National Academy of Western Art (June 8-September 9, 1974).

Olaf Wieghorst Exhibition (November 15, 1974-January 19, 1975).

Royal Western Watercolor Competition (February 8-May 4, 1975).

Third Annual Exhibition National Academy of Western Art (June 7-September 7, 1975).

Solon Borglum Memorial Sculpture Exhibition (December 5, 1975-January 5, 1976).

Royal Western Watercolor Competition (February 7-April 25, 1976).

Fourth Annual Exhibition National Academy of Western Art (June 11-September 12, 1976).

Clark Hulings Exhibition (December 3, 1976-January 9, 1977).

2. For lists of winners of Cowboy Artists exhibition, see annual catalogs published by Northland Press; and James K. Howard, *Ten Years with the Cowboy Artists of America, op. cit.*

3. All National Academy of Western Art exhibitions, winners, events, and seminars have been published in *Persimmon Hill*.

1973 National Academy of Western Art (June 7-9)

Exhibition Award Winners

Prix de West: *Grand Canyon, Kaibab Trail* (27" x 54" oil), Clark Hulings.

Gold Medal, oil: *On the Edge of the Sangre de Cristos* (36" x 48"), Robert Lougheed.

Gold Medal, watercolor: *Appointment in Town* (20" x 30"), Donald Teague.

Gold Medal, sculpture: *Where Trails End* (14½" high bronze), Edward Fraughton.

Gold Medal, drawing: *Head Study of a Young Navajo* (19" x 25"), R. Brownell McGrew.

Silver Medal, oil: *Grand Canyon* (51" x 92"), Wilson Hurley.

Silver Medal, watercolor: *At the Arroyo Hondo Cutoff* (20″ x 30″), Robert Lougheed.
Silver Medal, sculpture: *Layin' the Trap* (52½″ long bronze), Robert Scriver.
Silver Medal, drawing: *Su'tsi Man* (23½″ x 18″), Ned Jacob.

Judges

Katherine Haley	Joe Stacey
Bill Harmsen	Paul Strasbaugh
Walt Reed	Harold Von Schmidt
Robert Rockwell	Olaf Wieghorst

Seminars

Sketching in the field with Robert Lougheed, John Clymer, and Ned Jacob.
"Beginning of the Portrait"—Bettina Steinke.
Modeling and Sculpture demonstration by Robert Scriver and Harry Jackson.
Watercolor Painting demonstration by Donald Teague.
"Earl Heikka, Little Known Montana Genius in Bronze"—E. H. Hoy.
"William R. Leigh, Great Western Artist"—June DuBois.
"Painting the Real Thing"—Arthur Mitchell.
"Harold Von Schmidt Draws and Paints"—Walt Reed.
"Highlights of my Life as a Western Artist"—Olaf Wieghorst.
"Western Art, Its Past, Present, and Future"—Rudolf Wunderlich.
"The Biggest Lies I Ever Heard"—Ben K. Green.
"A Funny Thing Happened to me on the Way to the Book Store"—Fred Rosenstock.

1974 National Academy of Western Art (June 6-8)

Exhibition Award Winners

Prix de West: *The Wolfmen* (24″ x 34″ oil), Tom Lovell.
Gold Medal, oil: *Sacajawea* (24″ x 48″), John Clymer.
Gold Medal, watercolor: *March Snow in Elk Country* (20″ x 40″), Robert Lougheed.
Gold Medal, sculpture: *The Eagle Catcher* (25″ high bronze), George Carlson.
Gold Medal, drawing: *Tsinnajinnie Yazzie* (19″ x 24″), R. Brownell McGrew.
Silver Medal, oil: *Woodbearers of Chimayo* (30″ x 60″), Clark Hulings.
Silver Medal, watercolor: *Memories* (22″ x 30½″), Joseph Bohler.
Silver Medal, sculpture: *Uninvited Guests* (12″ high bronze), Clark Bronson.
Silver Medal, drawing: *Apache Child* (19″ x 13″), Bettina Steinke.

Judges

Gene Adkins	Freda Hambrick
Carl Dentzel	Dorothy Harmsen
Harrison Eiteljorg	William G. Kerr
Frank Getlein	Paul Strasbaugh
Ben K. Green	

Seminars

Sketching in the field with Robert Lougheed, Bob Scriver, and Conrad Schwiering.
"Sculpture Inside and Out"—Edward J. Fraughton.
"Painting the West"—Robert Rishell.
"Drawing in Charcoal"—Ned Jacob.

"Maynard Dixon, Western Painter and Illustrator"—Wesley M. Burnside.
"The Cowboy in Bronze"—Pat Broder.
"The Lure of the West"—Frank Getlein.
"The Taos School of Artists"—Carl Dentzel.
"Why Collect Western Art?"—William D. Harmsen.
"Homer Britzman was a Russell Collectkr"—Fred Rosenstock.
"Painting Big Game Animals"—Robert Kuhn.
"Wax, Bronze, and Guitar Music"—Harry Jackson.
"Our Prix de West Tour of Europe's Great Museums"—Clark Hulings.

1975 National Academy of Western Art (June 5-7)

Exhibition Award Winners
Prix de West: *Courtship Flight* (38" high bronze), George Carlson.
Gold Medal, oil: *Washday* (34" x 51"), Clark Hulings.
Gold Medal, watercolor: *Navajo Goat Lady* (22" x 36"), Ray Swanson.
Gold Medal, sculpture: *The Last Farewell* (38" high bronze), Edward Fraughton.
Gold Medal, drawing: *Country Kitchen* (40" x 30"), Tom Ryan.
Silver Medal, oil: *San Francisco Vallejo Street Wharf in 1863* (26" x 40"), John Stobart.
Silver Medal, watercolor: *Telling of Great Deeds* (30" x 20"), David Halbach.
Silver Medal, sculpture: *Way of the Eagle* (28" x 36"), Clark Bronson.
Silver Medal, drawing: *Old John, a Navajo* (19" x 24"), R. Brownell McGrew.

Judges

Patricia Broder
Thomas Buechner
Carl Dentzel
Don Hedgpeth
William G. Kerr
Iris Krakel

Malcolm Mackay
Robert Rockwell
George Schriever
Paul Strasbaugh
Rudolf G. Wunderlich

Seminars
Sketching in the field with Ed Fraughton, Robert Rishell, and Robert Lougheed.
"Dry Brush Technique"—Nick Eggenhofer.
"The Importance of Drawing"—Bettina Steinke.
"Western Art the Past Ten Years"—Robert Rockwell.
"Buying Western Art"—George Schriever.
"Solon Borglum"—Patricia Broder.
"A Year with the Teton Elk"—Dean Krakel II.
"Portrait of a Star"—Robert Abbett.
"Collecting Western Art"—Harrison Eiteljorg.
"True or False"—Thomas Buechner.
"When the West was Free"—Carl Dentzel.
"The Spirit of Winter"—Spike Van Cleve.

1976 National Academy of Western Art (June 11-12)

Exhibition Award Winners

Prix de West: *Out of the Silence* (30″ x 40″ oil), John Clymer.
Gold Medal, oil: *Time of Cold-Maker* (28″ x 50″), Tom Lovell.
Gold Medal, watercolor: *Barn-Algadones* (13½″ x 22″), Morris Rippel.
Gold Medal, sculpture: *The Story Teller* (32″ high bronze), Richard Greeves.
Silver Medal, oil: *Wetback* (34½″ x 52½″), Robert Kuhn.
Silver Medal, watercolor: *Rest on the Pecos Trail* (20″ x 40″), Robert Lougheed.
Silver Medal, sculpture: *Dancers of Norogachie* (29″ high bronze), George Carlson.

Judges

Robert Harris	Charles R. Kinghan
Gordon Hendricks	Everett Raymond Kinstler
Frank Harding	Dean Krakel
William G. Kerr	Paul Strasbaugh

Seminars

"Albert Bierstadt"—Gordon Hendricks.
"They are Coming to Norogachie"—George Carlson.
"Bounty from Brandywine"—Ginger Renner.
"Collector's Point of View"—Malcolm Mackay.
"Myths about Charlie Russell"—Fred Renner.
Oil Portrait demonstration by Everett Raymond Kinstler.
"Fakes and Frauds of Russells and Remingtons"—Rudolf Wunderlich.
Drawing demonstration by Tom Lovell.
Watercolor demonstration by Charles R. Kinghan.

Members of National Academy of Western Art, as of December 31, 1976

Clark Bronson	Harry Jackson	*Robert Rishell
George Carlson	Robert Kuhn	Conrad Schwiering
John Clymer	Robert Lougheed	Robert Scriver
Edward Fraughton	Tom Lovell	William E. Sharer
John D. Free	R. Brownell McGrew	Bettina Steinke
Clark Hulings	Kenneth P. Riley	John Stobart
Wilson Hurley	Morris Rippel	Donald Teague
		*deceased

Honorary Academicians

Nick Eggenhofer	Harold Von Schmidt
Arthur Mitchell	Olaf Wieghorst

4. The first Royal Western Watercolor Exhibition was held February 23, 1974.

Exhibiting Artists

James Bama	Clark Bronson	John D. Free
Joseph Bohler	Nick Eggenhofer	Walter M. Gonske

Tom Hill	Peter McIntyre	Donald Teague
Clark Hulings	Thomas C. Nicholas	Eileen Monaghan Whitaker
Ned Jacob	Morris Rippel	Frederic Whitaker
Robert Lougheed	Paul Strisik	Nick Wilson

Exhibition Award Winners

Gold Medal: *Logging Wagon, Pecos, New Mexico* (20″ x 30″), Clark Hulings.
Silver Medal: *The Ramada Corral* (17½″ x 35½″), Robert Lougheed.
Bronze Medal: *Desert Nesters* (19″ x 29″), Nick Wilson.
Bronze Medal: *Tsegi* (21″ x 16″), Morris Rippel.

Judges

Trustees of the NAWA, Mr. and Mrs. Paul Strasbaugh, Miss Freda Hambrick, and Juan Menchaca.

The second Royal Western Watercolor Exhibition was held February 8, 1975.

Exhibiting Artists

James Bama	John Falter	Morris Rippel
Joseph Bohler	Walt Gonske	Steven O. Scott
Sergei Bongart	Clark Hulings	Ray Swanson
Gary Carter	Robert Lougheed	Donald Teague
Nick Eggenhofer	Peter McIntyre	Nick Wilson

Exhibition Award Winners

Gold Medal, transparent: *Silent Beaver Pond* (20″ x 40″), Robert Lougheed.
Gold Medal, opaque: *El Jefe* (20″ x 30″), Donald Teague.
Silver Medal, transparent: *Orion* (13½″ x 22″), Morris Rippel.
Silver Medal, opaque: *Hosteen Sanchez* (18″ x 34″), Ray Swanson.
Bronze Medal, transparent: *Winter Move* (20¾″ x 28¾″), Kenneth Riley.
Bronze Medal, opaque: *Road to Creed* (26½″ x 39½″), Joe Bohler.

Judges

Freda Hambrick	Juan Menchaca
William G. Kerr	Paul Strasbaugh
Iris Krakel	

The third Royal Western Watercolor Exhibition was held February 7, 1976.

Exhibiting Artists

Joe Bohler	Jack Hines	Carson Schardt
Sergei Bongart	James Kramer	Ed Smyth
Gary Carter	Robert Lougheed	Bettina Steinke
Valoy Eaton	Bob Moline	Ray Swanson
Walt Gonske	Gary Myers	Donald Teague
Richard Greeves	Kenneth Riley	William Whitaker
David Halbach	Morris Rippel	Nick Wilson

Sources and Notes

Exhibition Award Winners

Gold Medal, transparent: *Call of the Crow* (12″ x 22″), Morris Rippel.
Gold Medal, drawing: *Comanche Plains* (30″ x 38″), William Whitaker.
Gold Medal, opaque: *They Passed in the Night* (15″ x 30″), Robert Lougheed.
Silver Medal, transparent: *Warm Morning* (21″ x 28″), Valoy Eaton.
Silver Medal, drawing: *The Old Way* (23″ x 14″), Bettina Steinke.
Silver Medal, opaque: *Night of the Dog Star* (13″ x 22″), Morris Rippel.
Bronze Medal, transparent: *Return from the Mountains* (18″ x 36″), Robert Lougheed.
Bronze Medal, drawing: *Puye Cliff Ceremonial* (33″ x 22″), Walt Gonske.
Bronze Medal, opaque: *Night Raid* (12″ x 16″), Donald Teague.

Judges

Clark Hulings
William G. Kerr
Dean Krakel

Richard Muno
Paul Strasbaugh

5. The Solon Borglum Memorial Sculpture Exhibition was held December 5, 1975 at the National Cowboy Hall of Fame.

Exhibiting Artists

Charlie Beil	Una Hanbury	Rusty Phelps
Truman Bolinger	Gary N. Herbert	Slim Pickens
J. Shirly Bothum	Joe Hobbs	Don Polland
Sid Burns	H. Grant Kinzer	Ace Powell
Jay Contway	Tom Knapp	Hal Rhodes
Clay Dahlberg	Ted Long	Eugene Shortridge
Bill Duncan	Pat Mathiesen	Randy Steffen
Lincoln Fox	George Montgomery	Jack Stevens
Glenna Goodacre	Richard Muno	Jim Thomas
Joe Halko	Gary Myers	Juan Dell Wade
	Mack Petty	

Exhibition Award Winners

Gold Medal: When the Password Was Winchester (21″ high), William G. Duncan.
Silver Medal: *The Water Bearer* (20″ high), Glenna Goodacre.
Bronze Medal: *Border Raiders* (11½″ high), Sid Burns and *Blessing Little Brother* (10½″ high), Lincoln Fox.
Honorable Mention: *Headin' for the Green River Rendezvous* (18½″ x 5′), Truman Bolinger; *Quick Lightning Nursing Wimpy Close by Tonto Bars* (9½″ high), Una Hanbury; *Unloadin'* (4¾″ x 5″ x 6¾″), Don Polland; *The Silent Enemy* (16″ x 30″), Ace Powell.

Judges

Edward Fraughton
William G. Kerr
Dean Krakel

Juan Menchaca
Paul Strasbaugh

369

6. Trustees' Gold Medals for outstanding contributions to Western Art have been awarded to:

1968	Harold Von Schmidt	1973	Nick Eggenhofer
1969	Dr. Harold McCracken	1974	Robert Rockwell
1970	Honorable C. R. Smith	1975	Rudolf G. Wunderlich and Dean Krakel
1971	William F. Davidson		
1972	Jasper D. Ackerman	1976	Frederic Renner and Clark Hulings

7. The film classic, *Buffalo Bill*, was produced by Harry Sherman and directed by William Wellman for 20th Century Fox in 1944. Co-starring with Joel McCrea was Maureen O'Hara.

8. Arthur Mitchell was born in 1889 on a homestead in Animas County, Colorado. He studied at the Grand Central School of Art under Harvey Dunn. After years as an illustrator in the East, he returned to a life as a Colorado artist and has been active in preservation of historical landmarks. He is now curator of the Colorado Historical Society's Bloom Mansion and Baca House Museums, Trinidad, Colorado. Mitchell also appears in chapter 10, "Nicolai Fechin."

9. Miss Freda Hambrick was born in Indiana but has for a long time been a prominent resident of Colorado Springs. Miss Hambrick is an investment banker; she is also active in garden groups, is a member of the National Cowboy Hall of Fame Board of Directors, and has served as a juror for Hall art shows.

10. Albert J. Mitchell was born June 1, 1934 at Raton, New Mexico. He attended Deerfield Academy, Deerfield, Mass. and earned a degree in animal husbandry at Cornell University. After serving in the U.S. Army, he now operates the 180,000-acre Tequesquite Ranch in northeastern New Mexico. Albert is active in various livestock organizations, is a director of New Mexico Boys Ranch, a trustee of Cardigan Mountain School, and a director of the National Cowboy Hall of Fame.

Index

Works of art are entered under both title and artist; titles are italicized. Page numbers in bold face refer to photographs.

AARONSON, ALFRED, 3, 37, 58, 325n
ACKERMAN, JASPER, 74-75, 81-83, 100, 108, 116, **181**, **196**, 215, 222-34, 281, 311-15, 343n, 353n; Bierstadt purchase, 231-33; *End of the Trail* project, 100, 116; role in Jones-Russell acquisition, 74-75, 80-82; purchase of *Mountain of the Holy Cross*, 225-30; role in Buffalo Bill project, 311-15
ADAMS, EARL C., 84, 267, 344n
AKELEY, CARL, 49-51
ALBERT K. MITCHELL COLLECTION, **205**, 316-20, 322
Alert (Russell), **198**, 269
AMERICAN MUSEUM OF NATURAL HISTORY, 49-50
American Scene magazine, 66, 164, 325n
AMON CARTER MUSEUM, 67, 87, 341n, 354n
Arizona Cowboy (Remington), 240, 245
At Rest (Ufer), 322
AUDUBON, JOHN JAMES, 18-20, 30, 271-72

Bad Day in Utica (Russell), 229, 354n
BAILEY, WILLIAM S., 3-4, 10-11, **177**, 325n
BAKER, BRYANT P., 168, 171, 351n, 352n; *Pioneer Woman*, 171, 352n
BARRIE, ERWIN S., 47, 54, **201**, 207-8, 210, 245-46, 336n, 355n
BARTFIELD, JACK, 129-30, 140-41, 166, **201**, 244-45

BARTON, FRED, 263-64, 358n
Battle Between Crows and Blackfeet (Russell), 69
Bear Hunt in Wyoming (Leigh), 47-49
Bearing Away the Bride (Fechin), **194**, 212-15, 219, 221, 280
BEINECKE, EDWIN J., JR., 172-74, 352n
BERNINGHAUS, OSCAR, 284, 359n; *Forgotten*, 284
BIERSTADT, ALBERT, 231-33, 249, 272, 329n, 354n; *Emigrants Crossing the Plains*, **197**, 231-33, 249, 272, 354n
Big Horn Sheep (Leigh), 76, 343-44n
BILTMORE GALLERY, THE, 84, 344n
Bird Hunting Near St. Louis (Russell), 77
BLACK HAWK, 33-34, 329-30n
BLAKELOCK, RALPH EARLE, 28, 328n
BLUMENSCHEIN, E.L., 321, 359n, 361n
BODMER, KARL, 1, 7, 324n
BOLAND, RALPH, 231-32
BONHEUR, ROSA, 282
BOONE, E.L., 263-64
BOREIN, ED, 225, 353n
BOREN, JAMES, 71, 95, 141, **195**, 210, 245, 267, 342n
BORGLUM, SOLON, 321
BOWER, ANTHONY, 84-87, 147-49, 153-54, 157, 161, 229-30, 350n
BRANHAM, EYA FECHIN, **195**, 208, 210-11, 247

371

BRENNAN, WALTER, 162, 351n
BRITZMAN, HOMER, 88, 343n; 345n
Bronc Twister, A (Russell), 70, 73, 266-67
Bronco Busters Saddling (Remington), 265
BRUSH, GEORGE DE FOREST, 28, 328n
Bucker and the Buckaroo, The (Russell), 317
BUECHNER, THOMAS, 293, 363n
Buffalo, The (Leigh), 76, 337n
Buffalo Bill (film), 310, 370n
Buffalo Bill (Legend of the Westerner), statue, **205**, 233, 310-15
Buffalo Hunt, The (Leigh), 246, 338n
Buffalo Hunt, (Russell), 70, 73, 263, 317
Buffalo-Indian Head Nickel (Fraser), 94, 116, **183**
Bug Hunters, The (Russell), **198**, 269
BUSH, MARTIN H., 91-95, 168, 346n

Call of the Law (Russell), 317
CARD, HELEN (Teri), 155-56, 257, 356-57n
Carmelita (Fechin), 210
CAROTHERS, MR. AND MRS. ARCHIE (Ruth Schreyvogel), 130-44, **187**, 260, 348n
CARTER, AMON, 35, 87-88, 243, 335n
CARY, WILLIAM DE LA MONTAGNE, 35, 331n
CASE, LELAND, 115-16, 347-48n
CATHER, WILLA, 280
CATLIN, GEORGE, 1, 7, 9-10, 29, 32, 324n, 326n
Changing Outfits (Russell), 70, 73
CHAPELLIER GALLERIES, 343-44n
Cheyenne Buck (Remington), **199**, 240-42
Chief White Eagle (Schreyvogel), 126, 135
Cinch Ring, The (Russell), 85-86, 146, 148, **189**
CLEGG, ALFRED E., 52, 337-38n
CLYMER, JOHN, **203**
CODY, WILLIAM F. (Buffalo Bill), 120, 136
COLE, PHILIP G., 17-18, 52, 128-29, 327n, 338n, 349n
Coming Through the Rye (Remington), 154-56, **189**
Commanche Warrior (Remington), 240
CONTINI, CESARE, 109-11, **184**, 347n
COOPER, NANCY. *See* Russell, Mrs. Charles M.
Corn Dancer, The (Fechin), 76, 80, 210, 215
CORNWELL, DEAN, 207, 352n
Counting Coup (Russell), 69, 73, 317
COUNTRY STORE ART GALLERY, 344n
COUSE, EANGER IRVING, 76, 249, 343n; *Sand Painter*, 76, 249

COWBOY ARTISTS OF AMERICA, **192**, 286-98, 300, 306, 361-62n
Cowboy Fun (Remington), 265
Cowboys in the Badlands (Eakins), 159, 351n
CROSBY, COLONEL JOHN SCHUYLER, 125-26
Custer Battle (Russell), 319
CUSTER, COLONEL GEORGE ARMSTRONG, 16, 123-25
CUSTER, ELIZABETH BACON (Mrs. George A.), 123, 125, 133, 349n
Custer's Demand (Schreyvogel), 123-26, 128, 133

Daniel Boone (Fraser), 93-94
DAVIDSON, WILLIAM F., 18, 25-36, 70-71, 84-85, 146-47, 153, **188**, **201**, 228, 242-44, 291, 332n, 327-28n; and Thomas Gilcrease, 25-36, 243; awarded Trustees' Gold Medal, 243-44; obituary of, 327-28n
DEARDEUFF, STAN, 270
DENNEY, MRS. CORWIN. *See* Gilcrease, Des Cygne
DILLEHAY, GENE, 100-2, 347n
DOBIE, J. FRANK, 35, 335n, 356-57n
DRAPER, STANLEY C., SR., 71-72, 342n
DRESSLER, MR. AND MRS. FRED, 117
DULANEY, LUTHER T., 71, 87, 108, 148-49, 155-61, 173, **188**, **202**, 231, 249, 281-83, 290, 295-96, 304-5, 342n, 359-60n; Okla. City Indus. & Cultural Facilities Trust, pres. of, 71; CAA organization break, 290, 295-96; death of, 304-5
DULANEY, MRS. LUTHER T., 108, 231
DUNN, HARVEY, 215
DYE, CHARLIE, 286-87, 289, 362n

EAKINS, THOMAS, 27-28, 159, 328n, 351n
EASTMAN, SETH, 149, 152, 280, 359n
EBERSTADT, EDWARD & SONS (dealers), 43, 336n
EGGENHOFER, NICK, 273, 303, 307, 359n
Emigrants Crossing the Plains (Bierstadt), **197**, 231-33, 249, 272, 354n
End of the Trail (Fraser), 90-105, 106-12, **184-85**, 240, 346n
End of the Trail: The Odyssey of a Statue (Krakel book), 274
Enemy Tracks (Russell), 317

FARIS, GLENN W., 92, 100, 309, 346n

FARNY, HENRY, 255-56

Fatal Loop, The (Russell), 317

FECHIN, ALEXANDRA, 208, 211-12, 352n

FECHIN, NICOLAI, 76, **194-95**, 207-21, 249, 279-80, 321, 352n; arrival in U.S., 208-9; as student in Russia, 216-18; in Taos, 218. *Bearing Away the Bride*, **194**, 212-15, 219, 221, 280; *Carmelita*, 210; *The Corn Dancer*, 74, 210, 215; *Mr. Gorson*, 321; *Self Portrait*, 215; *Sketch of a Girl*, 213-14; *Still Life*, 215; *Summer*, 219, 249; *Tea in Santa Monica (Mrs. Krag)*, 74, 210, 215

FECHIN STUDIO COLLECTION, **194-95**, 219-21, 279-80

FIELD, EUGENE, II, 268

FINDLAY, WILLIAM A., 88

Forgotten (Berninghaus), 284

Frank Hamilton Cushing (Eakins), 27-28, **177**

FRASER, JAMES EARLE, 90-95, 106, **182**, 274, 345-46n; *Lincoln*, 95; *Navy Cross*, 94; buffalo-Indian Head nickel, 94, 116, **183**; *John James Audubon*, 93-94; *Meriwether Lewis*, 93-94; *George Rogers Clark*, 93-94; *Daniel Boone*, 93-94

FRASER, LAURA GARDIN, 90-95, 108, **182-83**, 274, 346n; *Oklahoma Run*, 92, 94-95, 107; *Gen'l Robert E. Lee and Gen'l Stonewall Jackson*, 93-94

FRASER STUDIO COLLECTION, 92-93, 112, 116

FRYXELL, FRITIOF, 225

GAUL, GILBERT, 32, 329n

General Robert E. Lee and General Stonewall Jackson (Fraser), 93-94

George Rogers Clark (Fraser), 93-94

GILCREASE, BARTON, 31, 64, **177**

GILCREASE, DES CYGNE (Mrs. Corwin Denney), 31-32, 64, **177**

GILCREASE, MRS. THOMAS (Belle Harlow), 25, 327n

GILCREASE OIL COMPANY, 6, 24

GILCREASE, THOMAS, 1-43, **176-77**, 243, 257, 271, 280, 286; childhood of, 21-22; his concept of the Institute, 14, 25; with W. F. Davidson, 25-34, 243; financial difficulties of, 36-37; in France, 11-13; death of, 43

GILCREASE, THOMAS, JR., 31, 64-65, **177**

GILLE, AFTON, 112-13, 311

Going Into Action (Schreyvogel), 135

GORDON, JOE W., 113 14, **185**, 242, 312-14, 347n

GRAND CENTRAL GALLERIES, 47, 54, 207, 210, 245

Green Corn Ceremony (Sharp), 249

Green River Crossing (Moran), 320

GRIMES, OTHA, 3, 325n

HALL OF FAME OF GREAT WESTERN MOTION PICTURE ACTORS, 80, 299

HAMBRICK, MISS FREDA, **196**, 314, 370n

HAMMER, ARMAND, 247-48, 355n

HAMMER GALLERIES, 207, 215, 248, 320

HAMMER, VICTOR, 152, **195**, **200**, 207-8, 212, 215, 219, 247-48, 256, 355n

HARP, MERLE FISHER, 96-99, 102-4, 111, 346n

HARTFORD, HUNTINGTON, 52, 228, 337n

HAWN, MR. AND MRS. J. VERNE, 321

HAYS, WILLIAM JACOB, 257, 357n

HEARN, GEORGE A., 282, 360n

HEDGPETH, DON, 85, 344-45n

HEIKKA, EARLE ERIK, 254-55, 356n

HENRI, ROBERT, 76, 263, 269, 343n; *La Trinidad*, 76, 79, 269

HENRY BONNARD FOUNDRY, 259

HENRY, ROBERT L., 162, 171-73

HICKS, GORDON T., 3, 325n

HOOVER, JAKE, 228, 354n

HOPKINS, MR. & MRS. GERALD, 321

Hot Trail, A (Schreyvogel), 135

HULINGS, CLARK, 307

HUMBER, ROBERT LEE, 35, 331-32n

HUNTER, JACK R., 208-10, 352n

Hunters Camp In The Big Horns (Remington), 85, 146-47, 154, **189**

In From the Night Herd (Remington), 316

In Without Knocking (Russell), 87, 229, 354n

It Ain't No Job For a Lady (Russell), 73

JACKSON, ANDREW, 34, 330n

JACKSON, CLARENCE, 227, 354n

James Madison (Peale portrait), 20, 243, 272, 358n

JARVIS, JOHN WESLEY, 33, 330n

Jim and His Daughter (Ufer), 322

John James Audubon (Fraser), 93-94

JOHNSON, E. FRED, 8, 10-11, 326n

JOHNSON, FRANK TENNEY, 246; *Rough Riding Rancheros*, 246
JONES, CHARLES S., 67-71, 83-84, **180**, 342n
JONES-RUSSELL COLLECTION, 67-75, 81-82, 153, 266
JOPLING, R. C., JR., 139, 142-43, 148

KENNEDY GALLERIES, 246
Kennedy Galleries Quarterly, The, 246, 282
KENNEDY, MICHAEL S., 293, 363n
KERR FOUNDATION, 221, 281
KERR, WILLIAM G., 161, **195**, 220-21, 247
KHOURY, J. M., 160, **201**, 219, 249, 284, 355n
KIRKPATRICK, JOHN E., 74-75, 94-95, 100, 113-18, 173, **184**, 343n
KIRKPATRICK, MRS. JOHN, 108, **184**
KNOEDLER'S. *See* M. Knoedler & Company
KREBS, MRS. A. SONNIN, 212, 215, 219, 221
KREBS, SONNIN, 215

La Trinidad (Henri), 76, 80, 269
Last Drop, The (Schreyvogel), 126, 135, 349n
Leader's Downfall, The (Leigh), 87, 246
LEIGH, ETHEL TRAPHAGEN, 41, 50, 54-57, **178**, 245, 336-37n, 339n
LEIGH STUDIO COLLECTION, 41-42, 55-59, **178-79**, 245
LEIGH, WILLIAM ROBINSON, 41-66, 76, 87, **178-79**, 245-46; early career, 43-45; in Africa, 49-51; in the West, 45-49; later years, 53-54. *Bear Hunt in Wyoming*, 47-49; *Big Horn Sheep*, 76, 343-44n; *Buffalo* (bronze), 76, 337n; *Buffalo Hunt*, 246; *Leader's Downfall*, 87, 246
LEUTZE, EMANUEL, 273, 358n
Lewis and Clark and Sacajawea (Lion), 73, **181**
Lewis and Clark and Sacajawea (Russell), 69, **181**, 358-59n
Lin McLean (Remington), 321
Lincoln (Fraser), 95, 109-10, 116, **183**
LINDERMAN, FRANK BIRD, 163-66, **191**
LINDERMAN, RUSSELL rifle, 163-66
LINK, CARL, 77, 162-74, **190-91**, 351n; *Wolf Tail* 77, **191**; *Spider* **191**
LION, HENRY, 73
LOUGHEED, ROBERT, **203**, 300-3
LOVELL, TOM, **203**
LUDWIG, MR. AND MRS. W. B. (DOC), 321

M. KNOEDLER & COMPANY, 70, 84, 146-50, 152-56, **188**, 242-43, 350n, 355n
MCCARTHY, JOHN, 138, 140, 142-44
MCCLOSKEY, JAMES, 282-83
MCCRACKEN, HAROLD, 227-28, 354n
MCCREA, FRANCES DEE, 80, 117, **181**
MCCREA, JOEL, 77-82, 111, 117-18, 145, **181**, **196**, 205, 310, 344n
MCGEE, DEAN A., 110, 116, 233, 347n
MCGEE, MRS. DEAN A., 110, 116
MCGINNIS, WARD, 89
MCLAUGHLIN, CLARENCE T., **203**, 225, 296, 353-54n
MCMURRY, LEONARD, 99-108, **184**, **205**, 310, 314, 346-47n
MARY W. HARRIMAN FOUNDATION, 108
MAY, C. THOMAS, JR., 219, 353n
Meat For Wild Men (Russell), 69, 73
Medicine Man, The (Remington), 321
MELROSE, ANDREW, 28, 328n
MENCHACA, JUAN, 95, 99-104, 109, 311-12, 346n
Meriwether Lewis (Fraser), 93-94
MILLER, ALFRED JACOB, 1, 7, 28-35, 282-84, 324n
MILSTEN, DAVID R., 3, 18, 324n, 327n
MITCHELL, ALBERT J., 319, 370n
MITCHELL, ALBERT K., 116, **200**, 315-20
MITCHELL, ARTHUR, 215, 293, 301-2, 311, 370n
Moose, A (Runguis), 320
MORAN, THOMAS, 28, 160-61, 225-30, 249, 261-62, 329n; *Green River Crossing*, 320; *Mountain of the Holy Cross*, **197**, 225-30; *On the Maine Coast*, 261; *Ponce De Leon in Florida, 1513*, 160-61, 249
MOSIER, O.M. "RED", 130, 235, 254
MOSTELLER, L. KARLTON, 25, 327n
Mountain of the Holy Cross (Moran), **197**, 225-30
MOYERS, WILLIAM, 292-93, 362n
Mr. Gorson (Fechin), 321
MUNO, EDWARD, 85, 301, 344n
MUNO, RICH C., 95, 101-4, 109, 132, 143-44, **185**, **193**, 210, 219, 300, 319-20, 346n; *End of the Trail* project, 95, 101-4; Schreyvogel Studio, 132, 143-44; Fechin Studio, 210, 219; Albert K. Mitchell Collection, 319-20
MURPHY, RICHARD, 95
My Bunkie (Schreyvogel), 119-20, 135

NATIONAL ACADEMY OF WESTERN ART, **202**, 233, 247, 287, 298-304, 306-7, 364-67n
NATIONAL COWBOY HALL OF FAME AND WESTERN HERITAGE CENTER, 67, 70, 74, 150-52, **192**, **206**, 222, 299, 306-9; art collections of, 76-77, 150-52; break with CAA, 286-98; contemporary collections, 306-7; history of, 340-41n; programs of, 306-8; struggle for independence, 74, 222
NATIONAL FINALS RODEO, 76, 343n
Navy Cross (Fraser), 94, 116, **183**
Nearing the Fort (Schreyvogel), 77, **197**, 249
NEUHAUS, EUGENE, 60
NICHOLSON, REX L., 86, 345n

OKLAHOMA CITY INDUSTRIAL AND CULTURAL FACILITIES TRUST, 71-75, 161, 342n
OKLAHOMA CITY CHAMBER OF COMMERCE, 71-72
Oklahoma Run panel, 92, 94-95, 107, **183**
Old Dragoons of 1850, The (Remington), 282, 360n
On the Maine Coast (Moran), 261
On Neenah (Russell), **198**, 269
On Patrol (Schreyvogel), 135
One in a Thousand (Borglum), 321
OS RANCH STEER ROPING AND ART EXHIBIT, 295-97, 363n
OSBORNE, ROBERT, 154-55
Osceola As A Captive (Eastman), 280
OWENS GALLERY, 173

PAYNE, DAVE D., 113-14, 117, **184**
PAYNE, MRS. NONA S., 113-18, **184**, 233, 312, 315, 347n
PAYNE-KIRKPATRICK MEMORIAL, 112-17, **185**, 287
PEALE, CHARLES WILLSON, 20, 243, 272
Persimmon Hill magazine, 85, 294, 301, 308, 363n
PHILLIPS, FRANK, 52, 338n
Pioneer Woman (Baker), 171, 352n
POGZEBA, JOHN, 71, 342-43n
Ponce De Leon in Florida, 1513 (Moran), 160-61, 249
Portrait of Blackhawk and Whirling Thunder (Jarvis), 33, 330n
POSEY, ALEXANDER, 21-22
POST, WILEY, 24

PRIX DE WEST, 299-300, 363n
Proud Possessors, The (Saarinen book), 3

Quanah Parker (Scott), 321
Quarrel, The (Remington), 316
Queen's War Hounds, The (Russell), 317
Quest of the Snowy Cross (Jackson book), 225

RANNEY, WILLIAM T., 320
RAYBURN, BRYAN B., 87, **204**, 312-14, 345n
Ray's Troop (Remington), 316
Recollections of Charlie Russell (Linderman book), 163
Redman's Wireless (Russell), 67, 73, **181**
REISS, WINOLD, 169, **190**, **191**, 351n
REMINGTON ART MEMORIAL, 245, 258, 357n
REMINGTON, FREDERIC, 59-60, 76, 125-28, 146-48, 153-57, 240, 245, 256-59, 264-68, 282, 316-17, 321; and Leigh, 59-60; and Schreyvogel, 125-28; in Mitchell Collection, 316-17; *Arizona Cowboy*, 240, 245; *Bronco Busters Saddling*, 265; *Cheyenne Buck*, **199**, 240; *Coming Through the Rye*, 154-56, **189**; *Comanche Warrior*, 240; *Cowboy Fun*, 265; *Hunter's Camp in the Big Horns*, 85, 146-47, 154, **189**; *The Old Dragoons of 1850*, 282, 360n; *The Scalp*, **199**, 257-59; 357n; *Stampede*, 259, 357-58n; *Wild, Wild East*, 76, 343n.
RENNER, BILL, 311, 314
RENNER, FREDERIC, 35, **195**, 266, 325n, 355n
Rescue at Summit Springs (Schreyvogel), 120
REYNOLDS, CHESTER A., **192**, 309, 340n
RICHARDSON, SID, 35, 335n
ROCKWELL, ROBERT, 86, 129, **200**, 245, 293, 319, 338n, 345n
ROGERS, WILL, JR., 35, 335n
ROMAN BRONZE WORKS, 258-59, 357n
ROOSEVELT, THEODORE, 125
ROSENSTOCK, FRANCES (Mrs. Fred), **201**, 252-53
ROSENSTOCK, FRED, **201**, 249-53, 284, 355n
ROSSI, PAUL A., 11, 65, **179**, 326n
Rough Riding Rancheros (Johnson), 246
ROYAL WESTERN WATERCOLOR SHOW, 306, 368-69n
RUNGUIS, CARL, 320
RUSSELL, CHARLES M., 59-60, 67-77, 80-89, 127-28, 154, 163-66, **180**, 228-29, 245, 263-70, 273-74, 278-79, 316-17, 325n, 358n; C. S. Jones collection of, 67-77; development as a col-

orist, 278-79; Linderman-CMR rifle story, 163-66; A. K. Mitchell collection of, 316-17; and Schreyvogel, 127-28. *Alert*, **198**, 269; *Bad Day in Utica*, 229, 354n; *Battle Between Crows and Blackfeet*, 69; *The Bug Hunters*, **198**, 269; *A Bronc Twister*, 70, 73, 266-67; *Buffalo Hunt*, 70, 73, 263, 317; *Changing Outfits*, 70, 73; *The Cinch Ring*, 85-86, 146-48, **189**; *Counting Coup*, 69, 73; *Custer Battle*, 319; *In Without Knocking*, 87, 229, 354n; *Lewis and Clark and Sacajawea*, 73, **181**; *Meat for Wild Men*, 69, 73; *On Neenah*, **198**, 269; *Redman's Wireless*, 67, 73, **181**; *Scalp Dance*, 70; *Smoke Talk*, 67, 73; *The Wagon Boss*, 264; *The War Party*, 89; *When Mules Wear Diamonds*, 87; *Where the Best of Riders Quit*, 70; *Wild Man's Truce*, 85, 148, **189**; *Wolves Attacking in Blizzard*, 76, 344n; *Worked Over*, 71, 82, 84
RUSSELL, HUBBARD, 78, 344n
RUSSELL, MRS. CHARLES M. (Nancy Cooper), 69, 72-73, 84, **180**
RYAN, TOM, 295-96

SAARINEN, ALINE, 3, 324n
San Francisco Vallejo St. Wharf in 1863 (Stobart), 321
Sand Painter (Couse), 76, 249
SAUNDERS, J. B., 86, 108, 139, 145, 158-61, **187**, **189**, 345n
Scalp, The (Remington), **199**, 257-59, 357n
Scalp Dance (Russell), 70
SCHREYVOGEL, CHARLES, 77, 119-45, **186-87**, 249, 259-60, 348-49n; analysis of themes, 119-23; and Remington, 125-26, 135-36; obituary of, 137-38. *Chief White Eagle*, 126, 135; *Custer's Demand*, 123-26, 128, 133; *Going Into Action*, 135; *A Hot Trail*, 135; *The Last Drop*, 126, 135, 349n; *My Bunkie*, 119-20; *Nearing the Fort*, 77, 249; *On Patrol*, 135; *Rescue at Summit Springs*, 120
"SCHREYVOGEL CLUB," 145, 349n
SCHREYVOGEL, RUTH. *See* Carothers, Mr. and Mrs. Archie
SCHREYVOGEL STUDIO COLLECTION, 134-38, **186**
Scouting Party, The (Ranney), 320
Self Portrait (Fechin), 215
SHARP, JOSEPH HENRY, 249, 331n

SHIRLAW, WALTER, 32, 329n
Sign of the Buffalo Scout (Remington), 316
SINGER, JOE, 321-22
Single Handed (Russell), 317
Sitting Bull (Farny), 255-56
Sketch of a Girl (Fechin), 213-14
Sleep (Ufer), 76, 80
SMITH, C. R., 35, 52, 88, 254, 335n, 338n
Smoke Talk (Russell), 67, 73
SNIDOW, GORDON, 292, 362n
SOLON BORGLUM MEMORIAL SCULPTURE EXHIBITION, 306, 369-70n
SPEED, U. GRANT, 296
STACEY, JOE, 291, 362n
Stampede (Remington), 259, 357-58n
STAR BUILDING COMPANY, 112
STEINKE, BETTINA, 78
STENDAHL, EARL, 35-36, 335n
STEWART, SIR WILLIAM DRUMMOND, 283-84, 360-61n
Still Life (Fechin), 215
STOBART, JOHN, 321
STOUT, CEPHAS, 8, 9, 325n
STRASBAUGH, PAUL B., 71-72, **181**, 342n, 362n
STURGEON, DR. VIOLET, 321
SULLY, ALFRED, 32-33, 329n
SULLY, THOMAS, 32, 329n
Summer (Fechin), 219, 249

TAIT, ARTHUR FITZWILLIAM, **199**, 257, 357n
TAOS SCHOOL OF PAINTERS, 277, 284, 321-22, 359n
Tea In Santa Monica (Mrs. Krag), (Fechin), 76, 210, 215
TEENOR, EUDOTIA, 3, 25, 31-32, 64, **177**, 243, 323n, 325n
THOMAS GILCREASE FOUNDATION, 3, 64-66, 323n
THOMAS GILCREASE INSTITUTE OF AMERICAN HISTORY AND ART, 1-4, 11, 35, 57, 62, 65, 92, 128, 131, 166, 207, 245, 271, 323-24n, 326-27n, 332-35n, 335-36n; art collections of, 17, 26-33, 42, 327n, 332-35n; history of, 323-24n; manuscript collections of, 15-16, 326-27n; Tulsa ownership of, 37-38, 325n, 335-36n
TOWER, SENATOR JOHN, 116-17
TRAPHAGEN, ETHEL. *See* Leigh, Ethel Traphagen
TRAPHAGEN, JOHN C., 57-59, **179**

TROYE, EDWARD, 28, 329n

TRUSTEES' GOLD MEDALS, 307, 370n

TULARE COUNTY (CALIFORNIA) BOARD OF COUNTY COMMISSIONERS OR SUPERVISORS, 96-98

TULARE COUNTY (CALIFORNIA) HISTORICAL SOCIETY, 96-98

UFER, WALTER, 76, 321-22, 343n; *Sleep*, 76, 79

VISALIA, CALIFORNIA, 90, 96-97, 99

VON SCHMIDT, HAROLD, 257, 357n

Wagon Boss, The (Russell), 264

Wagon, Mules and Men (Eggenhofer book), 273

WALLER, MRS. R. O., 164, 167

War Party, The (Russell), 89

WATT, JOE H., 319

WEAR, BRUCE, 11, 66, 326n, 327n, 339n

WENGER, MARTIN, 2, 11, 251, 325n

WERNER, GRACE (Mrs. Herman), **193**, 284

WERNER, HERMAN, 284, 361n

WESTERN ART FUND, 139-40, 142-43, 148, 152-54, 157, 160, 162, 281, 350n

WESTERN HERITAGE AWARDS, 76, 80

When Mules Wear Diamonds (Russell), 87

When Wagon Trails Were Dim (Russell), 317

Where the Best of Riders Quit (Russell), 70, 317

WHIPPLE, LESTER, 25, 323n, 327n

WHITNEY GALLERY OF WESTERN ART, 243

WIEGHORST, OLAF, **203**, 307

WIESENDANGER, MARTIN, 18

Wild Man's Truce (Russell), 85, 146, 148, **189**

Wild Turkey, The (Audubon), 18-20, 30, 271

Wild Wild East (Remington), 76, 343n

WILDER, MITCHELL, 87, 154, 345n

WIMAR, CARL, 280, 320, 359n

WINCHESTER WESTERN GUN COMPANY, 145, 349n

Wolf Tail (Link), 77, **191**

Wolves Attacking in Blizzard (Russell), 76-77, 344n

WOOLAROC MUSEUM, 167, 338n

Worked Over (Russell), 71, 83, 84

WUNDERLICH, RUDOLF, 28, 35, **200**, 246-47, 282, 355-56n

ZUCKERMAN, BERNHARD, 109-11, 314-15, 347n